THE AMERICAN
ANIMATED CARTOON

DANNY PEARY has an M.A. in Cinema from the University of Southern California. He edited the anthology, *Close-Ups: the Movie Star Book,* and has written film criticism for *Focus on Film, Bijou, The Velvet Light Trap, The Boston Globe,* and other publications. He was fine arts and sports editor of *L.A. Panorama.*

GERALD PEARY has coedited two anthologies on the American novel and the movies and *Women and the Cinema: A Critical Anthology.* A former associate editor of *Take One,* he taught film history and criticism at Livingston College, Rutgers University. He is now film critic for *The Real Paper* in Boston.

THE AMERICAN ANIMATED CARTOON

A CRITICAL ANTHOLOGY

Edited by DANNY PEARY
and GERALD PEARY

A Dutton Paperback
E.P. DUTTON · NEW YORK

For information contact: E.P. Dutton, 2 Park Avenue, New York, N.Y. 10016

Library of Congress Catalog Card Number: 79-53348

ISBN: 0-525-47639-3

Published simultaneously in Canada by Clarke, Irwin & Company Limited, Toronto and Vancouver

Designed by Barbara Huntley

10 9 8 7 6 5 4 3 2 1 First Edition

JOE ADAMSON: "Chuck Jones Interviewed." Copyright © 1980 by Joe Adamson. Printed by permission of the American Film Institute and the author. "A Talk with Dick Huemer." Reprinted from *AFI Report* (Summer 1974). Copyright © 1974 by the American Film Institute and the University of California Board of Regents.

ART BABBITT: "Character Analysis of the Goof—June 1934." Reprinted from *Sight and Sound* (Spring 1974) by permission of the author. Copyright © 1974 by Art Babbitt.

TOM BERTINO: "Hugh Harman and Rudolf Ising at Warner Brothers." Reprinted from *Mindrot,* 5 (December 1976), by permission of *Mindrot* and the author. Copyright © 1976 by David Mruz.

PETER BRUNETTE: *"Snow White and the Seven Dwarfs."* Copyright © 1980 by Peter Brunette. Printed by permission of the author.

LESLIE CABARGA: "Strike at the Fleischer Factory." Excerpted from Leslie Cabarga, *The Fleischer Story* (New York: Crown Publishers, 1976) by permission of the author and Crown Publishers. Copyright © 1976 by Leslie Cabarga.

to JOSEPH and LAURA PEARY— loving parents

JOHN CANEMAKER: "A Day with J. R. Bray." Reprinted from the 1975 *Yearbook* of the International Animated Film Society (ASIFA-West). Copyright © 1975 by the International Animated Film Society. "Vlad Tytla: Animation's Michelangelo." Abridged from *Cinefantastique* (Fall 1976) by permission of *Cinefantastique* and the author. "Winsor McCay." Copyright © 1980 by John Canemaker. Printed by permission of the author.

JOAN COHEN: "The International Tournée of Animation—Talking with Prescott Wright." Copyright © 1980 by Joan Cohen. Printed by permission of the author.

E. E. CUMMINGS: "Miracles and Dreams." Reprinted by permission of Liveright Publishing Corporation. Copyright © 1930, 1958 by E. E. Cummings.

SUSAN ELIZABETH DALTON: "Bugs and Daffy Go to War." Reprinted from *The Velvet Light Trap,* 4 (Spring 1972), by permission of the author. Copyright © 1972 by *The Velvet Light Trap.*

SYBIL DELGAUDIO: "Seduced and Reduced." Copyright © 1980 by Sybil DelGaudio. Printed by permission of the author.

WILLIAM DE MILLE: "Mickey *versus* Popeye." Reprinted from *The Forum* (November 1935). Copyright 1935 by *The Forum.*

MANNY FARBER: "Saccharine Symphony—*Bambi.*" Reprinted from *The New Republic* (June 29, 1942). Copyright 1942 by *The New Republic.*

DAVID FISHER: "Two Premières: Disney and UPA." Reprinted from *Sight and Sound* (July–September 1953). Copyright 1953 by *Sight and Sound.*

JOHN D. FORD: "An Interview with John and Faith Hubley." Reprinted by permission of the Mid-America Film Center, Kansas City Art Institute, Missouri. Copyright © 1973 by the Mid-America Film Center. Funded in part by a grant from the National Endowment for the Arts, Washington, D.C.

E. M. FORSTER: "Mickey and Minnie." Reprinted from *The Spectator* [London], January 19, 1934, by permission of *The Spectator.*

GEORGE GRIFFIN: "Cartoon, Anti-Cartoon." Copyright © 1980 by George Griffin. Printed by permission of the author.

WILLIAM HORRIGAN: "Just About Krazy." Copyright © 1980 by William Horrigan. Printed by permission of the author.

I. KLEIN: "On Mighty Mouse." Reprinted from *Cartoonist Profiles,* 20 (December 1973), by permission of the author. Copyright © 1973 by I. Klein.

CONTENTS

PREFACE

With *The American Animated Cartoon,* the reputation of the Walt Disney Studio as the *only* worthwhile producer of American cartoon animation is, we hope, laid to rest forever. We locate an extraordinarily productive alternative tradition outside of *any* studio, from pioneer Winsor McCay before World War I through such contemporary cartoonist independents as George Griffin and John and Faith Hubley. We acknowledge the achievements of non-Disney industry animators, from Paul Terry to Ralph Bakshi, from Walter Lantz to Hanna-Barbera, from J. R. Bray to UPA. Finally, we bring together articles in praise of the still astonishingly underrated Warner Brothers cartoon factory. These last essays pose a serious WB alternative to the artistic hegemony enjoyed by the Walt Disney Studio animation since the early 1930s.

This anthology presents a loosely conceived "auteurist" ladder of cartoon production, with such estimable figures as Winsor McCay, Chuck Jones, Tex Avery, Vlad Tytla, and Max Fleischer catapulting instantly into the pantheon; they are challenged by other animation giants such as Art Babbitt, Ralph Bakshi, Bob Clampett, Otto Messmer, and John Hubley. If we utilize Andrew Sarris's provocative categories in *The American Cinema* (1968), are not Ub Iwerks, Robert McKimson, and Bob Cannon all Expressive Esoterica? And Frank Tashlin too, as much for his Warners Porky Pigs as for his live-action Jerry Lewis pictures? Perhaps the more impersonal Walter Lantz and Friz Freleng and early Hanna-Barbera are *metteurs,* or skilled artisans, instead of true *auteurs.*

How to crack open the Disney monolith? Who is the auteur of *Fantasia* or *Pinocchio* or *Bambi*? Essays herein about Vlad Tytla and by Art Babbitt suggest paths for future animation historians: breaking down the Disney films into individual sequences and determining which animators worked on each. Only afterward can we discuss the artistry of such obviously inspired Disney animators as Ward Kimball, Frank Thomas, Shamus Culhane, Grim Natwick, and Ben Sharpsteen. For now, note the special and groundbreaking contributions of *The American Animated Cartoon:* a critical appreciation of Robert Clampett, the only interview with Robert McKimson, a rare essay on Krazy Kat cartoons, plus E. M.

Forster and e. e. cummings on animation. Fifteen articles were prepared especially for this book. Only two essays have previously been anthologized.

Although *The American Animated Cartoon* celebrates its subject, we also keep in mind that cartoons shape consciousness, just as any film genre does; and animators are responsible to charges of gratuitous violence, racism, or sexism. The feminist critique by Sybil DelGaudio, "Seduced and Reduced: Female Animal Characters in Some Warners' Cartoons," is a role-model study that prefigures more careful scrutiny—political, ideological, semiological, psychoanalytic—of animated films to come.

On the same point, it is foolish to regard animation studios, businesses all, as repositories of fairy-tale, utopian values. In order to encourage an unclouded and non-nostalgic perspective on cartoon animation, we include two key historical pieces: a report on the labor strike at the Fleischer factory, and Walt Disney's testimony alleging Communist infiltration of Hollywood, delivered voluntarily before the House Committee on Un-American Activities.

Addendum: if you wish to read more about cartoon animation, these are the choices: *Funnyworld,* an excellent magazine of articles and interviews (Bakshi, Jones, Clampett) edited by Michael Barrier, P.O. Box 1633, New York, New York 10001; *Cartoonist Profiles,* mostly about newspaper cartoonists, P.O. Box 325, Fairfield, Connecticut 06430; *Millimeter,* a slick magazine of film production with minimally one animation article per issue, often on a young independent or commercial animation artist, from 12 East 46th Street, New York, New York 10017; *Filmmakers Newsletter,* much the same as the other magazines, but featuring a chatty column, "Animation Kit," by Howard Beckerman, at Filmmakers Newsletter, 41 Union Square West, New York, New York 10003; and *Mindrot,* a lovingly amateurish fanzine of cartoon gossip, quotes from animators, invaluable filmographies, and, very occasionally, a penetrating article; a "must" for cartoon devotees, available from David and Kathy Mruz, 3112 Holmes Avenue South, Minneapolis, Minnesota 55408.

We are extremely grateful to Mike Barrier, Jon Bloom, Cori Wells Braun, Paul Brenner, Leslie Cabarga, Carol Carey, Frederick S. Clarke, Mary Corliss, Susan Elizabeth Dalton, Tissa David, Kevin Finneran, June Foray, Greg Ford, Woody Gelman, Kathy Gorka, Ron Hall, Jud Herd, Faith Hubley, Pamela Jameson, Mark Kausler, Mary V. Kelly, Richard Koszarski, Maggie Kusick, Walter Lantz, Paul MacLardy, Ruth McCormick, Myron Meisel, David Mruz, Bob Nowacki, Linda Peterson, Suzanne Rafer, Barbara Reiss, Lenny Rubenstein, Charles Samu, Ronnie Scheib, Roger Shatzkin, Charles Silver; ASIFA-West; Eddy Brandt's Saturday Matinee; King Features; Metro-Goldwyn-Mayer; *Movie Star News;* The Museum of Modern Art's Film Stills Archive; Walt Disney Productions; and to our editor, Cyril I. Nelson.

EARLY
HISTORY

The Early History of Animation

by CONRAD SMITH

I envision the day when 100,000 men and women will be turning out animated comic strips to be televised over the networks under the sponsorship of breakfast foods' manufacturers for the entertainment of the nation's children.

—WINSOR MCCAY, radio broadcast (1934)

I. A Heritage of Newsprint and Vaudeville

The end of the nineteenth century was a period of immense growth for the American newspaper. Between 1870 and 1900 daily circulation rose from 2.6 million to 15 million copies. This same period saw a popularizing of the use of cartoons in newspapers, providing a number of early animators with the first mass market for their artistry. Sidney Smith, who released three Old Doc Yak cartoons in 1913 and then quit animation to devote his efforts to the "Gumps" newspaper strip (for which he was paid $100,000 per year), started as an artist on the *Bloomington Sun Eye* in 1895. About the same time J. Stuart Blackton (who later founded Vitagraph with Albert E. Smith and W. T. Rock sold his first cartoon to the *New York World.*

Winsor McCay became an artist and illustrator for the *Cincinnati Commercial Tribune* in 1897. John R. Bray started as a staff artist at the *Detroit Evening News* in 1900 and then moved to New York in 1901, where he met Max Fleischer while they both worked in the art department at the *Brooklyn Daily Eagle.* Also in 1901 Raoul Barré's caricatures about Indians and the life-style of French Canadian women were published as *En Rolant Ma Boule.* A few years later Paul Terry started as a cartoonist for the Hearst newspapers, and Wallace Carlson began drawing sports cartoons for the *Chicago Inter-Ocean.*

Not all of these men drew comic strips, but the newspaper comic strip, which had its origin in the circulation wars of the 1890s, was the predecessor of the animated cartoon. The two principal figures in early animation history, Winsor McCay and John Bray, both drew newspaper comic strips before they started their experiments in animation. McCay drew *Little Nemo in Slumberland* and

many other strips for the *New York Herald* and other newspapers. Bray drew a colored strip for the McClure newspaper syndicate.

McCay and J. Stuart Blackton had also traveled on the vaudeville circuit giving "chalk-talks," which were something like slow-motion animation. Blackton gave chalk-talks in the 1890s, and his *Humorous Phases of Funny Faces* (1906), usually considered to be the first animated film, is little more than a film record of a chalk-talk. *Little Nemo* (1911), the first full animation (Emile Cohl, preceding Winsor McCay, had animated outline figures in *Fantasmagorie* [1909], which moved in a less fluid fashion), reveals McCay's background with circus and carnival shows. The characters Flip and Impie move through fluid body distortions like reflections in a carnival hall of mirrors.

II. Evolution of the Animation Process

> *The artists who are doing this work have learned how, after weeks and months of scheming and labor. The successful ones have evolved systems which they guard as jealously as a miser does his gold, and for obvious reasons, too. When these secrets are explained to an outsider, the confidence is kept and not published.*
> —MARTIN JAMESON, "With the Cartoonists in Filmland" (1917)

Although it seems impossible to determine absolutely who first developed many of the basic animation techniques, it is possible to reconstruct these developments partially by viewing the extant films, citing the few available sources, and examining the relevant patents. Frame-by-frame examination of *Humorous Phases of Funny Faces* shows that three to six identical frames of each "position" of the drawing on the blackboard make for crude and jerky movement. Because this does not constitute "frame-by-frame" animation, and because it does not involve the use of separate drawings on discrete sheets of paper, it will not be considered as "animation" here. Emile Cohl's early work, such as *Fantasmagorie,* certainly qualifies as animation, yet information on its techniques or patent registration is unavailable.

The techniques used in Winsor McCay's first film, *Little Nemo* (1911), can be pieced together from careful examination of the filmed introduction. The drawings, which have crosses in the corners to control registration, were drawn on translucent (rice) paper and mounted on pieces of cardboard about nine inches square. The technique is probably the same as that used later in *Gertie the Dinosaur* (1914).

After each drawing was completed, and a serial number assigned to it, marks for keeping it in register with the other drawings were placed on the upper right and left corners. To facilitate handling and the photographing of the drawings, mounting them on slightly larger pieces of light cardboard became the next step. The left side and bottom of these mounts were cut at an absolute ninety degree angle, and the register marks printed on them had to correspond exactly with the

location of the register marks on the tissue drawings, which marks had to be placed precisely over those on the cardboard. The purpose of being so critical regarding this phase of the operation was the urgency of eliminating all unnecessary vibration of the picture on the screen.[1]

The finished drawings were mounted in a wooden frame in front of a horizontal camera. The bottom and left edges of the slot in the frame were the reference for registration. Before the drawings were photographed, the action was checked on a Mutascope-like device for smoothness. This may explain why the movement in McCay's early animation is so much cleaner and more realistic than in other early animated films.

Raoul Barré, who in 1913 established the first studio capable of producing animated cartoons in quantity, is credited with developing registration pegs and punched holes in the drawings to hold them in place. John Fitzsimmons also remembers coming up with the idea of registration pegs and punched holes in the drawings while helping McCay make *The Sinking of the Lusitania* (1918). The first animation "cycle" appears to have been introduced by Winsor McCay in *Little Nemo.* The same seven cels, depicting the motion of a cigar in Flip's mouth from a horizontal to an upward position, are used six times to constitute three successive up-and-down movements of the cigar. McCay's next film, *How a Mosquito Operates* (1912, also called *The Story of a Mosquito*), makes much more extensive use of animation cycles, as does *Gertie.*

McCay also deserves the credit for the first color animation. For display in his live vaudeville act, he hand-colored each frame of at least one of the prints of *Little Nemo* by March 1912. The existing remnant of this hand-colored print is a magnificent display of muted pinks, oranges, and reds, reminiscent of the look of Sunday comics of that era.

John Bray's first animated film, *The Artist's Dream* (or *The Dachshund and the Sausage*), was released in June 1913, followed by the July 1913 exhibition of the first of Sidney Smith's Old Doc Yak series. In December 1913 Bray released *Colonel Heeza Liar in Africa,* the first title in the Colonel Heeza Liar series. On January 9, 1914, he filed an application for a patent on his animation process, using stills from *Colonel Heeza Liar in Africa* as illustration. The patent, issued in August 1914, describes a method of registration using a long horizontal line with a right-angle vertical mark. It also describes the process of saving labor by printing copies of the background on translucent paper. These translucent sheets were *not* used as cels by placing them over a drawing. The purpose of printing the drawings on translucent paper, as described in the patent (1,107,193), was only to facilitate the positioning of moving objects in successive drawings.

In this patent Bray essentially says he invented the entire animation process himself:

[1] John A. Fitzsimmons, "My Days with Winsor McCay," unpublished typescript in the Woody Gelman collection at Nostalgia Press, Franklin Square, New York, pp. 21, 22.

... what I claim as new and desire to protect by Letters Patent is:
1. The process of producing moving pictures which includes the producing on separate sheets of translucent material a series of pictures, showing the same movable object in successive positions, and photographing said pictures in succession on a kinematograph film, the proper position for the object in each picture being secured by superimposing the sheet upon which the object is to be shown upon the sheet showing the object in the last successive position and with guide marks in registry, whereby the object shown on the second-mentioned sheet is visible through the first-mentioned sheet.

In other words, the process is the same that McCay had used two years earlier! Fitzsimmons remembers that a man claiming to be a journalist visited McCay to learn about his animation process shortly before this patent was filed, and that McCay was sued for infringement after the patent was issued. The suit was filed by Bray Studios. However, even if Bray did steal some of the information, his concept of mass-producing the backgrounds through printing was a major contribution to animation technology.

Another Bray patent (1,159,740), which was filed in July 1914, describes a method of shading by affixing solid cutouts to the back of drawings in such a way that they are visible from the front of the drawing. The third Bray patent (1,179,068) describes a process that was, in essence, cutout animation. The application for this last of the Bray patents was filed in July 1915.

Meanwhile, Earl Hurd of Kansas City had filed an application for a patent on the cel animation process. The way he used cels was somewhat different from the way it was later done, but the patent was written in such a way that it would cover all cel animation. Filed on December 9, 1914, and granted in June 1915 (1,143,542), Hurd's was probably the most basic and significant of the early animation patents.

During 1915, while John Bray and Earl Hurd were improving their animation methods, Max and Dave Fleischer were developing the process that they patented as Rotoscope. Max was Art Editor of *Popular Science* and was fascinated with mechanical gadgets. His brother Dave helped.

I used up every cent I had on the machine—about $100. . . . We built the machine, but we had nowhere to work it, so our missus said we could use the living room, if we didn't upset it too much. . . . We did make the room look very bad, I guess. We had electric wires from the chandeliers, motors, etc.[2]

The application for the Rotoscope patent was filed in December 1915 and granted in October 1917.

In most of these early studio cartoons, in-between cels were simply omitted. If a character turned his head from profile toward the viewer, one drawing of each of the positions sufficed. Thus, the movements of these early studio efforts tended

[2] Max Fleischer, "Max Fleischer Autobiography," unpublished typescript, Film Study Center, The Museum of Modern Art, New York, p. 2.

to be mechanical and jerky, with no effort to accelerate or decelerate movements, nor any effort to draw a few extra cels to make the motion smoother and more fluid. In one cartoon, I counted a 106-frame hold to allow the audience to read a caption in a balloon over the subject's head (*Colonel Heeza Liar, Hobo*). During the entire seven seconds nothing on the screen moved! Holds in the action for one or two seconds were common in all early studio animation.

By 1916 both Bray and Barré were producing one cartoon per week. It is common to see reflections from the cels, and fairly common to see mistakes in which a background was not moved every time it was supposed to. The result is sudden jerks in the otherwise smooth action of the panorama that passes behind the cartoon character while he runs, drives, swims, or whatever. Very few movements received less than two exposures per position, but the panoramic backgrounds were an exception. These were usually moved every frame (not to do so would cause severe strobing, especially at sixteen-frame projection speed). Since the eye can much more easily perceive changes that occur at a rate of eight per second than those that occur at sixteen per second (the eye retains images for about a tenth of a second), the double-framed movements looked much more jerky than if they had been done with a movement for each frame.

Also in 1917, Bray and Hurd combined their patents and formed the Bray Hurd Company. Subsequently, all major animators, including Winsor McCay, Walt Disney, and all of the Bray people who left his organization to form their own studios (such as Max Fleischer and Paul Terry), had to pay royalties to Bray and Hurd for the rights to the Bray-Hurd process.

III. Who Perfected the Animated Cartoon?

> [*J. Stuart*] Blackton says he believes he drew the first motion picture cartoon twenty years ago [*in 1896*]. —WALLACE CARLSON, "The Animated Cartoon" (1916)

> *The part of my life of which I am proudest is the fact I was the first man in the world to make animated cartoons. One or two other cartoonists have claimed this honor, or it has been claimed for them, but the facts are so well known that the claims have never been taken seriously.* —WINSOR MCCAY[3]

> *I produced the first life-like animated drawing that was ever made, and called it Ko-ko the Clown in Out of the Inkwell.* —MAX FLEISCHER

> *John R. Bray [was] the man who made the animated cartoon possible.* —JOHN R. BRAY[4]

French sources tend to credit Emile Cohl with the invention of animation. Although all of the people quoted (or described) above made important contributions to the development of film animation, Winsor McCay was the first to release a film that contained frame-by-frame animation and fluid, sophisticated move-

[3] Winsor McCay, "Movie Cartoons," *Cartoon and Movies Magazine* (April 1927), p. 14.

[4] John R. Bray, "Development of Animated Cartoons," *Moving Picture World,* 21 (July 1917), p. 395.

ment. While John Bray may have developed the same process independently (various accounts say he started working on his first animation in 1909 or 1910), he didn't unveil it until more than two years after the release of *Little Nemo*. It is probably fair to say that, in America, McCay realized the visual potential of the animated film, and that Barré and John Bray brought about the mass production of cartoons by their worktable compromise between quantity and quality.

As an artist, McCay received tributes from nearly all of his contemporary cartoonists. Wallace Carlson, who later worked for Bray, wrote in 1916, "To Winsor McCay probably belongs the honor of first perfecting this filming of cartoons." Martin Jameson wrote in *Cartoons* magazine in 1917: "Winsor McCay a few years ago opened up his pandora's box of ideas and out flopped the first animated cartoon." Paul Terry, who worked for Bray in the 1916–1917 era and went on to such fame in animation that he is considered to be one of the pioneers himself, credits McCay with arousing his initial interest:

> Together with more than a hundred other artists, I attended a dinner in 1914 at which McCay spoke. He showed us his cartoon "Gertie, the Dinosaur." It was the first animated cartoon we had ever seen, and as McCay told us his ideas about animation as a great coming medium of expression, we really hardly knew what he was talking about, he was so far ahead of his time.

The same 1940 Terrytoons publicity release says: "To McCay, Terry pays unstinted tribute, not only as the man who inspired him to start in the animation field, but as the artist whose knowledge, ability and keen vision were actually responsible for launching this uniquely American art-business."

Ironically, McCay stopped experimenting in animation. His later works, such as *The Centaurs* and *Gertie on Tour* (both c. 1918–1921), indicate the use of cels and many of the animation shortcuts characteristic of studio-produced animation. In *Gertie on Tour* the same back-and-forth motion on her hind legs that took an eighteen-cel cycle in the original *Gertie* (each drawing photographed only once) is accomplished with six cel assemblies, each one photographed two or four times. In *The Centaurs* there is a forty-frame hold as the centaur looks off to screen left; there is no movement at all for two and a half seconds.

IV. The Films of the Early Animators

Winsor McCay did not start out to mass-produce his animated films, and the meticulous care with which he worked, despite the absence of timesaving devices such as cels or printed backgrounds, is quite evident in the quality of motion seen in *Little Nemo, How a Mosquito Operates,* and *Gertie.* Generally, there is only one exposure per drawing, and the movement is very smooth. The wavering background in *Gertie,* because of the traced but stationary lines, is quite distracting. The wavering stationary lines in the earlier *Mosquito* are less evident.

The early Grouch Chaser cartoons by Barré are inserted into live-action stories. The live action is necessary for this purpose, because the quality of the an-

imation represented is abysmal. After a situation is established, such as the boy-friend flirting with another woman, a close shot of a book of Grouch Chaser cartoons is cut in to introduce the animation. It is strictly black-and-white, with no shading and very little imagination. The motion is jerky: incoming waves, for example, receive five exposures per drawing.

In a typical Grouch Chaser sequence the "henpecked" Mr. Hicks, who is about a third the size of his domineering wife, dreams he goes to Heaven and flirts with a seductive angel. He eventually falls from the cloud and lands in the arms of his wife. Another sequence is filled with crudely executed adolescent gags about the boarders in Silas Bunkum's boardinghouse. Another scene in the Grouch Chaser series find Silas stranded on a desert island, where an elephant rocks back and forth on its hind legs, much like Gertie. And there is a rather bizarre sequence in a Silas Bunkum used as an excuse to introduce a dancing pig and duck, the pig doing impersonations of John D. Rockefeller, Teddy Roosevelt, and other notable people of the era.

The early Colonel Heeza Liar films, such as *Colonel Heeza Liar and the Pirates* (1916) and *Colonel Heeza Liar, Hobo* (1916), illustrate a remarkable sense of both economy of drawing and promotion of the Bray Studios. Although *Hobo* is more than 1,600 frames long, there are only a few more than a hundred basic arrangements of the cels. There are numerous "hold" positions of sixteen frames and extensive use of cycles. Nearly all the movement is filmed at two exposures per cel assembly, with one short four-frame sequence, in which the Colonel jumps into the air, shot at one exposure per artwork position. The story is simplistic. (Again, the Colonel is a diminutive, henpecked man with a domineering wife three times his size, reminiscent of the Mr. Hicks sequences animated by Barré studios.) The wife drags the impatient Colonel along with her on a shopping trip and overrules every decision he makes. The drawings are of fairly good quality, with shading and complete background. Although the story is weak and the movement quite jerky, these cartoons show the presence of some artistic talent, at least, and hint at the still-unrealized potential for quality in the movements.

The self-promotion of the Bray cartoons is perhaps unequaled until Disney. The title of the film *Colonel Heeza Liar, Hobo,* proclaims in bold type that it is an animated cartoon by (larger type face) J. R. BRAY, THE FAMOUS CARTOONIST. Under the small, 1916 copyright notice the viewer is further informed that the animation process is patented by THE BRAY STUDIOS, INC., with dates of the first three patents. And each title card within the body of the cartoons contains a borderline around the words, in caps, BRAY STUDIOS, INC.

Earl Hurd produced the Bobby Bumps series of cartoons for Bray Studios. Early titles such as *Bobby Bumps and the Detective Story* (1916), *Bobby Bumps—Hypnotic Eye* (1916), and *Bobby Bumps in Before and After* (1916?) are examples of story lines that sound like good cartoon material but that are animated in a stiff, mechanical fashion. *Hypnotic Eye* relates a situation in which Bobby and his dog attend a hypnotist's performance, the dog becomes hypnotized and howls, causing the boy and dog to be kicked out of the theatre. But they get their money

back, plus some, by hypnotizing the streetcar conductor into believing that they have not only paid the fare but have change coming as well. In *The Detective Story* a dime novel comes to life, and Bobby and his dog walk through the pages. The father confiscates the undesirable magazine and starts to read it himself. Bobby cuts a hole in the ceiling and lowers the dog to retrieve the novel.

Max and Dave Fleischer's *Tantalizing Fly* and *Clown's Little Brother* (both 1915?) illustrate considerably more cleverness than any of the cartoons being made at the Bray Studios. In *Tantalizing Fly* Max draws the clown, which comes to life. A fly eludes attempts to catch it by both Max and the animated clown on the drawing board. Max tries to swat the fly, but hits the clown instead. The clown steps off the drawing board and picks up a drawing pen in an effort to hit the fly. He succeeds, however, only in spattering ink over everything, including Max's face. The fly is finally captured in the inkwell. *Clown's Little Brother* is even more interesting. The clown rides a small house cat and fights with it in a very believable-looking application of the Rotoscope technique. The technical quality of the real background action is not quite up to the quality of the animated clown, but the synchronization of movements is precisely and expertly done.

Although Wallace Carlson does not receive much mention today, his early Dreamy Dud series (begun in 1915) holds more visual interest than the work of either Hurd or Bray. In *Dud's Geography Lesson* (1920) there is a particularly striking dream sequence in which Dud falls asleep during a geography lesson. Dud dreams he is traveling in a balloon and lowers the anchor to earth to fetch all the people who have given him a difficult time. Included are the constable who chased him away from the swimming hole, the schoolmate who tattled on him, and the teacher who required him to stay after school because of the frog he let loose in the classroom. We see the balloon from above, the ground sliding smoothly and distantly beneath it. The camera angle changes often and imaginatively until Dud is out in space with the revolving earth behind and below him. At this point, he parachutes back.

The early Paul Terry cartoons (*Farmer Alfalfa's Catastrophe* [1916] and *Farmer Alfalfa's Wayward Pup* [1917]) are the first to prefigure the visual style of the Hollywood cartoons of the 1930s and 1940s. The plot may be simple, as in *Catastrophe,* where Farmer Alfalfa is simply trying to get rid of his cat, Glue (by sinking him in a well and a pond; by nailing him into a box of dynamite). In *Wayward Pup,* the pup steals the farmer's pipe. But the characters have more dimensions than the earlier stereotypes Bobby Bumps and Colonel Heeza Liar.

V. Bray, the Aggressive Businessman, McCay, the Passive Idealist

By all rights, McCay could have patented the basics of the early animation process, including the essential concepts of registration marks, drawing on translucent paper, holding the cels in register while they were photographed, and so on. But McCay didn't bother even to copyright his films (in fact, at least one imitation of *Gertie* was made during the early era of animation). When a stranger knocked at McCay's door asking about the animation process he had developed, he gladly

shared his knowledge from a love of what he was doing. McCay hired his neighbor, Fitzsimmons, and his friends from Cincinnati. He financed his projects from his own earnings.

J. R. Bray, on the other hand, was an astute businessman, helped by his wife Margaret. He patented the basic animation process, which had been used by at least three others (McCay, Raoul Barré, and Sidney Smith, who never thought of protecting themselves) before he filed his patent application and immediately set out to collect royalties from everyone who was making animated films. When Bray's wife Margaret saw Paul Terry's first animated cartoon, she promptly told him he would have to pay royalties to the Bray Studios for the rights to the process.

Bray was wise enough to persuade Earl Hurd, holder of the most important (cel) patent, to join with him so they could share the profits from their "pooled" resources. He was astute enough to hire talented people like Max Fleischer, Paul Terry, and Wallace Carlson, and thus "incorporate." Bray sold his films aggressively, and collected royalties from all who tried animation, charging $630 up front plus 10 cents per negative foot in a 1929 contract with Max Fleischer.

VI. Television Discovers 1915

The cycle has come full circle. Tuning in on the American commercial television networks any Saturday morning, we can see crude, characterless animation reminiscent of the early studio efforts around 1915. Whole scenes are shot with only the character's mouth moving through three basic positions that are used to express the whole English vocabulary; unimaginative panoramic backdrops repeat themselves so quickly that even children notice when their attention is drawn to it. The plots are often crude, with banal dialogue added to the mediocre artwork as an expression of modern technology.

Surely, this is not what Winsor McCay envisioned when he predicted that 100,000 animators would be working to bring cartoon animation to the nation's children over the commercial networks. Perhaps it is fortunate that he did not live to see the demise of cartoon animation as he knew it.

(*above*) Pioneer animator Otto Messmer, the man who brought Pat Sullivan's Felix the Cat to life. (Photograph by Cori Wells Braun, 1977) (*below*) J. R. Bray's *Colonel Heeza Liar in Africa* (1913). (Courtesy The Museum of Modern Art/Film Stills Archive)

Winsor McCay

by JOHN CANEMAKER

It is fortunate that we have Winsor McCay's animation at all. As John Canemaker has written elsewhere (Millimeter, April 1975), the long-lost classic films were "discovered" in Irving Mendelsohn's garage in Great Neck, Long Island, in 1947. They had been sitting there—perishable, flammable, 35mm nitrate movies in rusted cans—since McCay's son Robert had given them over to Mendelsohn, a friend "in fabric" of Winsor McCay, many years before.

Between 1947 and 1967 the films were painfully restored, with 16mm reduction prints made from the nitrate. In 1966 The Museum of Modern Art offered a showing of McCay's work; and there was a key McCay retrospective at Canada's Expo '67 Animation Symposium. The ten known McCay films, whole and fragmented, which establish his reputation among the greatest geniuses of animation, are housed in Montreal's Cinémathèque Québecoise on 35mm and 16mm safety film. The remaining original nitrates are in The Library of Congress.

Winsor McCay (1871–1934) was among the earliest experimenters in animated films; he created his films by himself, for himself, and never explored the commercial possibilities in mass-produced animated series. In this respect, McCay has much in common with today's crop of independent animation filmmakers. His patient experimentations with motion, timing, characterization, and even color, in his small oeuvre—ten known films—plus the exquisite quality of most of his work reveal Winsor McCay to be spiritually, if not chronologically, the true "father" of the art of animation.

Although he never achieved the fame or financial rewards in animation that he garnered as a comic-strip artist, McCay claimed late in his career, a few years before he died, "The part of my life of which I am proudest is the fact that I was one of the first men in the world to make animated cartoons."

Winsor McCay was born on September 26, 1871, in the woodlands of Spring Lake, Michigan. He was briefly a student at Ypsilanti Normal School, and it was here that he received his only instruction in art. McCay studied perspective under Professor John Goodison, a teacher of solid geometry. Then, in the great American tradition of artist-adventurers, he took to the open road. He landed in Chi-

cago where he worked for a poster company specializing in garish colored wood-cuts for traveling circuses and melodramas.

McCay may have traveled as a sign painter with one of the traveling carni-vals, for he arrived in Cincinnati around 1889 and became "a poster and scenic artist" for a resident freak show—Kohl and Middleton's Vine Street Dime Mu-seum. He lived in a room on the top floor of the museum and turned out a seem-ingly inexhaustible series of colorful freak art. This contact with "bearded women, sword-swallowers, fire-eaters, and similar attractions" would provide McCay with a taste for the fantastic, the exotic, clowns, distortion mirrors, and carnival/circus motifs that would enrich and enliven his newspaper and animation art.

During his fifteen years in Cincinnati McCay contributed illustrations to the *Cincinnati Commercial Tribune* and drew a series (from January 18 to November 1903) for the *Cincinnati Enquirer*'s Sunday supplement titled *Tales of the Jungle Imps* by Felix Fiddle. The success of the Imps series attracted the attention of James Gordon Bennett, publisher of the *New York Herald* and the *New York Eve-ning Telegram,* and he wooed McCay to New York in 1903 to work as a staff il-lustrator on his papers covering crimes, trials, and social events. For Bennett's newspapers, McCay created his early comic strips, *Hungry Henrietta, Little Sammy Sneeze, Pilgrim's Progress, Dream of the Rarebit Fiend,* and his greatest work, the epic strip *Little Nemo in Slumberland,* which began in the *New York Herald* on October 15, 1905.

McCay married Maude Dufour, a Cincinnati debutante, in 1891 and their son, Robert Winsor, and daughter, Marian, were the models for Little Nemo and the Princess of Slumberland. In this and in his other comic strips McCay began experimenting with animation principles, for example, progressive changes in characters and settings within the cartoon panels; metamorphosis, and sequential poses (or angles) of architecture.

Little Nemo in Slumberland was translated into several languages and McCay's newly found fame, plus his drive and flair for the theatrical, enabled him to devise and star in his own vaudeville act, in which he toured successfully for eleven years. In his twenty-minute act, which opened at Keith and Proctor's 23rd Street Theatre in Manhattan in June 1906, McCay first drew members of the au-dience at random. The pit orchestra played a two-step by Fred Day titled "The Dream of the Rarebit Fiend," a tune "full of queer, unexpected musical phrases of an amusing nature."

The major section of McCay's act was "The Seven Ages of Man," a series of forty chalk drawings, drawn and erased one every thirty seconds, depicting facing profiles of a man and a woman getting progressively older as the orchestra played "Ah, Sweet Mystery of Life." John A. Fitzsimmons, a teen-aged neighbor of the McCay family in Sheepshead Bay, New York, often watched the master artist at work at home and on the stage. "I never ceased to be amazed," claimed eighty-six-year-old Fitzsimmons recently. "The directness with which he could finish a complicated piece of art work was simply fantastic. . . . [D]uring the blackboard segment of his act with chalk and eraser he altered with lightning strokes the fea-tures of first one and then the other of two facing infant heads he had sketched . . .

With deftly placed strokes and erasures here and there, he carried the boy-girl theme of this fascinating demonstration through all the periods of romance and love from infancy to extreme old age."

The August 31, 1906, *New York Telegraph* detailed McCay's hectic professional schedule:

> In addition to playing twice a day at Hammerstein's for the past four weeks, Mr. McCay in that period drew four full-pages of *Little Nemo,* four one-half pages of *Rarebit Dreams,* four three column *Rarebit Dreams,* four three column *Dull Cares,* drew a twenty four sheet design, an eight sheet design, and a three sheet design for the Klaw and Erlanger production of *Little Nemo;* also designed a scene for that big spectacle, and in his odd moments while going to and from meals dashed off a souvenir cover and a programme cover for a theatre.

Finally, a three-act, twelve-scene "musical extravaganza" based on McCay's *Little Nemo* comic strip had music by Victor Herbert and employed almost 200 actors and stagehands.

Discovering Animation

McCay once wrote about how he became interested in making animated films: "Winsor, Jr., as a small boy, picked up several flippers of 'magic pictures' and brought them home to me. From this germ I established the modern cartoon movies in 1909 . . ." John Fitzsimmons describes these "magic flippers" in more detail:

> The *New York American* had a Sunday supplement, a half page of the comic section, a little heavier than the news stock. Whoever made it drew a series of pictures you could cut out and put together with a rubber band and flick through your fingers. We were talking about that one day. That must have been the start because they were a novelty, they had advertising, some drug company. It got to be a fad for kids. Get these things, cut them out. I know he was talking about it.

In 1906 newspaper cartoonist J. S. Blackton's short animated film *Humorous Phases of Funny Faces* had delighted movie audiences, and a few years later the imported shorts of French animator Emile Cohl proved popular. Both Blackton's and Cohl's techniques were as simple as their elementary drawing styles, for example, circle faces and stick figures. McCay was to bring something new to this "novelty" field: the glimmerings of a possible new art form.

Fitzsimmons remembers that McCay finally made his first film as the result of a friendly bet with cartoonist-cronies George *(Bringing up Father)* McManus (who from 1912 to 1914 worked on animated films with Emile Cohl during the Frenchman's brief stay in America), Thomas "Tad" Dorgan, and Tom Powers:

> . . . [T]he three or four of them were down in a saloon near the old *American* building at William and Duane Streets right under the Brooklyn Bridge. . . . I

think McManus kidded McCay because he was such a fast worker ... Jokingly, McManus suggested that McCay make several thousand drawings, photograph them onto film and show the result in theatres ... McCay claimed he would produce enough line drawings to sustain a four or five minute animated cartoon showing his *Little Nemo* characters and would use the film as a special feature of his already popular vaudeville act.

McCay had no precedents to study for his animation techniques; he was pioneering all the way. Silent movies flashed sixteen frames per second onto the screen and, according to Fitzsimmons, McCay "timed everything with split-second watches. That's how he got nice smooth action. For every second that was on the screen McCay would draw sixteen pictures ... He had nothing to follow, he had to work out everything for himself."

McCay's first three animated films were animated on six-inch by eight-inch sheets of translucent rice paper, the drawings were lightly penciled in first, then details were added in Higgins black ink with Gilliot #290 pens in holders. Fitzsimmons recalls, "After each drawing was completed, and a serial number assigned to it, marks [crosses] for keeping it in register with the other drawings were placed on the upper right and left corners." As each scene progressed to the "mounting" stage, the animation was checked for "smoothness of action" on a device McCay built based on a penny-arcade viewing machine. It was a box, twenty-four inches by twelve inches wide and twenty inches high, open at the top with a shaft running through it onto which a hub containing slits held the drawings. A crank revolved the hub and the drawings while a brass rod running across the top caught the cards momentarily, thus creating the interruption of vision provided by the shutter of a projector.

The Films

Little Nemo (1911). Approximately 4,000 drawings were photographed onto one reel at the Vitagraph Studios in Brooklyn by Walter Austin, with a live-action prologue directed by James Stuart Blackton. The prologue featured McCay, George McManus, various Vitagraph executives, and John Bunny, the screen's first "star" comedian. Completed in early January 1911, the film was shown on April 12 as part of McCay's vaudeville act at New York's Colonial Theatre on Broadway near 63rd Street. In the *New York Dramatic Mirror* of March 29, 1911, Vitagraph announced it was releasing the film on April 8 ("Winsor McCay, Famous Cartoonist of 'The New York Herald' with his unique moving picture comics. A distinct novelty. Approximate length, 647 feet.").

An odd review appeared in the *New York Telegraph;* it fully described *Little Nemo*'s live prologue but not the animation!

> Something new in the line of novelty entertainment was provided by the sketch artist, Winsor McCay. "Moving pictures that move" is the way the offering is described on the programme and the idea is being presented for the first time on any stage. On a screen the Vitagraph shows pictures of Mr. McCay in company with several friends at a club. He is telling them of his new idea. The idea is made a

subject of ridicule. They consider such an invention impossible. The artist, undismayed by this discouragement, signs a contract, agreeing to turn out 4,000 pictures in one month's time for a moving picture concern.

A slide is then thrown on the screen showing the artist at work in his studio. He makes good his threat and at the end of the month has fulfilled his contract. Congratulations from his friends now pour in on him and he produces his new discovery at the club, where the friends had scoffed at the idea. The fun derived from this invention in the moving picture field was thoroughly enjoyed.

The *Telegraph* reporter, Robert Speare, went on to describe McCay's in person chalk-talk act and never told what took place on the screen in *Little Nemo*'s animation. It is quite probable that the reviewer was confused by the quality of the animation, its smooth timing and realistic drawings, and didn't know what to make of it since nothing of its like had ever been seen before. McCay once admitted, "The first picture I made for stage use was Little Nemo and Flip, the Princess, Doctor Pill and the Imp, moving in a picture drama. It was pronounced very life-like, but my audience declared it was not a drawing but that the pictures were photographs of real children." This mistaken notion was reinforced in the vaudeville print of the film, for McCay had painstakingly hand-colored each character in every frame of the 35mm film in primary colors.

In the film, after the live-action prologue, McCay's hand, holding drawing 1—a profile of Flip with a cigar in his mouth—inserts it into a wooden slot in front of the horizontal camera. We, the camera's point of view, move in past the register marks of the drawing to a screen-filling close-up of Flip. The words "Watch me move" appear over his head, disappear, and his cigar tips jauntily up and down. He blows a sensuous Art Nouveau stream of smoke at us and majestically waves it away as he starts to bound in a dreamlike floating way into the distance. There are no backgrounds, just limitless limbo. Perspective is indicated by the enlargement and reduction of the figure sizes. There is no plot and the characters appear magically as abstract lines that metamorphose into Impy, Nemo, and the Princess. There is continual movement in the film: Nemo is formed by lines resembling steel filings attracted to a magnet (he is resplendent in a red cape and hat with red and yellow plumes); the Imp and Flip contort their forms as if they were funhouse mirrors; Nemo sketches the form of the Princess, she comes to life, and a rose grows just in time to be picked for her by Nemo. As a grand finale, a magnificent, three-dimensionally drawn and animated green dragon-chariot carries off the two children to Slumberland. Flip and Impy return in a jalopy that explodes and they land on Dr. Pill. The last drawing holds its position as the camera pulls back, revealing the wooden slot contraption that held the drawings in register.

The Story of a Mosquito[1] (1912). McCay wrote of his second film, "I drew a great ridiculous mosquito, pursuing a sleeping man, peeking through a key hole and pouncing on him over the transom. My audiences were pleased, but declared the mosquito was operated by wires to get the effect before the cameras." The 600-

[1] According to The Library of Congress, the American Film Institute, and animation historian Conrad Smith, the proper title is *How a Mosquito Operates*.

foot film was completed in December 1911 and was sold to Carl Laemmle with the stipulation that it would not be shown in the United States while it was being screened in McCay's vaudeville act. He had competed with himself with *Little Nemo* and wished to limit the availability of his future films. (His animation was widely circulated in Europe and perhaps this explains why he is better known as an animator there.)

It was at this time that McCay began to tout the novelty called animated cartoons as a new art form. He declared in interviews that in the future people would not be satisfied with going to an art gallery to view "still" paintings:

> Take, for instance, that wonderful painting which everyone is familiar with, entitled *The Angelus*. There will be a time when people will gaze at it and ask why the objects remain rigid and stiff. They will demand action. And to meet this demand the artists of that time will look to the motion picture people for help and the artist, working hand in hand with science, will evolve a new school of art that will revolutionize the entire field.

Gertie the Dinosaur (1914). On April 2, 1912, McCay told the *Rochester Post,* "I myself have already been approached by 'The American Historical Society' to draw pictures of prehistoric animals, the present evidences of which are limited to their skeletons, which would represent some connected incident in their lives . . . they could be shown on screens all over the world."

McCay considered his first two films "experiments," but he felt that with *Gertie* he had finally achieved "real success": "At last I had people convinced that they were looking at a picture drawn by hand, in which an animal was made to look like a living, breathing creature."

The initial performances of *Gertie the Dinosaur* took place at the Palace Theatre in Chicago in March 1914 and the following week at Hammerstein's in New York City. McCay lectured in front of the screen on which film of the cartoon dinosaur was projected. "Gertie was made to come out of a cave at my command and go through her stunts," he once explained.

> When the great Dinosaur first came into the picture the audience said it was a papier-mâché animal with men inside of it and with a scenic background. As the production progressed they noticed that the leaves on the trees were blowing in the breeze, and that there were rippling waves on the surface of the water, and when the elephant was thrown into the lake the water was seen to splash . . . I made her eat boulders and pull up trees by the roots and throw an elephant into the sea. Gertie was made to lie down and roll over and obey commands which I emphasized by a cracking whip . . . This convinced them that they were seeing something new—that the presentation was actually from a set of drawings.

McCay asked his young neighbor, John Fitzsimmons, to assist him by retracing the stationary background of the rocks, trees, and water that appear behind Gertie in over 5,000 drawings. "He had a master drawing of the background and he would make the drawing featuring the animal. I would lay that over the master background and trace in pen and ink," said Fitzsimmons. Fitzsimmons's

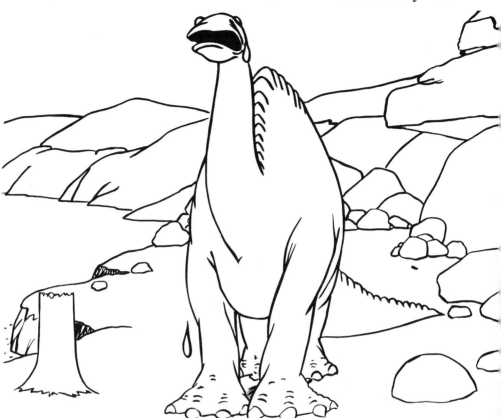

Winsor McCay's *Gertie the Dinosaur* (1914) is generally regarded as the first cartoon star. (Courtesy The Museum of Modern Art/Film Stills Archive)

tracings are remarkably consistent and the background objects vibrate mildly but do not distract from Gertie's foreground antics. The trees *do* seem alive and wind-blown, the earth warm, the water sparkling; McCay once noted that he preferred to "animate even the 'still' figures, which some movie cartoonists don't do . . . Unless all the live figures vibrate, the picture really isn't animated . . ."

McCay continued to experiment and improve upon his animation techniques with *Gertie*:

> When she was lying on her side I wanted her to breathe and I tried my watch, and also stop watch, to judge how long she was inhaling and how long it took her to exhale. I could come to no exact time until one day I happened to be working where a large clock with a big second dial accurately marked the intervals of time. I stood in front of this clock and inhaled and exhaled and found that, imitating the great Dinosaur, I inhaled in four seconds and exhaled in two. The result was that when the picture was run, instead of the Dinosaur panting as you would expect, she was breathing very easily. The breathing was shown by the sides of the monster expanding and contracting like a bellows.

McCay also discovered the laborsaving value in reusing drawings for a repeating "cycle" action. "When I drew Gertie breathing," he said, "I only drew her once, but I photographed that set of drawings over fifteen times." In the corner of the drawings, McCay would make notations for the cameraman, for example, "46 after 41," "45 back to 41," indicating the drawings to be reused.

McCay had, by this film, devised a technique he called the *split system,* which "greatly simplifies the process of timing and placing, which is intricate enough at best." Instead of animating an action "straight-ahead" from, say, drawing 1 to 33, McCay would "split" the action and draw first pose 1. He would then place another sheet of paper over the first drawing and make pose 33. On a third sheet of paper he would find the halfway pose, drawing 17 and continue to split the distance between drawings for the entire action. Most of the animators in the studios that began to spring up starting in 1913 preferred to animate straight-ahead. A few discovered their own split-system shortcuts, but it wasn't until the advent of sound cartoons in 1928 that Walt Disney insisted on the "pose (or extreme) drawings and in-between drawings" method, a refined version of McCay's split system.

The Sinking of the Lusitania (1918). On Friday, May 7, 1915, the English Cunard liner *Lusitania,* homeward bound from New York to Liverpool, was torpedoed without warning by a German submarine off the coast of Ireland. The ship sank in eighteen minutes, killing 1,198 people, including 124 Americans. The public's emotional response to this tragedy was a major factor in bringing the United States into World War I. "McCay was especially incensed at such wanton brutality," recalls John Fitzsimmons. "He proposed to make an animated cartoon graphically depicting the horrible tragedy."

This film, the only one McCay based on an actual historical event, is the first film in which he utilized celluloid instead of rice paper for the action drawings, thus allowing a stationary background to be used that didn't have to be drawn over again for each frame. Fitzsimmons, again assisting McCay, came up with the idea of using loose-leaf "binding posts . . . attached to drawing boards and the sheets of celluloid were punched to fit snugly to them, thus the annoying problem of movement or shifting of drawings while being traced was reduced to a minimum . . . [It] also facilitated the photographing of the drawings immeasurably and proved well-worth all additional expense."

Apthorp (Ap) Adams, "a very amusing friend" of McCay's from his Cincinnati newspaper days, who "liked to hit it every once in a while" [have a drink], visited New York and McCay "shanghaied him" to work on the film for two years. Ap was responsible for one of the bigger technical errors that plagued the picture: a principal scene showed the *Lusitania* sailing along a horizon of gently rolling waves in the moonlight. McCay devised a series of sixteen drawings of waves that would be redrawn in sequence on each drawing of the ship. When McCay had completed the 750 animation drawings of the ship, it was Ap Adams's chore to indicate by number which of the sixteen waves young Fitzsimmons was to draw on each celluloid. After several weeks when all the drawings had been

completed for the scene, McCay placed a large segment of them into the testing machine. "The result was a catastrophe!," wrote Fitzsimmons. "Instead of the waves flowing smoothly as designed, the foreground resembled nothing so much as a drunken sea with ink lines shooting every which way. All 750 drawings had to be cleaned off and the series started all over from scratch. I had not been fed the wave numbers in proper sequence."

The Sinking of the Lusitania, containing approximately 25,000 drawings on cels, took twenty-two months to complete and was copyrighted on July 19, 1918, and released the next day by Universal-Jewel Productions. "The picture attracted attention at this time by virtue of its length and because it was a propaganda picture for the war," wrote Earl Theisen, Honorary Curator of the Motion Picture Division of the Los Angeles County Museum of Art in 1933.

The film resembles an editorial illustration in motion. The somber mood of the film, the realistic timing of the animation, and the detailed draftsmanship make it appear, in certain scenes, less a cartoon and more of a live-action documentary. This impression is dispelled by the artificially patterned, serpentine smoke emerging from the ship's funnels and a full spectrum of gray tones used in the billowing smoke from the explosions within the ship's hull. This is one of the most unusual and beautiful animated films ever made by an independent animation filmmaker.

The Centaurs (c. 1918–1921). Three minutes and five seconds are all that remain of this fantasy cartoon. McCay was using celluloids for his characters and more detailed wash backgrounds. In the film a woman, nude to the waist, strolls through a forest of white birch trees, and soon we see her torso is that of a calico horse. A handsome centaur throws a rock and knocks a vulture out of the sky. He approaches the female and together they walk slowly toward a pair of elderly male and female centaurs. A baby centaur (literally a child's head and torso attached to a pony's trunk and legs) bounds into the middle of the group, shows off with back kicks, and the film abruptly ends. McCay chose mythological beasts again to prove to his critics that he worked independently of photographs and models. The centaurs and "centaurettes" in Walt Disney's *Fantasia* two decades later may have been inspired by McCay's character designs in this film. Many older Disney storymen were from New York and might have seen McCay's films when they were first released; for example, Dick Huemer re-created McCay's *Gertie* vaudeville routine, word for word from memory, for a 1955 *Disneyland* television show.

Flip's Circus (c. 1918–1921). Another fragmented film that lasts only five and a half minutes in its present condition. Flip, the rascal from the *Nemo* strip, returns to the screen as a trainer of a Gertie-like creature. Flip juggles, does balancing tricks, and beats the sluggish dinosaur-thing as it eats his automobile.

Gertie on Tour (c. 1918–1921). The shortest (1 min., 5 sec.) and strangest of the fragmented remains of McCay's films. Gertie, now on cels—one cel level for her

body, another for her head and tail—walks near a railroad or trolley track with the New York skyline in the distance. Cut to Gertie dancing on a rock surrounded by several "still" dinosaurs. In another brief scene she stops a trolley car.

The following three films were distributed in 1921:

Dreams of the Rarebit Fiend: The Pet. Reminds one of Tex Avery's 1947 M-G-M short, *King-Sized Canary.* Both films deal with house pets who drink a chemical that increases their small sizes to gargantuan proportions. In McCay's film there is an impressive "pan" scene of the ten-story-high monster-pet roaming à la King Kong among the skyscrapers and being buzz-bombed by a fleet of dirigibles and airplanes. This is a very tightly controlled, amusing narrative.

Dreams of the Rarebit Fiend: Bug Vaudeville. A hobo dreams he is attending a theatrical performance by a troupe of talented insects. He applauds heartily the juggling grasshoppers, a trick-cyclist roach, boxing beetles, an eccentric-dancer daddy longlegs, and a corps de ballet of white butterflies. This delightful short ends with a giant black spider attacking the hobo, rousing him from his seat and the dream.

Dreams of the Rarebit Fiend: The Flying House. "Drawn by Robert Winsor McCay using the Winsor McCay process of animated drawing," reads a title card at the film's head, but this was most probably a collaborative effort by McCay and his son. A husband and wife attempt to evade their creditors by equipping their house with wings and a motorized propeller. They succeed so well that they fly into outer space, encounter a giant on the moon, and are finally blasted by a rocket. They fall toward earth and wake up in their bed. It had only been a "dream" brought on by a supper of troublesome rarebit. The animation of the human characters is rather stiff, but the special effects of the tiny house flying through the galaxies is quite spectacular.

Winsor McCay stopped making animated films around 1921 or 1922, for reasons that can only be guessed at. He was in his early fifties when *The Flying House* was completed; and perhaps the work load of his newspaper duties plus the effort of creating his particular brand of complicated animation films without the aid of a staff finally began to wear down his phenomenal energy and drive. Perhaps he felt out of step with the times. He always insisted he had "invented" the animated film, but by the mid-1920s most people had forgotten McCay's animated efforts; Felix the Cat was at that time an international cartoon star, and by the end of the decade a mouse named Mickey would lead Walt Disney to total domination of the field.

"For a time McCay had the field to himself," wrote Claude Bragdon in a 1934 *Scribner's* magazine article that ironically was published the same month McCay died (on July 26, at his home in Sheepshead Bay of a massive cerebral hemorrhage). "[He] carried on single-handed the enormous labor of making thousands of drawings for a few brief moments of entertainment ... it seems a pity

that McCay, with his delightful fancy, should not have continued in this field which he had made his own. Walt Disney has so far eclipsed him that McCay's animated cartoons are remembered only by old-timers like myself."

Perhaps the real reason McCay stopped creating animated films was his deep disappointment that, as far as he could see, his beautiful dream of animation as an art had not happened. His distress over this fact is illustrated in an anecdote recently recalled by veteran animator I. Klein in the magazine *Cartoonist Profiles*. Klein tells of a dinner held in the fall of 1927, "a gathering of the animators of New York" (about thirty existed at that time) to honor "the originator and founder of animation—Winsor McCay." Both McCay and his son attended and after dinner and "a considerable amount of bootleg liquor" had been consumed by everyone, Max Fleischer, who was presiding, announced, "McCay created the miracle of animation and another miracle was getting all the animators into one big friendly gathering."

McCay was introduced, and his speech was brief. "[H]e gave some technical suggestions which I don't think his professional audience took much stock in," said Klein. "He wound up with a statement that has remained in my mind . . . 'Animation should be an art, that is how I had conceived it . . . but as I see what you fellows have done with it is making it into a trade . . . not an art, but a trade . . . *bad luck.*' He sat down. There was some scattered applause."

A Day with J. R. Bray

by JOHN CANEMAKER

Winsor McCay started the experimentalist, romanticist, no-compromise, Frank Lloyd Wright–like approach to cartooning; he is animation's first great Artist, with a capital A. John R. Bray understood in 1913 that simple cartoons can make money. *In* Creators of Life *(1975) author Donald Heraldson reports this conversation between the two cartoon giants (taken from a Bray memoir?)*:

> MCCAY: *It took me six months and several thousand drawings to make the* Gertie *film and it only lasted ten minutes or so on the screen.*
>
> BRAY (pondering): *I didn't doubt that statement. But a ten-minute film would take too long to produce and make too little money in return. I wanted to simplify the process so that cartoons could be supplied as a regular feature—as many as the public wanted.*

Bray was the consummate artist-businessman, so skilled that Bray Studios Inc. continues operation in New York City today, sixty years after its inception. The studio discovered its niche when Bray cooperated with the American government in World War I and produced cartoons to educate draftees. It still produces military training films.

As for John Randolph Bray, a life of commercial product and government defense contracts paid off a thousand times. Before he died in 1978, he had no trouble sitting down for this interview in his ninety-fifth year or attending a Museum of Modern Art tribute-retrospective in his ninety-sixth. At last, Bray's Colonel Heeza Liar has become an American cinema classic.

"I drew a picture of a dog lying on the floor along the baseboards, and there was a cabinet beside him. The cabinet was about four stories high and I had a plate up on top." J. R. Bray was describing to me his first animated cartoon, *The Artist's Dream,* released in June 1913. "I drew this picture, drew the plate, I put a sausage in the plate." Mr. Bray, when I interviewed him early in 1974, was proud of the fact that in August he would celebrate his ninety-fifth birthday, and I was very proud to meet him. I kept thinking, as we talked in his quiet apartment in a luxury condominium for retired senior citizens in Bridgeport, Connecticut, that this is the

closest I will ever get to meeting any of the earliest animation pioneers. Blackton, Cohl, McCay, Barré—all are gone and only Bray remained. "[T]hen somebody rapped on the door, so I went out to see who it was. While I was gone, the dog came to life."

The dog came to life and so did animation as an industry. Nat Falk, in his informative 1941 booklet *How to Make Animated Cartoons,* wrote: "The history of animated cartoons as a practical form of entertainment really dates from Bray's first cartoon . . . Up to this time cartoons had been little more than a novelty, used only at the end of newsreels or vaudeville acts. But after seeing this film there was a change in the public's attitude toward cartoons, and this picture must be hailed as the forerunner of the prevailing public vogue for animated cartoons." In 1914, Bray organized the second studio capable of producing cartoon films in quantity (Raoul Barré's was the first); his second cartoon animation, *Colonel Heeza Liar in Africa* (December 1913), exceeded the popularity of his first film and precipitated a series that ran uninterruptedly for five years, then was revived in 1922.

During his "experimental period" from 1914 to 1916, Bray was granted patents on technical processes involved in producing animated cartoons. The most important patent embraced a system of drawing the background on a translucent sheet placed over the character drawings; later Bray combined his patents with Earl Hurd's patent for using glassine paper for the action drawings, and for almost eighteen years the two men issued licenses for the use of the "cel" method they developed.

In 1915, Bray Studios signed with Paramount for the distribution of its films, and within five years Bray was heading one of the largest film organizations in the country, with offices in New York, Chicago, and Hollywood, producing theatrical shorts; with the war, Bray pioneered the use of motion pictures to expedite the training of a conscripted army. He received a citation from the Department of the Army in 1956 for "outstanding patriotic civilian service . . . The impetus given the training film program by Mr. Bray constitutes a major continuing contribution to the national defense."

When Bray went over to Paramount, he began releasing *The Bray Pictograph,* a screen magazine format containing a sport picture, a travelogue, and an animated cartoon. When the Kaiser's submarines were raising havoc with English shipping, Bray created a film showing how a submarine operates, and included it in the *Pictograph.* It proved successful with the audiences, and so Bray began production of a long series of educational pictures, for example, *How We Breathe, Action of the Human Heart, The Nervous System, How We Hear.* He opened an educational department and when Eastman developed 16mm safety film, Bray moved his backlog of many informational films right into the nation's schools, becoming a leader in yet another lucrative area of film production.

Early photographic portraits of John Randolph Bray are very formal, almost forbidding. His penetrating dark eyes peer out of black round-rimmed glasses perched on an unsmiling face; black hair and moustache are severely clipped, and he wears a dark suit, tie, and always, a vest. He looks in the photos

like a no-nonsense man who could build a company and see it thrive for over sixty years, as, indeed, the Bray Studios Inc. continues to this day making films for the armed forces, industry, and education. The gentle man with the thinning gray hair and moustache who spoke with me in 1974 was anything but forbidding; J. R. Bray, as he neared the century mark, was in good health and spirits, albeit a trifle hard of hearing, as one might expect at such an advanced age. What one didn't expect was his amazing, selective recall of events and personalities, his humor and modesty (yet awareness of his place in animation history), and his vigor, which he demonstrated most vividly after our talk by insisting on driving me in his car back to the bus depot for my return to New York. (J. R. Bray, I can report, was a skilled and careful driver, and I made my bus with time to spare.)

"I was born in Addison, Michigan," Bray recalled in response to my first question. "It was 500 people when I was born there and I understand it's still 500." He began drawing as a youngster, went to college for two years, then got a job as an artist on the *Detroit Evening News;* after a year Bray moved to New York and free-lanced for a year. Then, "I decided to get over to *The Brooklyn Eagle,* which was then a great big newspaper and was on a par with the New York papers at the time. I went there for a year and a half, then [in 1905] I got married." An early photographic portrait of Bray's first wife, Margaret (who died in the late 1960s), rests on a small table with other family pictures. It shows a beautiful "Gibson girl" dressed in a lace gown with her hair piled atop her head. In a later interview with Paul Bray, Jr., J. R.'s grandson who now heads the studio, I was told:

> My grandmother was a big factor in this company and in the industry. My grand-father had the ideas and she had the business brains to go ahead and get things going. At the studio my grandmother was the organizer—we still pay on Mondays here because the artists back then, if you paid them on a Friday, they're going out on a drunk and wouldn't show up till Wednesday . . . So what she did was say, "Work all week, we're going to pay you on Monday." So they'd stay sober over the weekend and come in to get their pay, and since they were here they would keep on working.

Soon after his marriage, J. R. decided he wanted to free-lance again. "So I asked my wife if she objected and she said no . . . she said, 'That's all right. I'll get a job and we'll work together.' " During his successful free-lance period, Bray contributed many cartoons to *Life, Puck,* and *Judge* magazines. He showed me a scrapbook full of an early effort, *Little Johnny and His Teddy Bears,* a strip whose style can be described as animated—well-drawn characters in a large variety of imaginative angles and poses.

I had read that Bray decided to try films after witnessing the work of his con-temporary, Winsor McCay; but at our interview Bray told me, "Oh no, I didn't know Winsor McCay was doing anything. I just got the idea that I wanted to make animated cartoons for the movies. Winsor McCay never thought of that. McCay made two cartoons before I did, and he had good animation, but he used

them only on the vaudeville stage, in the vaudeville skit he used to do in the summertime."

A Bray Studios publicity sheet from 1918 suggests how J. R. Bray prepared for his first animation: "Mr. Bray spent years in study before he attempted to make an animated cartoon. For months he haunted the Bronx Zoo in order to study the animals there and analyze their motions. He even bought a large farm across the Hudson from Poughkeepsie and stocked it with various animals in order to further extend his knowledge of animal anatomy." Bray signed his first contract for a film series with Pathé. "It was at the time the biggest producer and distributor in the whole world," Bray recalled. "I had to train artists, I didn't have anybody but myself at first. I went up to my apartment at 112th Street and Riverside Drive, got half a dozen artists trained and started in . . . after I got going for a few months, I took this place down on 26th Street and that developed into quite a place.

". . . Paul Terry, I had him. My wife found him. She happened to see Paul Terry's first drawing [*Little Herman,* 1915]. It was advertised, so she went to see him. She told him he had to have a license [for the cel process]. He didn't like that very well, but he took one out anyway. Then we gave him a job—that started him off." Terry turned out a series of Farmer Alfalfa cartoons for Bray. "I took in Earl Hurd, made him a partner in my patent company . . . I made an arrangement for him to make a series of pictures" [Bobby Bumps]. And Max Fleischer? "Well, he was a very nice boy. I met him on *The Brooklyn Eagle.* He was a retoucher of photographs; he wanted a better job, so I got him a job in Boston . . . One day I happened to go up to see [Adolph] Zukor, the president [of Famous Players, later called Paramount]. Max was sitting out in the lobby . . . he had a little 450-foot sample cartoon that he had made with his brother. His brother had posed as the artist and it was quite clever. I said we'll use your sample and if it goes over, why, we'll take you on. We made one a month after we tried it out. That was *Out of the Inkwell. Koko the Clown* came later."

Among the many other artists who worked for Bray were Carl Anderson and Louis Glackens who animated *Police Dog* and *Us Fellers,* and David Hand and Shamus [Jimmy] Culhane. "We had quite a studio. I brought them all out," Bray told me with pride. "They did their work in my studio and each one of them made good. Walter Lantz was the last one; he worked for us [on the Dinky Doodle series], then he went out to California and got a job with Universal, and he's been there ever since." Walt Disney? "When he first came to New York he came to my studio at 729 Seventh Avenue. I offered him a job; that is, I offered to take his stuff and release it, but he didn't want to do that. He had great genius, you know."

What did Mr. Bray think of the animation he saw on his television? He laughed, "they're all about the same. Some of them are crude. They've cut down on the number of drawings, they're a little jerky. That's because they don't put enough drawings in. In Disney's case, he puts in all the drawings you want to have."

I asked Mr. Bray how he felt about his place in animation history. "Well,"

he said in an aw-shucks sort of way, "I think it's pretty nice. Course, I'm very much pleased that they haven't been able to improve on the process. It's still the same old process that I invented. Just done a bit more crudely, not so many drawings and so on in most cases." The ancient entrepreneur stared off, remembering. "It was all exciting in the beginning," he quietly said. "Very exciting in those days. The introduction of animation all over the world."

Toward the end of our talk I asked Mr. Bray if he'd ever met Thomas Edison. "No," he said, "I knew of him but I never met him. He was a little ahead of me."

A Talk with Dick Huemer

by JOE ADAMSON

Richard "Dick" Huemer went from pre-World War I high school drop-out to top-flight animation director.

He began working in animation as a "tracer" at Raoul Barré's studio drawing Mutt and Jeff cartoons, and then advanced to Max and Dave Fleischer's Out of the Inkwell series. (Characteristically, he was the animator who jokingly experimented by planting buck teeth on Koko the Clown.) After employment at Columbia Pictures and other places, he went to the Disney Studio, where he was story or animation director on sequences of Snow White and the Seven Dwarfs *(1937),* Pinocchio *(1940),* Fantasia *(1940), and* Dumbo *(1941). His biggest personal thrill was actually directing two Disney cartoons,* The Whalers *(1938) and* Goofy and Wilbur *(1939).*

However, if Huemer could live his long life over again, he would choose to be a history professor. His bookshelves are lined with Dante and Milton, and he even struggled through the "dry-bones stuff" of Edward Bulwer-Lytton. When Joe Adamson interviewed him for the American Film Institute in 1968, Huemer had just completed Thomas Macaulay's History of England *and was delighted. As for a bi-ography of King James II: "What a fascinating sonofabitch! Really a mad monarch. You wonder why the English put up with him so long."*

Probably it is his historian's sensibility that makes Huemer's recollection of the early days of animation so sharp, focused, and refreshingly non-nostalgic. He re-members with wry amusement those golden days before 1920 when cartoons were more fun for the artists than for perplexed theatre audiences. Were early cartoons funny? "Funny as a crutch," admits Huemer.

DICK HUEMER: I was born in Brooklyn, January 2, 1898: the turn of the century. I became interested in animation when I was about ten years old, and I used to an-imate little figures in notebooks and flip them, little figures of boxers, or athletic events, and that really was the first animation I ever did. I got the idea from little photographic animation books that were current at the time. There had been a fire in the neighborhood drugstore, and they found many of these flip-books, which were about three inches square; and when you flipped them, you saw an action scene. I suppose they had been taken from films. They used to give them away as an advertisement.

JOE ADAMSON: Were you scribbling in your own school notebooks?

DH: That's right. Imitating them. I was the local high school cartoonist. I went to Morris High School in the Bronx and Alexander Hamilton in Brooklyn. And in both cases I drew cartoons for the annuals, and wherever cartoons were needed for bulletin boards. I always liked to draw, in other words.

The first movie I ever saw was of the Nelson-Ganz fight at Coney Island. They had signs outside these boardwalk restaurants saying "Basket Parties Welcome," which meant that you could go into these places, which were filled with tables and chairs. My father would order a glass of beer or coffee, and hot dogs for us kids, and we would break out our sandwiches and eat them while they projected these marvelous movies. One of these was the Nelson-Ganz fight, and I'm sure we saw some of Lumière's and other French producers' pictures then. In shocking pink color, some of them were.

Animated cartoon movies were done a bit later by somebody nobody ever mentions: Wallace Carlson. He did something called *Dreamy Dud.* And I saw those about 1914 at the local theatres in the Bronx. About the same time, I saw McCay's *Gertie the Dinosaur* [1914] at the Crotona Theater in the Bronx; and I was therefore able to re-create it later on a Disney TV show, wherein we reenacted McCay's performance including the picture *Gertie.*

JA: What were your reactions to these films?

DH: We didn't have the expression then, but if we had, I would have said "I flipped." I really was sold on animated cartoons, especially since I liked to draw. Involvement with live-action films seemed out of reach. I spent about a year at art school: Art Students League, in New York City. I studied under Bridgeman, the famous anatomy teacher. Really was famous. Didn't rub off much on me, though.

JA: What did you do, just sketch nudes and things?

DH: Yes, that's right. Studied anatomy and painted a little. But I always wanted to be a cartoonist. Up in Fordham, where I lived, almost every day I passed a sign on the door of the building opposite the university, which said, "Raoul Barré: Cartoonist." And this intrigued me no end, and one day I walked up the stairs and into the animating business. When Raoul Barré looked up from his desk and said, "What can I do for you?" in his strange Canadian brogue, I said, "I would like a job." He said, "Go to the next room and sit down, they'll put you to work." It was as simple as that. They put me to work at something that was called "tracing."

This was about 1916 and they were doing Mutt and Jeff cartoons. I had quit high school to go to the league, that's how much I wanted to be an artist, and now I was quitting the league to go into cartooning. I was abandoning the fine arts.

They already had the cel system, but not the way it's done today, which has the cels opaqued, to fit over the background. Our cels were used to contain the background and whatever lines on a scene were not "disturbed" by the character. All the action was carried on the paper. We inked on paper, with very flashy techniques, in imitation of Heinrich Kley once in a while. And I would take a series of cels that fitted over the paper to complete the picture. If the character walked in front of an object, the drawings that it took for him to pass that object had to have

whatever he "disturbed" drawn on that drawing. That's where the tracing came in, we traced that thing in the background onto those five or six drawings while he was passing the object. And then that went on celluloid and stayed there, because he wasn't disturbing it anymore. But he was walking in front of something else now, and then that had to be traced.

In other words, we broke the scene down into little groups of areas that were disturbed, so that we could trace those onto paper. The foreground stuff was on celluloid, and the ceiling would be on celluloid—which was *never* disturbed. So it took about three celluloids. I think that's the most we used. And then with the paper, you had your complete frame. So that's what I did as a tracer. I didn't do it very long, however; in three weeks I was animating. That's how easy it was in those days.

They were already using the top-peg system of registry in 1916. Before that they had used various different ways of keeping the drawings in register. One way was to have a number of pinholes on each sheet of animation paper at the top. These coincided exactly with holes in the animation board. The animator put the pins, ordinary straight pins, through the paper and into the holes. It worked until the peg system came along. (Another strange deviation from common procedure was that Paul Terry and his brother John did all their animation on transparent tissue paper. Everybody else, as far as I know, used the so-called light boards and regular paper. After all, how can you flip tissue paper?)

The staff consisted of about five animators and about five or six tracers. Actually, there weren't more than fifteen people at the studio. Barré made one film a week, which never ran over 450 feet. And, believe it or not, it cost about $1,000. And that's what he got for it, about $1,000. The most he ever got was $1,500.

JA: How did you get your promotion?

DH: By asking for it. And the genial Frenchman said, "Why not?" He was a very fine gentleman. Animation in those days was not a difficult art. If it moved, it was good. Actually, the novelty carried it. The business got into trouble when the novelty wore off, and the people expected to see gags and better animation and better ideas. Which, of course, Disney eventually succeeded in doing.

JA: How funny were these films at the time you wandered in?

DH: As we used to say in those days, as funny as a crutch. They weren't funny, actually. They really weren't. We got very few laughs. I can remember taking my family to see some bit of animation I was particularly proud of, and just as it went on, somebody behind me said, "Oh, I hate these things." We actually didn't consider the audiences as much as we should have. It was as though we were enjoying ourselves, doing what we liked, what *we* thought was funny. It was just not understandable to audiences very often. We were given a portion of the picture, over a very rough scenario. Very, very sketchy, no storyboards like we have today, nothing like that. The scenario would probably be on a single sheet of paper, without any models, sketches, or anything. You made it up as you went along. You were given a part of the picture and you did what you wanted. If it was a picture about ice-skating, you took a scene of somebody on ice skates, and you used your own gags and made it all up.

JA: How were these stories written?

DH: We all helped. We'd spend an evening talking about it. And that's all it amounted to. Sometimes if somebody had an idea, he would do it himself. Generally it was picking a theme. I can remember some of the titles. One was about house painting, and we called it *Painter's Frolic*. Then, all you did was animate whatever you wanted to, anything a painter did. Another one was called *The Steeple Chase*. This was a rooftop thing. We did pictures about Hawaii; we'd say, "Let's do a Hawaiian picture." "Fine. I'll do the surf stuff, you do the cannibals," or whatever else.

JA: How long would it take them to shoot one of the films, then, between the time you animated the stuff and saw it on the screen?

DH: That was very quick. Since we made one a week they overlapped in photography and other operations.

We used to look at our own work and laugh like hell. We thought it was great. But in the theatre, they didn't. We were pleasing each other, you know. Very strange thing. I remember a scene I did with Mutt and Jeff playing instruments. As well as I can remember offhand, Jeff is blowing like hell on this big tuba. All of a sudden a brick flies out and hits him on the head. Big laugh in the projection room. Gags like that. Later, he blows a flute and a snake comes out. It was dopey stuff. *We* thought that was very funny. But the stuff really wasn't built up to the way Disney subsequently learned to do. That is, to prepare, to establish things. We never seemed to bother much with that, or perhaps it never occurred to us. Disney always very carefully planned things, so that everything was understandable, and one thing happened after another, logically. There's gotta be logic in humor, I guess.

JA: So the serious part of comedy was what you were missing?

DH: Our mistake was we weren't establishing anything first. We were giving the payoff without the buildup. Of course, I'm only talking about myself, maybe other people did things differently. However, the operation was pretty much as I described it all over. In other words, that you sat by yourself and did what you felt like. And if it was good, you pleased the boss; if it wasn't, you didn't work there anymore. Simple as that.

Mutt and Jeff started as a comic strip. I don't know exactly how Barré got it to animate. I do know that he must have gotten it through Bud Fisher, the guy who drew it. Fisher financed Barré, but had nothing whatever to do with the pictures. We saw him very seldom. We heard he was a millionaire by then. Even at that time he was a fantastic businessman. He just had a knack for making money. The strip was enormously popular, it was probably the biggest strip in its day. Something like *Peanuts* is now.

JA: How much money did these films make, do you know?

DH: No, I don't, I don't think they knew either. There was a time when they were given away with features. It was a package deal. You got a feature, you got a newsreel, you got some other strange thing, then you got a cartoon. Very often they didn't even run the cartoons. If the exhibitor hated cartoons, he didn't run them. That's how interested they were.

JA: So the cartoons never really caught on, like the comic strip?

DH: Well *Mutt and Jeff* didn't. I think Terry's Aesop's Fables caught on slightly. Terry's cartoons were a little better; at least the characters were cute. The reason he could make slightly better pictures was he had a great deal with RKO—who had bought into his studio—which guaranteed that each one of his pictures would play all their houses for a good price. So Terry was the first one to really make money in this business. Pat Sullivan made money too, but in a different way: his pictures were so popular in England that they got all sorts of objects and artifacts, handkerchiefs with Felix the Cat on them, and this, similar to what happened to Disney, defrayed the cost of his pictures and gave him a nice profit. *Felix the Cat* was bigger in England than it ever was here.

By 1920, somewhere in there, I think that Bray was making a living; and Fleischer, who had been with Bray, started his Out of the Inkwell around 1915. These were released by something called "states' righting." For example, I could buy the rights to run a film in one certain state, say California. Now I have the rights, I have the film, I can release it in any theatre in California that I want to, having paid a certain amount of money for that privilege. So you see that in the forty-six states the producer was sure to get at least a certain amount of money just for giving people the rights to run his product. Then too, he didn't have to bother about it anymore. That was their affair, to make prints, to sell it locally, to send it around; whatever they wanted to do with it. It was kind of a precarious business, though. And that was because there was no actual demand for these cartoons.

Not that people weren't thinking about improving them. There was a guy at the Mutt and Jeff studio, Carl Lederer, who thought of making a feature way back in 1919. *Cinderella.* This was going to be a beautiful thing—silent, of course. He never completed it; he died. This same fellow, Carl Lederer, also had the idea of multiplane, or putting depth into a cartoon. He took three different speeds of a background, moved them in different graduations: half inch in the front, quarter of an inch farther back, one eighth in the horizon, and then the sky, tracing all three speeds on one piece of paper, then going back and laboriously tracing, so that when you used the traced set of papers, you got this effect of the speed in front and then less and less in the back. There was an amazing feeling of depth. We used it in *Mutt and Jeff.* We used it over and over again; we made two, one of a country scene and one a city scene. And they were great! But I don't think the audiences noticed them. In general, I think, they were still faintly hostile to the cartoons.

JA: The animation that I've seen of this time seems to have a completely different texture.

DH: Because it wasn't analyzed. Disney was the first person who really analyzed cartoon action. Old animation was done from pose to pose without much thought. It was almost like it was a flat design. Without any weight. Whereas Disney immediately gave his characters weight and life and breath, and naturalness, a character would come to a complete stop from a stride position; he'd come to a complete stop and there he'd freeze. And his eyes would blink. Or his hair would

stand up, or whatever. Or if his head did turn, the rest of him would still be stuck there stiffly. Whereas Disney got away from all that. He figured that in any action a figure never came to a complete stop all at once. Things overlapped. Overlapping action was an invention of Disney's. When a fat man jumps up, the top part of his body takes off first and then the lower part follows up a few frames later. And then when he comes down, this mass stretches out, keeps going up for a while, and then that drops after. This idea, one thing overlapping, movement within the figure, was something that Disney first brought to our attention. It was never done in the old days when everything was like a cutout, moving in one piece. No thought of his clothing following through, sweeping out, and dropping a few frames later, which is what it does naturally. That's why Disney's animation looked so different.

But nevertheless, as far back as 1916, when I came to the Mutt and Jeff studio, there was some attempt to improve animation. When I got there, they were all talking about a bit of animation done by a chap named Rigby, which had two goats butting each other, or something. By today's standards it's less than nothing, but this was considered so great that Rigby was the studio hero for a few weeks. This was 1916. And then around 1918, Albert Hurter, who did such great work at Disney's later on, had to draw an American flag; and he looked out the window, saw a flag, and wonder of wonders, he actually copied the movement—studied it and imitated it. Something that nobody had done before. If you had done a flag before, you would take three drawings and have it merely sort of vibrate. But he analyzed the action and its folds, et cetera. He was such a magnificent artist! And when this scene came out, we just thought "This is the end! The living end! This is the greatest!" In other words, we weren't really blind to improvement. As a matter of fact, another thing done at this time, which Walt Disney also did later, was what Barré—or Bowers, one or the other—instituted: art classes. We would come back at night to study the human form. Self-improvement, so that we drew better. Another Disney precept.

But it was all really fun. We did our stints quite comfortably; there was no stress. After all, 450 feet for about five or six men to do, that's not such a chore, especially if you like to draw.

JA: How many drawings would you do in an hour?

DH: About twenty. Maybe more, depending. In those days we did a lot of hold positions and just moved maybe an eye. When a character talked, all we'd have was a repeat and reverse of a mouth movement and the rest of the figure didn't move at all—it was traced on a cel. And then the mouth, just this little bit, was on paper. Then a balloon would come out, with lettering, and hold and then explode. As his mouth manipulated, the balloon came out very quickly, just bloop!, in about five drawings, and held while you read the balloon. And then it whirled away or exploded. We had various ways of accomplishing that. Characters did violent takes, like all the hair flying off. Once I had all the features fly off in the air, whirl around, and come back and slap on Mutt's face. This was really a "take."

When looking at a piece of film, I noticed that very often the action was

blurred in between when something was moving fast. And I decided that I would save all that work of in-betweening by just having a bunch of lines or smudges, just scrabble, from position to position when something moved fast. To prove it, I had an alarm clock flying through the air, and right in the middle of the action I put a brick. And when they ran the finished film, you didn't see the brick! It proved that you really didn't see what was in the middle. But I overdid it. Finally it looked like haystacks in between, from position to position, and then Barré told me to please knock it off. He was always polite. He said softly, "Let's make the in-betweens like everybody else, eh?" We experimented with all these crazy things.

JA: How did audiences react then?

DH: They didn't get it. I swear, they didn't get what we were doing. For one thing, out timing was way off or nonexistent. And we didn't have sound. Sound was the great savior of the animated cartoon.

Let me tell you the story that I've told many times, about what people thought of the business in those days. When we opened our second Mutt and Jeff studio in Fordham, we were in the Fordham Arcade. And down below on the street level there was this tailor who had a small shop we animators patronized. He was just burning up with curiosity about what we fellows were doing upstairs. We were in this loft that was originally meant for light manufacturing, and he couldn't figure it out. "What are you boys doing up there?," he persisted. And we explained, "We're making animated pictures," or at least we tried to explain . . . and finally I said one day, "Well, come on up, Mr. Pincus (or whatever his name was). I'll show you what we're doing." And one day, sure enough, he appeared at the door, hat in hand. I took him in tow and led him around from board to board. I flipped drawings. I showed him the tracers, camera room, how we did it all—as much as one can explain it to outsiders. Even today you can't do it much differently, you know, and it's still much the same principle. Well, I showed him everything, and he just stood there, shifting from foot to foot . . . occasionally he'd go, "Tsk, tsk, tsk," or "Hmmm." Never a word. I thought maybe he wasn't listening. Finally I said, "Well? What do you think, Mr. Pincus?" And he said, "Tell me . . . from *this,* you are making a living?" And that would be a good title for a book about this period, *From This You Are Making a Living?* It was all completely incomprehensible to him. Same as the word *animation.* It didn't mean anything at all to people. As far as some people knew, it meant mating animals.

JA: Give us an idea what the Barré studio looked like.

DH: The Barré studio was in an enormous bare loft, about one hundred feet by seventy-five . . . without any breaks . . . well, yes, at one end there was a wall for an office. The studio part had these long benches, with room for three or four light boards on each side, facing each other.

JA: No drawings hanging on the walls, or anything?

DH: Oh, no refinements, no, indeed. No curtains or carpets. We had bare board flooring.

JA: No, I mean like sketches.

DH: They couldn't afford it. No.

JA: You washed cels and used them over again at this time, didn't you?

DH: Yes, we had to. Had to cut corners. We counted pencils, too. We turned back the stub of a pencil to get a new one. It was a tight operation.

JA: What did you do with your old drawings after you had made your little films?

DH: They were always thrown away.

JA: Just thrown away . . .

DH: Oh, sure. You couldn't draw on the other side of the paper, could you?

Just About Krazy

by WILLIAM HORRIGAN

In the comic strips there is Krazy, the greatest cat of all and, for many, the most sublime of comic characters. But in the cinema, Otto Messmer's Felix the Cat takes honors; and Hanna-Barbera's Tom, not so lovable but more famous; and Sylvester at Warner Brothers; and, supporting characters, the Cheshire cat in Disney's Alice in Wonderland *(1951),* Figaro in Pinocchio *(1940), the Siamese twins in* The Lady and the Tramp *(1955).*

And yet there was a Krazy in the movies also, dim, obscured by all those charismatic cat creatures and by the Krazy newspaper legacy itself. William Horrigan passes slowly through the hypnotic George Herriman comic strip to offer a rare analysis in print of Krazy Kat cartoons.

Like the earlobe and the stain, bricks contain the heaviest energies of the West.
—TOM CONLEY, "A Pan of Bricks: McDonald, Renoir, Truffaut" (1977)

Ignatz Mouse, irascible, obsessed, and apoplectic with habitual disgust for Krazy's unswerving love for him, hopes—and hopes admirably without cease over the thirty-three-year life-span of George Herriman's comic strip—to dissuade Krazy by hitting him on the head with a brick. "Him?" An arrogant assumption, that, for Krazy's gender effectively changes from day to day, even within a single installment of the strip. Continuity in that register is evidently a low priority; witness also in this respect the protean constitution of the landscape in the strip's famous background designs, which simply change, "jump," from frame to frame, not at all in the service of any strict narrative urges. Simply put, Krazy's begetter, Herriman, is interested in deploying, as backdrop, landscape *such as this*—now a *mesa encantada,* now some lunatic cacti, now impossible perspectives, now a wounded-looking moon and stars.

Depending on the viewer's will to see it that way, the landscape's tendency to change its face, inexplicably, is indicative of a certain naïve Surrealism such as was found by the likes of Breton and Vache in the pulp serial cult and such as is often found in native architecture and craftwork, where it is understood by a clas-

sical sensibility as illiteracy about dominant cultural codes. The degree to which Herriman was a "conscious" artist could be debated, if it matters; those landscape mutations are, anyway, practically always secondary pleasures of any given installment, being, in fact, *back-ground* attractions, existing *behind* the foreground intrigue and liaisons. There, in front, the romance continues, and continues through mutual misapprehensions of the three principal characters of what properly constitutes the desired romantic agony. But, as Robert Warshow remarks in his magisterial commentary, this much is clear: "Almost every day for more than thirty years, Ignatz hit Krazy with a brick." It is clear, that is, what Warshow is onto: for him, for us, the essential, summary image, fixed as though primally recalled, is the drawn, typically two-panel passage through the air—the "zip!" of the throw, then the "pow!" of the hit—of Ignatz's convulsive brick, geared toward Krazy's skull.

The "zip!-pow!" combination is undoubtedly the national anthem of Krazy's homeland, Coconino County. For both Krazy and Ignatz, it's what passes as orgasmic, it's the instant of bliss. Krazy interprets (correctly, in the long view) the flung brick as a token of interest and affection on Ignatz's part, and indeed frequently supplies Ignatz with those very bricks. A perfect, because effectively endless, romance, were it not for the intervention of Offisa Bull Pupp, a dog, and the Law, and himself absolutely in love with Krazy, and therefore committed to coming between the approaching brick and Krazy's head, not realizing the erotic charge Krazy draws from one of Ignatz's well-aimed discharges. Deceit, desire, and anticipation, then: Krazy desires Ignatz, Ignatz despises Krazy, Offisa Pupp desires Krazy and despises Ignatz, Ignatz despises Offisa Pupp for not letting him despise Krazy in the most natural way possible—and meanwhile, usually but not always offstage, there remains Matilda, wife of Ignatz and mother of their three sons, Milton, Marshall, and Irving; she understands her husband, never reproves Krazy for pursuing him, and Krazy seems friendly enough to Matilda (naturally: they love the same mouse). Because this network of relationships is the strip's constant theme, the language of love assumes some importance, and so the "zip!-pow!" onomatopoeic figure of flight and collision takes its place as virtually a dialect: the voice of the brick (sometimes sounding, by the way, as "ziz!-pow!," "zaz-punk!," "jiz!-blaam!," "ping!-ziz!"), and it is a voice as honorable as any of the others spoken, for nearly all the characters placed in the strip—and certainly all three placed in the triangular romance—speak distinctly. Krazy speaks Ellis Island English laid over a native tongue entirely his/her own, speaks free from the example of cultured grammar and syntax, partial to malapropisms, speaks a speech profoundly misspelled; in contrast to Offisa Pupp, always grammatically immaculate, formal, "poetic"; in limited contrast to Ignatz, whose speech is sometimes hermetic, sometimes "phatic," never as vagrant as Krazy, sometimes as stilted but sardonic and cynical, too, in those cases in which he offers asides to his own other instincts, or to us. But even if none of them had ever spoken, there'd still have been the voice of the brick, speaking the strip's central interests, and dating from that day in 1911 when the romance of Krazy and Ignatz began on its

own (having been "spun off," like a television comedy series, from Herriman's already successful strip, *The Dingbat Family*) and continuing through until 1944, when Herriman died in Los Angeles.

The original cartoon versions of Krazy made from about 1915 to the early 1920s (the animated version, that is, as distinct from the strip version) concern themselves with something else again, and to one who values the project of the strip, the cartoon manifestation can only be seen as being of the most peripheral interest, not only vis-à-vis the strip itself but also to the synchronic state of animation art. In light of what Emile Cohl and Winsor McCay had been doing sometime before Herriman's foray into animation (for example, Cohl's ingenious exposure of the image's status *as* image, of its profound contingency, or McCay's understanding of visual narration's compatibilities with the dream state), and in light of how absolutely impoverished Herriman's Krazy seems in these and other respects, then one might as well conjecture that the cartoon Krazy had been brought to the screen out of motives mercenary and opportunist, motives not infrequently at work in the case of the "adapted" work. In his brief remarks on Krazy (in the course of which he proceeds to mischaracterize the language play at work in the strip), Raymond Durgnat provides the accurate and regrettable assessment that "the screen history of the Krazy Kat series typifies the fate that befalls too many of the popular arts' most haunting and poetic examples when transferred to the screen."[1] All the same, some things can be said,

The generational movement from strip-Krazy to cartoon-Krazy occurs in 1915 under the auspices of the Hearst-Vitagraph News Pictorial, Hearst and the *New York Journal* also still sponsoring the strip. Nominally "supervised" by Herriman (meaning he presumably provided each cartoon's title, narrative situation—there being no real story—and dialogue), the cartoon's actual artwork was produced, at least through 1920, by Leon Searl, William C. Nolan, Bert Green, and Frank Moser, and from the standpoint of the cartoon's visual, graphic qualities, Herriman distinctly recedes. Cartoon-Krazy, for example, bears only a haphazard resemblance to strip-Krazy, the former, in fact, looks something like a chimpanzee. The settings, too, are noticeably more fully dressed, more "realistic" than they typically are in the strip, and there are even attentive functional (narratively motivated) distinctions made between foreground and background space, as, for example, in *Krazy Kat, Bugologist* (c. 1916–1917).

An advertisement of 1915 begins by announcing, "The funny little animals that daily amuse millions of newspaper readers throughout the United States will come to life in the Hearst-Vitagraph News Pictorial," and goes on to note that the cartoon will be seen once a week within the News Pictorial's bi-weekly format. Printed beneath this information is a cartoon of Krazy and Ignatz, showing Ignatz uncharacteristically silent, listening to Krazy remarking:

[1] *The Crazy Mirror* (New York: Dell Publishing Co., 1972), pp. 99–100.

Hev it a lishen, Ignatzes; me and you is about to make a dee-buts into them "movie pitchers" as actors and hobble-nobble with "stars"—Y'know what it is a "star" Ignatz? No? Well, "Anita Stewart" is a "star" Also me—. You aint no "star" Ignatz, you ain't even a "moon"—a crude cheap face like yours is only good to be bad with like pirates and vilyins and other low lifes what toss bricks on my "bean"—always before Ignatz my talents has been in a stationary condition but now I can wiggles my eye-brow waggles my tails and make gestures just like "Sarah Bernhard" and all of em—so get your old brick throwing eye in good condition Ignatz because when you go to work as assistant to Mr. "Krazy Ket" the leading film ectress for the "Hearst-Vitagraph News Pictorial" you don't make a mistake and bounce that brick offa the audience instead of me—Well goojbye Ignatz, meet me under the lamps.

What's striking here (aside from the finally empty promises that there might be textual confusion engineered between cartoon and audience, or that there'll be brick-heaving enough, or that "Mr." Krazy Kat will indeed be an "ectress") is Krazy's abusiveness toward Ignatz: absolutely "out of character" for Krazy to speak in such a way. Nowhere in the thirty-three years of the comic strip does Krazy take the upper hand as s/he does in this advertisement (except when s/he is "possessed," as, for example, in the 1936 episodes dealing with Krazy's acquisition of the hallucinogenic Tiger Tea, and even then Krazy simply becomes—well, crazy); nowhere, that is, does the cat behave toward the mouse as cats always behave toward mice in other fables. Comic-strip Krazy, being a cat deviant from fabular catness (because utterly benign, oblivious to romantic rejection in a way proper only to the committed androgyne), can be seen as bypassing the ostensive principle at work in other humanized cartoon animals, whose characterizations tend to stem from popular notions of "dogness," "catness," "mouseness," and so on: characterizations, in short, that fix the drawn animal as a typical member of its actual species. *Ostension,* understood by Umberto Eco as "one of the various ways of signifying, consisting in de-realizing a given object in order to make it stand for an entire class," is clearly avoided by Herriman in evoking the comic-strip Krazy, who stands for no class of catness except in a negative, differential sense: cats are positively *not* benign, *not* in love with manic-depressive mice, both of which Krazy happens to be. What the version of Krazy within this advertisement suggests, then, is what the comic-strip Krazy had always admirably resisted—a retreat into ostension, a retreat into the gnostic norm. Aesop would have approved.

The ostensive tyranny predicted in the advertisement accounts only in limited measure for the overall lack of interest exerted by the cartoons themselves. There had always been more, after all, to the strip's achievement than Krazy's disavowal of catness. In the earliest stages of Krazy's cartoon life the relationship between Krazy and Ignatz is not one of the total role reversal threatened in the advertisement (that is, the old order of cat chases mouse is not massively, bilaterally reinstated) but neither does the relationship echo the one that had been elaborated in the strip. Instead, the Krazy-Ignatz relationship becomes one, generally, of animals "comically" adventuring in tandem, sometimes amicably and sometimes not, and the histories of those adventures, each one lasting only a few

minutes, retrace only briefly and occasionally the familiar contours of the strip. Under Herriman's "supervision," the cartoons aspire neither toward a naïvely direct duplication of the strip (alas) nor toward a radical reworking demanded by an opinion held of the new medium's ontological situation. That is to say, then, that the cartoons pay only rudimentary attention to the strip's visual attributes (its minimalistic backdrops and decors, not to mention its preeminently "cinematic" landscape mutations), restore practically not at all the strip's thematics, and, although Krazy and Ignatz do indulge in some occasional language play (for example, *Krazy and Ignatz Discuss the Letter "G"* [c. 1916–1917]), the option of maintaining in the cartoons the extreme phonetic and orthographic idiosyncrasies of the strip is not taken. This last failure derives understandably from a complex of factors centering on the difficulty of that language itself, which, in the strip, can be leisurely deciphered, whereas its appearance in the cartoons submits to the images' irresistible forward-motion flow, which precludes the possibility of the spectator determining his/her own reading pace.

But suppose all this had been otherwise. Suppose, that is, that the cartoon-Krazy had kept faith, from a strictly graphic point of view, with the strip. Suppose, furthermore, that the sadomasochistic economy of the central romance had been elaborated as provocatively as in the strip. And suppose the playful language experimentation had been carried over from the strip, too. Would all of this have made the cartoons more pleasurable than they are to us now? Would our attentions be irresistibly demanded?

Probably, probably. But one caveat necessary to sound regardless of the cartoon's ultimate fate: a caveat concerning duration. As Warshow intimates, in the epigraph to these remarks, the full import of Ignatz's launching of the brick is only understandable when one appreciates its profound single-mindedness, the virtual life-time freely granted to the pursuit of an obsession, and this species of dedication, it must be noted, bears an amplitude of duration expressible only through some givens available to popular cultural activity. Whatever else the strip-Krazy was, it was a daily routine, a habitual part of its reader's day: not special, hardly an event. Writing about the television soap opera, Renata Adler has characterized this kind of acquaintance as "the quotidian, running-right-along-side-life quality," and the description can't be bettered, and its significance can't be under-emphasized. Too little attention has been paid to this area, essentially an area having to do with the circumstances governing the work's reception, in the broadest sense. With respect to Krazy Kat, it's clear that a good deal of its achievement—and its appeal, its true suavity and stylishness—had to do exactly with its ability to have spoken to its readers every day and to have spoken every day by no means about the same things (there being, in fact, a startling diversity of situations, themes, and moods covered over the thirty-three years) but certainly with the same voice—Herriman's voice.

Transferred to the cinema, Krazy suffers in this respect. Routinely, intimately received in the strip format, Herriman's ensemble becomes instantly spectacular, available only intermittently, and even then only in the arena of spectacle.

As a consequence of the new site in which Krazy is now received, each installment must then aspire toward being a self-contained, "dramatically" and organically satisfying episode, unlike an installment in the strip format, in which what happens on any given day is free, and likely, to be apparently "pointless" or "unfunny."

The effect is largely cumulative. If Ignatz hit Krazy with a brick just once, it would have redounded in a vacuum, have meant nothing, as it does in the rare instance in the cartoons in which the brick actually gets thrown. But every day for more than thirty years? That's an altogether radical difference, giving rise to a double-leveled, respect-demanding dedication: the dedication of Herriman in constructing a fictive universe quite as nuanced and elaborate as that of any artist more easily assimilable into a cultural pantheon (and from among those so enshrined, Krazy would bear instructive comparison with Genêt, Keaton, and Ernst); and the dedication of those in Coconino County to being, every day, for the benefit of the reader, interestingly themselves. Again, not necessarily every day funny, every day even "comic," but just every day themselves. That's different from being every week or two a movie star, because then all your energies are compacted into making *appearances* every now and again, and then your life really isn't any longer your own.

A note on some sources. The ideal way to become acquainted with *Krazy Kat* is to go through all thirty-three years of any newspaper once carrying the strip. The less single-minded reader has other options. The standard source is the *Krazy Kat* compilation, issued posthumously in 1946, with an introduction by e. e. cummings; reissued in paperback in 1975. Included are examples of the full-color full-page installments Herriman did for the Sunday edition. The Real Free Press in Amsterdam has been issuing collections of the strip since 1974; to date, five have appeared. Several of the volumes include essays and other useful material (volume 2, for example, features Coulton Waugh's thoughtful piece, "Of Kats and Art," as well as reproduced advertisements for the cartoon-Krazy). In addition, these volumes offer a number of reproductions of Herriman's earlier strips, facilitating the investigation of Krazy Kat genealogy and/or archaeology.

About a dozen of the cartoons are available from several distributors, and I take this occasion to thank Ron Hall of Festival Films for access to their prints. The titles available (three per reel), dating from around 1916–1917, include: *Krazy and Ignatz at the Circus, Krazy and Ignatz Discuss the Letter "G," He Made Me Love Him; Krazy and Ignatz in a Tale That Is Knot, One-Act Tragedy, Krazy Kat, Bugologist; Krazy Kat Goes A-Wooing, Krazy Kat, Invalid, Krazy to the Rescue;* and, from around 1920, *Love's Labor Lost* and *A Chinese Honeymoon.*

Miracles
and Dreams
by E. E. CUMMINGS

Poet e. e. cummings is immortalized in popular culture annals for his inspiring intro-duction to the Krazy Kat *cartoon book in 1946. Yet, as this obscure essay reveals, cummings was thinking of cartoons many years earlier in the 1930s; he alone boldly praised Silly Symphonies and Aesop's Fables.*

Perhaps this commitment to Hollywood animation explains cummings's curi-ous opening lines to a later poem: "porky & porkie/sit into a moon."

The show of shows continues. A murdering mutter of profit and protest suggest-ingly haunts the theatre of theatres, but the curtain of curtains is conspicuous by its absence. And over and over the stage of stages monotonously marches our her-oine, Industria—carefully presenting to the audience of audiences her miraculous cinematographic face which has recently learned to speak.

Very occasionally, thanks to a social revolution, that face relinquishes its ha-bitual idiocy to look at us with such epics as *Potemkin* [1925]: in the silence of these immortal glances we read the meaning of ourselves. Occasionally, thanks to Aristophanes, the monster grins at us. Occasionally, thanks to Charlot, she smiles. But it is thanks to the progenitors of the animated cartoon that the miraculous eyes occasionally wink and the monotonous mobility forgets itself in fabulous clowning.

This clowning, by its very nature, burlesques the photo- and phonoplay, which is an achievement in itself. But let us not fail to observe that the animated cartoon does several other things—such as giving the uninitiate a revealing peek into the mighty mysteries of mathematical physics and summarizing, in a single inimitable sequence, several hundred volumes of psychology; not to mention pounding, naughtily and noisily, its own strictly mythical pulpit and proclaiming (to him that hath ears)—Ladies and gentlemen, verily verily I say unto youse, unto youse the Kingdom of Heaven is at hand; for verily verily I say unto youse, by accepting the gospel of science youse have become as little children!

And what the animated cartoon—or, to be scientific, Schizophrenia Trium-phans (Wake Up and Dream)—implies by such an astonishing statement is really all too obvious. Religions, being for children, are based on miracle; as witness our

own beloved religion, a successful cult of the truly miraculous. Science is that religion and that cult. To be sure, science is said to have dispensed with Santa Claus. But are not "the miracles of science" (that Super Santa Claus) everywhere—from Brooklyn Bridge to Morning Mouth? Do not "the miracles of science" move and think and feel for us? Do they not die and hate for us? Do they not wash us this day our daily teeth and forgive us our debts even as we forgive (*sic*) our debtors? Then, in the sacred name of Uncommon Sense, shall not the exploits of the animated cartoon—whose technique is miracle *per se*—rank with the most strictly Super Santa Claus exploits of the telescope and the microscope and all the other holy instruments of our religion?

"So huge is this watch that it takes light traveling through space at the rate of 186,000 miles a second, or 6,000,000,000,000 miles a year, 3,000 centuries to traverse its diameter and nearly 1,500 centuries to cross its thickness. Our solar system is way off to one side of this watch, near the rim"—the Bishop of Telescopy is loudspeakering. Miraculous? Yes; but come into the projection room!—A steamboat, a stern-wheeler with two funnels, is hurrying over a tempestuous sea; the funnels are jazzing to your favorite ditty; suddenly these funnels reach down and pick up what might be called the steamboat's body, revealing feminine underthings from which legs protrude. Why this unexpected transformation? Because Milady Steamboat is every inch the scientist. A chain of rocks having miraculously appeared (as so frequently happens in mid-ocean), Super Santa Claus is equal to the occasion.

"Father," said one day a little human being to the Vicar of Microscopy, "how long would it take everybody on earth to count the number of molecules in one (1) drop of water, if every inhabitant of our planet was counting three molecules every second?" "My child," the benevolently smiling man of God responded, "it would take only ten thousand years." Miraculous? Yes; but let me invite you to a séance with Oswald the Rabbit!—The heroine has been tied to a railroad track; tied, not with any ordinary substance such as rope, but with her miraculously mobile self: first she has been stretched beyond recognition and then she has been copiously knotted. Alas she is helpless! The villain now boards his train and attempts to run over her—but the locomotive, making all sorts of faces and noises and vigorously changing its shape, refuses. Is she saved? No! The villain (being a villain) has an idea: he backs the train full speed into a sumptuously two-dimensional distance conveniently composed of Alps, preparatory to gathering an unholy impetus and thoroughly annihilating his helpless prey. Enter the hero. Nimbly he unknots the heroine and lightly he casts her aside. Gently he seizes in each hand a rail and bends the rails away from each other, spreading them several parasangs apart without the least difficulty. Enter, from afar, the train—whereupon he calmly drops the widespread rails and awaits developments. The train makes for him like Hell. In less than a second it has reached the point at which the rails have been miracled. Presto!—the train splits neatly and exactly in two: one half of the locomotive, one half of the villain, one half of the rest of the train, faithfully follow one rail—the other half of the locomotive and villain and rest of the train faithfully follow the other rail. Between these impotently onrushing halves stands the hero: unscathed, triumphant.

But enough of crass materialism—let us visit the realm of the psyche; taking for our guide and mentor, no mere layman, but that illustrious extra- or infra-scientist, Sigmund Joy. All aboard for Slumberville! We are now asleep, without (of course) having ceased to be awake. Given this purely miraculous condition, such trifles as impossibility don't trouble us at all; everything (even a banana) being "really" something else. Let contradictions contradict—to the pure all things are impure, but we, by heaven, understand our dream symbols ... and speaking of dream symbols, will you kindly look at that mouse, I mean cat—that is, dog! Anyway, whatever it is, it wears pants, and he's got a tough break: his best beloved has just been abducted to the top story of a skyscraper which is even now shimmying with her screams. In vain does her would-be rescuer thunder at the portcullis, the shimmying skyscraper will not let him in. Something must be done—something scientific, miraculous! But is the potential avenger of outraged virtue a scientist, a miracle man? He is—and Lady Chatterley's Lover to boot. For, with one hand pulling his pants free from his stomach, he seizes with the other hand his long black flowing tail (which fortunately becomes at this moment a rigid crank) and winds it vigorously: causing a ladder (*sic*) of strictly miraculous or scientific proportions to mount from his humble pants up, up, up, even unto the tiptopmost story of the skyscraper!—And the day of days is saved ...

Such feats of arms, such deeds of do, are merest quid pro quos and baga-telles to the omnipotent protagonist of the animated cartoons. The language of this organ (if I may mix a metaphor) being the language of miracle, I mean sci-ence—that is, dream!—there results, not truth or falsehood, but wish: not what is, but what would like to is. And we of the Like To Is era, we of the "standardiza-tion," we of the "interchangeable parts," who have been summoned to conceive such subliminal sublimities as "the planetary electron" successfully avoiding itself like an eternal flea in a temporary nightshirt, are not uneasy when (before our very eyes) a head and its body successfully maintain separate existences, or ele-phants and other tiny objects successfully defy gravitation, or a cop successfully transforms himself into a six-piece orchestra to escape successfully from the very crook whom he is at the moment successfully pursuing, or (believe it or not) per-fect emptiness successfully generates absolute what-have-you.—No indeed; we are not uneasy. And if by accident, we were to become uneasy, we should only have to remember that "nothing succeeds like success" for "in dreams, it is often the rabbit which shoots the hunter."

Meantime, the show of shows continues and Industria, via the animated cartoons, encourages us to laugh. Full well she knows that a strictly Super Santa Claus epoch requires enormous quantities of laughter for the greasing of all those miraculous wheels! Hence Mickey the Mouse, Oswald the Rabbit, Krazy Kat, Aesop's Fables, Silly Symphonies, I know not what. And if you—this means you—are an abnormal individual so healthy, so fearless, so rhythmic, so human, as to be capable of the miracle called "laughter," patronize your neighborhood wake-up-and-dreamery!

BIBLIOGRAPHY

BRAY J[OHN]. "Development of Animated Cartoons." *Moving Picture World,* no. 33 (July 21, 1917).

———. "History of the Animated Motion Picture." Unpublished manuscript. The Museum of Modern Art Film Study Center, New York.

CANEMAKER, JOHN. "The Birth of Animation—Reminiscing with John A. Fitzsimmons, assistant to Winsor McCay." *Millimeter* (April 1975).

———. "Otto Messmer and Felix the Cat." *Millimeter* (September 1976).

———. "Profile of a Living Animation Legend: J. R. Bray." *Filmmakers Newsletter* (January 1975).

———. "Winsor McCay." *Film Comment* (January–February 1975).

DI LAURIO, AL, and RABKIN, GERALD. "The Search for Buried Treasure." In *Dirty Movies: An Illustrated History of the Stag Film 1915-1970.* New York: Chelsea House, 1976.

FELL, JOHN. "Mr. Griffith, Meet Winsor McCay." *The Journal of the University Film Association,* no. 3 (1971).

FISCHER, LUCY. "Independent Film: Talking with Robert Breer." *University Film Study Center Newsletter* (October 1976). [Felix the Cat]

GREEN, BERT. "The Making of Animated Cartoons." *Motion Picture Magazine* (May 1919).

HERRING, ROBERT. "Over the Moon." *Close Up* (November 1929). [Krazy Kat]

HOFFER, TOM W. "From Comic Strips to Animation: Some Perspective on Winsor McCay." *The Journal of the University Film Association* (Spring 1976).

JAMESON, MARTIN. "With the Cartoonists in Filmland." *Cartoons 2* (January 1917).

LANGER, MARK. "Max and Dave Fleischer." *Film Comment* (January–February 1975).

MCCAY, WINSOR. "Movie Cartoons." *Cartoon and Movie Magazine,* no. 31 (April 1927).

ORNA, BERNARD. "Cartoons Before Films." *Films and Filming* (December 1954).

O'SULLIVAN, JUDITH. "In Search of Winsor McCay." *AFI Report* (Summer 1974).

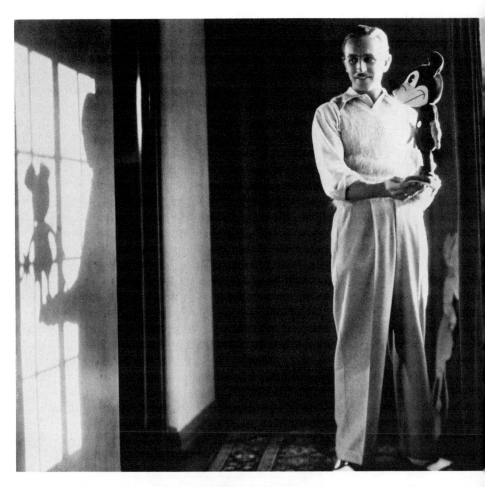

Walt Disney, the voice and creator of Mickey Mouse, the most famous movie star in the world. (Courtesy The Museum of Modern Art/Film Stills Archive)

Mickey, Walt, and Film Criticism from *Steamboat Willie* to *Bambi*

by GREGORY A. WALLER

Walt Disney was unquestionably the most widely discussed filmmaker during the 1930s and early 1940s, much as D. W. Griffith had dominated the 1910s and Chaplin the 1920s. Naturally enough, popular journalism noted the millions of moviegoers who gave Disney their box-office stamp of approval and demanded that their cereal bowls and wristwatches be graced with Mickey Mouse's icon. Thus, cover stories in Time *and articles on Disney in* McCall's Magazine, *the* Woman's Home Companion, *and a host of other general-interest magazines. But Disney got almost as much coverage in more cosmopolitan magazines like* The New Yorker *and* The New Republic, *as well as in film, theatre, and art periodicals, and even academic journals like the* American Imago *and the* Journal of Aesthetics and Art Criticism. *Not only do these reviews, articles, and interviews give us a firsthand account of one of the most extraordinary episodes in the American entertainment industry, but they reveal much about the implicit evaluative standards and broadly accepted assumptions of film criticism between* Steamboat Willie (*1928*) *and* Bambi (*1942*).*

G. A. W.

I.

I like Mr. Disney as a scenario writer much better than I do Mr. Dostoievsky, Mr. Dickens, or Sir James Barrie. He has more depth, more truth, more whimsy than any of them or all of them. —KATHERINE BEST (1935)[1]

"Europe's Highbrows Hail Mickey Mouse," announced *The Literary Digest* in 1931, and the phrase became something of a cliché for the rest of the decade, even though only one of these Continental panegyrics—Philippe Lamour's "The New Art: Mickey Mouse"—was ever translated into English: "Mickey is, quite simply, *a new mode of human expression.*" Elsewhere, British cartoonist David Low even argued in *the New Republic* (1942) that Disney was "the most significant figure in graphic art since Leonardo." The finale of *Fantasia* (1940), Low affirmed, "drives right up to the foothills of the New Art of the Future." With Disney also being

[1] All the books, articles, and interviews directly quoted in the text and footnotes are listed in the bibliography for this section. When the source for a quotation is not readily apparent in the text, I have identified the author in parenthesis after the quotation.

compared to Rembrandt and Brueghel, no wonder James Thurber asked that he film *The Odyssey*.

The father of Mickey Mouse may have been "Leonardo da Disney," for some like Low, but for other appreciative critics, he was plain old "Uncle Walt." From their self-consciously lowbrow perspective they felt the danger was that "high art" would prove the perfect mousetrap and sully the enviable innocence of Disney's popular entertainment.

Compare the "high" and "low" response to Disney's films in two articles, Jean Charlot's assessment of Disney in *The American Scholar* (1939) and Dorothy Grafly's in *The American Magazine of Art* (1933). In order to prove Disney's work was "art," Charlot emphasized the plastic language of the animated cartoon—above all, its ability to compose in time as well as in space—and noted the affinity with Cubism, Impressionism, and the Japanese haikai. Grafly, on the other hand, saw the animated film as "the folk art of a sophisticated century," and she praised Disney because Silly Symphonies broke completely with the intentionally elitist "incomprehensible . . . egocentric, self-conscious trend" in modern abstract painting and sculpture.

If Charlot and Grafly disagreed about whether Disney was more akin to Marcel Duchamp or to Mack Sennett, they both believed that his films were enormously popular because they provided an escape for audiences stuck in the Depression. Rarely was this "escape" condemned by critics as "escapism," as an irresponsible retreat from reality; more often, Disney was praised for whisking the populace from day-to-day drudgery into the bountiful land of childhood fantasy and wish-fulfilling dreams. "He takes," Robert Herring noted in 1931, "a piece of our mind that we have probably never been conscious of, and gives it to us to recognize and rejoice over."[2] Walt Disney himself agreed. He described Mickey of 1933 as speaking to "that deathless, precious, ageless, absolutely primitive remnant of something in every world-wracked human being."

Aside from Emilio Servado's interpretation of *Three Little Pigs* (1933) as an Oedipal drama (translated and reprinted in the film journal *Internecine* as a sort of Italian curiosity piece), there was almost no speculation about *whose* wishes Disney was fulfilling or *where* the audience was escaping to. In this respect the discussions of Disney typify one facile aspect of film criticism in the 1930s: for most "psychological" writers, the terms *escape, fantasy,* and *wish-fulfillment* told the whole story—Hollywood was a dream factory, and that was that.

Thus it is curious to read Fritz Moellenhoff's "Remarks on the Popularity of Mickey Mouse" in the *American Imago* (1940), a journal devoted to psychoanalytic interpretations of art and society. Moellenhoff offered a detailed Freudian analysis of why audiences identify with Mickey Mouse. There is Mickey's enviable smallness, his sadistic impulses, and his total allegiance to the "pleasure principle." However, the coup de grace is Mickey's hermaphroditism:

[2] Among others, Lin Yutang in his essay, "On Mickey Mouse" (1936), Munro Leaf in his discussion of *Snow White* for *The Stage* (1938), and William Kozlenko in *New Theatre* (1936) all emphasized the "dreamlike" fantasy of Disney's films and their appeal to the "child" in man. e. e. cummings also described the "miracles and dreams" of the animated cartoon, although cummings made no distinction between Mickey Mouse cartoons and other cartoons.

the symbolic meaning of Mickey's figure is obvious. Symbolically, we should have to call it a phallus but a desexualized one. Mickey's actions and adventures demonstrate his lack of genital interest. His audience feels that, and although he remains a mouse and a phallus, he does not stir up wishes which have to be suppressed and consequently he does not rouse anxiety.

Other critics were less psychological and more sociologically bent. The *Saturday Review* deemed the Disney films "faithful, if symbolic, representations of the harsh mechanisms of the machine age." Caroline Lejeune, film critic for the London *Observer* and the *Manchester Guardian,* was much bolder. She argued in 1931 that Disney's "work is a whispered and wicked commentary on western civilization" in which "every foible and passion of humanity is reflected except the one crowning passion for ugliness." Quite possibly, it was Lejeune's vision of a curiously Swiftian Disney as well as the widely accepted interpretation of *Three Little Pigs* as a Depression-era fable that led William de Mille (Hollywood director and brother of Cecil) to write "Mickey *versus* Popeye" (see pp. 241–244), an article for *The Forum* (1935) that brilliantly parodied the solemnity and reductive logic common to too many early attempts at sociological film criticism.

II.

To understand better the cinema devotees' outcries of admiration for Disney in the 1930s, it is necessary to backtrack. The dominant strain in film theory in the 1920s, which grew out of editorials in the *Moving Picture World* and other trade magazines and books like Vachel Lindsay's *The Art of the Moving Picture* (1915) and Hugo Münsterberg's *The Photoplay: A Psychological Study* (1916), was preoccupied with establishing the uniqueness—and therefore the aesthetic legitimacy—of the film medium. There were innumerable attempts to define the peculiar language and fundamental "essence" of the cinema, for most critics assumed that the only valid film was a "pure" film. Thus the widespread rejection of literary adaptations, and more important, theatricalism—"deadly stage blight," Gilbert Seldes called it in 1925. It is therefore logical that, even in the 1920s, certain critics like Elie Faure in his *Art of Cinéplastics* (1923) suggested that the animated cartoon was potentially the highest form of cinematic expression.[3]

In the late 1920s sound threatened to destroy the primacy of the image; movement and montage gave way to static mise-en-scène. The "purist" critics responded with a barrage of vitriolic articles designed to curse the sound film out of existence. But gradually and grudgingly, with sound accepted as a fait accompli, these same critics changed their tactics to demand a "pure" and nontheatrical au-

[3] See also S. L. M. Barlow, "The Movies—An Arraignment," *The Forum* (1922) and Robert Nichols, "The Movies as Medium," *The Realist* (1929). Creighton Peet's 1929 assessment of the "cartoon comedy" is most revealing: "when it comes to 'pure cinema,' 'visual flow,' 'graphic representation,' 'the freedom of the cinematic medium,' and all the other things learned foreign cinema enthusiasts talk about, nothing that Jannings or Lubitsch or Murnau or Greta Garbo or Rin Tin Tin can do has more than a roll of celluloid's chance in Hell beside Felix the Cat and the other animated cartoons."

diovisual cinema in lieu of Hollywood's "photographed theatre." Then came Mickey and the Silly Symphonies, sound films yet still moving pictures par excellence, and the "purists" were ecstatic. Disney was immediately enshrined as a bona fide cinéaste.[4] At last, Seldes wrote in 1932, "the movie [is] developing in its own field, borrowing not at all from inappropriate sources . . . everything possible is expressed in movement and the sound is used for support and clarification and for contrast." Similarly, Paul Rotha argued in *The Film Till Now* (1930) and *Celluloid: The Film Today* (1931) that Disney's cartoons were "perfect examples of the sound and visual cinema." But of the many testimonials, perhaps Caroline Lejeune's best summarizes the reasons that so many "purists" judged Disney's films to be "the most satisfying productions that can be found in the modern cinema":

> Disney has become a giant overnight by bringing back movement to the moving picture—we might almost say by inventing it. . . . using the modern technique of sound, and the newest equipment of camera and laboratory, he has cut away the whole tradition of the static and the theatrical that has been gripping the cinema more and more tightly with the years.

The case was most eloquently stated by Lewis Jacobs in his much-acclaimed *Rise of the American Film* (1939), a critical history that included a chapter devoted to "Walt Disney: Virtuoso." In Jacobs's words: "the wise heir of forty years of film tradition, he [Disney] consummates the cinematic contributions of Méliès, Porter, Griffith, and the Europeans." "Pure" film had found its champion: theoretical prophecies and ultimatums had been fulfilled by the creator of Goofy and Pluto. And Robert Gessner called *Fantasia* an "event of historical importance," on a par with *The Birth of a Nation* (1915).

III.

Enough has been written about Disney's life and hard times already to stamp the bald, Algeresque outlines of his career as familiarly on the minds of many Americans as the career of Henry Ford or Abraham Lincoln. —*Fortune* (1934)

Many articles were far less concerned with the films than with the inner workings of the Walt Disney Studio and, above all, with Walt himself, who *McCall's Magazine* called the "Young Man Who Made Good." Harry Carr's *American Magazine* article (1931) may serve as a prototype: beginning with obligatory hosannas to Disney's achievement with the animated film, Carr quickly moved to a sympathetic biographical sketch of Walt and an inside peek at the mysteries of Disney's

[4] Eric Walter White affirmed in 1931 that Disney had "triumphantly solved" the "problem" of sound accompaniment, and thus his films approached the "purely cinematic." A similar opinion was expressed by Robert Herring in 1929, and Philippe Lamour saw in Disney's use of sound as the "harmonious complement of the image" a much-needed improvement over "filmed theatre." Seldes offered the same opinion of Disney five years later in *Esquire:* "No one else has found so agreeable a color scheme and no one else has so successfully integrated pictures and music." See also, "Walt Disney and Mickey Mouse," *Sight and Sound* (1935); Dallas Bower, *"Plan for Cinema"* (1936); and Marcia Davenport, "Not So Silly," *The Stage* (1936).

production methods from story to screen. As if a host of journalists were treated to the same interview, taken on the same tour of the Disney Studio, and handed the same press releases, Carr's "facts" and format played like a broken record for the next ten years in articles written for *The New Yorker* (1931), the *National Board of Review Magazine* (1931), *McCall's Magazine* (1932), *Movie Classic* (1933), *Time* (1933 and 1937), *Cosmopolitan* (1934), *The Rotarian* (1934), *The New York Times Magazine* (1934), *Fortune* (1934), *Woman's Home Companion* (1934), *Scholastic* (1935), *The Literary Digest* (1936), *The Atlantic Monthly* (1940), the *Ladies' Home Journal* (1941), and *Reader's Digest* (1942), as well as in books such as *Hollywood by Starlight* (1935), *Behind the Cinema Screen* (1934), and *Movie Merry-Go-Round* (1937). (Interestingly, many of Carr's biographical "facts" directly follow Disney's own misty memories in interviews and articles under his name, "Mickey Mouse: How He Was Born" [1931] and "The Life Story of Mickey Mouse" [1934], both published in the *Windsor Magazine*.)

When seen through the rose-tinted prism of popular journalism, Disney's life story became a homespun mythic saga and a reassuring affirmation of the American Dream. Douglas W. Churchill seriously described Disney in *The New*

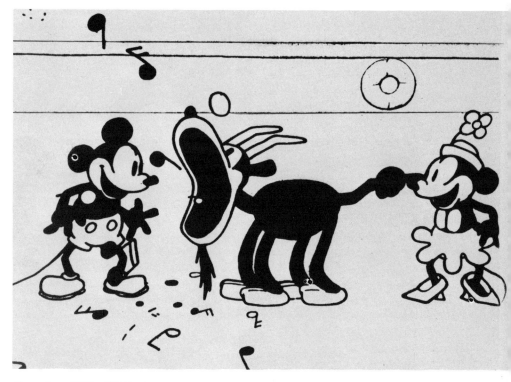

Steamboat Willie (1928), the first sound cartoon, was highlighted by a sequence in which Mickey and Minnie play makeshift musical instruments. Sound gave Disney a jump on his competitors. © Walt Disney Productions. (Courtesy The Museum of Modern Art/Film Stills Archive)

Pinocchio (1940) has always been a favorite of the critics, even those who usually dislike Disney's products. Here Pinocchio is joined by Figaro (the cat), Cleo (the goldfish), and Jiminy Cricket. © Walt Disney Productions.

Bambi (1942) has always been a favorite of Disney fans, but critics have attacked it for its sentimentality. © Walt Disney Productions.

York Times Magazine as the "Horatio Alger hero of the cinema . . . who through industry, courage and all the other Algerian virtues attained international recognition." He was pictured as a wholly unpretentious entertainer and praised by the *Ladies' Home Journal* as a "living testimonial to the importance of moderation in education."

Furthermore, Disney was invariably portrayed as an independent who had successfully challenged the motion-picture establishment. For example, almost all of these articles noted that he shunned the infamous night life and flamboyant extravagance of the movie colony, preferring instead to live frugally and pour all his profits back into his ever-expanding studio. Above all, the public biography emphasized that Disney was "down-to-earth, middle class" (Churchill, 1934)—neither a crafty European immigrant nor a jaded Eastern sophisticate nor a temperamental Continental artiste, but rather, in Robert Feild's phrase, a "conspicuously average American" with a "combination of innocence and a determination to follow his star wherever it might lead."

At the end of Walt's rainbow stood the Disney Studio, and most articles in praise of Disney also swooned over his production methods, offering the layman a glimpse into what *Newsweek* termed the "workaday side of an airy fantasy." Indeed, up to and even after the fierce strike by the Screen Cartoonists Guild in 1941, magazine readers could not help but think that the Disney Studio maintained a harmonious and profitable balance between efficient productivity and creative freedom, and that all Disney's employees whistled while they worked. Thus Robert Feild concluded his 300-page hymn to *The Art of Walt Disney* (1942) with a description of the studio as the modern-day equivalent of "that great workshop tradition that underlies so much of man's achievements in the past—a tradition in which the artist as worker is dedicated to the fulfillment of a purpose and is satisfied to remain anonymous." Other critics sang the same conclusion: the Disney Studio was a "twentieth-century miracle" (*Fortune* [1934]), a "jewel in the flats of Burbank" (Paul Hollister in *The Atlantic Monthly* [1940]), with Walt, the grand patriarch, dispensing wisdom like a "Hindu God" (Thomas Burton in the *Saturday Review* [1940]). Even leftist observers often played down Walt's paternalism in order to extol "The Communalistic Art of Walt Disney," the title of Mack Schwab's piece in *Cinema Quarterly* (1934). And William Kozlenko, in the Marxist-oriented *New Theatre,* characterized the Disney Studio as an ideal illustration of the "marvellous creative values engendered by collective collaboration."

When Otis Ferguson reported on the strike at the Disney Studio for *The New Republic,* he offered a less merry melody—Walt no longer guided an Edenic workshop but commanded a Hollywood "sweatshop." (See also "Snow White and the 1,200 Dwarfs," Anthony Bower's description of the strike in *The Nation* [May 10, 1941].) Otherwise there were few attempts to demythologize the legend, besides two articles by Charles Glenn in *The Daily Worker,* which insisted that Disney was "like any other producer in Hollywood, any other banker on Wall Street." And although negative criticism of Disney's films began as early as 1931, and surfaced repeatedly during the next ten years, it never constituted more than

a minority report. Perhaps this was because Harry Alan Potamkin, the man who seemed destined to write *the* critique of Disney, died in 1933.

Secretary of the Worker's Film and Photo League (a radical film collective) and regular contributor to *Close Up, Cinema,* and the *New Masses,* Potamkin was probably the most prolific and surely the most well-informed American film critic of his day. Although none of his essays was exclusively devoted to the animated cartoon, Potamkin often discussed Disney's films, most notably in "Film Cults," an article that appeared in the *Modern Thinker and Author's Review* (1932), and in his 1931 surveys of the Soviet cinema for *Close Up* and *Theatre Guild Monthly.* He saw Disney's work as "a graphic that is not much more than a scrawl, line-contours with an occasional dull wash for setting, a lycanthropy with a bit of puerile sophistication, an absence of a pointed, developing narrative idea, an unoriginal turkey-in-the-straw musical motif, 'perpetual motion.'" As an alternative to Mickey Mouse and the Silly Symphonies, Potamkin offered *Post,* a Soviet cartoon that incorporated "poster-illustrations, patterns in line, living images of humans as interludes, and even newsreel excerpts" into designs that moved in "diagonals" and "circles" as well as "horizontals." Above all, *Post* contained "ideas," an essential component that Potamkin felt Disney had entirely overlooked.

Disney's lack of ideas also troubled William Troy, *The Nation*'s film reviewer during the mid-1930s, and Claude Bragdon in *Scribner's* (1934) questioned the "narrow limits of the merely funny." But not until the release of *Fantasia* did some critics begin to suggest that the major problem with Disney's films was less lack of ideas than omnipresence of bourgeois ideology. For Harry Richmond of *The Daily Worker,* the finale of *Fantasia* was yet another "propaganda payoff . . . that aims by a metaphysical approach to life to dull and blur the true picture of the struggle of class forces in the world today." "Beginning with *Snow White,*" Dorothy Thompson wrote in her review of *Fantasia* for *The New York Herald Tribune,* Disney has "developed a gloomy, fatalistic, pantheistic philosophy to record the Fall of Man and to record it with a sadistic relish. . . only the animals are in a state of grace in any of the later Disney films." However, it should be emphasized that criticism of Disney was at most sporadic dissension rather than open revolt. *Time* magazine lauded *Fantasia* as the harbinger of "an art form that immortals from Aeschylus to Richard Wagner have always dreamed of."

IV.

We have a realm all our own, where little animals and even inanimate objects can talk and think and act like human beings, only more charmingly.
—WALT DISNEY, "Mickey Mouse Presents" (1937)

There were dozens of critics like British documentary filmmaker Basil Wright who felt that Disney was "most successful when he delineates animals with all the raiment and some of the characteristics of men and women." Robert Herring might dub Disney's domain the "world of the stuffed-toy department," yet Dumbo and Jiminy Cricket and all the other personable inhabitants of Disney's human animal kingdom got the kind treatment usually reserved for Shirley Temple and Mickey Rooney.

Actually, it was not Disney's anthropomorphism but his attempts at "realistic" animation that were most often criticized. Even Lewis Jacobs and other Disney enthusiasts saw Snow White and her charming Prince as patterned on Hollywood stereotypes. Siegfried Kracauer noted a similar tendency toward conventionality in *Dumbo* (*The Nation* [1941]), and charged that Disney had betrayed not only Mickey but the cartoon itself, a genre that "tends toward the dissolution rather than the reinforcement of conventional reality," and that must not "draw a reality that can better be photographed." Lawrence Wright rejected *Snow White* (1937) for very similar reasons. "Birthday-card prettiness" and the "illusion of real living movement" had no place in a distinctively "nonrealistic" form. Christopher La Farge also found Disney weakest when he tried to "compete with the movies" instead of exploiting the abstraction of the animated film.

Still, most critics felt that Disney's failure with Prince Charming was superseded by his success with Dopey *et al.* And for Otis Ferguson, probably the most perceptive film reviewer between 1934 and 1941, "realism" was always one of Disney's greatest virtues. In his many reviews of Disney films for *The New Republic,* Ferguson returned again and again to Disney's "solid basis in observation." For example, he praised *The Band Concert* (1935) because "natural action is caught and fixed in a typical gesture, rendered laughable through exaggeration or through transference into the unfamiliar." And according to Ferguson, in *Snow White* the Disney artists "are practically zoological. . . . the incidents start from a firm basis in reality."

Although Ferguson had reservations about the didacticism of *Pinocchio* (1940) and *Fantasia*'s "bend of the knee before Art," he remained one of Disney's most vocal proponents. On the other hand, Manny Farber, Ferguson's successor at *The New Republic,* offered the most severe criticism of Disney since Potamkin's early articles. Farber was almost as much of a Mickey Mouse cultist as Gilbert Seldes, but his review of *Bambi* (1942) fully articulated the several undercurrents of dissatisfaction with Disney's feature films. Farber found *Bambi* bogged down with "starched heavy" moralisms, and, like Kracauer, he attacked Disney's attempt to imitate the stale formulas of nonanimated features. Farber argued that Disney's once innovative use of color had become a "synthetic reveling in vulgarity," "sweet sugary tints," and "tinseled loveliness."

Farber's review of *Bambi* is a devastating critique of the Disney world, and it is very tempting to see this review as a turning point toward a revisionist view of Disney in the 1940s. Tempting, but hardly true, once we remember that Robert Feild's *The Art of Walt Disney*—an unqualified tribute to the man, the mouse, the studio, and the style—also appeared in 1942, and received uniformly exuberant reviews. In fact, there was more written about Feild's book than about Bugs Bunny and the entire Warner Brothers animated menagerie. Three months after his review of *Bambi* Farber offered the first and only appreciative assessment of Leon Schlesinger's Merrie Melodies unit at Warners published during this entire decade. And Popeye and Olive Oyl did not fare much better than Bugs and Elmer. For almost all critics and journalists and reviewers of the 1930s and early 1940s, the animated cartoon was quite literally Disney's land.

The Making of Cultural Myths— Walt Disney

by ROBERT SKLAR

What was so astonishing about the Mickey Mouse films Disney began to make in 1928 was how completely they formed a world of their own. It was Disney's brilliant use of sound that immediately caught the public's attention and catapulted him to success and leadership in the animation field: the first Mickey Mouse release, Steamboat Willie (*1928*), *came at a critical moment in the industry's transition from silence to sound, and Disney's bold inventiveness with integrated visual and sound effects gave animated shorts a popularity and aesthetic significance they had never had before. But his triumph with sound should not obscure the rich and complex pictorial world thus made audible.*

Disney's interpreters invariably described the early Mickey Mouse films and the Silly Symphony series that followed in 1929 as crude—in drawing, story, and the behavior of their characters. The basic thrust of such criticism is technical: as the years went by, Disney and his animators became increasingly proficient, elaborating their drawings, adding color (again, as with sound, ingeniously integrated with the drawings and story and perfected well in advance of the larger studios), and even producing the effects of three-dimensional depth through another technical achievement, the multiplane camera.

This argument from technical growth describes a clear-cut process of advancement: when the mouse series was inaugurated, Disney was capable only of primitive and simple animation, but he and his staff swiftly got better and better—more sophisticated and more complex. To say that later is better than earlier, however, is to ignore a more fundamental kind of change. In the early Mickey Mouse and Silly Symphony films, Disney and his animators created one kind of fantasy world. Then they gave it up, putting in its place not a fantasy but an idealized world. A preference for the later over the earlier cartoon shorts should be recognized as an aesthetic and cultural as well as a technological judgment.

R. S.

In his classic anthropological work, *The Savage Mind* (1966), Claude Lévi-Strauss attacks the common notion that modern civilization is necessarily higher, or better, than "savage" societies. Modern life is not a sophisticated version of a simple life; it is an altogether *different* life, based on an entirely separate understanding of

(*above*) *The Skeleton Dance* (1929), the first of Disney's Silly Symphonies. © Walt Disney Productions. (Courtesy The Museum of Modern Art/Film Stills Archive) (*below*) Disney's *Three Little Pigs* (1933), the most popular Silly Symphony, was innovative in that each character was given a distinct personality. © Walt Disney Productions. (Courtesy The Museum of Modern Art/Film Stills Archive)

"The Pastoral Symphony" in Disney's *Fantasia* (1940). (a) What was conceived, and (b) what was used. © Walt Disney Productions. (Courtesy The Museum of Modern Art/Film Stills Archive)

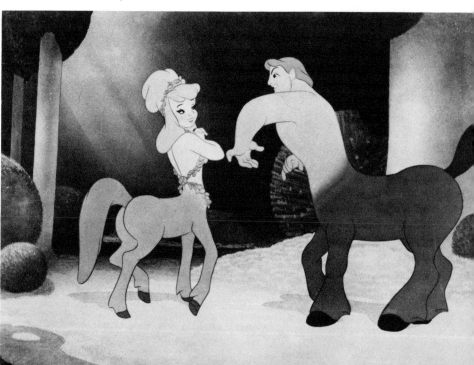

the world. Indeed, according to Lévi-Strauss, "savage" peoples, with their highly elaborated knowledge of terrain, flora, fauna, kinship, and ritual, may live a more complex life than we do. Somewhat the same distinction applies to Disney's cartoons. The two worlds, the fantasy of the early period and the idealization of the later, stand in direct contrast to each other, and both possess their separate kinds of sophistication and complexity.

The early Mickey Mouse and Silly Symphony cartoons are magical. Freed from the burdens of time and responsibility, events are open-ended, reversible, episodic, without obvious point. Outlandish events occur without fear of consequence. There is no fixed order of things: the world is plastic to imagination and will. Yet its pliant nature also renders it immune to fundamental change. Almost presciently, this comic fantasy world portrays the cultural mood, the exhilarating, initially liberating, then finally frightening disorder of the early Depression years.

Around 1932 the Disney cartoons began to change; by 1933 a whole new world view had emerged. The later cartoons are tales, many of them moral tales. They rejoin the straight and narrow path of time. They have beginnings and endings, and everything that happens in between has consequences. The world has rules, and you'd better learn them or watch out. Don't be too imaginative, don't be too inquisitive, don't be too willful, or you'll get into trouble—though there's always time to learn your lesson and come out all right. This idealized world was a full year or two ahead of feature films—perhaps because the features took longer to plan, produce, and market—in expressing the spirit of social purpose, the reenforcing of old values, in the culture of the later 1930s.

Mickey Mouse survived in both these worlds. He personified each in turn, though not without some major changes. Like no other twentieth-century motion-picture character except Chaplin (on whom some say the mouse was modeled), Mickey possessed the world's imagination. He, too, was a creature of many masks, expressing what we all like to think are the best traits of our humanity: sweet sentiment, unfeigned pleasure, saucy impudence. Mickey was all heart, but in the beginning he did not wear it on his sleeve.

At first he was very much a rodent. His limbs were thinner and his features smaller than the later, anthropomorphic version. In *Plane Crazy* (1928), his first film, made as a silent, then released with sound after *Steamboat Willie,* he went barefoot and barehanded, but by *Steamboat Willie* (1928) he wore shoes and soon acquired white four-fingered gloves. He was unselfconscious and egocentric, wearing the same confident, self-satisfied grin Edward G. Robinson was to flash a couple of years later as the immigrant gangster Rico in *Little Caesar* (1930). Unlike Rico, however, Mickey had no end. Success eroded him in other ways. "Mickey's our problem child," Disney said later. "He's so much of an institution that we're limited in what we can do with him."[1] He became respectable, bland, gentle, responsible, moral. Donald Duck was added to the Disney cast to provide the old vinegar and bile.

The first four Mickey shorts were released in 1928. The next year the Disney Studio produced sixteen cartoons, including a handful of Silly Symphony films.

[1] Quoted in Leonard Maltin, *The Disney Films* (New York: Crown Publishers, 1973), p. 8.

Thereafter they completed a cartoon short about once every three weeks—a total of 198 from *Steamboat Willie* to the end of 1939. About half were in the Mickey series, and the other half in the Silly Symphony series, the name for all the shorts without the mouse.

In *Plane Crazy,* Mickey is an inventive, willful aviator, a barnyard Lindbergh. He builds his craft from any material at hand, live or inanimate; to provide power for the plane he twists a dachshund like a rubber band, and for its tail he plucks a turkey feather. Once constructed, the airplane also becomes a living thing, as must the objects in its determined path: a church steeple folds itself down to avoid being hit.

It turns out that Mickey's goal is not fame or heroic achievement, it's lechery. He has built the plane to impress his girl friend, Minnie, and get her up in the air where she won't be able to run away from his advances. Instead of submitting, however, she jumps from the plane, pulls a cord on her bloomers, and they billow out to float her safely down.

The public first saw Mickey and Minnie in *Steamboat Willie,* in which the brilliant fusion of music with visual images adds immeasurably to the magic possibilities of plastic forms. A goat eats up Minnie's sheet music. She swiftly twists its tail into a crank, turns it, and the notes come pouring out of the goat's mouth as "Turkey in the Straw" (a scene reminiscent of Chaplin in *The Tramp* [1915] pumping a cow's tail and filling his pail with milk). Mickey also made music by playing animals for different sounds—he got melody from, among others, the tails of suckling piglets and then from the teats of the sow.

Disney's early films had their share of raunchy scenes and outhouse humor. Some official responses, however, were even more ludicrous. Ohio was reported to have banned a cartoon showing a cow reading Elinor Glyn's novel of adultery, *Three Weeks* (1909)—perhaps because the Buckeye State thought it safe to drink milk only from monogamous cows. Then the Hays Office ordered Disney to take the udders off his cows: thereafter, no matter what they read, their milk at least would not harm anyone.

A taste for the macabre was another strong element in Disney's style, and in early 1929 he launched the Silly Symphony series to express the grisly humor that was out of place in Mickey's sunny world. The first Silly Symphony, *The Skeleton Dance,* depicted a nighttime outing of skeletons in a graveyard, dancing and cavorting to music. One skeleton makes music on another, like a xylophone. *Hell's Bells* (also 1929) was even more grotesque: it takes place in hell, whose inhabitants include a three-headed dog and a dragon cow that gives the devil fiery milk (even Hades has its barnyard aspects).

Disney and his animators knew the value of shock and titillation before the feature producers, and though he often borrowed ideas from popular features, it is as likely that his cartoons fertilized the imaginations of other filmmakers in the early Depression years. In a 1930 Mickey Mouse comedy, *Traffic Troubles,* Mickey and Minnie crash into a truck loaded with chickens and end up covered with feathers, clucking and crowing—a comic fate Tod Browning transmuted into horror for Olga Baclanova two years later in *Freaks.*

Living and inanimate things reverse their roles. In *The Opry House* (1929) Mickey begins to play the piano, but the piano and its stool kick him out. The instrument plays its own keyboard with its front legs, and the stool dances. When it's over, Mickey comes back out and all three take a bow. Mickey's taxicab in *Traffic Troubles* bites a car to grab a parking place, licks a flat tire, and goes crazy after drinking "Dr. Pep's Oil." What have those fantasies to do with a culture's myths and dreams?

It would be easy to claim too much for these cartoons, yet their immediate and steadfast popularity makes them of prime interest. In the long-standing style of American humor their extravagance, exaggeration, and grotesque imagination serve as mythic constructs of their society. Moreover, as animations they stand at an even further remove from the requirements of verisimilitude. Their fantasy nature frees the viewer's mind from normal expectations of what the world is like, and the simplicity of the drawings, far from signaling stylistic crudity, is a necessary aspect of opening up the imagination. (Disney's press agents later coined the term *imagineering,* which is an accurate description of what the later cartoons do—structure all effects so there is no room for the viewer's imagination to operate.)

The early fantasy cartoons are deeply committed to the old American tradition of individual initiative and enterprise. Yet the extreme of their fantastic possibilities, the ease and plenitude of their magical metamorphoses, puts the viewer at a distance from the usual motifs of individualism—hard work, self-denial, upward striving—and throws some of its deeper meanings into bold relief. In the real world people do indeed turn themselves into instruments and machines to pursue their goals; and machines do in fact take on a life of their own, directing and dominating their supposed masters, taking them places they did not want to go. In a profound way these fantasies do not create myths so much as expose them.

The first signs of the dissolution of the fantasy style came with the increased tempo of violence in Disney's cartoons. By 1932, even in such superbly inventive films as *Touchdown Mickey* and *Building a Building,* the fantasy elements have been almost completely replaced by a spirit of physical and material violence. Pain and injury cause no permanent damage, but that is no longer magical, it is merely a convention.

At the same time, the emotional range of the characters and plots begins to expand. There are more joys and sorrows, pleasures and terrors, but they are cast in a sentimental formula mold. Creatures become more anthropomorphic and less versatile. These changes are prominently exhibited in the first Technicolor cartoon short, *Flowers and Trees* (1932), about a villainous old tree who tries to stop a romance between a boy tree and a girl tree, which won Disney his first Academy Award. Mickey Mouse, too, begins to succumb to the pattern of conventional melodrama, heroes and villains and happy endings, in such films as *The Mail Pilot* (1933), which ends with a clinch between Mickey and Minnie, instead of the old Chaplinesque impermanence of relations (though it should be said that Chaplin's endings in his silent features, like *The Kid* [1920] and *The Gold Rush* [1925], had become more sentimental, too).

Disney's most popular and influential cartoon short, *Three Little Pigs,* came at the climax of his stylistic transition and unites essential aspects of the old and the new. It was drawn in the new style of full-color idealization, and it told a familiar moral tale, but by an uncanny prescience Disney picked a story that was open-ended, that left the individual imagination free to decide what it all meant.

Three Little Pigs was released in May 1933, in the midst of Roosevelt's "hundred days" campaign of legislation to combat the Depression and raise public morale. Its upbeat theme song, "Who's Afraid of the Big Bad Wolf?," became a nationwide hit, and Disney could not supply enough prints of the film to meet popular demand. Richard Schickel, in *The Disney Version* (1968), argues that Disney's retelling of the fairy tale of the home-building pigs and the hungry wolf had a basically conservative point, in keeping with the producer's conservative political allegiance: the pig who exhibits old-fashioned virtues, hard work, self-reliance, self-denial, is the successful one. It's just as plausible, however, that the most effective pig is the one who does not minimize the fact of crisis and builds with modern material and tools. No doubt there were some contemporary viewers who, like Schickel, saw the film as a paean to Herbert Hoover, but the film's extraordinary popularity appears to have stemmed, whatever Disney's intentions, from its apparent expression of the confident, purposeful spirit of the early New Deal.

Three Little Pigs was among the last of Disney's cartoons open to multiple interpretation. Thereafter there was no mistaking the films' moral messages. In *Lullaby Land* (made later in 1933) a baby with his toy dog wanders in a dream through a world where nature has been transformed into inanimate household objects. He enters a "Forbidden Garden" filled with plants and trees made of knives, clippers, scissors, pens, hammers, razors, matches, and pins. "Baby mustn't touch," watches growing on a tree sing out, "they'll hurt you very much." He gets burned by matches and chased by bogymen before the sandman rescues him.

This is a message of survival, not by old-fashioned initiative and self-reliance, but by sticking to society's rules, a very different kind of conservatism. The hare in *The Tortoise and the Hare* (1934) is the clever, ambitious one—the preening male who can run so fast that he can pitch a ball and bat it himself, shoot an arrow and be waiting for it like William Tell's son with an apple on his head—and we all know who won the race. The mouse who wanted to fly in *The Flying Mouse* (1934) also learns the hard way: he frightens off the birds he wants to play with and scares his own family with the shadow of his wings, but he doesn't fool the evil bats, who sing, "You're nothin' but a nothin'." The good fairy who gave him his wings rescues him with the admonition: "You've learned your lesson. Do your best. Be yourself. And life will smile on you."

Even Mickey is recruited to the new morality. In *Pluto's Judgment Day* (1935) he's so anthropomorphic that he's an owner of domesticated animals. He rebukes Pluto for chasing the cat, and the dog settles into a troubled sleep near the fire, dreaming of punishment in hell for his misdeeds. The underworld scenes have interesting affinities with *Hell's Bells* that illuminate the transformation of

Disney's style. In the earlier film they are a fantasy, in the later, a dream, carefully bounded by waking reality: they are not magic, not out of time, they are part of Pluto's imagination, not accessible to the viewer's.

No account of Disney's later 1930s cartoon shorts would be complete without paying tribute to their remarkable feats of sound, color, and animation, their sustained inventiveness, their frequent brilliance of design and conception. Such films as *The Band Concert, Music Land* (both 1935), and *The Old Mill* (1937) are tours de force of tight construction, pace, and the steady building of effects to a spectacular and satisfying climax. But one should not lose sight of what their style signifies; there is one right way to imagine (as elsewhere there is one right way to behave). The borders to fantasy are closed now. The time has come to lay aside one's own imagination, and together all shall dream Walt Disney's dreams.

Snow White and the Seven Dwarfs

by PETER BRUNETTE

Ever since Walt Disney's Snow White and the Seven Dwarfs *opened in 1937, there have been those who insist on seeing it as more than mere childish entertainment. A delightful example is the word battle that broke out in the summer of that year in the august* Christian Century *magazine. One parson, writing to the editor, praised the film as a myth about the Garden of Eden: the Queen is the embodiment of Sin; while Prince Charming represents the power of Love, the grace that God bestows after Innocence, Snow White, has been temporarily defeated. Another letter writer, taking an opposite tack, castigated* Snow White's *songs, symptomatic of the anomie of the Depression times. He found "I'm Wishing" and "Someday My Prince Will Come" particularly offensive; and "Whistle While You Work," he suggested sarcastically, should be retitled "Whistle If You Work."*

As there is precedent for analysis, let us proceed with impunity in investigating Snow White. *We shall begin with the source of the story, the Grimm Brothers fairy-tale version, to see what plot and character elements were available to Walt Disney and how the Disney Studio utilized them.*

P. B.

The tale was first published in the Grimms' *Kinder- und Hausmärchen* (*Child and Household Tales*), which appeared in 1812 and 1815. Many versions exist in nearly all the folk traditions of Europe, often with variations reflecting local conditions, culture, climate, among other things. The Grimms were the first to go about the countryside collecting the tales as actually told by mothers to children and the first to set them down. Therefore the Grimm "Snow White" has assumed precedence over all the others.

An investigation of the Grimm version leads to some interesting revelations. First, the original story is actually quite short—no more than ten or fifteen pages. Second, many of our deepest memories of the fairy tale turn out to be pure Disney, and conversely, many key elements of Grimm are missing in the film. For instance, we are shocked to realize that in the Grimm version the dwarfs are absolutely un-individualized: Dopey, Sneezy, Grumpy, and the others were born in the Walt Disney Studio. On the other hand, nowhere does Disney make mention

of Snow White's mother and father, or of why she came to be living in the castle.

In another example, Prince Charming is interjected only at the very end of the Grimm tale, after Snow White has eaten of the the poisoned apple and gone into a deathlike trance. The Prince decides that the sleeping princess is so exquisitely beautiful, even in death, that he simply must have her with him. The dwarfs reluctantly agree. As her bier is being removed, the Prince's servants stumble over a bush "and with the shaking the bit of poisoned apple flew out of her throat." Snow White revives, and she and the Prince decide to marry. The wicked Queen, Snow White's nemesis, attends their wedding, although unaware of the bride's identity. "And when she saw her she knew her for Snow-White, and could not stir from the place from anger and terror. For they had ready red-hot iron shoes, in which she had to dance until she fell down dead."

And thus the tale concludes. In Disney's version, the Prince is introduced briefly near the very beginning, just long enough to entrance the shy young Snow White and to be entranced. The effect is to give Snow White a romantic longing throughout the film, which provides the occasion for songs like "I'm Wishing" and the immortal "Someday My Prince Will Come." When the Prince returns at the end, our expectations are fulfilled and satisfied. In addition, Disney realized the awkwardness in having Snow White's salvation come when the servants trip over the bush. The rescue is effected solely by the Prince. Disney's solution was to steal a bit of business from another Grimm tale that he would later bring to the screen, "Sleeping Beauty," and have the Prince's kiss provide the antidote that awakens her. The movie ends as the Prince and Snow White ride off into the sunset amid a glowing Maxfield Parrish-like setting, the image of the castle, now purified, forming slowly in the clouds. Appropriately, Disney eliminated the Grimm wedding scene. It would have been anticlimactic, especially with the Queen already long dead.

Another difference in the versions is Snow White's partaking of the luscious red apple. In the Grimm version, this is the *third* temptation. The first time, the Queen, disguised as an old hag, tempts her with a corset, which the Queen tightens until Snow White faints. She is revived by the dwarfs, who rescue her a second time after the Queen has overcome her with a poisoned comb. Last comes the apple. In print, this triadic pattern, compressed into several pages, is satisfying in its very repetitiveness, like the standard three-part joke. On the screen, three so similar reenactments would probably have become tedious.

In purely visual terms as well Disney transformed the source material to enhance the viewer's sensual experience. The incredible expressionist scene of Snow White in the dark forest, which so magnificently externalizes her subjective state, is a fortunate Disney elaboration of sketchy suggestions in the original. And the Queen's incredible metamorphosis into an old hag down in the bowels of the castle is another thrilling visual improvisation from Disney. Other minute details are adjusted to achieve maximum humorous impact. Whereas in Grimm the dwarfs work in a copper and gold mine, in Disney they work in a much more photogenic diamond mine. (This also allows for a great kaleidoscopic clowning shot of Dopey with diamonds stuck in his eyes.) Lots of "stage" business is also provided by

making the dwarfs' cottage a two-floor model rather than the one-floor one of the Grimm tale. Many humorous bits with both animals and dwarfs occur on the stairs between floors, or on the darkened upper floor. For example, when the dwarfs come home from work, Disney maximizes both "scariness" and humor in the discovery of Snow White upstairs sleeping on their beds. Disney's dwarfs are a fearful lot, initially scared to death of Snow White, whereas the Grimms' dwarfs aren't the least bit afraid and find her straightaway.

Some changes seem to have been made to lessen or at least sanitize the violence inherent in the Grimm version. For example, where the Grimm version has the wicked Queen *eat* what she thinks are the *lungs* and *liver* of Snow White (really the organs of a wild boar) after she has dispatched the huntsman to kill her, Disney has the huntsman present the Queen the supposed *heart* of Snow White, hidden from our sight in a pretty casket. She politely holds back her appetite. We are also spared the vision of the wicked Queen dancing herself to death in the hot iron shoes at the wedding. In Disney's version, we never actually see her die. Instead, she is chased to the top of a cliff by the dwarfs (amid violent rain and lightning, which recall the genuine terror of Snow White's first night alone in the forest), and when she tries to roll a boulder down on them, a piece of the cliff breaks off and she falls with it. The camera astutely remains on two macabre vultures who follow the Queen's descent with their eyes, then fly off their branch and spiral downward as the camera goes swiftly out of focus. Much of the Disney-invented violence is tame: Dopey is continually pummeled by his fellow dwarfs and constantly runs into things, but he never shows any ill effects. This sort of idealized violence is, of course, part of the very nature of animation, where the excitement of the violence can be conveyed without having to confront its repulsive and often permanent "real-life" results.

Disney also expanded his source structurally in terms of location, repetitive patterns, shadows, and colors. In the Grimm version, nearly all the story takes place in only two key locales: the castle and the cottage in the woods. In the first part of the film Disney enhances the differences between the artificial and the natural by a series of alternating scenes that shift more frequently from one location to the other. Finally, the two-settings concept is violated when the Queen, who has been thoroughly identified with the castle, now transformed into an old hag, visits—and corrupts—the cottage. At this point, the dwarfs' mine becomes the place of innocence and simplicity as it stands momentarily in structural contrast to the cottage where the Queen is practicing her wicked wiles. When the animals warn the dwarfs of Snow White's danger, Disney crosscuts faster and faster between the dwarfs galloping toward the cottage (the continuing parody of the Western is seen here—Grumpy even rears back on his "horse," a formerly cute deer now galvanized into action by the peril) and the cottage itself, where the Queen is doing evil things to Snow White. The cottage and its environs become the single focus of all the action, and thus the prevailing dualism of location breaks down dramatically in the confrontation at the dwarfs' house between good and evil. Not a bit of this battle is in the Grimm version.

Another structuring device, this time purely visual, is Disney's repetitive,

continually changing use of shadows, as when the dwarfs are frightened out of their wits by the stranger upstairs. When the Queen becomes a hag, the first visual sign of her transformation is a giant shadow cast upon the wall; similarly our first view of the vultures, companions to the Queen, is by means of their shadows. Thus all three are linked as denizens of a *film-noir*-like world of corruption and sin. In contrast: when the dwarfs return from work singing "Heigh-ho," their giant shadows, reflected against the side of a cliff, are a warm, earthy brown instead of the black we associate with the other characters.

One last point might be made about structuring devices in terms of motifs of color. The Queen is swathed in a heavy black cape and the colors normally associated with her throne and the face in the mirror are discordant greens and blues, suggesting decadence and spoilage, as opposed to the browns, whites, and reds, all healthy earth colors, associated with Snow White. Green, of course, is also the color of envy and the evil traditionally associated with cats (who are usually green-eyed), so it is appropriate that the Queen as well as the huntsman, whom she sends to kill Snow White, have green eyes. Although it is impossible to determine the color of the Prince's eyes, since he is on for such a short time and is never shown in closeup, Snow White and five of the dwarfs have brown eyes, obviously a more neutral, earthy color. (Remember, in a cartoon, eye color is *chosen*, not arbitrary.) The two exceptions are Dopey and Grumpy. Dopey, as the mascot or child figure, appropriately has "cuter" blue eyes. Grumpy, on the other hand, who acts throughout most of the film like an *alienatio* figure from one of Shakespeare's comedies, refusing to participate in the joyous activities of the rest of the group, of his community, has black eyes. The point here is that even the most minute filling-out of the Grimm version is purposeful in some way.

One of the more important changes from Grimm is the overwhelming presence, in Disney, of *animals*. Disney's well-known predilection for idealizing and sanitizing nature was indulged to the fullest in *Snow White*. In the printed version the single reference to animals occurs near the end, before Snow White has awakened from her deathlike trance: The dwarfs "set the coffin out upon the mountain and one of them always remained by it to watch. And the birds came too and mourned for Snow White: first an owl, then a raven, and last, a dove." Disney enlarged upon this symbolic hint and made the animals the constant companions of Snow White, her willing assistants in cleaning up the dwarfs' cottage, the rapt audience for her songs, and her protectors. But they are animals never seen in nature; they are simplified, de-sexed, de-brutalized, made anthropomorphic, and seem to suggest for Disney a prelapsarian view of a long-gone Golden Age.

However, Disney was not merely striving for the ultimate in cutesiness here. We can expect that he used the animals in functional ways as well. For one thing, they serve to contrast Snow White's orphaned state, structured as they often are in families. An example would be Mom and Dad Bird beaming proudly as Baby Bird tries his best to outsing Snow White. Also, the omnipresent animals point to important character distinctions between Snow White and the dwarfs. Despite her whole life within the castle, Snow White has a surprising rapport with the animals

of the forest—after her initiate's "dark night of the soul." Not so the dwarfs, who live in nature all the time. The animals joyously help Snow White clean up the cottage. The dwarfs have a small deer who works for them in the mine, but he seems most unhappy. Similarly the animals first run away when they hear the dwarfs approaching, then return to harass and scare them when the dwarfs enter their cottage. (Interestingly, though, nearly all of the carved woodwork throughout the cottage is of animals—especially rabbits. Can the dwarfs, present in nature but not one with it like Snow White, thus approach the animals only through the taming power of art?)

Several comic bits concern the dwarfs battling flies, which never seem to trouble Snow White. Finally, when the animals rush to the mine near the end, they must fight, bite, and pull the alien dwarfs to make them understand the dangers to Snow White. The only time the dwarfs and animals coexist peacefully is at Snow White's bier, where they unite in simple grief over the apparent death of the kind and loving young maiden.

In ways, though, the animals seem to double the dwarfs. The turtle serves as the animal counterpart of Dopey: they are both marginal figures within their communities, as well as being the easiest for children to identify with, purging fears of looking foolish and not being one with the "gang." Both are hopelessly awkward—they tumble down the stairs, run into the door, and so forth—in ways the other animals and dwarfs are not.

On the negative side of the animal world, we have the beasts of the castle. There is the Queen's pet, a craven raven, who seems to be kept locked in the castle dungeon. He is meant to stand in obvious contrast to the loving, happy animals that surround Snow White. The Queen is also associated, and fittingly, with the pair of vultures, witnesses to her terrible death.

I have deferred to last the most important and furthest-reaching changes Disney made in altering the psychological "meaning" of the Snow White tale. In his provocative *The Uses of Enchantment: The Meaning and Importance of Fairy Tales* (1976), Bruno Bettelheim describes the "rite of passage" he finds in the Grimm Brothers version. Snow White passes from the Oedipal level, where the jealous (step)mother is her rival, through the latency stage, her time living with the dwarfs, to the final genital or sexual stage and love, marriage, and parenthood.

Bettelheim sees the dwarfs as primarily phallic (they are short and stubby and they work in tunnels), and yet paradoxically stuck at the latency stage that Snow White must transcend. For Bettelheim, each temptation the Queen offers Snow White is a temptation toward a sexual life for which she is not yet ready (note that both the corset and the comb in the Grimm version can be seen as objects by which a woman makes herself more sexually alluring); each time she is overwhelmed; each time the dwarfs rescue her by recalling her to their own latency stage. The final temptation, and the only one in the Disney version (the apple that brought Adam and Eve to sexuality and the knowledge of good and evil), puts Snow White beyond the assistance of the forever-arrested dwarfs. If she

is to be saved, it must be by someone who will call her to a full participation in adult love and sexuality.

Thus Bettelheim would fundamentally disagree with critic Donald Barr's assertion that "Disney terror is mere scare. Unless it happens to touch on a particular child's particular phobias, it simply does not disturb children, for it has no reference to any of the unease and tension that arise from a child's private trials" (quoted in Richard Schickel, *The Disney Version*). If this is indeed true, Bettelheim would argue, it is because Disney has mutilated the original beyond recognition and short-circuited the message encoded for the child's psychological benefit. Actually, Bettelheim himself only mentions the Disney version of the fairy tale in one footnote:

> Giving each dwarf a separate name and a distinctive personality . . . as in the Walt Disney film, seriously interferes with the unconscious understanding that they symbolize an immature pre-individual form of existence which Snow White must transcend. Such ill-considered additions to fairy tales, which seemingly increase human interest, actually are apt to destroy it because they make it difficult to grasp the story's deeper meaning correctly.

And although Bettelheim doesn't go beyond this single critique of the Disney version, further liberties Disney has taken with his source also, if Bettelheim is right, seriously distort other aspects of the "message."

For example, the Grimm version begins with Snow White's mother pricking her finger, causing drops of blood to fall on the snow. It is this chance occurrence that makes her want "a child with a skin white as snow, lips red as blood, and hair as black" as the ebony of her embroidery frame. Disney has eliminated this whole section, and Bettelheim's "message" is eliminated along with it:

> Here the problems the story sets out to solve are intimated: sexual innocence, whiteness, is contrasted with sexual desire, symbolized by the red blood. Fairy tales prepare the child to accept what is otherwise a most upsetting event: sexual bleeding, as in menstruation and later in intercourse when the hymen is broken.

Also, in the Disney version, *all* references to Snow White's father are omitted, and this too serves to blunt the force of the Oedipal message.

Snow White's relationship with the dwarfs is also fundamentally altered in the Disney version. In Grimm, the dwarfs are earnest, Protestant-ethic types who introduce Snow White to the world of work. Far from being the cuddly half humans of the film, they are friendly but only agree to shelter Snow White if she will become housekeeper to their *already* immaculate abode: "If you will keep our house for us, and cook, and wash, and make the beds, and sew and knit, and keep everything tidy and clean, you may stay with us, and you shall lack nothing." In the Disney version, Snow White comes upon a slovenly house, with dishes stacked to the ceiling and dirt and cobwebs everywhere. She decides that the inhabitants of the cottage need a "mother" and proceeds, with the help of the animals, to

clean up after "the sloppy little boys," disciplining them, forcing them to wash up, telling them when it's "bedtime." In effect, Disney simply translated the Grimms' German paternalism into the American "Momism" that he so deeply respected. Furthermore, this way the utterly pure Snow White can have the best of both worlds by becoming a mother without having to give up her virginity.

Many commentators have noted that this is Disney's own propaganda "message" to the children in the audience: be good little boys and girls and obey Mommy when she wants you to clean up. This is even more strikingly obvious when we consider the elaborate washing-up scene that Disney has inserted, in which all the dwarfs are required to wash before they are allowed to eat "Mom's" cooking. Critic Jonathan Rosenbaum has suggested that Disney introduced this bit of propaganda in order to please the *parents* in the audience as well as the children because of the huge amount of money he had tied up in the affair, but it should also be remembered that in Disney's later film, *Peter Pan* (1953), Wendy functions in much the same way as Snow White, as a civilizing influence, cooking and sewing, as Mother for the Lost Boys.

But there seems to be more to it than this, especially considering the rather surprising prominence given to these cleaning and washing scenes, which alone account for a large chunk of *Snow White*. Although a psychoanalytic biography on the order of Freud's study of Leonardo da Vinci or Erikson's book on Luther is not in order here, I think a few tentative conclusions can be drawn about the Disney version.

Once we give ourselves over to Bettelheim's system of analysis, that is, once the general validity of Freudian criticism is granted, I think we must see that what Disney has done by subverting the Oedipal nature of the tale is, in however confused a fashion, to retell *Snow White* as a story of an earlier phase of personality development, the anal stage. The continual emphasis on washing and cleaning and turning the dwarfs' cottage into a nice little middle-class suburban habitation clearly leads in this direction. It also suggests, to us, at least, if not to Disney, that Snow White must have remnants of an anal-obsessive personality to overcome as well if she is to grow to full sexual maturity with the Prince.

Still other sexual elements are present in the movie, albeit in a piecemeal and confused fashion, and probably do not provide any consistent psychological message (conscious or unconscious) for the child viewer. Phallic images, for example, abound in the otherwise highly anal housecleaning scene with Snow White and the animals. *Every* animal equipped with a tail uses it vigorously during this scene, and one of the deer even plunges his tail into a decorative hole on the back of a chair and swirls it around. (Perhaps this association of sex and obsessive anality is a tribute to the tenacity of the Puritan mind-set in American culture.) The stairs that figure continuously in the film, especially in terms of the dwarfs' initial, hesitant approach to Snow White, are a standard Freudian symbol for sexual intercourse. Similarly, when the Prince first comes upon Snow White, they are both looking down a well, a typical Freudian vaginal symbol; and in this case the scene represents a too early threat to Snow White's virginity. Naturally frightened, she

runs into the castle, appropriately closing a huge door behind her for protection from the "sexual advances" of the Prince.

The few unincorporated sexual elements that remain have to do with the dwarfs' relation to Snow White. In the Grimm version, as I have said, the dwarfs are locked permanently into the latency stage, so there is not the slightest hint of sexual interest in Snow White. Yet in the film, the dwarfs (especially Dopey) vie for kisses from her, ask her to tell them a love story, and participate vicariously in her wishful song about Prince Charming. Of course, since they are "freaks," in spite of their cuteness, they cannot be serious contenders for Snow White's sexual affections. They are forced to sublimate their desires—they refuse to sleep in the same bedroom with her, for propriety's sake; but, during the "hoedown" scene, they indulge in an elaborate wish-fulfillment. Since none of them is a "real man," primarily because they are so "short," Dopey climbs on top of Sneezy so that they can dance with Snow White as one real-sized man. This gesture is directly addressed to the child viewer and his longing to be taken seriously as a full-sized adult, but it seems also to function on this level of repressed sexual desire as well. The futile charade falls apart when Sneezy sneezes violently, sending topmost Dopey straight up like missile; this act also can be seen as a disguised form of the wished-for sexual explosion and climax.

At any rate, these disparate elements do not seem to form an overall psychological pattern of the kind that Bettelheim sees, quite rightly I think, in the Grimm version of the tale. So what kind of conclusion can we come to? Is Bettelheim right when he says that "the poet understands the meaning of fairy-tale figures better than a film-maker"? Or Richard Schickel, when he says that Disney "always seemed to diminish what he touched"?

What is sometimes forgotten is that the business of the filmmaker is not to provide a perfect replica of a fairy tale (or a novel) on celluloid, but to *adapt* the work. Of course Disney's version of *Snow White and the Seven Dwarfs* distorts the psychological message of the Grimm version, but the Grimm story itself is only one of innumerable versions of the tale.

As I have tried to indicate, the film is, in so many ways, an admirable transposition. Did Disney not end up by creating another, *different* fairy tale, one with its own clear legitimacy? For the millions who have feasted on *Snow White* the world over, the answer, for better or worse, can only be yes.

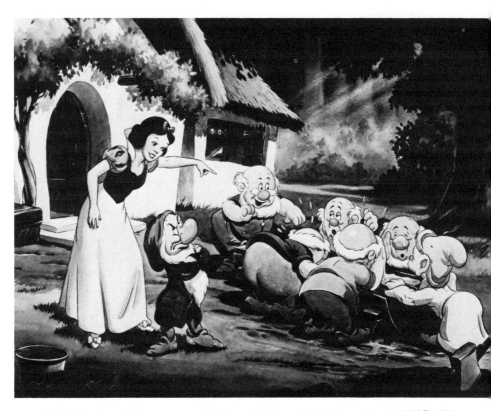

(*above*) The hand-washing sequence in *Snow White and the Seven Dwarfs* (1937), Disney's first feature-length cartoon. © Walt Disney Productions. (*below*) *Dumbo* (1941) with Timothy Mouse. © Walt Disney Productions.

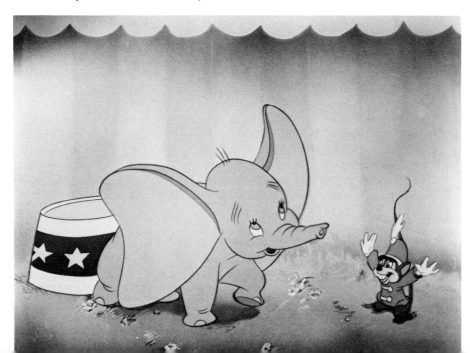

(*above*) Mickey Mouse appeared in only one feature cartoon; he was the star of "The Sorcerer's Apprentice" sequence in *Fantasia* (1940). © Walt Disney Productions. (*below*) Vlad Tytla at his most expressive: the worshipers of evil gather during the "Night on Bald Mountain" sequence in *Fantasia* (1940). © Walt Disney Productions. (Courtesy The Museum of Modern Art/Film Stills Archive)

Dumbo

by MICHAEL WILMINGTON

The Walt Disney Studio, in 1941, was at its peak. It seemed able to handle almost any visual effect, to create any kind of illusion. The colors were twice as rich as anything seen in life. The multiplane camera—a device whereby several layers of drawings can be manipulated and shot at once—brought depth of field and rounded contours. But Disney's passion for perfection had clapped an albatross around his neck. World War II had dried up the European market; and costs for both Pinocchio *and* Fantasia, *in production since the box-office smash of* Snow White and the Seven Dwarfs *in 1937, had soared incredibly prior to their 1940 releases. Although their eventual combined gross topped $23 million after numerous rereleases,* Pinocchio *and* Fantasia *incurred immediate financial losses for Disney.*

So, into the breach came Dumbo *(1941), originally conceived as a thirty-minute featurette; something the studio, geared up at the moment to turn out cartoon equivalents of the Chartres Cathedral, could crank out to recoup the losses.* Dumbo *was a light, breezy, apparently low-pressure project. It also, to me, emerges as Walt Disney's animation masterpiece.*

M. W.

Dumbo, as everyone knows, is the story of a flying elephant. Its widely known logo shows a cherubic, blue-eyed baby elephant, wearing a tiny clown's hat, and radiating a pure Kaspar Hauserish innocence and charm, soaring blithely with outswept, gigantic ears. Yet *Dumbo* is not about the adventures of a *flying* elephant. We do not see Dumbo fly until the film is into its last ten minutes, and the consequences of his flying (which would seem the film's natural subject) are telescoped into a brief, rapid-fire montage at the end. Instead, the film covers Dumbo's birth, infancy, and the misfortunes that befall him because of his "freakish" large ears. He becomes the butt of cruel humor; loses his mother, when, trying to protect him from tormentors, she is imprisoned as a "mad elephant"; and he is relegated to outcast status by his fellow elephants. Defying all odds, he discovers his wild talent and becomes the circus' biggest attraction. Or, as the irrepressibly buoyant and ringwise Timothy J. Mouse puts it: "The very things that are

holding you down, are gonna carry you up, up, up!" The film is about the education of a misfit. Like many another Disney story, it is a Horatio Alger piece.

Despite its bright surface and numerous gags most of *Dumbo* is an elaborate and heartrending portrait of pain, degradation, and despair. The film opens on a shot of threatening gray thunderclouds, slashed with bolts of lightning, through which the storks are attempting to break with their newly-born burdens. Rain and gloom also dominate the scene where the circus tent is erected, through the combined efforts of the animals and what seem to be faceless, black roustabouts. Throughout, we are constantly made aware of grinding, driving, almost futile expenditures of energy: the storks pushing through the storm clouds; the roustabouts lifting the tent; Casey, Jr., the circus train, desperately puffing and wheezing through tunnels and over hills; the lady elephants straining and struggling and coated with rivers of sweat as they attempt to form a pyramid. We tend to see the world as little Dumbo does, an arena of vast, painful, and at times, incomprehensible struggle.

Several other themes emerge in these opening few minutes: the exhilaration of flying, the solace of mother love, and, most important, the awareness of alienation. Later on, the film will be dominated by low-angle compositions. But, for now, we have a stork's-eye view, as the messengers soar through the night, and let their bundles float placidly down to a succession of delighted animal mothers. Next, in the daytime, we see an "odd bird out," separated from his squadron, winging confusedly through the clouds in search of Dumbo's mother. (He finds her finally, on Highway 61—revisited—as Casey, Jr., puffs through a storybook-map Florida far below.) This scene may seem oversweet or trivial, yet it establishes Dumbo's otherness, as well as implying that his "difference" somehow elevates him. The others were born in gloom; he is a child of light. After his arrival, a doting dowager elephant tickles his chin. He sneezes, his huge ears suddenly flap into view, and the other elephants—except his mother—gasp and recoil. From then on, Dumbo, like the stork who brought him, is an animal apart, alienated, desperately trying to catch up.

From Edgar Allan Poe to Rudolph the Red-Nosed Reindeer, the artist as superfreak has been a standard American legend. But, in *Dumbo,* the alienation is at its purest and most terrible. The little elephant with the yearning eyes and the outlandish ears wants only to be loved, but he is steadily forced into a nightmarish life-style where his "flaw" is not only exposed, but reviled and savagely exploited before an unseen, shadowy circus audience. He is wrenched from his mother when she goes berserk trying to protect him. For every child under ten who sees the movie, the chaining and imprisoning of Mrs. Jumbo must be a nearly traumatic experience. Those repeated shots of animal mothers cradling and soothing their young (once to the strain of a melancholy lullaby) have an incantatory insistence. They endow mother love with a dimension of universal solace and universal grief. That sad image of Mrs. Jumbo's trunk snaking out from between the bars to caress the distraught Dumbo—isn't that a reprise of the legendary "homecoming" shot of Mae Marsh's arms stretched to the Little Colonel in Griffith's *The*

Birth of a Nation (1915)? Later on, the scene in which the clowns place Dumbo on a fiery pinnacle and whirl below him in grotesque futility as comic firemen is heightened in its cruelty by the fact that one of them imitates his mother.

The persistent psychosexual motifs in *Dumbo,* conscious or not (and it is entirely irrelevant to their *effect* whether the filmmakers intended them that way), heighten the whole atmosphere of alienation and isolation. So—and this obviously *is* conscious—does the visual style of the film, with its obsessive low angles, allowing us to peer up at the world as little Dumbo does: crushing down on him, irrevocable, merciless. The sequence in which Dumbo accidentally topples the elephant pyramid, for example, is a direct, and nightmarish, inversion of the film's joyous climax. Instead of soaring above the crowd (as he will later, on his own), bounding from the catapult to the peak of the pyramid, the terrified Dumbo trips over his ears and plummets into the ball on which the head dowager elephant is balancing. There follows a horrid, surreally slapstick display of startled elephants spilling out in all directions—briefly "flying," then crashing through high wires and trapezes, and, finally, snapping the circus tent's center pole. When the big top, now empty, slowly sinks down over the wreckage, the last shot is of Dumbo's trunk, creeping out through a loose patch, and forlornly waving his flag, which then snaps just like the center pole. This is an oddly poetic moment: It reminds us of the erection of the circus tent—a scene carrying overtones of birth and emergence—and crystallizes the image of Dumbo as low man on society's totem pole.

That wrenching of maternal ties at the core of *Dumbo* is reinforced by the absence, in most of the film, of father figures. Dumbo's real name is Jumbo, Jr. ("Dumbo" is a moniker hung on him by the lady elephants), but "Jumbo, Sr.," is nowhere to be found. For that matter, there aren't any other bull elephants. Except for Dumbo, the pachyderm society is exclusively distaff, and—if we can take their parodied kaffeeklatsch chatter as any clue—a group well past menopause. The rest of the circus isn't sexually segregated; none of the tigers, hyenas, ostriches, or others, is shown as the product of a broken home. But Dumbo is—and the schisms of sex and age increase his isolation.

The *human* members of the circus are almost exclusively male but they don't function as father figures either: not the roustabouts, or the excitable Teutonic ringmaster (whose voice was provided by actor Herman Bing), and, most especially, not the clowns. (The clowns' routines are frenzied and sadistic, rather than funny, particularly since we tend to see them through Dumbo's eyes; and some of the clowns, incredibly, are malicious caricatures of striking Disney Studio cartoonists executed by the strikebreakers who worked on *Dumbo.* Their mercenary mistreatment of Dumbo and their unsympathetic song, "We're gonna hit the big boss for a raise," are conservative comments on the labor unrest sweeping through Hollywood at the time.) The closest thing to a father substitute Dumbo finds—until the crows—is Timothy, who, in many ways, is the real central character of the film.

Timothy, a brash Brooklynese rodent in a garish red-and-gold marching outfit, is a familiar Disney figure. Not only do we see traces of Mickey in his char-

acter (his indomitability and resilient optimism), but he is also a distant cousin of Jiminy Cricket in *Pinocchio* (1940), Gus and Jaq in *Cinderella* (1950), the Seven Dwarfs, even, to an extent, Tinker Bell in *Peter Pan* (1953). His most notable quality is his incongruous fearlessness. He has an aggressiveness and aplomb that are entirely out of proportion to his minuscule dimensions. He is a hustler who lives by his wits, a promoter, a spellbinder, a con man—and he ends up as Dumbo's business manager. Along with the crows, Timothy is the best animated of all the movie's characters, the most expressive and mercurial. His versatility is astonishing. He has a soothing word for Dumbo; a frightening Napoleonic pose for the lady elephants; even an impromptu getup as "the voice of your subconscious mind" to brainwash the sleeping ringmaster.

If Dumbo's torments provide the film's emotional resonance, Timothy supplies the intellectual and ideological motor mechanism. Still, he is a softie underneath, his voice characterization (by Edward Brophy) is redolent with warmth and pizazz. Despite his hard-shell mannerisms and tough veneer, Timothy's support for Dumbo is instantaneous and instinctive—they both have large ears—and reminiscent of the bond between quick-witted George and hulking, childish Lennie in *Of Mice and Men* (a hit movie of the year before [1939] which prompted several cartoon parodies, including Tex Avery's Screwy Squirrel). Like Lennie, Dumbo is isolated by physical oddness and childlike sensitivity. Like George, Timothy simultaneously exploits his partner's strengths and salves his easily bruised feelings.

Timothy functions as Dumbo's "alien brother." He represents a sort of animal "detente"; especially since the movie uses the traditional antipathy between mice and elephants as the basis for an early sight gag. And also, perhaps, he really is for Dumbo what he only pretends to be for the ringmaster: the "voice of his subconscious mind," a role that Jiminy Cricket filled for Pinocchio. The crows, on the other hand, are Dumbo's real father figures; and it is with their entrance— after the stunning, virtuosic sequence of the "Pink Elephant Dance"—that the film achieves its greatest brio and exuberance.

The dance of the pink elephants is a dream sequence: apparently, a mutual drunken reverie of Dumbo and Timothy's after they accidentally drink the clowns' whiskey and become smashed. It is at this moment, I think, that *Dumbo* stops being merely a very affecting and accomplished film, and becomes a great one. The horror and sentimentality of the early sections are intense, but somehow predictable (particularly in the wake of *Snow White* and *Pinocchio*), but the "Pink Elephant Dance" is magnificently unexpected and it is one of the Disney Studio's great individual set pieces. Like the ballet of lovelorn hippopotamuses and lecherous crocodiles to the tune of "The Dance of the Hours" in *Fantasia*, it is both cute and frightening. It manages to synthesize those two separate strains that were Disney hallmarks ever since the dual success of the early Mickey Mouse and *The Skeleton Dance* (1929). In terms of wild invention and galvanizing imagination, it surpasses anything in the other features, save perhaps the more bizarre and experimental sections of *Saludos Amigos* (1942) and *The Three Caballeros* (1945).

There is an extremely clever prelude: the two intoxicated chums play with the water-whiskey bubbles, which Dumbo is blowing in various shapes and sizes, and on which Timothy is frolicking and floating. Finally, the largest bubble of all, instead of bursting, dissolves into a huge transparent elephant with delicate pink outlines, who immediately blows up some other elephants before the startled eyes of Dumbo and Timothy. Far from being sinister, these sudden apparitions are roguish and flirtatious. They are also totally unrestrained by the laws of nature and logic, and they dance and shift forms, becoming, in quick succession, belly dancers, pyramids, snakes, trains, fountains, and even a huge eye, with the glaucous fluidity of hot paraffin.

The dance itself constantly shifts keys and tempos. First it is straight slapstick and parody, yet mixed with horror. Then it becomes progressively surreal, then lyrical, then driving and lubricious. It has a puckish irreverence that consistently undercuts what might be, for a child, disturbing intensity and even rawness. The climax of the dance, for example, contains what may be the Disney Studio's only direct metaphor for sexual intercourse. In the middle of a frenzied rumba a male and female pink elephant point their trunks at each other, and a bolt of electricity sizzles between them. The male pulls it down and rubs it under his jogging rump; then he shoots it back at the female and it hits her head and explodes. Instantly, the dance floor is filled with a dozen more writhing couples. (The electricity carries an even heavier sexual charge when we remember the lightning that accompanied the delivery of the animal babies.)

In retrospect, we discover the "meaning" of the "Pink Elephant Dance." Dumbo, smashed to the gills, has taken off and is gliding through the night, Timothy on his back, on his maiden flight. The images of elephants freed from the shackles of sense or nature, becoming trains and airplanes, flying around, and defying all convention, are the alcoholic fancies surging through his and Timothy's minds as they soar through the evening sky. The dance ends with another explosion (orgasm?) and with the gently baroque image of pink elephants floating down and becoming clouds.

Following this astonishing sequence, we meet Dumbo's father figures. Fascinatingly, they are a quintet of raffish, impudent crows, whose voices and mannerisms are obvious parodies of proletarian blacks. These crows (marvelously animated by Ward Kimball, who considers them his best work at the studio) have been the subject of furious debate. To some, they are the last word in implicit racism. Even the name of their ringleader, jaunty, swaggering Jim Crow (voice by Cliff "Jiminy Cricket" Edwards), has become risible. Again, the argument seems plausible—but only if you've never seen *Dumbo* with an audience of kids. They all love the crows, and their number, "When I See an Elephant Fly"—complete with jazz licks, soul harmonies, and a prophetic moment in which two crows fling their legs out ecstatically in Robert Crumb's "Keep on Truckin' " motion—is the biggest hit of the movie. Far from being shambling, oafish Step 'n' Fetchit types—the boiling point for any attack on racial stereotypes—Jim Crow and his "brothers" are the snappiest, liveliest, most together characters in the film. They

are tough and generous. They bow down to no one. And, of course, it is they who "teach" Dumbo to fly.

We should remember that the great unifying theme of *Dumbo* is an *attack* on prejudice against physical characteristics. The irony of having blacks guide Dumbo to his vocation can't have escaped the writers and artists. And it seems unlikely they would sabotage their own theme with gratuitous racial slurs. It is because the crows' attitudes are reflections of a lower-class, minority mystique that they respond so quickly to Timothy's impassioned rhetoric and so sympathetically to Dumbo's plight. The film's climax—the crows perched on a telephone pole as Dumbo and Mrs. Jumbo wave good-bye—is a tribute to them.

The sort of messages that Walt Disney wanted to send the world are based on a few simple, recurring ideas: the inevitability of inversions, the beauty of eccentricity, and the triumph of the small and apparently helpless. Another idea, and one that seemed almost to obsess him, was the creation of a "magic land," where the natural order was "lyricalized"; where everything—humans, animals, trees, houses, and the elements—took on personalities and obeyed the rules of music. Many of his features present maturity or growth as a sort of "necessary evil" (as in *Bambi* [1942] or *Peter Pan*), an exile from the magic land. *Dumbo*, however, like *Pinocchio*, sees childhood as a world of horrors—bright, lacquered, but finally insidious.

What *Dumbo* ultimately speaks to are all those neurotic repressions and obsessive fears that infiltrate the lower, darker strata of the American Dream. Very convincingly and vividly, it re-creates the pain and anxiety of many children— especially the most sensitive. The *positive* side of the film is more mysterious. Is Dumbo's flying a symbol of artistic endeavor? upward mobility? or just alcoholism? Is material gain alone his final salvation? There's no clear answer to any of this, and perhaps there shouldn't be, for the *ostensible* moral is obvious: rise above your handicaps, and don't let the crowd get you down.

But, more subtly, the film says that there *are* superior beings among us, and that, quite frequently, they are scorned by the world and noticed only by a prescient few. The whole story is built, classically and symmetrically, on a number of inversions: the last shall be first; the lowest shall be highest; the most persecuted, the most powerful. And, most strikingly, the smallest creature of all (the mouse) shall be revealed as the most omniscient and strong.

It's a seductive message. Whatever else Disney was, he was a master at coating the bitterest pills with sugar. And he and his artists, in their obsessive pursuit of perfection, left behind them dozens of images that—quirkily, nightmarishly, or sweetly—lodged forever in the American psyche. It takes only a second or two to summon them up—those charming mice, guffawing goonish dogs, fairies, foxes, dwarfs, mischievous rabbits, hyperbolic ducks who rage and storm, and, gliding above them all, elephants who fly.

Vlad Tytla:
Animation's
Michelangelo
by JOHN CANEMAKER

There is a scene in Walt Disney's Snow White and the Seven Dwarfs, *animated by Bill Tytla, that remains a tour de force of animation technique in exploring cartoon personalities: Snow White informs the dwarfs that they must wash before supper or they'll "not get a bite to eat." Reluctantly they make their way to an outdoor water pump and tub—all except the recalcitrant Grumpy, who jeers at their attempts at cleanliness from the sidelines. After singing a hearty washing song ("Bluddle-Uddle-Um-Dum"), the six dwarfs attack Grumpy and throw him into the tub for a rousing reprise.*

In Tytla's sequence we have a veritable mob scene with seven *characters, who are of similar shape but have seven completely different personalities, and thus seven different motivations and reactions. Tytla's successful solution to this problem of cartoon identity can be regarded as a small miracle, a tribute to his powerful gifts.*

Donald Graham, the gifted instructor in charge of the Disney Studio art classes that began in 1932, frequently used film examples of Tytla's animation in his action-analysis classes. "[Tytla] does not animate forms," Graham observed in 1937 to a group of novice animators, "but symbols of forces . . . this is a revolutionary conception . . . instead of seeing a character as a round body, beautifully modeled in drawing, he sees the animating forces inherent in it. It is a confirmation of all the instructors have been trying to do here in the drawing classes. Tytla's work has been a revelation!"

Vladimir William Tytla is almost totally unknown outside of the animation industry, but audiences all over the world have experienced his artistry through unforgettable cartoon performances in thousands of animated films, most notably in scenes from the Disney features: Snow White and the Seven Dwarfs *(1937),* Pinocchio *(1940),* Fantasia *(1940),* Dumbo *(1941), and* Saludos Amigos *(1942). In the profession, he is a legend, "the Michelangelo of animators," claims Chuck Jones.*

In many ways, Tytla's career parallels the brief history of film animation itself: he began when both he and the art were in their teens in New York and went on to flourish during animation's "Golden Era" at the Disney Studio; there the vital Tytla was at the height of his creativity and in total command of his dynamic powers, which were challenged by each new assignment. The dark side of the Tytla legend concerns his slow, tragic decline after leaving Disney. Tytla's frustration with television anima-

tion, which never challenged his magnificent talent, plus his depression over the reali-
zation that he would never again attain the peaks he reached at Disney, eventually
took their toll. Tytla did not live to participate in the current resurgence of animation
as an industry and as an art form.

<div align="right">J. C.</div>

By age seventeen, in 1921, Tytla was working at Paramount Pictures in New York
lettering main titles and balloon captions for that studio's films, which earned him
the nickname "Tytla the Titler." Soon he was animating Judge Rummy and
Happy Hooligan at John Terry's Greenwich Village studio; according to I. Klein,
veteran Disney animator and a contemporary of Tytla's in those early animation
days in New York, "Bill Tytla regarded John Terry as a worldly and wise man to
whom he could always turn to for advice. Long after Bill went to work for other
studios, he always went to John for his opinion before coming to a decision."

By 1923, Tytla was animating Aesop's Fables for John Terry's brother, Paul.
I. Klein met Tytla on the street a few years later and noticed that he was now a
"dapper dude" and was "sporting a fancy hirsute adornment above his upper lip.
He seemed to think an explanation was in order. To wit: he was now earning a
very fine salary as an animator and wanted to look mature, to match his salary-
earning capacity." It was a suave type of moustache, sort of a Dali-thing in its
early stages—the change to the Stalin-type of heavy moustache developed much
later.

Tytla roomed with two commercial artists, Maurice Rawson and Henry
Berger, at the Kit Kat Club at Seventh Avenue and 14th Street, an association
that rented studios to artists. Klein lived in a studio below Tytla's and notes that
Tytla and his friends "attended some evening life-sketch classes, did some paint-
ing, and led a lively afterwork young artists' life."

In 1929, Tytla, Rawson, and Berger took their savings and sailed for Europe
to travel and study painting. In Paris, Tytla studied sculpture briefly with Charles
Despiau, and it has often been noted that Tytla's animation has the solidity,
weight, and dynamism of sculpture.

It was in Paris that Tytla first heard of Walt Disney. "I went to a movie
there," he remembered, "and saw one of his shorts. I wondered who he was . . .
Later I had the opportunity to watch some stolid Germans as they sat through a
Disney short. They didn't laugh at all. Throughout the film they turned to each
other and made a motion of a wheel turning by their ear. They thought he was
screwy . . . they didn't understand him at all."

Henry Berger recently recalled their visit to London: "The usual sightseeing,
museums, cathedrals, historical sites, etc. While there Bill tried to interest the
Russian Embassy in his animation abilities. Bill had thoughts of heading a Dis-
ney-like studio in Moscow. They didn't go for it."

During his eighteen months in Europe, Tytla painted some Cezanne-ish
landscapes and still lifes, and went to Vienna specifically to gaze upon the work of
his idol, Brueghel. There Tytla assessed his own artistic potential and decided to
concentrate on the commercial, rather than the fine, arts. When Paul Terry con-

tacted him in Paris, asking him to work on the new Terrytoons sound cartoons, Tytla accepted immediately and returned to New York.

The New York animation industry in 1930 was made up of men who were mainly cartoonists with no background or training as fine arts draftsmen. Tytla once spoke to a Disney animation class about his problems returning to this rather rough-and-tumble atmosphere:

> I worked for a company that was considered tops and aces in the East and they were making a tremendous amount of money. When I suggested a model, we had to hire him ourselves and of course they wouldn't consider engaging an instructor for us. We thought the lead animators could help us, but they couldn't do much if you took them off cats and mice. If there was a scene of an old man hit by a club and beautiful girls floated around him in his daze, the lead animators couldn't animate the girls—we would have to . . .
>
> Finally, we had to give it up—the fellows would make wisecracks about the girls who posed for us. So after two or three sessions even these classes stopped . . . the time I speak of, they said anyone who goes to art school is a "homo Bolshevik." They'd say, "What the hell do you want to go to art school for—you're animating, aren't you?"

It was at Terrytoons that Tytla first met Art Babbitt, who today is recognized by his peers as one of the world's finest animators. He and Tytla were to become lifelong friends, and Babbitt recalls,

> Bill taught me to have the courage to invent. He was sort of a reticent personality, he was shy, and yet there was an exuberance about him. You felt little sparks of electricity coming off of him all the time. We hit it off right from the start and within a week, we were sharing an apartment up in the Bronx not far from the studio.
>
> He burned many of the paintings that he had brought back from Paris. Bill just didn't think they were good enough and that was his attitude towards all the work he ever did. He was never satisfied with what he had done. Although he sat across the aisle from me [at Terry's], I never observed too closely at the time just how he did work. I had the impression he wasn't struggling too hard. He seemed to have confidence in what he was doing, as opposed to his insecurity at Disney's later on. Bill was very highly regarded in the animation industry even at that time.
>
> When I first came out to California [in 1932] and had my first interview with Walt Disney, I immediately started talking about the marvelous talents of Bill Tytla. He had heard about Bill from other guys like Ted Sears and Norm Ferguson [New York animators who joined Disney], and Disney asked me, "Now how soon can we get this guy Tytla out here?" So I wrote to Bill and when Terry heard of it, Terry gave him a $25 raise. A month or two later, Disney asked me again, "Let's get this guy Tytla out here!" So again I wrote to Bill and again Terry gave him a $25 raise. Now this happened about three times, so I finally gave up trying to get Bill out here. So I figured, just for the hell of it, I'll send him a telegram which said nothing specific. It was stated something like this: "There are many opportunities in the West"—and Bill got another $25 raise!

"In 1934," Tytla recalled in 1968, "I flew from New York to the Disney Studio. Jesus, but I was impressed. It was such a beautiful plant . . . Walt and Roy knew of me because of what I did for Terry. They would look at Terry's productions and could recognize my animation. Roy would call me up whenever he was in New York . . . I returned to New York to tie up my affairs and in November of 1934 started to work full time at the [Disney] studio."

In the fall of 1934, Walt Disney was already deeply involved in the basic structures of the greatest challenge of his career, the feature-length cartoon, *Snow White and the Seven Dwarfs,* which would be completed three years later. Into this highly charged creative atmosphere stepped Bill Tytla, one of the best paid and most highly respected young animators in New York. The brilliance with which he would handle all his assignments during his brief nine-year tenure at the studio would provide Walt Disney with some of his finest cinematic moments and would build Tytla's reputation to legendary status.

David R. Smith of the Walt Disney Archives provided a summary of Tytla's contributions to the Disney shorts: 1935: *Cock of the Walk* (most of rooster and girl); *Cookie Carnival* (boy cookie sings to girl and leads her away; Angel Food; Devil's Food); *Mickey's Fire Brigade* (Clarabelle); *Broken Toys* (Step 'n' Fetchit; Jemima); 1938: *Brave Little Tailor* (Giant); 1941: *Golden Eggs* (rooster); 1943: *The Grain That Built a Hemisphere* (Indians); *Education for Death* (Sleeping Beauty sequence; teacher); *Reason and Emotion* (Hitler). Tytla also worked on the feature *Victory Through Air Power.*

After beginning on the Mickey Mouse and Silly Symphony shorts, Tytla was soon assigned as Supervising Animator, with the late Fred Moore, on *Snow White and the Seven Dwarfs,* and it was these two who were responsible for defining the distinctive personalities of the Seven Dwarfs.

Bill Shull, Tytla's assistant on *Snow White and the Seven Dwarfs,* once remarked on Tytla's instinctive use of distortion and exaggeration, the keys to dynamic animation: "I get a kick out of the way Tytla will distort something," said Shull, "the forefinger of a hand perhaps—stretch it out so that it looks almost silly. When you see it on the drawing, you would swear it meant nothing, but on the screen these things seem to hold the scene together."

A prime example of this magical distortion is Tytla's superb realization of the character Stromboli, the evil puppeteer in *Pinocchio.* An overweight monster of mercurial moods, capable of wine-soaked, garlic-breathed Old World charm one second and knife-wielding, chop-you-up-for-firewood threats the next, the Stromboli character is larger than life, frightening and comic by turns. Stromboli, as Tytla captured him, is one of the most three-dimensional of all the Walt Disney cartoon villains.

"In my estimation," states Art Babbitt, "the greatest animator of all time was Bill Tytla." Commenting on the breathtaking Tytla animation of the gigantic devil in "The Night on Bald Mountain" sequence of *Fantasia,* Babbitt notes, ". . . the power of the devil, the drawing where he turns his hands around—this is something that has been forgotten. The so-called animators of today couldn't come near the craftsmanship that Bill was capable of in those years."

Versatility, the rare ability of an animator to assume completely different roles, was yet another attribute of Tytla. "Bill was a very sensitive and sentimental man," explains Babbitt,

> and he was perfectly capable of being tender, as he was with the little character Dumbo. In fact, there's one memorable scene in *Dumbo* where he comes to visit his mother who is locked up in a cage, and I have seen this picture in several places around the world and each time people in the audience weep. It could have been so crude and maudlin but instead it was done with great sensitivity and taste. It's assumed you can make somebody laugh with funny little drawings, but to be able to use these funny little drawings and to make a person feel so deeply that he weeps—in my estimation, that is true artistry.

When he arrived in Hollywood, Tytla moved in with old pal Babbitt in his beautiful home on Tuxedo Terrace. The two well-paid bachelors led busy "playboy" existences after work, and Tytla, who loved horses, took up polo, only to temporarily give that sport up when a horse fell on him and cracked his pelvis. He was in the hospital on the critical list for months, then on crutches, and finally he recovered without a limp.

It was at a Disney drawing class one evening in 1936 that Tytla met his future wife, Adrienne le Clerc, an actress from Seattle who worked at the Hollywood Playhouse. In addition, Miss le Clerc was a fashion model and worked for artists and illustrators including, on this fateful occasion, the Walt Disney Studio.

Today, Mrs. Tytla maintains the acres of property Tytla purchased in East Lyme, Connecticut, in the 1930s. She is still easily moved to tears when discussing her late husband.

> We were together for three years and when we finally got married on April 21, 1938, we had dinner at Victor Hugo. That was it—we never went on a honeymoon. The next day he had to get right back to work. He loved to hunt, he loved horses, he loved the out-of-doors, but most of all he loved his work. He was always under a lot of pressure. He was like Vesuvius but he worked best under pressure. No matter what he worked on, every time he would come home with a different assignment, he would say, "Oh God! I don't know. I've never done an elephant before, I've never done a whale before. Jesus! How am I going to do a giant? And dwarfs? And seven of them at the same time and all of 'em different."

Babbitt concurs with this picture of the insecure Tytla: "Everytime he was handed an assignment he would come to me and say, 'Art, I can't do it. I'm gonna quit. I'm gonna go back to New York.' And of course, whatever he tackled just turned out beautifully. And he was very highly regarded at Disney's."

Tytla once spoke about his problems in dealing with Walt Disney's cryptic way of demanding the best from his men:

> I had to animate one sequence in *Pinocchio* and I gave it everything I had. There were several scenes I showed to the other animators. They all said "great" or "nothing else needed" or "don't change a thing." I felt pretty good about it.

Finally the time came for Walt to see it. He was subdued and even jolly in the "sweatbox" [projection room]. He said "That was a helluva scene, but"—there's always that cruel "but" in there—"if anybody else had animated it I would have passed it. But I expected something different from Bill!"

Well. he sunk a ship with that remark . . . it took a couple of weeks before I could work again. I was crushed. But one day I took up my pencil and started to draw again, differently. It was as if something hit me and I started all over. This time I showed it to Walt, he said, "Great! Just what I was expecting!" He never did explain what was wrong. It was as if by some magical way you would know.

At some point, Tytla read Boleslavsky's *Acting: The First Six Lessons* (1933) and used the book's six premises of concentration, memory of emotion, dramatic action, characterization, observation, and rhythm in his animation. "On all my animation," he once said, "I tried to do some research and look into the background of each character. So for the devil on Bald Mountain in *Fantasia* I did some reading about Moussorgsky. Now I'm Ukrainian and Moussorgsky used terms I could understand. He talked about 'Chorni-bok,' the Black Art. Ukrainian folklore is based on 'Chorni-bok'—I related to this and studied up."

Tytla's baby son Peter provided the characterization for the star of *Dumbo*. *Time* magazine of December 20, 1941, glowingly reviewed the film and quoted Tytla as saying, "I saw a chance to do a character without using any cheap theatrics. Most of the expressions and mannerisms I got from my own kid. There's nothing theatrical about a two-year-old kid. They're real and sincere . . . I tried to put all those things in Dumbo."

Art Babbitt was a leader in the company union and he had a serious personal confrontation with Disney over a wage differential between himself and his assistant. Finally, Babbitt switched his allegiance to the new Screen Cartoonists Guild, which was affiliated with the AFL. Disney fired Babbitt, which was in direct violation of the Wagner Labor Relations Act, and the union agreed unanimously to go out on strike on May 29, 1941. To Walt Disney's amazement, Bill Tytla joined the strikers.

"I was for the company union," Tytla explained later,

and I went on strike because my friends were on strike. I was sympathetic with their views, but I never wanted to do anything against Walt.

The food supplied by the union wasn't for me, so one lunch hour I went to a nearby greasy spoon for lunch. There was Walt in a booth. I went up to him and we shook hands. I told him the strike was foolish and unnecessary. He asked me to return to his office with him to work out a solution. I was dressed in old clothes, so I asked to go home, shower, and change. We made an appointment for later that afternoon.

I drove to my home in La Canada and my wife said that Walt had just called to cancel our meeting. Somebody had gotten to him and told him not to work with me. I wasn't an officer of the union and I really couldn't speak for anybody.

Babbitt states, "I know that Disney respected Bill's integrity and craftsman-
ship to the highest degree. Although they never socialized very much, if at all, I
could feel that Bill was one of the few people that Walt permitted himself to be
fond of. Even after the strike Walt couldn't quite bring himself to completely
write off Bill Tytla. I know one of Bill's most prized possessions was an auto-
graphed picture of Walt Disney and Bill posed together [in 1959]."

Tytla resigned from the Disney Studio on February 25, 1943, almost two
years after the strike was settled. Adrienne Tytla suggests several reasons for his
decision:

> Will felt unhappy there after the strike. He felt discriminated against for his "dis-
> loyal opinions" against the studio. Will had created a lot of heavies for Walt. Now
> he had been cast as one, by him. And there was too much tension and electricity in
> the air. With Will everything was instinctive and intuitive, and now the vibes were
> all wrong. . . .
>
> Paul Terry made a special trip out to California to try to get Will back. He
> wined and dined us at posh restaurants with his wife, Irma, and old friend Claire
> Trevor. And he offered Will a job back at Terrytoons.

The Tytlas moved to their 160-acre farm in Connecticut on March 1, 1943,
and Tytla returned to Terrytoons as a director of animation; I. Klein was working
there at the time and observed that "Bill was in a new atmosphere where the Dis-
ney-type of perfection at any cost did not exist. Animation was just a commercial
commodity to be produced in the most economical way . . . Terrytoons work
schedule was tight, efficient and fast. Bill adjusted grudgingly. After several years
he moved on to Paramount Cartoon Studios where he directed Popeye . . . here
too the schedule was tight and efficient."

George Bakes, his friend and assistant animator, recalls that Tytla "was very
depressed, got discouraged from the work and the lack of work and the lack of
something meaningful to do . . . He was offered a whole bunch of Popeyes [to pro-
duce] at one point. They were going to do a limited-animation version of it. He
didn't do one of them. He didn't like the budget."

Tytla turned to directing commercials for television and worked on close to
two thousand cartoons for Tempo Studio, Academy Pictures, and finally, his own
William Tytla Productions, Inc. He maintained an apartment/office in Manhat-
tan and went home to Connecticut on weekends.

"Bill was not a businessman, he was an artist," says George Bakes. "His
business got pretty bad because he was a bad businessman. Eventually it died and
he went looking for work." Adrienne Tytla recalls, "He would go out to the Coast
and everybody knew how great he'd been and they were sorry for him and they
gave him stuff to do, but he couldn't keep up with the amount of footage that was
required. Within a five year period he had three strokes, [and] he'd periodically
get a hemorrhage in the left eye. He was blind in that eye for three years and he
never let anyone know that."

Tytla created the three Post Sugar Crisp Bears and did many lucrative ads
with them on television and in *Life* and *Look* magazines. He directed odds and

ends for Hanna-Barbera and in 1962 was in charge of the animation sequences in *The Incredible Mister Limpet,* which combined live action with animation and starred Don Knotts. He worked nine months on that film in Hollywood, and Art Babbitt saw him during this period: "It was a tragedy to see this man disintegrate. His mind just gradually dissipated. He still made sense but he was not the strong, vibrant person I had known when he was young."

While in California, Tytla tried to sell a cartoon film idea he had been planning for five years, "Mousthusula, the 2000 Year Old Mouse," and for which he had made many charming and vigorous sketches; but there were no takers. "He got sick out there with pneumonia," Bakes recalls.

> He came back in terrible shape, a beaten man. I saw him in the street one day trying to go around, like he was staring in the air. I saw this thing [drawings of Mousthusula] under his arm. I said, "Bill, I don't want you to go anywhere. You stay home. I'll go get some work." He had moved out of New York after his studio folded and went to live in Connecticut on the farm. I started to get some free-lance work and I gave Bill some footage to do. Whenever the date for it came due, he'd have half of it done. If I gave him five feet, two and a half was done. If I gave him twenty-five feet, twelve and a half was done. And his animation was *rough* when he started to do it again after the sickness, but it was getting better and better.

While in the hospital for a "routine prostate operation," Tytla had another stroke and was unable to speak or write for weeks after. He tried to print words during this period and even managed to draw some additional Mousthusula sketches, but these drawings are sad to see—scribblings of a giant who had lost the power.

On December 29, 1968, William Tytla died on his farm. George Bakes had just negotiated to produce a series of TV commercials and was going to share his luck with Tytla. "That was a big change from just free-lancing for producers," Bakes said.

> I was waiting to tell Bill about this thing because this is a character [the Trix rabbit] that goes on and on. If he got used to the character and got to know him, he could really get back into animation.
>
> But he died before I could tell him. Saddest thing I ever heard of. That the guy was emotionally taking a pounding because of his great love for animation that turned into a great frustration. That's what killed him. 'Cause of this tremendous pride—he started out so young and was on top and then to have this kind of animation that came around that didn't have any craft in it. It was discouraging that he had to compete with that. There was no place he could do what he could do outside of Disney's.

Saccharine Symphony—*Bambi*
by MANNY FARBER

It was Manny Farber, first of all American film critics, who first railed loudly and unapologetically against Disney feature cartoons. His attack here on Bambi *was a 1942 warm-up for his truly radical 1943* New Republic *essay, "Short and Happy" (reprinted in his book* Negative Space *[1971]), which rhapsodized about Warners cartoons and declared the Merrie Melodies "superior to Disney's product." Why radical? Because Farber's heretical defense was perhaps the* only *pro-Warners article for almost thirty years.*

The new Disney cartoon, *Bambi,* is interesting because it's the first one that's been entirely unpleasant. The robust irrationality of the mouse comedies has been squelched completely by the syrup that has been gradually flowing over the Disney way. In an attempt to ape the trumped-up realism of flesh and blood movies, he has given up fantasy, which was pretty much the magic element. Mickey Mouse and Donald Duck lived in a beautiful escape land, where they flew through the air, swam under water, died a thousand deaths, and lived to see the end of each picture. These comedies were perfectly suited to a moving camera; held down by nothing human, they had terrific pace and action. It was a wonderful movie shambles.

But not *Bambi*. The animals here behave just as Hollywood thinks we do, and behaving that way it's old stuff and boring because of it. Everything is straight-faced, with feet flat on the ground. The animals give birth, grow up, fall in love, get shot at, and killed. Besides, it is moral, starched, heavy. The hero is a deer named Bambi, whose mother is killed by the villain, Mr. Man, whose sweetheart is attacked by Mr. Man's dogs, whose terrestrial paradise is destroyed by Mr. Man's fire. There's no harm in Disney's being righteous, unless, as in this picture, the accent is on the cute and pretty rather than on the comedy invention that produced the righteous Donald. Only so much amusement can come from fairy-like naïveté, after that it's just one long squirm. Along the way *Bambi* has all the stereotyped mechanisms of the formula movie—the heavy side to the love triangle, the fight for the doe's ("Feline") affections, the wise old king deer whose place Bambi wins over in the closing shots.

In keeping with this new spirit, *Bambi* talks itself dizzy to the exclusion of

movement and action. The animals are horribly equipped with human voices, not the neuter piping of Mickey or the incoherent gabbling of Donald, which were so perfectly right, but the cuddly or waspish voices of ladies and gentlemen. Like their counterparts in the regular movies, the animals here gather round and trade chitchat, very sweet, and it is grotesque. And there are songs everywhere, coming out of the mountains, from under the trees, flooding you with the most maudlin sounds a director ever let happen. Example: "Drip, Drip, Drop, Little April Shower."

The bogus art that has been creeping into the Disney pictures is really hammered at you in this one. Again, it is an affectation of reality, like a Maxfield Parrish painting. No more the flat house-paint colors of the early comedies, in which there were no half-tones or dull intensities, with every red the same hot, pure scarlet, every black like coal, and nothing flimsily grayed. The films are now doused in sweet sugary tints, flowery violets, fancy-pants pinks, and he'll waste ten minutes if he can end up with a gold-splashed sunset. Whereas the early color was fresh, simple, and in the comedy spirit, this new development is a synthetic reveling in vulgarity. The worst effect of all this artiness is the preference now for cheap painting, the Vanishing American kind you buy in Kress's, in place of the movement that was the main thing before. No longer do the trees and flowers carry on like mad: they are there for pretty; and as the camera moves slowly over them and you drink up all this tinseled loveliness, there is the lone deer on the distant hilltop, a gold aura around him.

Mickey wouldn't be caught dead in this.

Walt Disney making sketches during the preparation for *Bambi* (1942). (Courtesy The Museum of Modern Art/Film Stills Archive)

The Testimony of Walter E. Disney Before the House Committee on Un-American Activities

On May 10, 1941, Anthony Bower reported in The Nation *on attempts by the Screen Cartoonists Guild, an affiliate of the AFL, to unionize the Disney Studio. "The minimum wage at Disney's is still about $17 a week, while at other studios, such as Schlesinger's [WB], where the guild has been recognized, the minimum wage is about $23. Some six months ago the Disney Studio imposed a wage cut, using the loss of European markets as an excuse, and Disney himself made a speech about everyone pulling together in a time of national emergency for the sake of the studio; this speech recruited more members for the Screen Cartoonists Guild than a year of campaigning."*

A strike over recognition ensued, a bitter strike, and in the end the guild emerged as the bargaining agent for the whole studio. Along the way Disney animator Art Babbitt was fired four times for union activities. (Disney reluctantly rehired Babbitt three years later, but he refused to speak to him again.) Vlad Tytla was against the strike but stayed out in sympathy with his friends. He was blackballed by Disney. Dick Huemer became, by default, vice-president of Disney's company union, and he walked through hissing picketers on the way to work. Frank Tashlin, a militant unionist, was made head of animation at Columbia Studios in 1941. "So now I'm in charge of the studio, I'm management," he told cartoon historian Mike Barrier in 1971, "but management, on the way to the studio, would go by Disney's and walk in the picket line and call Walt Disney dirty names as he drove through in the Packard."

Tashlin used the occasion to recruit disenchanted animators for his own projects. John Hubley and others walked out on Disney and formed UPA. Some young cartoonists like Virgil Partch ("Vip") and Walt Kelly (Pogo) just quit animation altogether. As for Disney, he stayed enraged. His chance for revenge arrived when the House Committee on Un-American Activities turned to investigating the motion-picture industry. They were searching for Communists or, some say, they were there to help Hollywood companies smash the unionization of their employees. On October 24, 1947, an extremely "friendly" witness testified about alleged Communist activity at the Disney Studio.

[ROBERT E.] STRIPLING [CHIEF INVESTIGATOR]: Mr. Disney, will you state your full name and present address, please?

WALTER DISNEY: Walter E. Disney, Los Angeles, California.

RES: When and where were you born, Mr. Disney?

WD: Chicago, Illinois, December 5, 1901.

RES: December 5, 1901?

WD: Yes, sir.

RES: What is your occupation?

WD: Well, I am a producer of motion-picture cartoons.

RES: Mr. Chairman, the interrogation of Mr. Disney will be done by Mr. Smith.

THE CHAIRMAN [J. PARNELL THOMAS]: Mr. Smith.

[H. A.] SMITH: Mr. Disney, how long have you been in that business?

WD: Since 1920.

HAS: You have been in Hollywood during this time?

WD: I have been in Hollywood since 1923.

HAS: At the present time you own and operate the Walt Disney Studio at Burbank, California?

WD: Well, I am one of the owners. Part owner.

HAS: How many people are employed there, approximately?

WD: At the present time about 600.

HAS: And what is the approximate largest number of employees you have had in the studio?

WD: Well, close to 1,400 at times.

HAS: Will you tell us a little about the nature of this particular studio, the type of pictures you make, and approximately how many per year?

WD: Well, mainly cartoon films. We make about twenty short subjects, and about two features a year.

HAS: Will you talk just a little louder, Mr. Disney?

WD: Yes, sir.

HAS: How many, did you say?

WD: About twenty short subject cartoons and about two features per year.

HAS: And some of the characters in the films consist of——

WD: You mean such as Mickey Mouse and Donald Duck and *Snow White and the Seven Dwarfs* [1938], and things of that sort.

HAS: Where are these films distributed?

WD: All over the world.

HAS: In all countries of the world?

WD: Well, except the Russian countries.

HAS: Why aren't they distributed in Russia, Mr. Disney?

WD: Well, we can't do business with them.

HAS: What do you mean by that?

WD: Oh, well, we have sold them some films a good many years ago. They bought the *Three Little Pigs* [1933] and used it through Russia. And they looked at

a lot of our pictures, and I think they ran a lot of them in Russia, but then turned them back to us and said they didn't want them, they didn't suit their purposes.

HAS: Is the dialogue in these films translated into the various foreign languages?

WD: Yes. On one film we did ten foreign versions. That was *Snow White and the Seven Dwarfs.*

HAS: Have you ever made any pictures in your studio that contained propaganda and that were propaganda films?

WD: Well, during the war we did. We made quite a few—working with different government agencies. We did one for the Treasury on taxes and I did four anti-Hitler films. And I did one on my own for air power.

HAS: From those pictures that you made, have you any opinion as to whether or not the films can be used effectively to disseminate propaganda?

WD: Yes, I think they proved that.

HAS: How do you arrive at that conclusion?

WD: Well, on the one for the Treasury on taxes, it was to let the people know that taxes were important in the war effort. As they explained to me, they had 13,-000,000 new taxpayers, people who had never paid taxes, and they explained that it would be impossible to prosecute all those that were delinquent and they wanted to put this story before those people so they would get their taxes in early. I made the film, and after the film had its run the Gallup poll organization polled the public and the findings were that twenty-nine percent of the people admitted that had influenced them in getting their taxes in early and giving them a picture of what taxes will do.

HAS: Aside from those pictures you made during the war, have you made any other pictures, or do you permit pictures to be made at your studio containing propaganda?

WD: No; we never have. During the war we thought it was a different thing. It was the first time we ever allowed anything like that to go in the films. We watch so that nothing gets into the films that would be harmful in any way to any group or any country. We have large audiences of children and different groups, and we try to keep them as free from anything that would offend anybody as possible. We work hard to see that nothing of that sort creeps in.

HAS: Do you have any people in your studio at the present time that you believe are Communist or Fascist, employed there?

WD: No; at the present time I feel that everybody in my studio is one-hundred-percent American.

HAS: Have you had at any time, in your opinion, in the past, have you at any time in the past had any Communists employed at your studio?

WD: Yes; in the past I had some people that I definitely feel were Communists.

HAS: As a matter of fact, Mr. Disney, you experienced a strike at your studio, did you not?

WD: Yes.

HAS: And is it your opinion that that strike was instituted by members of the Communist Party to serve their purposes?

WD: Well, it proved itself so with time, and I definitely feel it was a Communist group trying to take over my artists and they did take them over.

CHAIRMAN: Do you say they did take them over?

WD: They did take them over.

HAS: Will you explain that to the committee, please?

WD: It came to my attention when a delegation of my boys, my artists, came to me and told me that Mr. Herbert Sorrell——

HAS: Is that Herbert K. Sorrell?

WD: Herbert K. Sorrell, was trying to take them over. I explained to them that it was none of my concern, that I had been cautioned to not even talk with any of my boys on labor. They said it was not a matter of labor, it was just a matter of them not wanting to go with Sorrell, and they had heard that I was going to sign with Sorrell, and they said that they wanted an election to prove that Sorrell didn't have the majority, and I said that I had a right to demand an election. So when Sorrell came, I demanded an election.

Sorrell wanted me to sign on a bunch of cards that he had there that he claimed were the majority, but the other side had claimed the same thing. I told Mr. Sorrell that there is only one way for me to go and that was an election and that is what the law had set up, the National Labor Relations Board was for that purpose. He laughed at me and he said that he would use the Labor Board as it suited his purposes and that he had been sucker enough to go for that Labor Board ballot and he had lost some election—I can't remember the name of the place—by one vote. He said it took him two years to get it back. He said he would strike, that that was his weapon. He said, "I have all of the tools of the trade sharpened," that I couldn't stand the ridicule or the smear of a strike. I told him that it was a matter of principle with me, that I couldn't go on working with my boys feeling that I had sold them down the river to him on his say-so, and he laughed at me and told me I was naïve and foolish. He said, you can't stand this strike, I will smear you, and I will make a dust bowl out of your plant.

CHAIRMAN: What was that?

WD: He said he would make a dust bowl out of my plant if he chose to. I told him I would have to go that way, sorry, that he might be able to do all that, but I would have to stand on that. The result was that he struck.

I believed at that time that Mr. Sorrell was a Communist because of all the things that I had heard and having seen his name appearing on a number of Commie front things. When he pulled the strike, the first people to smear me and put me on the unfair list were all of the Commie front organizations. I can't remember them all, they change so often, but one that is clear in my mind is the League of Women Shoppers, *The People's World, The Daily Worker,* and the *PM* magazine in New York. They smeared me. Nobody came near to find out what the true facts of the thing were. And I even went through the same smear in South America, through some Commie periodicals in South America, and generally

throughout the world all of the Commie groups began smear campaigns against me and my pictures.

JOHN MCDOWELL: In what fashion was that smear, Mr. Disney, what type of smear?

WD: Well, they distorted everything, they lied; there was no way you could ever counteract anything that they did; they formed picket lines in front of the theaters, and, well, they called my plant a sweatshop, and that is not true, and anybody in Hollywood would prove it otherwise. They claimed things that were not true at all and there was no way you could fight it back. It was not a labor problem at all because—I mean, I have never had labor trouble, and I think that would be backed up by anybody in Hollywood.

HAS: As a matter of fact, you have how many unions operating in your plant?

CHAIRMAN: Excuse me just a minute. I would like to ask a question.

HAS: Pardon me.

CHAIRMAN: In other words, Mr. Disney, Communists out there smeared you because you wouldn't knuckle under?

WD: I wouldn't go along with their way of operating. I insisted on it going through the National Labor Relations Board. And he told me outright that he used them as it suited his purposes.

CHAIRMAN: Supposing you had given in to him, then what would have been the outcome?

WD: Well, I would never have given in to him, because it was a matter of principle with me, and I fight for principles. My boys have been there, have grown up in the business with me, and I didn't feel like I could sign them over to anybody. They were vulnerable at that time. They were not organized. It is a new industry.

CHAIRMAN: Go ahead, Mr. Smith.

HAS: How many labor unions, approximately, do you have operating in your studios at the present time?

WD: Well, we operate with around thirty-five—I think we have contacts with thirty.

HAS: At the time of this strike you didn't have any grievances or labor troubles whatsoever in your plant?

WD: No. The only real grievance was between Sorrell and the boys within my plant, they demanding an election, and they never got it.

HAS: Do you recall having had any conversations with Mr. Sorrell relative to Communism?

WD: Yes, I do.

HAS: Will you relate that conversation?

WD: Well, I didn't pull my punches on how I felt. He evidently heard that I had called them all a bunch of Communists—and I believe they are. At the meeting he leaned over and he said, "You think I am a Communist, don't you," and I told him that all I knew was what I heard and what I had seen, and he laughed

and said, "Well, I used their money to finance my strike of 1937," and he said that he had gotten the money through the personal check of some actor, but he didn't name the actor. I didn't go into it any further. I just listened.

HAS: Can you name any other individuals that were active at the time of the strike that you believe in your opinion are Communists?

WD: Well, I feel that there is one artist in my plant, that came in there, he came in about 1938, and he sort of stayed in the background, he wasn't too active, but he was the real brains of this, and I believe he is a Communist. His name is David Hilberman.

HAS: How is it spelled?

WD: H-i-l-b-e-r-m-a-n, I believe. I looked into his record and I found that, number 1, that he had no religion and, number 2, that he had spent considerable time at the Moscow Art Theatre studying art direction, or something.

HAS: Any others, Mr. Disney?

WD: Well, I think Sorrell is sure tied up with them. If he isn't a Communist, he sure should be one.

HAS: Do you remember the name of William Pomerance, did he have anything to do with it?

WD: Yes, sir. He came in later. Sorrell put him in charge as business manager of cartoonists and later he went to the Screen Actors as their business agent, and in turn he put in another man by the name of Maurice Howard, the present business agent. And they are all tied up with the same outfit.

HAS: What is your opinion of Mr. Pomerance and Mr. Howard as to whether or not they are or are not Communists?

WD: In my opinion they are Communists. No one has any way of proving those things.

HAS: Were you able to produce during the strike?

WD: Yes, I did, because there was a very few, very small majority that was on the outside, and all the other unions ignored all the lines because of the setup of the thing.

HAS: What is your personal opinion of the Communist Party, Mr. Disney, as to whether or not it is a political party?

WD: Well, I don't believe it is a political party. I believe it is an un-American thing. The thing that I resent the most is that they are able to get into these unions, take them over, and represent to the world that a group of people that are in my plant, that I know are good, one-hundred-percent Americans, are trapped by this group, and they are represented to the world as supporting all of those ideologies, and it is not so, and I feel that they really ought to be smoked out and shown up for what they are, so that all of the good, free causes in this country, all the liberalisms that really are American, can go out without the taint of communism. That is my sincere feeling on it.

HAS: Do you feel that there is a threat of Communism in the motion-picture industry?

WD: Yes, there is, and there are many reasons why they would like to take it

over or get in and control it, or disrupt it, but I don't think they have gotten very far, and I think the industry is made up of good Americans, just like in my plant, good, solid Americans.

My boys have been fighting it longer than I have. They are trying to get out from under it and they will in time if we can just show them up.

HAS: There are presently pending before this committee two bills relative to outlawing the Communist Party. What thoughts have you as to whether or not those bills should be passed?

WD: Well, I don't know as I qualify to speak on that. I feel if the thing can be proven un-American that it ought to be outlawed. I think in some way it should be done without interfering with the rights of the people. I think that will be done. I have that faith. Without interfering, I mean, with the good, American rights that we all have now, and we want to preserve.

HAS: Have you any suggestions to offer as to how the industry can be helped in fighting this menace?

WD: Well, I think there is a good start toward it. I know that I have been handicapped out there in fighting it, because they have been hiding behind this labor setup, they get themselves closely tied up in the labor thing, so that if you try to get rid of them they make a labor case out of it. We must keep the American labor unions clean. We have got to fight for them.

HAS: That is all of the questions I have, Mr. Chairman.

CHAIRMAN: Mr. Vail.

R. B. VAIL: No questions.

CHAIRMAN: Mr. McDowell.

J. MCDOWELL: No questions.

WD: Sir?

JM: I have no questions. You have been a good witness.

WD: Thank you.

CHAIRMAN: Mr. Disney, you are the fourth producer we have had as a witness, and each one of those four producers said, generally speaking, the same thing, and that is that the Communists have made inroads, have attempted inroads. I just want to point that out because there seems to be a very strong unanimity among the producers that have testified before us. In addition to producers, we have had actors and writers testify to the same. There is no doubt but what the movies are probably the greatest medium for entertainment in the United States and in the world. I think you, as a creator of entertainment, probably are one of the greatest examples in the profession. I want to congratulate you on the form of entertainment which you have given the American people and given the world and congratulate you for taking time out to come here and testify before this committee. He has been very helpful.

Do you have any more questions, Mr. Stripling?

HAS: I am sure he does not have any more, Mr. Chairman.

RES: No; I have no more questions.

CHAIRMAN: Thank you very much, Mr. Disney.

BIBLIOGRAPHY*

ADAMSON, JOE. "Walt Disney on Olympus—an Interview with Dick Huemer." *Funnyworld,* no. 17 (Fall 1977).

AGEE, JAMES. *"Victory Through Air Power."* In *Agee on Film.* Boston: Beacon Press, 1964.

BARRIER, MIKE. *"The Black Cauldron*—Disney's Production for 1984." *Funnyworld,* no. 20 (Summer 1979).

————. "Building a Better Mouse Trap—Fifty Years of Disney Animation." *Funnyworld,* no. 20 (Summer 1979).

BOWER, ANTHONY. "Snow White and the 1,200 Dwarfs; Attempts to Organize the Disney Employees." *The Nation* (May 10, 1941).

BRASHARES, C. W. "Walt Disney as Theologian." *The Christian Century* (August 10, 1938).

BREWER, ROY. "Walt Disney, RIP." *National Review* (January 10, 1967).

BRIGHT, JOHN. "Disney's Fantasy Empire." *The Nation* (March 6, 1967).

BROWN, JOHN MASON. "Mr. Disney's Caballeros." *Saturday Review* (February 24, 1945). [*The Three Caballeros*]

BURTON, THOMAS. "Walt Disney's *Pinocchio.*" *Saturday Review* (February 17, 1940).

CALVERTON, V. F. "Snow White Fiasco." *Current History* (June 1938).

CANEMAKER, JOHN. "Animation History and Shamus Culhane." *Filmmakers Newsletter* (June 1974).

————. "Animation Journal—Jules Engels." *Millimeter* (October 1975).

————. "Art Babbitt—the Animator as Firebrand." *Millimeter* (September 1975).

————. "Grim Natwick." *Film Comment* (January–February 1975).

————. "Sincerely Yours, Frank Thomas." *Millimeter* (January 1975).

————. "A Visit to the Walt Disney Studio." *Filmmakers Newsletter* (January 1974).

CARE, ROSS. "Cinesymphony—Music and Animation at the Disney Studio 1928–42." *Sight and Sound* (Winter 1976/77).

————. "Ward Kimball: Animated Versatility." *Millimeter* (July–August 1976).

CARR, HARRY. "The Only Unpaid Movie Star." *American Magazine* (March 1931). [Mickey Mouse]

CHARLOT, JEAN. "But Is It Art? A Disney Disquisition." *The American Scholar* (July 1939).

CHURCHILL, DOUGLAS. "Disney's Philosophy." *The New York Times Magazine,* March 6, 1938.

DELEHANTY, THORNTON. "The Disney Studio at War." *Theatre Arts* (January 1943).

DISNEY, ROY. "Unforgettable Walt Disney." *Readers Digest* (February 1969).

* Compiled by Gregory A. Waller.

DISNEY, WALT. "The Cartoon's Contribution to Children." *Overland Monthly and Outwest Magazine* (October 1933).

———. "Growing Pains." *The American Cinematographer* (March 1941).

———. "Hedda Hopper's Hollywood." *The New York Daily News,* June 14, 1965.

———. "How I Cartooned Alice." *Films in Review* (May 1951).

———. "Humour: My Sixth Sense." *Films and Filming* (February 1961).

———. "Mickey Mouse Presents." In *We Make Movies.* Edited by Nancy Naumburg. New York: W. W. Norton, 1937.

ENGLISH, HORACE B. *"Fantasia and the Psychology of Music." Journal of Aesthetics and Art Criticism,* nos. 2 and 7 (1942, 1943).

ERICSSON, PETER. "Walt Disney." *Sequence,* no. 10 (1950).

"Father Goose." *Time* (December 17, 1954).

FERGUSON, OTIS. "Extra Added Attractions: 'Band Concert' and 'Who Killed Cock Robin?' " *The New Republic* (August 7, 1935).

———. "It's a Disney: *Pinocchio." The New Republic* (March 11, 1940).

———. "Walt Disney's Grimm Reality." *The New Republic* (January 26, 1938).

"Fifty Million Customers." *Newsweek* (March 14, 1955).

GESSNER, ROBERT. "Class in *Fantasia." The Nation* (November 30, 1940).

GLENN, CHARLES. "Exploding Some Myths About Mr. Walt Disney." *The Daily Worker,* February 17, 1941.

———. "Hollywood Genius, the Myth of Walt Disney." *The Daily Worker,* January 1, 1940.

GRAFLY, DOROTHY. "America's Youngest Art." *The American Magazine of Art* (July 1933).

GREENE, GRAHAM. "Three Little Pigs in England." *Living Age* (May 1934).

GROVE-BAXTER, GRANGE. "Snow White Meets the Blue Meanies." *Film* (Spring 1969).

HARTUNG, P. T. "Once in a Lifetime: *Fantasia* Is a Rare Treat." *Commonweal* (November 29, 1940).

HERRING, ROBERT. *"Fantasia." Life and Letters Today* (December 1941).

HEYLBUT, ROSE. "The Music of the Walt Disney Cartoon—A Conference with Paul J. Smith." *The Etude* (July 1940).

HICKS, JIMMIE. *"Fantasia's* Silver Anniversary." *Films in Review* (November 1968).

HISS, TONY, and MCCLELLAND, DAVID. "Profiles—the Quack and Disney." *The New Yorker* (December 29, 1975). [Clarence Nash]

HOLLISTER, PAUL. "Walt Disney: Genius at Work." *The Atlantic Monthly* (December 1940).

HOOLERING, F. *"Fantasia;* Walt Disney plus Bach or Beethoven." *The Nation* (November 23, 1940).

HURWITZ, LEO T. "P. Roy and W. Disney, Comparison of Their Methods." *Creative Art* (May 1931).

JACOBS, LEWIS. "Walt Disney: Virtuoso." In *The Rise of the American Film*. New York: Teachers College Press, 1968.

KOZLENKO, WILLIAM. "The Animated Cartoon and Walt Disney." *New Theatre* (August 1936).

KRACAUER, SIEGFRIED. *"Dumbo." The Nation* (November 8, 1941).

LA FARGE, CHRISTOPHER. "Walt Disney and the Art Form." *Theatre Arts* (September 1941).

LAMOUR, PHILIPPE. "The New Art: Mickey Mouse—A Note on the Talking Film." *New Hope* (September 15, 1934).

LEJEUNE, CAROLINE. "Disney-Time; Not-so-silly Symphonies." *Theatre Arts* (February 1934).

LOW, DAVID. "Leonardo da Disney." *The New Republic* (January 5, 1942).

MACFADDEN, PATRICK. "Letting Go." *Film Society Review*, 4, no. 1 (1968).

MACGOWAN, KENNETH. "Work of Walt Disney." *Hollywood Quarterly* (July 1946).

MAYERSBERG, PAUL. "The American Nightmare." *New Society* (April 1968).

MCDONALD, JOHN. "Now the Bankers Come to Disney." *Fortune* (May 1966).

MCREYNOLDS, WILLIAM. "Disney Plays 'The Glad Game.' " *Journal of Popular Culture* (Spring 1974).

MORITZ, WILLIAM. "Fischinger at Disney (Or Oskar in the Mousetrap)." *Millimeter* (February 1977).

MORKOVIN, B. V. "Cooperative Imagination." *Cinema Progress* (May–June 1938).

PAUL, WILLIAM. "Art, Music, Nature and Walt Disney." *Movie*, no. 24 (Spring 1977). [*Pinocchio*]

PAVOLINI, CORRADO. "Psychoanalysis of 'The Three Little Pigs.' " *Internecine* (January 1935).

PEARSON, RALPH M. "The Artist's Point of View." *The Forum and Century* (November 1937).

POTAMKIN, HARRY. "Film Cults." *Modern Thinker and Author's Review* (November 1932).

RAFFERTY, MAX. "The Greatest Pedagogue of All." *The Los Angeles Times*, April 18, 1967.

RICHMOND, HARRY. "A Dissenting Report on Disney's *Fantasia." The Daily Worker*, December 6, 1940.

ROSENHEIMER, ARTHUR, JR. "Fanfare for *Fantasia." Films*, 1, no. 4 (1941).

ROSENBAUM, JONATHAN. "Dream Masters I: Walt Disney." *Film Comment* (January–February 1975).

SAYERS, FRANCES. "Walt Disney Accused." *Horn Book* (December 1965).

SCHWAB, MACK W. "The Communalistic Art of Walt Disney." *Cinema Quarterly* (Spring 1934).

SELDES, GILBERT. "Disney and Others." *The New Republic* (June 8, 1932).

———. "No Art, Mr. Disney?" *Esquire* (September 1937).

———. "Walt Disney." *The New Yorker* (December 19, 1931).

SHALE, RICK. "Donald Duck Joins Up—The Walt Disney Studio During World War II." *Funnyworld,* no. 17 (1977).

———. "The Life and Good Times of Mickey Mouse." *Cinegram* (Winter 1976/77).

SMITH, DAVID R. "Ben Sharpsteen . . . 33 Years with Walt Disney." *Millimeter* (April 1975).

———. "Disney Before Burbank—The Kingswell and Hyperion Studios." *Funnyworld,* no. 20 (Summer 1979).

———. "The Sorcerer's Apprentice—Birthplace of *Fantasia.*" *Millimeter* (February 1976).

"South American Caravan." *California Arts and Architecture* (July 1942).

STRAVINSKY, IGOR. "Stravinsky Replies to Walt Disney." *Saturday Review* (March 12, 1960). [*Fantasia*]

THOMPSON, DOROTHY. "Minority Report." *The New York Herald Tribune,* November 25, 1940. [*Fantasia*]

THURBER, JAMES. "Odyssey of Disney." *The Nation* (March 28, 1934).

TUCKER, NICHOLAS. "Who's Afraid of Walt Disney?" *New Society,* no. 11 (1968).

VAN DOREN, MARK. "Fairy Tale in Five Acts." *The Nation* (January 22, 1938). [*Snow White and the Seven Dwarfs*]

WAGNER, WALTER. "The Wonderful World of Walt Disney" [interview with Ward Kimball]. In Walter Wagner. *You Must Remember This.* New York: G. P. Putnam's Sons, 1975.

"Walt Disney Goes to War." *Life* (August 31, 1942).

WEINBERG, HERMAN G. "Tribute to Walt Disney." In Herman G. Weinberg, ed. *Saint Cinema.* New York: Dover Publications, 1973.

WHITE, KENNETH. "Animated Cartoons." *Hound and Horn* (October–December 1931).

WILLIAMS, RICHARD. "Character Analysis of the Animator—January 1974." *Sight and Sound* (Spring 1974). [Art Babbitt]

WOOLLCOTT, ALEXANDER. "Letter to Walt Disney—January 12, 1942." In *The Letters of Alexander Woollcott.* Edited by Beatrice Kauffman and Joseph Hennessey. New York: The Viking Press, 1944.

WRIGHT, BASIL. "*Snow White and the Seven Dwarfs.*" *The Spectator* (March 4, 1938).

WRIGHT, LAWRENCE. "Barking Up the Wrong Tree." *Sight and Sound* (August 1938).

WARNER
BROTHERS

Hugh Harman and
Rudolf Ising
at Warner Brothers

by TOM BERTINO

Harman-Ising reads "harmonizing," and the pun could not be more apt for this skillful animation duo who operated like a songwriting team. They created Looney Tunes in 1930 and thus spawned the immortal Warner Brothers cartoon tradition, the most important challenge to the style, form, and subject matter of the Walt Disney school. Their first film, a Bosko cartoon called Sinkin' in the Bathtub *(1930), began, according to film historian Greg Ford, where Disney left off in* Steamboat Willie *(1928) ". . . Mickey Mouse organ-grinds a billy-goat's tail for organ-grinder's music," says Ford. ". . . in* Sinkin', *Bosko, putt-putting along in his car, cranks the tail of a cow-in-the-road to raise her up like a tollgate—the cow resents it and marches off insultedly, her udders swinging to-fro to 'Pomp and Circumstance.' "*

Before Harman-Ising departed Warners for M-G-M in 1934, taking Bosko with them, they launched the Merrie Melodies series. They also trained as their chief animator one Isadore "Friz" Freleng who stayed on for decades of Bugs and Daffy as the no-nonsense backbone of the Warners animation department. In addition they found Bob Clampett. He later recalled, "They gave me a number of secondary characters to animate in the very first Merrie Melodie, Lady Play Your Mandolin *[1931]."*

We join the story of Harman and Ising in May 1929. After nine years in the cartooning business, Hugh and Rudy had gotten virtually nowhere. Their last venture, a continuation of Disney's Oswald, the Lucky Rabbit series, had just been pulled out from under them and put in Walter Lantz's hands. At this point Hugh and Rudy officially became a team and set to work producing their first sound picture—a demonstration reel for a possible series. Hugh Harman, the artist of the pair, cooked up a little black boy, dubbed "Bosko." The film followed the Fleischer Out of the Inkwell pattern, as a live-action Rudy Ising socialized with the animated character. *Bosko the Talk-Ink Kid* (1929) marked the first time a cartoon character actually spoke dialogue on the screen, as opposed to just making noise.

After several unsuccessful attempts to peddle a proposed Bosko series, Hugh and Rudy crossed paths with Leon Schlesinger, at the time head of Pacific Art and Title. Schlesinger sold Warners on the idea of a talking cartoon series starring

Bosko. Thus was born Warners' Looney Tunes, a hit from the first. One exhibitor's datebook for 1930/31 shows Bosko overtaking Mickey Mouse in the frequency of bookings, just as Mickey Mouse had overtaken Felix the Cat in the 1929/30 season. So successful were the Tunes that in the 1931/32 season they were accompanied by a new Warners series, the Merrie Melodies, each carrying a different character and each swinging to the tune of a popular song of the day. Harman and Ising had arrived.

Bosko was H and I's entry into the "Let's-come-up-with-a-character-who-will-take-the-sound-cartoons-by-storm" race, bucking such competition as Flip the Frog, Bimbo, a newly sound-tracked Oswald, and, of course, Mickey Mouse. Aesthetically, Bosko may be the most pleasing of the lot. All the vital elements of design are there: black nose, huge eyes that blend into a doughnut mouth, big hands and feet, with a body balance ready for action. The fact that he is black becomes, after the first Tune (*Sinkin' in the Bathtub* [1930], in which he speaks in an exaggerated stereotypical drawl), mostly unimportant. Occasionally, his racial identity is exploited, as in *Bosko the Doughboy* (1931), in which Bosko's entrance is heralded with an instrumental chorus of "The Kinky Kids' Parade," or in *Bosko the Lumberjack* (1932), where he savors a sandwich by declaring "Dat sho' is fahn!" Otherwise, except for a rare exclamation of "Mammy!" (notably in the earlier pictures), H and I never called attention to Bosko's racial status, and certainly steered him clear of dice and watermelon.

The first H and I Looney Tune, *Sinkin' in the Bathtub,* premièred on May 6, 1930, and already there was an absolute adherence of music and image. In follow-up Warners cartoons, music was everything, surpassing the synchronization at all studios except, perhaps, the Fleischers. Whereas other animators used specially written music or music in the public domain, H and I used the popular tunes of the day to set the pace, favoring flashy trombones over the violin sounds of other studios. But except for musical advances, their 1930 releases remained fairly basic, with little visual innovation. Gags were of the sniggling schoolboy variety,

Bosko's Easter Eggs (1937) was made at M-G-M. By this time Bosko has become a black caricature. © Metro-Goldwyn-Mayer, Inc.

of which Disney was so enamored, with much dependence on nudity, underwear, toilets, spitting, cows' udders, crotches, and the like. There was an occasional foray into the Fleischers' domain of imaginative sexual gags, as in *Congo Jazz* (1930), in which a coconut tree goes into a marvelous bump-and-grind, its coconuts swinging madly.

The series hit its stride mid-1931, and the Harman-Ising product became distinctive. The gags, which had elicited chuckles, started to aim for solid laughs. *Bosko's Soda Fountain* (1931) featured slapstick gags reminiscent of 1920s comedy shorts. And all animation elements came together with gusto in *Bosko the Doughboy,* the best of H and I's Looney Tunes. The exploding bombs, scattering debris, booming cannons, and charging armies are still impressive almost fifty years after. The black-and-white animation is of unusually high standard, the musical score runs a gamut of dramatic emotions, the gags include all manner of cartoon exaggeration and visual puns. The cartoon is a gem, a milestone of animation.

This inventiveness was not to last. During 1932, Bosko's girl friend Honey took a more active part in the series; and although the art remained of high quality, the stories and characterizations started to smack heavily of Mickey Mouse routines. Films like *Bosko the Lumberjack* and *Bosko at the Beach* (1932) succeeded well enough by copying the Mickey formula; but other Disney imitations were doomed to failure by their coyness. For instance, *Bosko's Party* (1932) is attended by a plethora of cloyingly cute, albeit artistically pleasing, animals. The film limps along with little action or humor. It is only when Bosko and Honey, armed with a ukulele, do one of their Johnny Marvin–Aileen Stanley routines on "Sugar" that the film suddenly takes on a life, carrying *Bosko's Party* to a raucous finish.

That the Boskos slipped a notch or two during this period is probably due in part to the fact that Rudy Ising, the idea man of the pair, had switched his attentions to the fledgling Merrie Melodies series, while the Boskos became largely Hugh Harman's babies. In general, the Melodies of 1932 and 1933 tend to stand up better today than the Looney Tunes of the same vintage; and they usually surpass Walt Disney's Silly Symphonies of the period, which, prior to *Three Little Pigs* (1933), tend to drag along, being a string of "descriptive fantasies," played by salon orchestras and dramatized by a stock company of bugs, birds, and demonic squirrels. (*The Skeleton Dance* [1929] and *Mother Goose Melodies* [1931] are impressive exceptions.)

The Merrie Melodies are a different matter, alive and joyous, with the blending of music and action reaching its zenith here. The earliest pictures made use of Abe Lyman's Brunswick recording orchestra on the tracks, and they played some of the hottest "whoopee tunes" of the day, such as "Smile, Darn Ya, Smile" and "Freddie the Freshman."

A standout aspect of the Melodies is that they are among the most accurate portraits of an era that the animated screen has ever produced. Plots tend to revolve around "period" subjects, such as speakeasies (*Goopy Geer*), the vaudeville stage (*You Don't Know What You're Doin'!* [1931]), the college football craze

(*Freddie the Freshman* [1931]), and even Rasputin (*Wake Up the Gypsy in Me* [1933]). Constant spot references to popular culture and trends appear, often subliminally, throughout the series.

One advantage the Melodies had over the Symphonies was their impressive array of characters. Each picture featured a protagonist who, if not capable of carrying a whole series, proved entertaining enough for a single cartoon. Still the fox star of *Smile, Darn Ya, Smile* (1931) had definite possibilities. And the marvelous pig in *You Don't Know What You're Doin!* was good enough to become a sort of unofficial mascot for the series; although he appeared in only one cartoon proper, he showed up on the end title of many entries to shout the obligatory, "So long, folks!"[1] The few cartoons that were not real successes, such as *You're Too Careless with Your Kisses* (1932) and *The Dish Ran Away with the Spoon* (1933), were those that lacked any real character interest, being carried by, respectively, bugs and kitchenware.

The closest the Melodies ever came to an actual star was Goopy Geer, the central character of—what else?—*Goopy Geer* (1932). Some people have alleged that Goopy was Harman and Ising's answer to Disney's "the Goof" (eventually Goofy), but the similarity in names is sheer coincidence—the songwriter who wrote "Goopy Geer" could hardly have been thinking about Disney's as-yet-unnamed character.

Goopy is a wisecracking entertainer in the Clayton, Jackson, and Durante mold: part comedian, part musician, part dancer. His personality is beautifully defined. His remarkable eccentric dance (apparently quite a cause célèbre for the animators) is one of the best pieces of animation that Warners ever produced. Goopy scored big enough to precipitate a guest appearance in *Bosko in Dutch* (1932), in which he performs his trademarked terpsichore on ice skates!

Perhaps the most important and certainly the most entertaining innovation of the Harman-Ising studio was a comedy setup all their own: the "coming-to-life syndrome." This bit made its first appearance in *Smile, Darn Ya, Smile,* when Smith Brothers and Dutch Cleanser ads on a runaway streetcar sprang to life and started singing. The final outcome of this idea was the classic *I Like Mountain Music* (1933), a tour-de-force fantasy of photos in various magazines running wild. This gimmick turned up in Warners cartoons made a full ten years later.

Finally, mention should be made of the highly idealized cartoon homages to various cultures. *Pagan Moon* (1931) is well attuned to its South Seas island theme song and plot. *One Step Ahead of My Shadow* (1932) may not seem to ask for a Chinese motif, but it fits quite nicely. *Crosby, Columbo and Vallee* (1932), however, is just silly, with a band of renegade Indians dancing around a campfire and griping about how the radio crooners have lured their women away.

If all seemed well on screen, it was not "back at the Warners ranch." Leon Schlesinger, notorious for his tightness with a buck, had had several go-arounds with Harman and Ising regarding finances. After the 1932/33 season the pair left Warner Brothers and went, albeit indirectly, to M-G-M, which released their pictures for another decade.

[1] Although the Looney Tunes closed with "That's all, folks!" from the beginning, the Merrie Melodies used "So long, folks!" until after Harman and Ising left Warners.

Somewhere along the line something went wrong. At first, films like *A Toyland Broadcast* (1934) and *Good Little Monkeys* (1935) were full of the old H and I spirit of fun, but as the 1930s went on, M-G-M's emulation of Disney became obvious and labored, as puffy-cheeked baby animals and water nymphs began to take over a world once populated by Jewish Indians and dogs in raccoon coats. This is not to imply that H and I's shift was all downhill. *Swing Wedding* (1937) is one of the finest one-reelers in all of animation. But their material from 1938 on rarely merits a second look, Harman's *The Bookworm* (1939) and Ising's *Romeo in Rhythm* (1940) being exceptions. Although all the later films are technically well made, the content of most is trivial.

And what of Bosko? He followed Harman and Ising to M-G-M where, between 1934 and 1938, he appeared in eight films. Though usually enjoyable, he had undergone a dramatic change. By the time of his farewell appearance (*Bosko in Bagdad* [1938]), he was no longer the ambiguous inkblot of the Looney Tunes, but a recognizable, semi-"realistic" black caricature, with kinky hair and sepia skin. Gone was his unguessable age. He was now officially a "little Negro boy" (movie-style) and behaved as such. Bosko now spoke in perfect "dem-dese-and-dose" English.

The fate of Bosko sums up the fate of the Harman-Ising cartoons in general. He—and his animators—belonged to an era, and any attempt at updating them could never have been a success. Whereas their M-G-M cartoons largely seem to say, "We are animators painstakingly executing our craft and you are the audience seeing our consummate skill," the Warners releases generally assert, "Look, you and I know this is a silly world, so why not have fun with it?" And when we come down to it, isn't *that* what cartoons are all about?

Peace on Earth (1939), Harman and Ising's antiwar cartoon, a far cry from their Bosko series. © Warner Bros., Inc. (Courtesy The Museum of Modern Art/Film Stills Archive)

Tex Arcana:
The Cartoons
of Tex Avery
by RONNIE SCHEIB

To some admirers, he is, after Disney, the single most important figure in the history of animation, a surrealist genius whose self-reflective intrusions into his cartoons are no less sophisticated than Brecht's "alienating" devices. To others (bluenoses especially) Fred "Tex" Avery represents everything loathsome about cartoons, from exaggerated violence to extra-corny sight gags, from outrageous silliness to crude sexual innuendo. Avery would not deny the charges, but would revel in them. Avery's idea of a gag: "a guy would no sooner get hit with an anvil than he takes one step over and falls in a well." His thoughts on anthropomorphic realism: ". . . we used any kind of distortion that couldn't possibly happen." About characterization: "I've always felt that what you did with a character was more important than the character itself. Bugs Bunny could have been a bird" (Joe Adamson, Tex Avery: King of Cartoons *).*

Avery admits he was never a great artist; so he became a director instead, working at Warners between 1936 and 1942 and creating cartoon history. His animations are as much a part of the famed Warner Brothers style as those proletariat roustabout movies of Cagney, Bogart, and Pat O'Brien, short on bombast and budget but high on energy, speed, inner-city urbanity, and sheer wit. Avery directed the first real Bugs Bunny cartoon, A Wild Hare *(1940) and it was he who planted "What's Up, Doc?" in Bugs's repertoire. He invented Porky Pig and Daffy Duck (and later, elsewhere, Droopy and those bizarre bugs killed off in Raid commercials). He trained Bob Clampett and Chuck Jones as his animators (and Bob Cannon too, of UPA McBoing-Boing fame) and his influence on their work is immeasurable. To trace only one line, of many: Jerry Lewis learned his cartoonish visual style from the best director of Martin and Lewis vehicles, Frank Tashlin; and Tashlin, of course, learned to make live-action narratives by directing cartoons at Warners in the "wild and woolly" Avery tradition. As Tashlin told Mike Barrier: "I would never once think I was ahead of Tex, anytime, anyhow. Tex was just marvelous."*

In *Believe It or Else* (1939), one of Tex Avery's Warners cartoon takeoffs on the newsreel docu format, Egghead, an early, recurring Avery standby, hero by default, divine retribution, or insistent incongruity, periodically pops up for short

walk-ons protesting "I don't believe it" or, for variation, bearing a sign proclaiming It's a Fake. "Suspension of disbelief," Coleridge's aesthetic equivalent of soft lights and music, is hardly a mainstay of Avery's oeuvre. Yet, as Greg Ford makes clear, the "anything-is-possible-in-these-here-cartoon-pictures" implosive bag of tricks Avery developed at Warner Brothers would be inconceivable without the bedrock foundation of believability and solidity Disney brought to the sound cartoon. For Avery's mind-wrenching reversals, inversions, and violations of physical and psychological laws are only possible if these laws exist. Gravity, cause and effect, logic, subjectivity, personality, all the Disney-incorporated processes must weave their web of expectations, their dream of continuity, to set the stage for the violent shock of awakening that shudders through an Avery cartoon. Associations run wild, metaphors take on a life of their own, as the world of the mind in all its analytic clarity and preconditioned consciousness-streaming, its waking stupor and madly creative slumber, collides head-on with the world of the physical in ways that are only possible in "these here cartoony pictures," although no one knew it before Avery and no one could forget it after him.

Almost from his arrival at Warners in 1936, the cute little pigs, squirrels, cats, bugs, and mice of the collectivistic Merrie Melodies and the bumpkin barnyard "stars" of the more narrative Looney Tunes lost much of their wide-eyed innocence as the cartoons took on a new audacity, the pace quickened, and gags telescoped into gags. In as typical a Merrie Melodie as *Penguin Parade* (1938), one of Avery's many forays into the Frozen North (until by poetic injustice he wound up with the thankless Chilly Willy at Lantz), a penguin orders a Scotch and soda, with a lemon twist, and the bartender promptly picks him up, pours in the proper ingredients and shakes briskly, producing instant inebriation. An aspiring swami in *Hamateur Night* (1938) confidentially thrusts swords into a basket containing an audience volunteer, then, after peeking into the ominously quiet receptacle, hands it gravely to the usher intoning "Give this gentleman his money back." In the midst of fully orchestrated and choreographed renditions of whatever Warner Brothers tune a particular Merrie Melodie was pushing, characters suddenly freeze into grotesque attitudes in Avery's early plays with the extreme "extremes" that were to become the hallmark of his work at M-G-M.

Avery's films at Warners were generally structured around parody of an existing film or cartoon genre, the impact of his gags tending to explode the fundamental assumptions underlying these genres. Thus the "documentaries," a series Avery invented at Warners, composed of spot gags gathered under a mock-monolithic "subject" and glued together by an omniscient, paternalistic narrator, targeted a simplified condensed world of analogy that, under the guise of education, unifies all things under the sun until the unknown becomes an exploitable variation on the known. Avery short-circuits the deadening "everything's-basically-the-same-as-us-but-not-as-good" effect of such analogy by blatantly literalizing the implicit equation (whether between animals and humans or America and other cultures): a shapely female lizard in *Cross-Country Detours* (1940) sheds her skin—peeling it off slowly in time to slinky striptease music; by sudden reversals: one of the "primitive" inhabitants of *The Isle of Pingo Pongo* (1938) turns to snap

a picture of the condescension-oozing narrator; or analogy-stretching word association: a frog croaks—by blowing its brains out with a revolver, destroying in the process that basic belief of the documentary that "seeing is believing." Voice-over narration's overly patient, overly "bright" tone, generally reserved for madmen, morons, children, and documentary film audiences, also affords Avery some great narrator/audience gags, including mad, unreadable diagrams "explaining" football formations (*Screwball Football* [1939]), a patently nonexistent optical illusion, in proof of which the audience is told to close one eye (half the screen blacked out), then the other (all black), and admonished "no peeking" as a slit opens on the screen (*Believe It or Else*), and the cap-off in *Cross-Country Detours* a split screen, on one side "for the adults" a horrible gila monster and, on the other, "for the kiddies," a recitation by Shirley Temple of "Mary Had a Little Lamb," until Shirley, demolishing the split-screen line, frightens the gila monster away.

Heroes and Other Walk-Ons

In *Hamateur Night,* Egghead, who has sporadically interrupted the scheduled acts with his unsolicited renditions of "She'll Be Comin' Round the Mountain," is awarded the prize by popular acclaim—cut to an audience composed of hundreds of frantically cheering Eggheads, one of Avery's many evocations of the nightmare of conformity and a fair indication of his assessment of his audience and their need for identification.

It is this need that Avery consistently refused to satisfy (although coming close enough to spawn the two greatest Warners stars, Bugs Bunny and Daffy Duck), choosing instead to put into question the very idea of a hero. In *The Village Smithy* (1936) the narrator (reputedly and significantly the first offscreen narrator in cartoon history) interrupts his out-of-sync rendition of the Longfellow poem to introduce, for a split second, "our hero—Porky Pig." In *Little Red Walking Hood* (1937) Egghead appears unexplainedly in the goshdurndest places, whistling a tune and toting a violin case, and when finally challenged by the legit cast, "Who the heck *are* you anyway?," replies, "I'm the hero in this picture," extracting a mallet from his case and clobbering the villain.

For it was particularly the popularized fairy tale, with its whole apparatus for suspension of disbelief in a self-enclosed, coded never-never land, the innocuous "children's world" of boxed-off fantasy, replete with hero, villain, damsel in distress, local color, happy ending, and sugar-coated moral, minus only the sexual terror, death, and repressed fears of the original, that inspired Avery's most elaborate audience rug-pullers. A split-screen phone call from Red Riding Hood to Goldilocks warning of the Wolf's imminent arrival (*A Bear's Tale* [1940]), a Grandma/Wolf chase interrupted by a telephoned grocery list ("one dozen eggs, a pound of butter, a head of lettuce, and a pint of gin") in *Little Red Walking Hood,* giant flashing neon signs, a drunk fairy godmother delivered in a police van, trumpeting royal pages breaking into a rousing chorus of "She'll Be Comin' Round the Mountain" (*Cinderella Meets Fella* [1938]) are but a few of the little context-destroyers Avery introduced at Warners and continued at M-G-M. In *Who Killed Who* (1943) the victim, so designated by a large neon sign on the back

of his chair, is discovered reading a book titled *Who Killed Who—From the Cartoon of the Same Name.* Characters pause to comment on the action: "Do these things happen to you girls out there?" "I do things like this to him all through the picture." "Heh, kissed a cow." "I like this ending. It's silly." A seemingly endless series of identical tied-up butlers topple out of a closet like a riffled deck of cards in *Who Killed Who,* one pausing long enough to comment, "Ah yes, quite a bunch of us, isn't it?"

Even corny, forced gags, fully admitting their compulsive nature, become funny in the teller's relation to it (in *Land of the Midnight Fun* [1939] a timber wolf alternately cries "Timber" and cracks up at the idea, knowing full well the joke's on the audience), or in the complicity they create with the audience (a skunk in *Porky's Preview* [1941], asked for a five-cent admission, replies, "I only have one [s]cent," turning to the audience with a winked "get it?"). Little signs spring up commenting "Corny gag, ain't it?," or "Monotonous, isn't it?"

"Hey You, in the Third Row!"

For Avery never lets his audience forget they are watching a cartoon, filling his films with cartoon-reality jokes, even portraying the audience in the film. Shadow figures of audience members play prominent roles in the action, creating cartoons-within-cartoons (one audience member turns informer in *Thugs with Dirty Mugs* [1939]), blurring all frame-line distinctions (Prince Charming has no sooner found Cinderella's note informing she has gone to see a movie in *Cinderella Meets Fella,* than she calls out, "Yoo hoo, here I am in the tenth row," and her shadow figure makes its way through the audience to join him on the screen). Bugs Bunny comes out to read the title credits of *Tortoise Beats Hare* (1941), a false-start opener Avery was to use repeatedly at M-G-M. *Swingshift Cinderella* (1945) begins with the wolf chasing Red Riding Hood through the woods and past the credits before they realize they're in the wrong cartoon. A quarter of the way through *Batty Baseball* (1944) one player stops the action, demanding the M-G-M lion and opening credits, which haven't yet appeared. The cartoon-reality gags became wilder and wilder at M-G-M, as characters race past sprocket holes into a white void, cross a Technicolor line into black and white, or reach down to pluck out an animated projection hair.

"Look Fellas—I'm Dancing"

The most disorienting and absurdist gags in a Warners Avery still refer mainly to the fun of cartooning, a fun the audience is invited to share fully, in heightened consciousness of the possibilities of an ever-changing perspective. The increasing abstraction and plays with means of representation permit a liberation from the enclosure of believability and a delight in the process of animation, movement, change. Yet it seems obvious, at least in hindsight, that by 1940 Avery was beginning to chafe a bit at the strictures imposed by the Merrie Melodies format and the childlike circle-upon-circle character design that persisted (with notable ex-

ceptions, chief among them Avery's invention of and design for Bugs Bunny) into the early 1940s. Avery's last Porky pic, *Porky's Preview,* a hilariously ingenuous cartoon-within-a-cartoon, constitutes both a loving parody of a Merrie Melodie and a celebration of the wondrous possibilities of animating any design, no matter how rudimentary. It is a magnificently animated film, for all its deliberately "crudely drawn" stick figures, childish inverted lettering, mock-primitive sloppiness (a train with infinitely expandable wheels zips up and down mountains and past a THE END sign, no end to this frame line), overly visible process of production (a riotously forced-sync Mexican dancer, frozen until the music starts, animated, crossed-out, reanimated, recrossed-out and, when choreographic ingenuity runs dry, is whirled weightless through the air in time to the circular beat), Grand Finale of "September in the Rain" with a rain cloud that rushes back on cue, and fully justifies the obvious pride of its creator, Porky Pig (whose cross-eyed self-portrait labeled "me" frequently appears alongside a matching approximation of the audience ticketed "you"), who explains modestly, "Shucks, it wasn't hard 'cause I'm an artist."

The Shield and the Lion

This is not to say that cartooning ceased to be fun when Avery moved to M-G-M in 1942, or that the cartoons he made there are any less funny. Quite the contrary. But they are far more disturbing, more manic, the world they portray is increasingly fragmented, as indeed was the world after the war. If the Warners films continually reintroduced elements incongruous to the repressive enclosure of "suspension of disbelief," bringing the audience in on the joke, never letting it evade the freedom of consciousness, the M-G-Mers unleashed repressed psychic processes upon an audience subjected to the runaway logic of obsession, with only the painful distance of absurdity as guarantee of sanity. It is at M-G-M that Avery joins such live-action directors as Buñuel, Rossellini, Fuller, and Godard in the elaboration of a modernist film vocabulary, disjointing narrative linearity, isolating libidinal forces, dislocating sound and image, piling up the excesses of multi-layered contradiction, de-normalizing the whole process of linkage articulating the absurdities of Our Daily Lives.

Two developments, the breathless acceleration of the gags and a new control of extremes,[1] both made possible by an increased flexibility in character design and animation technique, marked Avery's work with his new unit at M-G-M (in-

[1] Disney was the first to divide the work of animation into "extremes," drawings of poses or attitudes of the characters, to be executed by the animators, and "in-between," the intermediary drawings of the movements leading from one extreme to the other, to be executed, not very surprisingly, by the in-betweeners. This distinction is a very hairy one, because the division into extremes and the division of labor vary greatly according to animator, director, studio, and individual cartoon. Disney's animation style tended to erase any visual distinction between drawings, giving the illusion of a smooth continuous movement. Avery and Jones, on the other hand, tended to emphasize extremes and make them stand out sharply, introducing a radical discontinuity in the visible process of production and allowing the audience to experience movement and change as an open process rather than as an irreversible organic becoming.

cluding such veteran animators as Ray Abrams, Irv Spence, Preston Blair, and Ed Love), allowing him to explore areas only hinted at in the Warners films (although Warners itself was to undergo a parallel development in animation style and technique at about the same time). The speeding up of the pace not only altered the relationship of the audience to the cartoon but also allowed Avery to experiment with new narrative structures more dependent upon complex rhythmic forces than plays with given formats. The emphasis on the extremes underscored the dialectic of process, the stop-and-go rejection of alternatives implicit in the very violence of the one "chosen." The impact of Avery's extremes is perhaps most visible in his celebrated "takes"—bodies that break apart like a mad contradictory gaggle of exclamation points or zip out limb by limb, jaws that drop open to the floor in shock, necks that sprout multiple hydra-heads of surprise, tongues that jaggedly vibrate in horror or infinitely expand in desperation, eyes that grow to the size of millstones or spring out of their sockets or multiply to form sets popping out in rows toward their object of lust or terror.

Avery's "extreme" animation, with its jolting juxtapositions and violent fragmentation, is very different not only from the "natural continuous order of things" of a Disney cartoon, but also from the unconscious dream flow of what Greg Ford calls the "mindscape" of a Clampett cartoon. Rather than defiantly flaunting taboo in the exuberant ego defiance of the adolescent, for whom anything is madly, wonderfully, and unthinkingly possible (Clampett), Avery's films, like those of Buñuel, present every form of madness with hallucinatory clarity and analytic distance, tracing the absurd and tragic forces of repression and the fullscale marine-landing return of the repressed, and exposing in the process the logic of that ganglion of enforced obsessive compulsions labeled "normal behavior."

Yet there seems to be little in the Avery M-G-M cartoons that is not already present in the Warners cartoons—but now sped up, pushed to excess, and very differently structured. A comparison between Avery's Bugs Bunny series at Warners and Screwy Squirrel series at M-G-M is a case in point. The Bugs Bunnys were part of a hunting format Avery developed at Warners, structured around the mind games perpetrated on a dumb hunter by his vastly intellectually superior prey. (Avery had an undying love for not-so-bright characters, often giving them his own "duh" voice.) The beautifully balanced exchange between the amused, highly conscious "underdog," constantly, effortlessly, and artistically reversing the situation, and genuinely grateful to his pursuer for the never-fail fallguy setups (witness the soon-to-be-classic smacking kisses Bugs bestows on Elmer in *A Wild Hare* [1940], the first true BB cartoon) and the stuck-in-his-role-playing hunter, so programmed that nothing passes through his brain and totally devoid of all sense of proportion or humor, was to lay the groundwork for countless later smart-aleck/dumb patsy Warners cartoon showdowns.

Avery himself was to cast various characters in these roles, but in Bugs and Bugs alone was Avery to create a character whose grace and charm were a gift to audience identification, whose energy could animate action, whose delight could spin gags. To a certain extent Screwy Squirrel was Avery's M-G-M equivalent to

a mischievous table-turning huntee. But where Avery's Bugs Bunny cartoons have a lyrical contemplative beauty (compare Bug's oft-repeated, traced, and re-traced mock death scene, graceful pirouettes, and supple carrot-feeling fingers in *A Wild Hare*), the Screwy Squirrels are rapid-fire cacophanic assaults on the audience. For Screwy, true to his name, is truly and certifiably insane, nutso, bonkers. His escape from the asylum in *Happy-Go-Nutty* (1944) is ample proof: sawing through the bars of an open cell door, he then compulsively climbs over a wide-open gate.

Heckling Hare (1941) features an extended falling sequence ending with the formerly terror-maddened duo Bugs Bunny and dumb dog matter-of-factly slapping on the brakes and screeching to a halt inches from the ground—fooled ya'. In *Happy-Go-Nutty,* when the dog is precipitated over a cliff by Screwy, the squirrel is waiting for him at the bottom, hawking an "extra" headlined "Dumb Dog Falls for Corny Old Gag" with a feature photo of the dog going over. The obvious exaggeration of the *Heckling Hare* fall and the reaction to it and the suddenly gained character and motor control at the end bespeak a joy in the possibilities of the situation exploited to the hilt by the characters as actors playing to and with an audience. The Screwy Squirrel gag, on the other hand, like so many of Avery's meta-gags, calls into question the provenance of the image, the whole relationship between an event and its recording, creating a stupefaction in the somehow duped audience not synonymous with its very real pleasure in the excellence and daring of the joke, and divorced from any surrogate figure to incarnate that pleasure. The speed of the gags in the Screwy cartoons is such as to astonish, bewilder, and generally disorient the audience, left far behind in the wake of the manic madcap.

A Wild Hare (1940). **Tex Avery may not have thought up Bugs Bunny, but he was the person most responsible for the character's evolution from primitiveness to sophistication. © Warner Bros., Inc.**

Whereas Bugs constantly defines the spirit and source of humor, shared with the audience and directed at some form of blindness, Screwy can refer only to the mad cartoonist in the sky: in *Happy-Go-Nutty* the characters rush into a very dark cave, sounds of crashing objects, and Screwy lights a match to tell the audience, "Sure was a great gag. Too bad you couldn't see it." While Warners, particularly in the brilliant films of Chuck Jones, was to develop Avery's Bugs and Daffy until their personalities could encompass, control, and structure all levels of action and meaning, Avery's characters at M-G-M become more and more visceral representations of abstract social and psychic forces beyond personality control.

Sign Language

In *Happy-Go-Nutty* the dog bags Screwy only to find another Screwy in front of him. Disgusted, he dumps the first Screwy out, picks up the second, and throws him in a bin marked For Extra Squirrels. The blatancy of the labeled garbage can, expressly there for the avowed absurdity of the gag, contrasts strangely with cartoon's usual inventive and unexpected use of available props or sudden intrusions of incongruous elements, allowing the audience no illusion of vicarious fantasy control over the image, which begins increasingly to write its own logic. Indeed, *Happy-Go-Nutty* is full of insolent objects, as solid and realistically drawn as they are alien to the landscape: an anvil outside the nuthouse walls, whose only purpose seems to be as a surface for Screwy to compulsively bang his head against; a ringing telephone in the middle of nowhere as setup for a vaudeville gag; a Coke

Tex Avery's Screwy Squirrel and the Dog in *Screwball Squirrel* (1944). © Metro-Goldwyn-Mayer, Inc.

vending machine to afford the pause that refreshes to hunter and hunted who drink, say a burp apiece, and continue. In *The Cat That Hated People* (1948) a cat on the moon is subjected to the surrealist logic of inexorable functionality as pairs of synthetically made-for-each-other objects (a scissors and a piece of paper, a tire and a nail, a lipstick and a giggling pair of lips) chase each other across the lunar landscape, playing out the Marxist nightmare of alienation. Together with the breakneck pace, the insistent physicality of objects enabled Avery to work out wildly elaborate violations of the time-space sense. *Droopy's Good Deed* (1951) features such a variation on a classic Avery paranoiac meta-gag: a good-for-nothing bulldog, in a murderous attempt to defeat Droopy, become the best Boy Scout, and meet the president (!), disguises himself as a woman, and stuffs several sticks of dynamite into a purse he ostentatiously drops in front of Droopy. He then jumps onto a cow, which gallops to an airplane, which speeds alongside a taxi, which instantly transports him to a building, the entire trip occurring in a matter of seconds, the vehicles becoming larger and larger in the frame, more and more instantaneous in their trajectory. But he has no sooner shut the door to his apartment, panting in exhaustion, than there is a knock at the door and there stands Droopy, who politely explains, "You dropped your purse ma'am," hands it to him, and departs, leaving the bulldog to gape in stupefaction at the purse, which then explodes in his face. But the real object lesson comes in *Bad Luck Blackie* (1949) in which a sadistic bulldog gets his comeuppance in the terrifying forms of larger and larger objects that materialize from nowhere to fall on the luckless beast. In the awesome overkill finale a kitchen sink, a bathtub, a piano, a steamroller, an airplane, a bus, and an ocean liner thud from the sky, one after another, one behind the other, pursuing the dog toward the receding horizon, like victims of some avenging God-made disaster.

The new drawing style at M-G-M made possible many such plays with varying forms of representation. But, increasingly, the cartoon image began to reflect a world composed of images, the representation of a world perceived through a barrage of multiple and conflicting forms of representation. *Blitz Wolf* (1942), the first and one of the greatest of the Avery M-G-Mers, casts the Disney Three Little Pigs in the role of defenders of a Free Pigmania, their old archenemy, the Big Bad Wolf, is fittingly slotted into the role of Hitler. *Blitz Wolf* is more than a film about the war, it is a film about the perception of the war back on the home front, a perception formed through representations, images, and words divorced from their unimaginable context. Thus everything is labeled and word-associatively activated: a scream bomb that screams; an incendiary bomb that gives Hitler a hotfoot; Hitler's tank, inscribed Der Fewer Der Better, and subtitled German dialogue; shells explode to form the words *BOOM* or *WHOOSH;* a labeled Tokyo sinks, rising sun and all, in a single frame to leave a boasting sign: Doolittle Dood It. Wild and wacky analogies measure both their distance from reality and their closeness to some inverted survival sanity: a Mechanized Huffer and Puffer blows the first pig's house down, leaving only a sign: Gone with the Wind, and another sign with an arrow sprouts up to comment, "Corny Gag, Ain't It?"; a screaming shell is halted inches from its target by a copy of *Esquire* held up

by Sergeant Pig; the shell retreats and returns with several of its whistling buddies, who then fall over in a dead swoon.

Narrative Frame-ups

Signs and labels of all description are but a part of the multilayered text that is an Avery cartoon, fragmenting the context, emphasizing the process of the gags, underscoring the director-audience complicity in awareness of the cartooniness of the cartoon. Live-action footage, magazine-ad drawings, and contrasts in proportion, texture, and drawing style were also extensively used by Avery. But unlike the disruptive use of such devices at Warners (as early as 1938 Daffy, in *Daffy Duck in Hollywood,* slaps together an amazing montage of live-action stock footage), at M-G-M these incongruities became the very stuff of the film, no longer disrupting a given format but creating its own. The incredible speed of the gags and the wide spectrum of representational styles allowed Avery to create totally new narrative structures, able to contain the most divergent shifts in texture and tone. While some cartoons (like the magnificently structured *Bad Luck Blackie,* considered by many to be Avery's masterpiece) perfectly orchestrate these divergences in a complex equilibrium of tensions within a more classical narrative framework, others seem to take off in all directions at once, held together by some self-generating centrifugal force.

Take, for instance, *The Shooting of Dan McGoo* (1945). The cartoon casts three Avery regulars, the Wolf and the sexy redheaded beauty of the fairy tales (see below) as villain and "gal named Lou," respectively, and Droopy, the sadsack basset hound, as hero, although, as in all the Droopy-Wolf cartoons, the Wolf steals the show with context-mastering lines like "What corny dialogue!" and wild and wolfy reactions to Red's explosive Preston Blair–animated number "Oh Wolfie." Lou's number (an incredibly sexy multiservice salute to our fighting boys out there), the Wolf's braying and howling reactions, and Droopy's unemotional wet-blanketing of the Wolf's overheated "takes" (rolling up and neatly tucking in the Wolf's length-of-the-table extended tongue, holding up a menu to block the latter's vision, through which the Wolf's eyes immediately burn two charred holes) form the core of the cartoon, while around it local color runs riot in fifty directions, each gag taking on a rhythm, visual style, and context all its own and, in its very separation, interreacting violently with everything around it. The camera pans past a bartender strategically stationed in front of a typical saloon cheesecake painting of a supine woman, only her head, shoulders, and legs visible, and returns for a better look. The bartender, crossing his arms, advises, "You might as well move on, I don't budge from here all through the picture." In the later free-for-all gun battle he does move, only to reveal a sign lamenting "I ain't got no body" where the rest of her should be. Whole gamuts of disparate graphic styles are incorporated into a single sequence: the Wolf orders a drink, cut to a close-up insert of gag-labeled bottles (4 Noses, with appropriate proboscis cluster); and when he drinks, pan to an Alka-Seltzer cutaway diagram of his stomach, where the drink as a rebounding fireball sends the whole Wolf, now totally transformed

into an abstract fiery comet, ricocheting around the ceiling beams; in the midst of a verbal altercation, the Wolf suddenly menaces Droopy with an enormous ten-foot penknife that materializes from thin air, its mock-phallic resonance underscored by the hot fanfare opening of Lou's act, which interrupts the action. The very air abounds in incongruities, including wild disparities in the level of gags: immediately following a particularly gruesome-grotesque introduction to the town (a sign reading Double Header Today—pan to two gallows with nooses, then pan further to a smaller gallows with sign: Kids 15¢), comes a typical Avery "funny-you-should-think-it's-funny" joke as anticlimactic mirror of the first: saloon doors over which a sign reads Beer and a pan to the right for a miniature set of matching doors labeled Short Beer.

Whatever narrative unity is provided by the voice-over intoning of Robert Service's overblown Yukon saga, of which the cartoon is supposedly an enactment, is undercut constantly by overliteralizations of the text (at the words "the drinks are on the house" everyone rushes out of the saloon to down a libation on the roof—*on* the house, get it?) or mock-fidelity to the plot (the "dramatic conclusion" unfolds in about three seconds, ridiculously and matter-of-factly sped up to be on cue with the text). Between the calling-the-shots narrator and Droopy's "explanatory" asides to the audience (along the disorienting lines of "Hello, you happy taxpayers"), which are more alienating than complicity-inducing or action-forwarding, the whole narrative races to its prewritten conclusion, cycloning along in its wake entire worlds of don't-quite-fit-in associations, in a perfectly controlled rhythmic chaos that only Avery could conceive and only Avery could execute.

Droopy

Droopy, Avery's nearest approximation to a "star" at M-G-M, a kind of ambulatory nonidentification principle, quite similar in that respect to Egghead, but unlike Egghead, an embodiment of a moral heroic code, was featured in most of Avery's later genre pics, mainly Westerns. Unlike the Warners costumers, structured around the multiform reactions of Bugs and Daffy to their eagerly assumed (Daffy) or philosophically accepted (Bugs) roles, Droopy is plopped down in a situation he neither fits nor interacts with, passively following the rules, while all attempts to defeat him backfire by the laws of that Divine Providence that always (if arbitrarily) protects the "good." A continual graphic and verbal understatement, he is set against a wonderfully overstated villain, the Wolf, who plays his part with all the orchestrated panache of a seasoned scene-stealing character actor. Droopy is usually cast as sheepherder or homesteader interloper, dogged, unconscious domesticating force of civilization (Droopy and his flock of sheep inexorably mowing a vast swath of locust-devastation through the Texas landscape of *Drag-Along Droopy* [1954]) against the I-took-this-land-from-the-Indians-so-don't-nobody-fence-me-in cattleman Wolf (taking off his hat reverently to his trusty gun, reluctantly shot to take it out of its wounded yelping misery, and intoning his oft-repeated credo, "It's the lawh a' the West," or gleefully chortling as he pumps a cow full of air until it floats gigantic and balloon-distended above the barn in *Home-*

steader Droopy [1954]). Droopy was also featured in a series of rivalry cartoons between 1949 and 1952, usually against a try-anything, bag-of-dirty-tricks bulldog named Spike. Although brilliantly animated, these situational duels (involving circus feats, Olympic games, bullfighting, and so forth) number among Avery's weaker efforts, the quid-pro-quo structure lending itself to more personality-directed animation, the enforced symmetry of the conception resisting Avery's more manic narrative buildup.

But Droopy perhaps worked best as foil to the Wolf's subjectivity in Avery's paranoia masterpieces, *Dumb Hounded* (1943) and *Northwest Hounded Police* (1946), where his inexplicable omnipresence perfectly embodies the inevitable futility of any endeavor at psychic breakout from obsession and the impersonal forces of understated repression lurking under every unturned stone. In *Northwest Hounded Police,* everywhere an escaped-convict Wolf goes in his increasingly desperate flight (in a nest atop a virtually unscalable promontory, underwater, behind fifteen locked multicolored and -form doors, on a deserted three-foot island), he finds Droopy already in occupancy (within an egg in the nest, in a school of passing fish, under a pebble-sized rock), finally reaching Dostoievskian proportions: the Wolf, attempting to get a new face from a plastic surgeon, has the bandages removed and gazes upon his new face in the proffered mirror—Droopy's. The Wolf's extreme reactions (a compendium of Avery's most memorable takes) paint a vivid picture of the violence of his realization that there is no escape (many of Avery's films portray imprisonment of one kind or another). The entire film has the logic of the unconscious: the Wolf's escape has the ease of a cartoon dream (he escapes by penciling in a door, then goes by the warden's office all the way around the doorframe—gravity inoperative), and his pursuit all the mounting relentless illogic of nightmare, until even the cartoon-reality gags share in the madness: the Wolf flees into a movie theatre only to see Droopy follow the M-G-M cartoon credits on screen. Yet it is also the logic of the fanaticism of the Mounties ("We aim to police" over their headquarters). The last shot of the cartoon is a revelation of both rampant paranoia and its very real basis (in a stacked deck of 1,000-to-1 odds): a corridor of multiple Droopys stretching to infinity. Avery perfectly understood the terrible impersonality of the heroic principle backed and justified by limitless forces of repression.

"Oh, Wolfie!"

If Avery declined to create heroes with whom his audience could identify, the Wolf could be rather cornily said to represent "the animal in all of us," with a relish and visual pizzazz few audiences, alas, can equal, unequipped as they are with yo-yo eyes and regenerative limbs. For in all the Wolf/Red films, the Wolf is, above all, an audience. Sex enters Avery's M-G-M films as a reciprocal act, a duo between performer and audience, a perpetual cycle of temptation and frustration. At the same time it is a double act: the Wolf's feverish takes (magnificently conscious choreographed celebrations of the wild and wondrous id) supplying perfect counterpoint to Red's smooth and silky come-ons. Thus Red, as Little Eva (*Uncle*

Tom's Cabana [1947]), suggestively demure in a low-cut Southern belle ball gown with matching parasol, yearns with velvet voice for someone to carry her back to Ole Virginny, while Simon Legree (a barely human version of the Wolf), all controls spinning madly, compulsively and blindly runs the gamut of time-honored sex substitutes: in his sexual insanity, Legree unwittingly smokes his own nose, stubbing it out in an ashtray, "celeries" the saltcellar and munches on it (his teeth dropping out into a convenient butter dish), slices himself a wedge of table and chomps away, butters his hands and devours them up to the elbow, and gallops off with the middle chunk of a stage-prop Colonial pillar in his arms, instead of the redhaired plantation belle, Little Eva.

To what extent it is all an act, extending beyond and through the characters, a series of movie-imitative roles the characters eagerly, if naïvely, assume to disguise their rural origins and create a social persona to impress each other and themselves, can be measured by the rapid metamorphoses these characters can undergo: in *Red Hot Riding Hood* (1943), Avery's first M-G-M foray to grandma's house, Red's torchy rendition of "Daddy I Want a Diamond Ring" encompasses within the continuum of sheer provocativeness an amazing variety of tones, simultaneously funny and sexy, from a raucous "Hey Paw" to an imperious "Fahther" to a mock childish-awkward knock-kneed "Daaaddy." In the tête-à-tête that follows Red's number the Wolf shifts from crude familiarity when talking about Red's grandmother ("forget the old bag") to suave French-accented persuasion ("Come with me to zee Casbah"), to hillbilly guffaw ("What's yer answer to that, babe?") with lightning speed, while Red caps her refined-affected Katharine Hepburn disclaimers with a bellowed No loud enough to knock the Wolf clear across the room.

The Wolf and Red in *Wild and Woolfy* (1945). © Metro-Goldwyn-Mayer, Inc.

But it is above all as a force that sex invades Avery's cartoons, a blind energy oblivious to all physical laws—until it rushes headlong into intersubjectivity, in the form of conflicting desire or active repression. The aggressor, hot on the trail of the sexual object, suddenly finds himself the object of another's sexual aggression: the Wolf no sooner embarks on his pursuit of Red (*Red Hot Riding Hood*) than he encounters her overlibidinous grandmother or (in *Swingshift Cinderella* [1945]) her martini-swigging fairy godmother—and the chase is on. It is this sexual drive that structures the films, from the frenzied stasis of act/audience crosscutting (more complex in cartoons like *Swingshift Cinderella, The Shooting of Dan McGoo,* and *Little Rural Riding Hood* [1949], where a "third," repressive element constantly intrudes, with mallet, baseball bat, or ball and chain, in repeated attempts to squelch the Wolf's undying lust) to the express-train propulsion of the steeplechase pursuit. The nonstop rhythm (the Wolf and fairy godmother whizzing around the walls in *Swingshift Cinderella* or through a dizzying and constantly displaced series of trapdoors in *Little Rural Riding Hood*) slackens somewhat (the Wolf flings open a door and dashes into the brick wall it opens out on, the camera holding on the sign affixed to the bricks: Imagine that, no door!) or screeches to a halt for a momentary pause (the Wolf lovingly contemplating the hatpin he is about to jab into grandmother's temptingly presented posterior), only to take off again with renewed vigor.

Nor is the sexual drive isolated: sexual teasers crop up continually in Avery's films to further or divert other obsessive drives. *Uncle Tom's Cabana* throws a new twist into the sex-money nexus: Simon Legree, absconding with the cash register under his coat, catches sight of Little Eva and rings up a whopping erection, the cash drawer suddenly springing from his pelvis. Nor is the sexual structure always explicit: Uncle Tom, prevented by age, race, and Harriet Beecher Stowe from having other than paternalistic interest in Little Eva, voice-over narrates himself into rather ambiguous sexual relation to Simon Legree—cast alternately as Superman (repelling machine-gun bullets with his ill-fitting costume) and victim of escalating Legree-propelled forces (camels, elephants, battleships, and steamrollers), sometimes even in situations generally reserved for the damsel in distress (tied to a floating log about to pass through a whirring saw, lashed to railroad tracks), until, in the phallic finale, he tosses the Umpire State building with Simon Legree on top over the moon.

The Nature of Force and the Force of Nature

Sex is not the only drive that structures Avery's cartoons. In *King-Sized Canary* (1947), what starts as a scrawny alley cat's desperate ransacking search for food (in a comfortable, if foodless, suburban household) rapidly escalates, with the help of a little bottle of Jumbo Gro, into a runaway power struggle, as first a canary, then a cat, then a dog, and then a mouse drink and grow to larger and larger proportions, the suburban-dwelling canary and dog quickly dropping out of the action as the initial survival impetus reasserts itself. The enormous distended bodies of the characters, with their tiny heads and hands and giant swollen bellies, give a peculiar edge to the inexorable Hegelian duality of postwar realpolitik that destroys the initial class solidarity between suburbia-excluded lower-class cat and

mouse (mouse to cat: "You can't eat me—I seen this picture before, and before it's over I save your life"). This solidarity is at least momentarily regained as the cartoon ends when the gargantuan cat and mouse, barely able to straddle the much smaller globe of Earth, arms around each other, wave to the audience, having explained "Ladies and Gentlemen, we're going to have to end this picture. We just ran out of the stuff."

If many Avery cartoons follow the manic rhythm of mounting obsessive forces (the brilliantly animated *Slap-Happy Lion* [1947] equaling *Northwest Hounded Police* in that respect), many, like *Lucky Ducky* (1948) and *Half-Pint Pygmy* (1948), possess a curious contemplative beauty, even within as linear a structure as the chase, as they trace the process of that other great force—nature. *Lucky Ducky* follows with detached fascination the extended pursuit by a duo of hunters in a boat (George, short and irascible, and Junior, large and very dumb, two Avery regulars) of a small new-hatched duck with the face of an ingenue (coyly stripteasing out of its shell), the mechanical staccato laugh of a toy devil, and the superhuman strength (picking up the large boat as if it were a feather and batting it all over the horizon) of a force of nature, which indeed he is (the cartoon ends with the integration of this newest member into the indigenous community of ducks as they conga-line their defiant ring around the after-hunting-hours impotent hunters). Unlike the manic cartoons, which create a paranoid homogeneity through extreme subjectivity (everything is part of the same nightmare), the contemplative cartoons, through a total lack of structuring subjective consciousness, create a phenomenological homogeneity where everything in the frame, be it anthropomorphic, mechanical, or natural, is an interchangeable part of the same impersonal process: Junior starts the boat by absent-mindedly wrapping the starter cord around George's head and pulling, which whirls George's head around and somehow makes ignition contact simultaneously; the duck confronts George's rifle with an African mask, whereby the rifle screams horribly, tongue protruding, and shrinks to the size of a toy, disgorging its bullets; a mother tree snatches its baby from the path of the oncoming boat in a Disney-like shot that is held for a disconcertingly un-Disneyish length of time in a long, calm, empty aftermath of action.

The shattering of the illusion of control (over oneself, others, or nature), which almost all Avery's films are about, creates less anxiety in the nature films (probably because it carries no subjective weight at all) than a vague feeling of malaise, mitigated by an enjoyment of the free play of totally unhierarchical, unsubjective forms. A long lyrical sequence traces the progress of a coconut launched by a pygmy George and Junior are chasing in *Half-Pint Pygmy*. The cannonball coconut first knocks out George, then Junior, lands on a zebra whose stripes fall like steel bands, strikes an ostrich, causing his head in the sand to pop out of a further hole, flies into one kangaroo's pouch and out another's, makes a leopard's spots drop like poker chips, knocks a turtle out of its shell, bonks a giraffe on the noggin, causing his neck to contract while that of an adjacent hippo expands, squelches a long-legged crane, flies over two goalposts to loud cheers,

shatters a rhino's armor plate to expose a dessicated body underneath, inverts the humps on a camel, and finally backfires to lay out the pygmy who started the whole thing.

Animation of Tomorrow

In the 1950s, as the animation became more limited, the drawing style more streamlined, and the perspective flattened out, Avery's cartoons began to be more formally structured around spatial ideas already operative in his earlier films. There are myriad magical gags concerning a mysterious third dimension that opens somewhere within the very two-dimensional surface, so that a train can disappear into a house and reappear coming out of a nearby barn, a moose can run into a barn, the barn door can be folded up very small and tossed aside, whereupon it unfolds into a trapdoor and out charges the moose (*Homesteader Droopy*). *Rock-a-Bye Bear* (1952) and *Deputy Droopy* (1955, codirected with Michael Lah, Avery's major animator in the 1950s) are foreground/background exercises in spatial compulsion, as characters, working in a space where they cannot make a noise and continually besieged and goaded to utterance, must rush themselves or (when bodily trapped) each other's disembodied heads or screams-in-a-bottle to a neighboring knoll, there to give voice to their pain. *Flea Circus* (1954) explores the relationship of long shot to close-up in tracing the stage and private lives of a company of performing fleas.

Within a revised spot-gag structure, *TV of Tomorrow* (1953) uses a frame-within-a-frame setup to depict the take-over of the suburban household by a small box and the reciprocal smaller-than-life domestication of the image. The jarring implications of television's insidious replacement of direct experience and total integration of technology into the home are highlighted in a contract bridge set featuring a live-action black-and-white TV "fourth," who deals cards directly from the screen to an animated, colorful cardplaying threesome in a brilliantly drawn and coordinated sequence. But the confusion of inner and outer, of the unlimited fantasy power of the image and the packaged enclosure of the box-as-possession (an age-old sexual problem given new impetus by the overweening voyeurism of sex through technology) is most explicit in Avery's lineup of boob tubes, including a keyhole-shaped set for peeping toms, a slot-machine model "for those who like to gamble on their channel," which rolls first the beautiful head and arms, then the lovely legs of a woman, only to turn up a lemon in the center, and a new low of displaced sexual drive: a TV set with a deeply plunging, lace-trimmed neckline.

More formal narrative structures began to succeed the more associative, all-inclusive, textually richer films of the 1940s, abstracting still further the drives and compulsions of the characters, themselves more one-dimensional, as the 1950s nightmare of dehumanizing mechanization, embodied in the movements of limited animation, invaded the screen. Avery inaugurated a whole series of cartoons at M-G-M structured around single, non-narrative repetition-compulsion situations. In *Billy Boy* (1954) the goat of the title eats everything in sight and, rocketed

to the moon in a desperate attempt to end its ravaging destruction, eats that too; the film ends before we can discover what's next on the menu. *Cock-a-Doodle Dog* (1951), one of Avery's many cartoons about induced insomnia, is the sad tale of a sleep-craving bulldog haunted by a scrawny, half-dead rooster, who is driven by some obscure ineluctable need to crow over and over again, undaunted by all attempts to silence or murder him, like some recurring nightmare, and a horrible, neck-wringing rasping mechanical screech it is. The cartoon ends with the bulldog, now completely insane, crowing compulsively. Madness is also the fate of the little bongo player, Mr. Twiddle, nerves frayed to a frazzle by raucous music, who seeks silence at Hush-Hush Lodge in *Sh-h-h-h* (1955), Avery's last cartoon, but meets instead the steady inexorable sound of a wah-wah trombone and a woman giggling inanely in an otherwise totally silent void.

As Avery moved toward more limited animation, his cartoons began to reflect the knee-jerk reflexes of the bourgeoisie, the relatively innocent movie-imitation role-playing of the basically lower-class characters of the fairy tales giving way to the empty mechanisms of socially determined compulsions (as the scrawny alley cats of the 1940s give way to the back-stabbing, get-to-the-top bulldogs of the 1950s). Clothes make the man in *Magical Maestro* (1952), where at each flick of an avenging magician's wand an opera singer flashes without warning from one outlandish costume to another, with vocal accompaniment, gestures, and miscellaneous materializing rabbits to match, from tuxedoed high opera to skipping sailor-suited little boy to tutued ballerina to fruit-saladed Carmen Miranda. *Cellbound* (1955) explores the dilemma of an escaping convict trapped in the warden's television set and forced to play all the roles on all the channels. The frantic activity of the convict (portraying hero, villain, and girl in a Western, knocking himself out in a prizefight, playing all the instruments in a dixieland band and, finally, acting out his own insanity) contrasts chillingly with the very limited animation of the warden, whose occasional departures from wound-up automaton are switched off suddenly to return to dour normality. *The Crazy Mixed-Up Pup* (1955), perhaps the most imaginative of the four films Avery directed at the end of his career for Universal, exploits limited animation to emphasize and reinterpret the cartoon's tendency to de-humanize the human and humanize the de-human. A cross-eyed mix-up with blood plasma causes a reversal of the master/slave dialectic worthy of Buñuel, contrasting the vitality of the hip lower classes with the push-button mentality of the square, flag-sprouting bourgeoisie. The humdrum, paper/slippers routine of lifeless middle-class suburbia is laid bare by two complexly interwoven simultaneous intrusions: the sudden anthropomorphism of the pet dog who comes on with the suave sexual assurance of a Humphrey Bogart on this sterile "Father Knows Best" set; and the out-of-control mechanisms of long-repressed animal instincts in suddenly dog-ized people.

It is somewhat ironic that the one full-animation director who could brilliantly redefine his praxis to fit the possibilities of limited animation (already experimenting in the form in 1951 in the hilarious literalizations of idioms of *Symphony in Slang* before it became the order of the day by the mid-1950s) should choose, despite continued offers, to continue in the medium only in the limited

form of TV commercials, although Avery's Raid commercials are masterpieces of the genre and have had no small influence on commercial animation.

Epilogue

It would hardly be an exaggeration to say that Avery's was probably the greatest post-Disney influence on studio cartoons. In the fertile cross-pollination of animation, where what one director innovated, another incorporated and transformed in an endless creative cycle, it is often difficult to pinpoint influence. Yet Avery's effect on the cartoon was all-pervasive, accelerating the pace (the difference between pre- and post-Avery timing is extraordinary), enlarging the cartoon vocabulary (giving more scope and heterogeneity to the levels of gags), and emphasizing the importance of more visible extremes, to name only the most obvious. Myriad Avery gags and narrative structures reappear time and time again in others' cartoons: Avery's magnificent takes were incorporated with varying levels of success into an incredible diversity of cartoon characters and animation styles. Avery's contribution to animation is inestimable, his 130-odd films, many of them among the greatest cartoons ever made, brought to the cartoon and to its audience an analytic consciousness matched only by an accompanying mad, free-associative liberation of the unconscious, the aspiration of the Surrealists that so few of them could realize. An Avery cartoon is a series of shocks: the reversal of patterned expectations, revealing the possibility of change and the forces that resist it; the creation of new connections and the destruction of the physical, moral, and psychological iron links between cause and effect; the redefinition of psychological time and space; nongags, exposing the gag itself as a form of compulsion; meta-gags, bringing the process of production into the cartoon. Avery's cartoons stretched the possibilities of the medium so far that, although few followed him all the way, the cartoon was just never the same again.

Chuck Jones
Interviewed
by JOE ADAMSON

Blend the racy wit of the Tex Avery school at Warner Brothers with the subtle three-dimensional characterizations of Disney with the modernist stylized drawings of UPA, and we are on the way, but only on the way, to characterizing the Chuck Jones cartoon. There remains the strange philosophical outlook, borrowed liberally from such favorite Jones sources as Joyce's Ulysses *and Sartre's* No Exit, *to account for. And there is the sheer indescribable joy found in magnificent cartooning art.*

 The best "introduction" to Jones is found in his colorful and thoughtful interviews: a classic discussion with Richard Thompson and Greg Ford for the special 1975 animation issue of Film Comment; *a long-ago dialogue in the French magazine* Positif *with Robert Benayoun, translated into English for the Spring 1969* Cinema Journal; *a talk with Mike Barrier for* Funnyworld; *and this interview below with Joe Adamson for the American Film Institute, which has never before been published.*

JOE ADAMSON: Did you dream of going into animation?

CHUCK JONES: When I was a kid I knew the Keystone Cops because they used to come shoot in front of our house on Sunset Boulevard. I wanted to be one of those characters, but by the time I grew up, they were gone. My father was in despair because there was nothing I could do properly; but because I could draw a little he sent me along with my sisters to Chouinard Art Institute, then the top supplier of animators to the industry. So I just fell into animation; it was the only field in which I could get a job.

 I went to work with Ub Iwerks when he was away from Disney's, on the Flip the Frog series. He was a brilliant animator and a fantastic technician, and a very bad storyman. I washed cels and inked things—everybody started that way—and I became an "in-betweener," and then slid gradually into animating.

 After being with Ub for a while, I worked a few weeks with Charlie Mintz, under George Winkler, and then I went to Universal and worked for Walter Lantz. I had much more variety in the first year than I had later on. Then I went back to Ub Iwerks when he was in Beverly Hills, and my wife, Ub's secretary, was ordered to fire me. Then I went on a cruise for three months and I was

shipwrecked—which gave me all the romance I needed. So I came back and sat on Olivera Street drawing caricatures.

JA: How well did you draw?

CJ: I guess I was prolific, but I didn't draw very well. Pretty crude, compared with people like Bob Givens, Norm Ferguson, Freddy Moore. I realized when I was much older that I had to do an awful lot of schooling, so I went to Don Graham's class at Disney's. I spent about ten years at nights working to develop my serious drawing.

JA: How much responsibility does the animator have for the action that is finally seen on the screen?

CJ: The animator has the same responsibility a fine actor has. Peter Sellers, for instance, is extremely versatile and can move in any direction. My animator, Ken Harris, can do the same thing. He is an *animator*—not a graphic artist. And there is a difference. Even people who write about animation don't seem to understand that when you have a drawing of a character, you don't have a character. This is the first Bugs Bunny model sheet. Notice that it says *"Bugs'* Bunny"—possessive. The name Bugs came from Bugs Hardaway, who we can safely say did the first Bugs Bunny who was called Bugs Bunny. But saying "This is the first Bugs Bunny" has no meaning. What is important is how Bugs came to stand and move and act, and what his feelings are, and his thoughts, and what kind of personality he is. That *developed* over a period of time.

Chuck Jones continued to develop Bugs Bunny after Tex Avery and Bob Clampett had departed from Warners. © Warner Bros., Inc.

JA: When you handle a character and somebody else handles the same character, there is a distinct difference in the personality.

CJ: Well, my Bugs Bunny was actually quite different from Friz Freleng's. Maybe his cartoons were funnier; and when you think of *Sahara Hare* [1955] and his others, they were more physical, with things happening quickly. Bugs would cleverly do something at the last moment. My Bugs, I think, tended to think out his problems and solve them intellectually, and I insisted upon stronger provocation. Two or three things would happen before he got mad enough—no, he wasn't mad, just the logic would move in—and he'd say, "Of course, you realize this means war." This is not a pugnacious statement, it's a logical statement. Von Clausewitz said that war is politics carried a step further. At that point I would say, "OK, hostilities start *here*." You couldn't get rid of Bugs then. He was willing to engage in danger, but only because he was put upon.

Bugs is a counterrevolutionary, you know. He's not a revolutionary. He's not a Woody Woodpecker, which is how Bob Clampett used him. Clampett's Bugs Bunny did not involve the disciplines that we would put in.

JA: In *Claws for Alarm* [1955] and *Jumpin' Jupiter* [1955] you also modified Sylvester's character. Freleng always put him in the role of the evil cat.

CJ: Friz used him quite differently. I used Sylvester as a sympathetic character and usually he was with Porky and knew what was going on. Porky never knew what the hell was happening and kept picking on Sylvester, who was trying to protect him. I don't think you can make comedy unless you're involved with the characters. It has never occurred to me that these were not living things.

JA: Are your characters autobiographical?

CJ: I think any caricature worth getting involved in must represent the bombastic side, or the innocent side, or the evil side, or the ineffectual side of your own character. I love the Father Bear in the Three Bears cartoons because he represents a part of my character. In *The Dot and the Line* [1965] I associated completely with the line!

Pepe Le Pew was everything I wanted to be romantically. Not only was he quite sure of himself but it never occurred to him that anything was wrong with him. I always felt that there must be great areas of me that were repugnant to girls, and Pepe was quite the opposite of that.

And Bugs, of course, is based on many things, but one of them is the idea of how wonderful it would be to be a super-rabbit, which is really what he is.

JA: And Daffy?

CJ: What you do is multiply your weaknesses, I guess, in a character like Daffy Duck. I had no problem with him after I began to understand what he was all about. My Daffy and Friz's are a little different. Friz was the one, you might say, who kind of got him into that cowardly self-preservation. The minute he did it, I understood; I knew how I'd feel. It's the awfulness, when you're on the battlefield, of realizing that when your buddy is shot that your basic feeling is one of relief that it wasn't *you*. Right? Well, Daffy says that. He says, "I may be a mean little duck, but I'm an alive little duck." And when he gave Bugs up to the Abomi-

nable Snowman, he said, "I know ith a dethpicable thing to do, but I'm different from other people: pain *hurts* me." I was just getting hold of Daffy when the damn studio shut down. I love Daffy. He's a marvelous, marvelous character.

Daffy Duck was like Lew Ayres, who got so involved making the Dr. Kildare films just before the war that he actually volunteered for the Medical Corps. In *The Scarlet Pumpernickel* [1950], when Daffy's trying to convince J. L. Warner that a great script is perfect for him, I'm sure that he thought that everything in there was possible, that he was Super-Duck, or whatever.

We're basically working in terms of human dignity, which is true of Daffy, or the Coyote or any of the others. *Robin Hood Daffy* [1958] is one of the best parodies I ever worked on. Daffy is Robin Hood but Porky won't believe that because Daffy is such an idiot, running into trees and doing all kinds of things Robin Hood obviously wouldn't do. Daffy is not trying to achieve anything except to get Porky to believe he's Robin Hood. That's a natural thing. We can stand either love or hate but it's impossible to survive continuing indifference because it is humiliating. The preservation of [Daffy's] dignity depends on the avoidance of humiliation. And when the Coyote falls, he gets up and brushes himself off in an attempt to preserve his dignity. It worries him when he ends up looking like an accordion. A coyote may not be much, but it's better than an accordion. And the director must believe that too; you can't just make a thing, you've got to really be involved in it.

JA: How does Porky fit in to this?

CJ: When we first started him, Porky was a Boy Scout kind of character. But in *Rocket Squad* [1956] and *Robin Hood Daffy* and in some of those others at the very end, Porky was beginning to develop into something interesting. I always felt that Porky Pig was the most subtle of all the characters because he was consciously playing a part. He was obviously putting Daffy on, but it was a very subtle thing. In *Duck Dodgers in the 24½ Century* [1953] he was playing the space cadet, but he was "playing" it.

JA: You have said that you never understood Tom and Jerry at M-G-M.

CJ: Well, I didn't understand them the way Bill Hanna and Joe Barbera did. They used a kind of violence which I seldom used, and if I did use it, it was a mistake and I regretted it. They would have an ax come down and take off all the fur on Tom's back and tail. In their golfing film the ball hit Tom in the teeth and left a hole there, and then the teeth fell out. That kind of thing, to me, is much more hurtful than somebody falling off a cliff.

I tried to make them like Bill and Joe, but it didn't work, so I just kind of changed the characters to fit my own way of thinking. So mine were, I'd say, much gentler than theirs, and probably not as funny.

JA: What about the differences in the characterizations?

CJ: I thought they did a smashing job on Jerry. I was never able to give him as much character. I probably got more human a personality out of Tom than they did, but not the same character. Tom was pretty vicious in their stuff, and was a clear-cut villain. I used the idea that nothing's clear-cut, because in comedy

you should be able to understand both the villain and hero. That's why *Bully for Bugs* [1953] was a particularly good Bugs Bunny, because the losses were equally shared. Bugs had almost as many problems as the bull did.

JA: Did you enjoy making the Inki and Minah Bird cartoons?

CJ: I didn't understand them. Nobody understood them. Disney brought his writers out and showed them that stupid bird walking around, and he asked, "What the hell is he doing?" I didn't know. They didn't seem particularly funny to me. We showed the first one to a studio audience, and there wasn't a laugh. We sent it to New York, and New York said, "Yucch! We don't want any more of these!" And then the damn thing went out and started knocking them over in theatres, and they said, "We want more." So I made another one and the studio audience was dead and New York said, "It isn't as good as the *other* one." And so it went out and did better than the first one. And so I ended up doing a few more. Finally I went to Leon Schlesinger and said, "No more! I'm not going to put myself through that kind of agony." So he asked the other directors if they would do one, but nobody could understand them.

Another picture I didn't understand was *Now Hear This* [1963]. I called it "Chuck Jones's Revenge" because it was one of the last pictures I made for Jack Warner, and I was trying to find some way of infuriating him. So I made that picture and a couple of others like *I Was a Teenage Thumb* [1963]. But I didn't succeed in getting him mad. Maybe he didn't see them.

JA: How did the Three Bears series originate?

CJ: I was working with a layout man named Art Heineman; and Mike Maltese, my writer, and I got the idea that it would be funny just to reverse character shapes, to have the baby the biggest and wearing a diaper, and the father a little bitty, bombastic character. You see elements of him in Yosemite Sam and Colonel Shuffle, in the bombast: "AAAaaa, I hate rabbits." These are the elements of comedy: somebody hates rabbits just because he hates rabbits. I always liked that.

JA: Why did the Three Bears die?

CJ: They didn't die. Jack Warner said he didn't want any more because everybody was making Three Bears pictures. It was a shame. I'd like to make some more of these; I think they were enormously funny. To me, the finale, the Father's Day thing, in *Bear for Punishment* [1951] is one of the greatest pieces of action.

JA: Some of your cartoons have no talk at all while others are talkfests, with constant verbal exchanges.

CJ: That's right. We tried a lot of variations. We'd use a lot of dialogue at the beginning, or dialogue at the end, or I'd use "Morning, Ralph" and "Morning, Sam." In *Go Fly a Kite* [1957], which I always liked, about the eagle who raised a cat so it could fly, we used dialogue at the opening and never used it again.

JA: The discipline in *One Froggy Evening* [1956] that I finally realized was so important to its success is that the humans never talk.

CJ: I decided that the picture would be funnier if that discipline was imposed. For one thing, it had an explosive quality. You never knew when the sonofabitch frog was going to sing, but you always knew that nobody was going to

hear it except the poor guy. That scene we did from outside the window, having the guy do the frog's act in pantomime, gave us a lot of fun. That was a difficult film to do but I think of all my pictures, I like it best. Incidentally, Mike Maltese and I wrote "The Michigan Rag" for the frog. We wanted something ragtime and Mike had always been good at that. He wrote Italian music, too, for *Charlie Dog in Italy*—"Whattsamatta, whattssamata, whattsamatta with you?" And he wrote a couple of songs for the Three Bears. He also had a lot of training in soft shoe, in dancing, and he worked with Ken Harris on that kind of thing.

JA: The Road Runner cartoons are funny because all the humor comes from the same thing; it's the same gag with twenty million variations.

CJ: They're based on ineptitude, they're based on the failures of the anthropomorphized Coyote and the fact that he makes mistakes. To me, he's everybody that works in a home workshop. The Coyote is his own worst enemy. I don't see how he can catch the Road Runner. But that's the point: the more frustrated, the more wildly inventive he becomes. Santayana said that a fanatic is one who redoubles his effort when he's forgotten his aim. And that's what the Coyote is.

JA: Did your philosophical view of the Road Runner series develop as you worked?

CJ: Well, some of the early ones were rough because I didn't really know what I was doing, although as far as audiences were concerned, none of the Road

Wile E. Coyote, created by Chuck Jones, is the cartoon world's most celebrated comic-villain.
© **Warner Bros., Inc.**

" WILE E. COYOTE "

Runners ever did badly. The first one I did as a parody. But since no one was taking it as a parody, I said to hell with it and just tried to make them funny. There was a little experimental area in there, and I wasn't sure what the buildups were; for instance, I felt that I had to indicate how hungry the Coyote was by having him catch a fly or something. You know, that's Chaplin. After a while it became obvious to me that it *wasn't* necessary.

JA: Don't coyotes chase roadrunners as a rule?

CJ: I doubt it. My opinion, in looking back—I didn't think about it much at the time—is that the Coyote probably started chasing the Road Runner during some time of incredible famine. Then when he no longer had to chase the Road Runner, he'd still never caught him. So he continued chasing him.

JA: After a while, the Road Runner becomes unimportant. What's important is the next contraption the Coyote's going to set up.

CJ: Precisely. And that's what brought the Acme Company into being. I felt that to improvise things was not nearly as much fun as it was to send away to the Acme factory and get a half mile of railroad track, or a pair of jet-propelled tennis shoes, or a fifth of bumblebees. There are factories that do supply people with things, it's perfectly logical; so the only difference here is that there seems to be no money transaction between the Coyote and Acme, and you never see any actual communication between them. There's just a factory that supplies coyotes.

JA: Who did your editing on these cartoons?

CJ: We had a brilliant guy in Treg Brown, who was the sound cutter, and I got him in the habit of doing those incongruous sounds for the Road Runner and Coyote. In one of them the Coyote had his leg caught in a harpoon gun and he was dragged along the ground: we used hums and bells and sirens and rasps and chain saws and everything *except* the right sound. And it was funny. We had one running gag that ran for 150 feet, and another that ran on for 300 feet, and I feel that if I had stayed another year, I would have made a Road Runner or Sheepdog cartoon with just one gag. It could have been done.

I learned an enormous amount about timing during my parallel association with Friz Freleng. Because in timing, I think he is one of the most brilliant men that ever lived. And timing, of course, is the essence of comedy.

Everybody learned from Tex Avery. He was only at Warners from 1935 to 1942 but he had an immense effect. He had an exquisite sense of what you might call "ridiculous timing." He's the only man I know who can do things that I wouldn't ever begin to try, and that includes his joke of panning up the barrel of a gun, and just going and going and then coming to a sign that says, "Long, isn't it?," and then going on and on. And his timing always works.

Our pictures were exactly 540 feet long, and the three of us—Friz, Tex, and I—reached a point where we could lay out a film and by the time we finished timing it we were probably within 10 feet of 540. I think it was some damn good training.

JA: How restricted did you feel about following this kind of set pattern?

CJ: My early cartoons, like the Sniffles things, were often too long. When I had the extra time, I'd tend to make the pans too long and the movement too slow.

Our budgets at Warners, around $30,000, were upped a little bit after the

war, but not much. We compensated by making our films a bit shorter, from seven minutes to six minutes. We discovered that 540 feet seems to be the optimal length for a cartoon.

JA: A lot of your films revolve around music of some sort: *The Rabbit of Seville* [1950], *What's Opera, Doc?* [1957], *High Note* [1961], and *Nelly's Folly* [1962]. What you show of the music is so accurate. What exactly is your music training?

CJ: I don't have any music training. I know so little about it that a quarter-note shape is interesting to me. But I'm fascinated by it. I'm like the person who doesn't know how to drive, with the result that I'm more aware of an automobile than a person who can drive. I know enough about music to get it down, but Friz is an accomplished musician. He plays a couple of instruments and writes a lot of his stuff, just like a composer.

What's Opera, Doc is probably the most difficult film I ever did because everything was done right to the music. It was all prescored. We took the entire *Ring of the Nibelung,* which runs I believe sixteen hours or something like that, and condensed it into a six-minute picture, a chestnut stew. There were 104 cuts in six minutes, which is some kind of record.

JA: Talk about Carl Stalling ...

CJ: He was a strange little man, but probably the most innovative musician who ever worked in animation. He invented the "tick" track, which is used by everybody. He was the one who did the original music for *Skeleton Dance* [1929] when he was at Disney before coming to Warner Brothers. He was a brilliant musician. But the quickest way for him to write a musical score—and he did one six-minute cartoon a week—was to simply look up some music that had the proper name. If there was a lady dressed in red, he'd always play "The Lady in Red." If somebody went into a cave, he'd play "Fingal's Cave." If we were doing anything about eating, he'd do "A Cup of Coffee, a Sandwich, and You." I had a bee one time, and my God if he didn't go and find a piece of music written in 1906 or something called "I'm a Busy Little Bumble Bee."

JA: Was there any problem with the rights to these things?

CJ: The original purpose of Merrie Melodies was to plug Warner Brothers songs. They owned four or five big music companies, so if he couldn't find music there, Stalling would find it in public domain. Stalling was good at writing his own music, but he seldom did.

JA: Talk about the writers you have worked with.

CJ: I seldom give enough credit to Mike Maltese and the other writers who worked with me. The basic thing is that the director takes all the risks, and that's one of the reasons he tends to be egocentric in relationship to his past. The writer thinks that what he sees on the screen is what he wrote. And it seldom is. But I was lucky enough to work with Maltese and Tedd Pierce. Mike is really not as much a writer as he is a gagman. He is brilliant at bringing up gags. Pierce was a much better writer than a gagman. Pierce and Warren Foster were both good men at structure. But Mike has an eye for oddities and he comes up with nutty ideas. He has a marvelous, almost Grandma Moses cartoon style. It's really kind of terrible and very effective. He gets his point over.

JA: What about voice specialist Mel Blanc? I saw Gloria Wood's credit next to his on *Nelly's Folly,* and it startled me that somebody else was getting voice credit on a Warner Brothers cartoon.

CJ: Well, Mel for a long time had a contractual agreement with Warner Brothers, giving him full credit whether he did the voices or not. June Foray didn't get credit for a long time. She always did Granny, and she did Witch Hazel part of the time, and she did most of the girls we used. Of course, the Road Runners didn't have any dialogue, but the voice that there was for "Beep! Beep!" oddly enough was not Mel Blanc's but background man Paul Julian's. Let's see, Bea Benedaret did Mother Bear, Billy Bletcher was Papa Bear, and Stan Freberg was Baby Bear.

JA: When I talked to Freleng, he said that he used a layout man who was strong on character and that you used one who was strong on background. He was trying to say that the emphasis in his cartoons was on character and in yours it was on graphics. But I haven't found that to be true.

CJ: No. I don't think that's what he meant. Friz is a brilliant cartoonist who always said that I drew better than he did, which isn't true. His stuff, all the characters and everything, was great. All the funny little things he did with Sylvester and Tweety Bird and so on were really his original drawings. But he always had Hawley Pratt clean up his drawings, and I never did that. I just sent my drawings directly to the animator.

What Freleng meant is that I went in a lot more for different kinds of design. I liked unusual staging. My first layout man was John McGrew who did *The Dover Boys* [1942] and *The Unbearable Bear* [1943]. He was kind of a nutty man.

A Humbug and a Spelling Bee argue in *The Phantom Tollbooth* (1971), a feature-length cartoon Chuck Jones made for M-G-M. Jones made only shorts while at Warners. © 1969 Metro-Goldwyn-Mayer, Inc.

After the war, he went to Paris to live and taught jazz piano and he never spoke a word of English there until he learned French. And he's lived there ever since. I've never been able to find him. He was a great designer. Then Berenyce Polyfka and Gene Fleury were layout people who were very influential in setting some of our styles. Maurice Noble was my most important layout man because he worked for me so long and because, as far as style is concerned, he was the most versatile. He had great staging techniques and he understood what very few background men do understand: that the purpose of a designer is to design an area where the actor can perform, and the animator can perform; and where the action shows itself to its best advantage.

JA: You have basically the same animators in all your films. I think you've had Ken Harris since 1942.

CJ: Oh, no, before that. He started with me as animator on my first picture, *Night Watchman* [1938]. Phil Monroe was another I've had with me for many years. Rudy Larriva was an assistant before he became an animator. Ben Washam was an assistant at the beginning. In the early days Ben was not a flowing animator but he developed. Ben became a fine personality animator. *The Phantom Tollbooth* [1971] was a superb animation breakthrough for him. He was about forty-five, and all of a sudden these things came leaking out of him.

Dick Williams, who is the sole person I know who is completely capable in every facet of the business, adores Ken Harris. They worked together on *A Christmas Carol* [1971]. Ken is an animator in the truest sense. He is an animator who can't make a single drawing, just a flurry of drawings. Norm Ferguson was a marvelous example of this at Disney's. He was an animator that didn't draw well, but he was an artist as an animator.

JA: What is the relation between the director and animator?

CJ: The director does 300 or 400 drawings for a cartoon, character layouts, with key positions, and from that the animator works. The animator is not beholden to use any of my drawings, and shouldn't even try. Ken Harris will change everything. He'll use an idea, but the action will flow through and go beyond it. Or he might forget it completely. But his animation will indicate what I had in mind.

JA: I've gotten the impression that in the thirties, everyone in animation considered themselves behind Disney.

CJ: We all did. Strange thing: that was probably healthy for all of us. We would look at his stuff and say, "No matter what we do, Disney is going to be a little ahead of us, particularly in technique." So without thinking, we evolved our own style. An animator at our studio was supposed to do 30 feet a week, which seems like nothing now because they do 300 feet a week at Hanna-Barbera, but seemed enormous then. The average guy at Disney did about 5 feet. But our stuff was still damn good animation.

Anybody who knows anything about animation knows that the things that happened at the Disney Studio were the backbone that upheld everything else. Disney created a climate that enabled all of us to exist. *Three Little Pigs* [1933] was the real breakthrough as far as all our animation was concerned, because it

was the first time that it was proven that you could bring characters to life: the three pigs looked alike, but each had a different personality. It's really kind of astonishing when you think it was made forty years ago.

In the thirties, very few of the animators or directors or other top people left Disney. They were paid very well. Today, after his death, they're still treated with great reverence over there: the so-called Nine Old Men. Disney felt, and rightly so, that he was a better writer than any of his writers. But he couldn't animate, so he adored and respected his animators. It was with the bottom people that the problems developed, and that's why the union came into existence.

JA: There were a whole lot of people leaving Disney's around 1942.

CJ: Because of the strike, Bill Tytla, who was one of the greatest animators, left. He wasn't a striker, oddly enough. He left in sympathy because he wouldn't pass through the picket lines. And, of course, Art Babbit left. He was very deeply involved in the union.

JA: You told me you were one of the leaders of the strike against Disney in 1941. Yet you weren't working for Disney then . . .

CJ: No, but the whole industry was striking. We had a strike at Leon Schlesinger's that he settled in three days. Then the Disney people fired Art Babbitt and a number of others for union activities, so the union called a strike, and everybody in the business went on the picket line. That went on for a long time. It was acrimonious and kind of too bad. But somebody'd gotten the idea of paying people $6.00 a week, which we couldn't very well sit down for.

JA: How well did you know Disney?

CJ: When Warner shut down the plant, I went to work at Disney's for a while. I couldn't stand it. He asked me what kind of job I wanted, and the kind of job I wanted was his. But I got to know him and like him. Walt called me in when he was going to underwrite the Chouinard Art Institute and the all-new California Institute for the Arts. I got very close to him in his latter years.

Richard Schickel's book, *The Disney Version* [1968], is one of the most atrocious misrepresentations of a personality that anybody's every done. Schickel comes up with the idea: "Disney's a businessman," and he spends a whole goddamn book trying to prove it. To call Disney a businessman is about like calling Adolf Hitler a humanitarian. He was the *despair* of the business. He made *Fantasia* [1940] for $3½ million when all he had in the studio was $2½ million! He kept doing things nobody believed in. Only now can people look back on Walt and say, "He was a commercial man." He wasn't anything of the kind. His films didn't even pay a dividend until he died.

As far as general-audience entertainment is concerned, Disney probably had the best touch of anybody in the whole world. Walt was a strange kind of guy, but he's still by all odds the most important person that animation has ever known.

JA: What was the advantage then in being employed instead at Warners?

CJ: Warner Brothers was a tremendous lab for everybody, but particularly for directors, because we had to do everything including recording and layouts, neither of which was done by directors at Disney's. As we weren't paid very much, we tended to experiment a lot. Hell, I never knew what was going to happen. On

the Road Runners I would just start where the Coyote had a bow and arrow, and then see what happened. You never had a completed script; and what the storyboard writer fed the director was maybe one-tenth of what eventually ended up on the screen.

Laurel and Hardy and the early Chaplin were primarily interested in money and having fun making films. And it showed. They were just as innocent, in a way, as we were. Innocent in that we were simply trying to make funny pictures, without pretense, and without recourse to the "plight of man." (If you don't have anything profound to say, trying to be profound won't help.) One of the important things is that we never thought of ourselves as artists. We never used the term.

JA: Talk about your producers at Warner Brothers.

CJ: The first producer we had, Leon Schlesinger, was just lazy and that was good for us. We could get fired for not doing the right pictures, but he never bothered us when we were working. Schlesinger had a lisp and his voice is where Daffy Duck's came from, and also Sylvester's voice since Daffy is just a speeded up Sylvester. "Hey, fellath," he'd say, "Whatcha up to?," and we'd say we were doing a Porky Pig, and he'd say, "That thoundth great." How great can that sound? And off he'd go to the races. And the only time he ever saw the films was when they were in test-reel form (which are now called line tests) or the finished product.

Eddie Selzer was a fox gnawing at my innards for twelve years. He's one of the two people in the world I disliked, and I can't remember who the other one was. He was a despot who demanded that we present things to him, and he'd scream and threaten torture. I just went ahead and did what I was doing, and the picture would go out and prove itself, because he was always wrong. He was just one of those people who spend their lives saying No.

Selzer looked like Mr. Magoo, and he was a very strange man. He would go up and take the Academy Awards for our films, and keep them. He took two of the three I was given, and I think he took four of the five Friz was given. The first cartoon I won an Academy Award for was *For Scent-imental Reasons* [1949]. Selzer said there wasn't anything funny about talking French double-talk and that nobody would understand it, and he *forbade* me to do it. And I did it just because he forbade me to. And so, in a way, he was sort of a gadfly on our rumps. If I thought he'd done it intellectually, I'd adore him, but he didn't.

Old Leon Schlesinger was one of the last of the robber barons. He was kind of like Hollis P. Huntington or William Hearst or Jack Warner, a breed of cat of which there aren't many left. And Selzer was sort of the model for Magoo. He had three gods: Jack, Harry, and Sam Warner. Anything they said was gospel to him.

JA: You don't get any residuals from the things you did at Warner Brothers. How do you feel about that?

CJ: Well, rationally I know that it isn't fair. Sure I could speak up and say, "Those shitheads! They paid us low salaries and they didn't give us any participation in the profits! That's wrong!" But I'm over being mad now. That's where the fun of work of any kind is, I think—getting rid of it and going on to the next. If you linger over it, then you've diminished yourself.

JA: Did you complain at the time?

CJ: There wasn't anybody to complain to. If you asked them to share, they'd say, "Well, Jack Warner doesn't share with anybody." That's like Stephen Potter's thing where two men are playing golf: One of them knocks the ball into the rough, and he goes over, throws it back on the fairway, and says, "I always do that." So Jack Warner said: "I do not share. These are my pictures. I own them." Until the unions came along and forced them to do anything, Warners didn't do it. They didn't do anything voluntarily.

JA: What did the unions force them to do?

CJ: Share residuals. That was originally done by Jimmy Petrillo who was damned by everybody as being some kind of Fascist nut or Communist nut because he demanded participation for musicians, and that was in the 1930s. Everybody, even people like *us,* thought Petrillo was a didactic bastard. Maybe he was, but he set up the ASCAP, and the result is that all musicians who ever published anything know that they'll get a certain percentage of the overall take. And then came 1948, and the actors went in. And they took away most of it. In my opinion, they were selfish.

JA: What is your opinion of UPA?

CJ: UPA was interesting and important because it got away from the old Brindle kind of backgrounds. The UPA supposition was that animation was dead, and that the thing now was graphics, which turned out to be only partially true. When we work with deep space, the depth is identified by movement, not by perspective lines. The fact that the character diminishes off into the distance is what determines how deep the background is. There's no way you can possibly get the same effect out of a still drawing of a background.

JA: And what do you think of John Hubley?

CJ: Hubley did a lot of lovely things, but a lot of people don't realize that in nearly all of his notable pictures there was a lot of dialogue. *Moonbird* [1960], *The Hole* [1963], *The Hat* [1964]: Hubley's stuff is basically a sound track. I don't think that Hubley contributed anything new to the art of animation.

Animation in itself is an art form, and that's the point I think always needs clarification. The animation exists without any background, or any color, or any sound, or anything else. You don't even have to have a camera. I don't know if you've ever taken any of the great Disney animation, or even some barfly animation, and held any of those big thick scenes in your hand and flipped them. God! It's so beautiful, you can't believe it. That pink elephant sequence in *Dumbo* [1941] is a perfect example of what I'm talking about; there are no backgrounds, no nothing. Animation does everything.

JA: I want you to talk about television animation. What do you think about the Jay Ward stuff?

CJ: I think Jay Ward would be lost if he used full animation. I think his stuff is extremely funny, but Ward has a reverence about his own style which inhibits him. He sticks by that old Terrytoons, Farmer Alfalfa kind of drawing. Jesus!

JA: What about Saturday morning cartoons?

CJ: The Saturday morning thing is really what I call illustrated radio: it's a

radio script with a minimum number of drawings in front of it, and if you turn off the picture, you can still tell what's happening because you hear it. I always worked things out visually first and then I'd go back and type the dialogue right on the drawings; I didn't write it as a script. In my opinion dialogue should never be redundant. Bob McKimson would have a character say, "There he goes." My opinion is that if he was going, you don't have to say it. Everything on Saturday morning moves alike. That's one of the reasons it's not animation. The drawings are different, but everybody acts the same way, moves their feet the same way, and runs the same way. It doesn't matter whether it's an alligator or a man or a baby or anything. You certainly can't imitate these characters.

I don't want to criticize. I'm *sorry* that people who are as good as Bill Hanna and Joe Barbera once were are not doing the kinds of things they are capable of. I'm sorry that Friz isn't doing the kinds of things he's capable of. I'm sorry *I'm* not, for that matter, but at least I'm not doing that kind of crap.

JA: I was wondering: do you think of children as your basic audience?

CJ: Somebody is always saying to me, "How come so much violence in your cartoons?" I just don't know how to answer that. If you think they're too violent to show to children, all I can say is, don't show them to children. They weren't made for children. They were made for me.

Robert McKimson
Interviewed
by MARK NARDONE

If there is a director of animation awaiting belated recognition, Robert McKimson fits the bill. Even Chuck Jones, who always praises colleague Tex Avery to the sky and has written articles about (and for) Friz Freleng, mysteriously skips by discussing his former head animator. McKimson himself was so modest and undramatic a person that the tiny interview below, conducted a few months prior to his death at sixty-six (September 27, 1976), is perhaps the only biographical discussion anywhere.

As for the critics, Manny Farber in 1943 praised his artistry in passing and offered the one-sentence capsule description, "McKimson is a show-biz satirist with throw-away gags and celebrity spoofs." In 1975 for Film Comment, *Greg Ford added: ". . . [His] early work, from 1944, captures some of Clampett's initial raw, anarchic energy in reckless films such as* Daffy Doodles *(where Daffy fiendishly paintbrushes moustaches on every billboard in Manhattan),* Gorilla My Dreams *(where Bugs Bunny and a simian go vine-swinging from tree to tree through the Bingzi-Bangzi jungle), and whose early Foghorn Leghorn films (*Walky Talky Hawky *[1944],* Crowing Pains *[1947]) contain some wonderfully reckless limbs-thrashing-every-which-way movement, as Henry Hawk is never allowed to get a word in edgewise over the very boisterous babblings-on of the Southern blowhard rooster ('. . . that boy's about as sharp as a bowling-ball')."*

For Robert McKimson, that's all folks, and a shame. While too much time has been spent arguing who "really" was responsible for the creation of Bugs Bunny, very little credit has been given to the people, McKimson especially, who developed Bugs Bunny's character and design through the years.

ROBERT MCKIMSON: I was born in Denver, Colorado, and grew up with two brothers and two sisters. My mother taught us all how to draw when we were just little. Later, my two brothers and I worked together at Warner Brothers, my older brother until 1944 and my younger brother until 1953. I was with Warners as far back as 1930, and before that I was with Harman-Ising and before that Disney. In those days almost anybody that could draw at all, Disney put to work. I started at Disney in 1928 when there were only about thirty people in the whole place.

MARK NARDONE: How did you get interested in animation?

RM: Actually, I had been drawing ever since I could hold a pencil and I had been painting even before I'd had any training. Then I studied anatomy for ten years just as a doctor studies it. I got so that I could spend three hours on an index finger. I painted portraits on the side at times, and this fits nicely into animation because all of the characters are actually based on human figures. I went to Don Graham during the 1930s, before he went to teach at Disney, and studied with him for one semester just to see what he had to offer. Actually he was so enamored with my training in anatomy that he spent all his time with me. He was saying, if only the other people could have such a basis . . .

MN: But you didn't become a cartoon director for fourteen years at Warners. You continued as an animator until 1944, when Bob Clampett and Frank Tashlin left the studio.

RM: That's right. The reason I had turned down the director job for seven years was that I felt that, to be a director, you had to know every phase. Chuck Jones moved up to direct by that time, and Tex Avery had gone over to M-G-M. There were three directors—Jones, Freleng, and myself—and each was responsible for ten cartoons a year, one every five weeks. We all had to do two Bugs Bunnys; and there were other characters we used once in awhile, and each of us had characters that he was pretty much responsible for. I had Foghorn Leghorn,

The rambunctious Foghorn Leghorn, one of Robert McKimson's major characters. © 1956 Warner Bros. Pictures Inc.

for instance. Friz Freleng had Yosemite Sam to himself, and he took over Tweety and Sylvester when Clampett left. Jones was responsible for Pepe Le Pew and the Road Runner, of course. Also, two cartoons a year were taken up by new characters that we came up with. And the way that we worked, which was the only good way of working, was that each had his own storyman, and we would sit down with him and figure out a story line. Then we would draw up a storyboard until we had a good cartoon planned out, we'd get together in a "jam session" of all the directors and all the storymen. And if someone came up with something that was better than what the director and his storyman had, it would be used. So it made a good, fresh way of working.

MN: Was there ever a proposal on the part of the animators themselves concerning a feature-length cartoon?

RM: A lot of our people wanted to try a feature. But Warners felt it would tie up too much money, and they didn't know if it would go.

MN: How much did it cost to produce one Bugs Bunny cartoon back in the 1940s?

RM: It was about $25,000 per cartoon. They always made profits, but very little. But once they started letting television use them, the money was big.

MN: Do you get royalties?

RM: That's the pathetic part. The three of us who really created it all never got a nickel. The voice people and the music people get money every time they're shown. It's entirely unfair, but that's the way it goes.

MN: What was the influence on you of other contemporary animators?

RM: We always looked to learn from Disney. He was the quality producer. But nobody would look up to anything like Terrytoons or what Fleischer was doing. Popeye cartoons are horrible. When you're looking for quality, you don't look at these things. It's like a child drawing something. Somebody will say "Oh, isn't that wonderful" only because a child did it.

MN: There is an obvious, gradual change in Warners graphic style. How much did UPA and their minimalist, abstract style influence the Warners animators?

RM: UPA took more from us than we took from them. A lot of our people worked at UPA on the outside, which influenced UPA. Now UPA went in for a lot of design things. But you see, a lot of the times the characters would get lost in the background. We had one like that that Chuck Jones did, where he let his background man go wild. Bugs was on an island, and the background was so full of design you could hardly find the rabbit. And so that was the last time that happened. Backgrounds kept getting less complicated all the time so that the characters read well over them.

MN: Did animators at Warners have a goal of what you wanted to do through animation?

RM: Well, of course. What we liked to do was make people feel that each of the characters were alive and that they had heart. And we had people, kids especially, come in there wanting to meet Bugs Bunny. We'd just tell them that he was out to lunch or something.

MN: What did Jack Warner think of the animation?

RM: Jack Warner loved cartoons. There was this Tasmanian Devil of mine. This executive at the studio, Ed Selzer, said to stop making them, that this character was too obnoxious. So after two of them I stopped. Then one day, Jack Warner called him in and demanded, "What happened to the Tasmanian Devil?" Warner fumed that he'd better tell me to make more because there were boxes and boxes of letters coming in about the character. So, I made about three more after that.

Sketch of the Tasmanian Devil by Robert McKimson. Character © Warner Bros., Inc. (Photograph courtesy Robert McKimson)

"GOOFY GOPHERS"

(*above*) Sketch of Goofy Gophers by Robert McKimson. © 1957 Warner Bros. Pictures Inc. (Photograph courtesy Robert McKimson) (*below*) Sketch of Speedy Gonzalez by Robert McKimson. © Warner Bros. Pictures Inc. (Photograph courtesy Robert McKimson)

"Speedy Gonzales"

MN: Did the Warners animators have a theory of comedy? A lot of the cartoon characters have handicaps and impediments that are at the center of all the laughter.

RM: Well, we didn't go in for any of that. You see, Bugs was a pixie character, the kind of character that did everything that people would love to do, but don't dare. And Daffy was just . . . off the beam, a greedy little guy. Foghorn Leghorn was just a loudmouth. Porky was just an ineffectual comedy relief. But each of them had their own particular twists. But none of them was based on an inability to do anything, like Magoo.

MN: Well, Porky wasn't the most articulate character around.

RM: Well, that's true. Porky at first, around 1935–36, had a voice by a guy who actually stuttered, and this was almost impossible to use. A little later, Mel Blanc limited the stuttering to just a few words per sentence. Sylvester was just . . . juicy, a slobbering cat. And Daffy is just like Sylvester only Daffy is sped up electronically. The voices were always recorded first, by the way. The animation comes after.

MN: I've noticed that in the earliest cartoons all the characters seem to be much larger.

RM: Actually, we always tried to keep the characters small, because they're cuter. In other words, we figured that a character was about right if he had to reach up to open a door. Most of the characters were three feet tall and no more than four feet tall.

MN: Elmer Fudd began as a pretty burly guy . . .

RM: Well, he had quite an evolution. He started off with a small head and a big body and then he went to a small head and a small body and then he went to a bigger head and a smaller body. Porky did the same thing. He started off very small when I first animated him in 1935. But he went from a small head and a small body to a small head and a big body till he came down to a bigger head and a smaller body.

MN: The credit for changes made in Bugs Bunny, be it his appearance or manner, is a subject for much debate among the animators.

RM: I made all of the first models on Bugs Bunny, the first drawings. Actually, a lot of people give credit to Bugs Hardaway for creating Bugs Bunny. But to me, he had no part in it. He had a completely different character. It was called Bugs' Bunny. If it had been a horse, it would have been a Bugs' Horse. I give Tex Avery credit for creating the character. I drew the way he looks. At first he was more of a Roman-nosed character with an oval head. Then we made him cuter, brought his cheeks and head out a little more and gave him just a little nose.

MN: There were some characters that were created that never made it past their first or second cartoon.

RM: We would go to different theatres and watch the audience, or we would preview them. It was audience reaction and letters that determined if a character was right or not. There's one called Beaky Buzzard. We didn't make many of him. He was a stupid character in the first place. He was hard to work with because he would have to be in a certain locale. Quentin Quail. We couldn't do anything with him. He wasn't mobile. And Chuck Jones had one called Charlie Dog, which

didn't last. In fact, Bugs Bunny, after five or six pictures, was thought to be exhausted. But we came up with new ideas so that he lasted from 1938 to 1962.

MN: What about female cartoon characters in the Warner Brothers cartoons? There are hardly any.

RM: For some reason or other, cartoons never went in for female characters. There was Honey Bunny and Petunia. But the stories that came up never lent themselves to female characters.

MN: Why don't we see Porky and Bugs together at all? Was it a conscious choice to avoid this character combination?

RM: We worked Porky in with Daffy. They worked well together. But Bugs would take away from Porky or vice versa. It wasn't a particularly conscious effort. The stories just didn't come up.

MN: Could a person recognize your work at Warners against that of the other directors?

RM: It would be nothing conscious. In a lot of ways the cartoons are almost identical. But in other ways they are not. Each of us would have a little different timing, and each of us had a little different idea about what was funny.

MN: What was your responsibility as director?

RM: Each unit was composed of director, storyman, layout man, background man, and the animator and his assistants. The director coordinated the whole thing. Chuck and I would stage the thing and draw in the characters and time out the action on sheets. We'd tell the animators how to do it. Timing the action was very important. Accents on the dialogue track were always important in drawing the characters in movement.

MN: What did the editor have to do on these cartoons? Was he just a splicer?

RM: Mostly. You see, we laid these things out so that everything was exact. And if we wanted to change something, we would have had to change the music and sound effects. A lot of times we would work out music for the whole picture before we even started the picture.

MN: How would you compare Tex Avery's work at M-G-M with his work at Warners?

RM: When I worked with Tex, he never drew too well. And I would take his rough characters and make them work. At M-G-M, it seems that he did a lot of the drawing himself. A lot of it is crude and overdone. That's the way that Tex always thought. He always wanted everything overdone. It works fine for some things, but not for everything.

MN: Why don't you talk a little more on what happened toward the end of the Warners years?

RM: In the 1940s and 1950s, especially, I thought the funnier cartoons were made. It's towards the end of the fifties and into the early 1960s, just before we closed down, that things got too subtle, with everything underplayed.

MN: This is especially true in the Bugs Bunny character.

RM: Right, he became too much of a suave character. I thought that was bad. You know, you have to progress, and this underplaying was a different way of doing things. Sometimes you don't always progress in the right direction.

MN: Did you have any idea that the end of Warner Brothers cartoons was in sight?

RM (*laughing*): We didn't know until about six months before it closed down. For fifteen or twenty years they had been telling us that one of these days they were going to close us up. It got so that it was crying wolf, you know. And, finally, they did close it down.

MN: You're involved with Saturday morning cartoons now, with *The Pink Panther.* How is it for you to produce limited-animation cartoons after working in full animation for so long?

RM: The limited animation is all they can do nowadays because of economics. When I was at Warners, there was a time when I could do up to 50 feet a week by myself, which was exceptional. Now, with the limited-animation techniques, a guy can do up to 200 feet a week because a lot of times they only need to use two drawings per foot. That's why most of the Hanna-Barbera characters have little personality. They're just things.

MN: What of your work on *The Pink Panther?*

RM: Well, what I'm doing now is putting things together as a director, except that I do very little drawing. There is not much pride in doing it. I'm just concerned with getting the things out. I put them together as best I can and try to make them as funny as I can.

MN: But *The Pink Panther* cartoons are a cut above the other Saturday morning shows.

RM: Yeah, it's a cut above but it's still close to limited animation. I'm really not creating anything.

MN: So how do you exercise your creativity now?

RM: Well, you see, most of my work is free-lance, even at DePatie-Freleng. I do a lot of commercials, and I did something that was very interesting to me. I designed all the characters for Marriot Hotel's Great America up in Santa Clara. They're all Warners characters, so you see a six-foot-tall Sylvester or Foghorn Leghorn or even a Tasmanian Devil. And then they have a forty-minute play using these. Oh, it's great! It cost them $70 million to put it on. They've got another one in Gurney, Illinois, and they're hoping to put up another one in Bethesda, Maryland. But I'm just trying to do as little as possible these days. After beating my brains out for so many years, I just feel that I need a rest.

Robert Clampett
by PATRICK MCGILLIGAN

There is a revealing photograph, of around 1940, of the Warners cartoon unit, posing in sports jackets like a baseball team before opening day. In the strategic middle, smiling, stands Bob Clampett, clutching a Bugs Bunny statuette in his hands. The photo is typical of decades of Clampett self-promotion, culminating in Bugs Bunny Superstar, *a recent theatrical-release compilation of Bugs Bunny cartoons, but only those directed by Clampett. As if Freleng, Jones, Avery, and McKimson had never existed. There are more details below.*

The peculiar thing is that Clampett has no need for self-aggrandizement. His best cartoons, including such classics as Porky in Wackyland (*1938*) *and* Bacall to Arms (*1946*), *make the case for him. In fact, there are select students of animation who rate Clampett at the very top of the Warners auteurs: "Of all the WB animators none drew so imaginatively from this batch of comic topics more madness and savage wit than Robert Clampett" is the verdict of Mitchell S. Cohen in his study, "Looney Tunes and Merrie Melodies"* (The Velvet Light Trap, *no. 15 [Fall 1975]). And Greg Ford, who prefers Jones and Avery, still compliments Clampett, "whose most undisciplined sproinging rubbery character-motion gave him some of the most eminently stretchable-bendable characters in Cartoon History, and whose anything-for-a-laugh temperament prophesied today's Sick or Black Humor."*

Granted, the writing of history is often a messy variable affair, complicated by egos and short convenient memories. But the dustheap of rancorous claims by the cartoonists of Termite Terrace is worthy of the attention of Jarndyce and Jarndyce, a venerable legal firm that is familiar with nasty and compounding disagreement. Tch, tch, and among old friends yet. At the center of the gathering fury is a dapper, tousle-haired fellow named Robert Clampett, who still exhibits the coltish air of the juvenile animator who joined the incipient Warner Brothers cartoon staff in 1931, animating the secondary characters in the first Merrie Melodies cartoon, *Lady, Play Your Mandolin;* Clampett subsequently worked for the studio from 1931 to 1946, becoming a full-fledged director, early on, in 1936. More so than (in alphabetical order) Tex Avery, Friz Freleng, Chuck Jones, and Frank Tashlin, his principal director-collaborators during the rainbow years at Warner Brothers, Clampett became something of a household word after his departure,

thanks largely to the clever international merchandising of the 1949/54 "A Time for Beany" and the 1961/62 "Beany and Cecil" television shows (including T-shirts, puppets, and so forth). Thanks also to a theme-ditty for the popular kiddie cartoon show that incorporated the animator's name. Thanks also to the fact that Clampett is an inveterate self-promoter and has been barnstorming college campuses and television talk shows for a decade, behaving like a cure-all salesman of himself; to hear him tell it, he was instrumental in nearly everything that happened at the Warner Brothers cartoon factory, short of sharpening the pencils.

Clampett's version is remarkably inclusive: he named Porky Pig (inspired by Campbell's you-know-what and beans) and suggested a "comic relief character" for *Porky's Duck Hunt* (1937) that metamorphosed into Daffy Duck (whose name was inspired by Dizzy Dean's brother); he assisted in the development of seemingly every major and minor cartoon figure at Warner Brothers, from the mouse Sniffles to Yosemite Sam to Elmer Fudd; and, this is where the canker gnaws, he also gave birth to the irascible Bugs Bunny. Clampett's version is that he received the inspiration for Bugs Bunny during a conversation with producer Rudy Ising in 1931; that he added carrot-munching after being impressed by a hitchhiking Clark Gable in Frank Capra's *It Happened One Night* (1934); and that he gazed protectively over Tex Avery's shoulder during the evolutionary stages of the character. Well, being proprietary about Sniffles is one thing (even that is firmly disputed by Jones), but claiming Bugs Bunny means war; the saga of Bugs's origin is undoubtedly long and thorny, and Clampett's associates at Warner Brothers (some of whom have their own convincing claims to Bugs Bunny) have been stirred to ire. Jones, for example, circulated a letter among film buffs and anima-

Bob Clampett is another of Warners' old animators who claims to be the primary developer of Bugs Bunny. Bugs Bunny © Warner Bros., Inc. © Hare Raising Films, 1975.

tors in late 1975 denouncing the "cheap claims of such immoral or amoral opportunism," while Avery added that "for thirty years, I have been sickened by 'super' Clampett's false claims to characters and cartoons that you, Friz and myself created."

This is more than bad blood among ex-cronies; history is at stake. But the rotating credits utilized by producer Leon Schlesinger have corrupted history beyond precision, in this instance. And the situation is further muddied by the clamorous cult of devotees who gather in each animator's circle: *Film Comment,* for example, concentrated on Chuck Jones in its prestigious animation issue, barely mentioning Clampett; the technique-oriented *Funnyworld* (which ignited controversy with its exhaustive Clampett interview) meanwhile sided with the Clampettism of *The Velvet Light Trap* (a magazine in which an overwrought writer asserted "not only did Clampett play a major role in the development of Bugs Bunny and Daffy Duck, [but] Clampett's cartoons are consistently wilder, more original and just plain funnier than most of those produced by his contemporaries"). (Insult to injury was added by the recent anthology-documentary celebrating Warner Brothers cartoonery, *Bugs Bunny Superstar* [1976]. Although the producers of the film evidently intended to present an accurate overview of the Burbank studio, they saw fit to spend time interviewing only one of its creators—Robert Clampett.) Such chauvinism has fueled an internecine rivalry, although that rivalry has possibly always existed (a 1936 sketch exists of Jones and Clampett en route to the studio with their backsides glued together, fearing the proverbial knife-in-the-back); possibly it stems from Clampett's runaway commercial success in the post-Warners era, during a period when his former associates have had to scramble unceremoniously for their respective livelihoods.

Whatever, Clampett's exact contribution to the Warner Brothers cartoon oeuvre may never be unraveled; but his style and personality are a different proposition. Certain characteristics are common to the group, which fancied itself the poor man's Disney: the FDR–New Deal outlook, for example; the lightweight satire of the topical, the trendy, and the Warner Brothers studio itself (notice the in-house jibe at Busby Berkeley in *Goofy Groceries* [1940], for instance); the mildly proletarian impulses (notice how often Katharine Hepburn's upper-crust snobbery is lampooned); the breakneck pacing and tightly gagged structure; an attitude that could be called anything from irreverent to tasteless; the musicality, which is indebted to Disney; and the sheer revelry in nonsense. Like anybody else, Clampett had his individual strengths and weaknesses, but it somehow seems that his individuality is less definable, less pronounced, than any of his cohorts—save perhaps Friz Freleng, who was the workhorse of the gang, and an adaptable *metteur-en-scène*. Tashlin, for example, epitomized the repressed sexuality of Warner Brothers animation, and he eventually parlayed his kinky talents into the live-action field, working with the likes of Jayne Mansfield; Jones was the impeccable liberal ("I never made a cartoon which didn't contain some flick-of-the-wrist at the establishment of the day") and the scattershot intellectual; and Avery was incorrigibly wacky and the acknowledged master of the crowd-pleasing one-liner (there is poetic irony in the fact that Avery, in the twilight of his career, specializes in television commercials, including those for Raid bug spray). Such personalities

translated dynamically into cartoonery; compared with them, Clampett pales a little; he becomes something of a riddle.

Clampett never approached Tashlin's subversive naughtiness, or even tried to; he was too much the straight arrow. While Tashlin taunted the censors and leered at the flesh and exulted in characters such as the overripe Petunia Pig—who, as Greg Ford has observed, is "a Jayne Mansfield-progenitor"—Clampett veered closest to open sexuality by having Daffy Duck striptease before surrendering to an oven in *The Wise Quacking Duck* (1943). Tashlin would have relished such a titillating moment; Clampett burlesqued it. Sex? It either embarrassed—as when the silkworm knits a brassiere for Porky Pig in *Porky's Party* (1938), triggering a mortified blush—or disinterested him. Sex was played strictly for laughs. Thus Clampett's secondary characters inclined toward bland sexless androgyny, in disposition as well as anatomy. (Excepting the major collective characters: the macho Bugs Bunny and the milquetoast Porky Pig; they may not have exhibited ornaments of gender but they were undeniably male.) In this category are the irrepressible Tweety (who was designed, as Clampett likes to point out in interviews, without the slightest notion of sex) and the Gremlin from the Kremlin of *Russian Rhapsody* (1944) or the pesky flea of *An Itch in Time* (1943). Interesting that the last two are throwaway villains, because Clampett, who was tradition bound in many of his values, often associated villainy with sex; little wonder that his most memorable evildoer turned out to be a she, the sultry Natasha of the "Beany and Cecil" television show.

A publicity still from Bob Clampett's popular television cartoon series, "Beany and Cecil." © Bob Clampett.

Neither was Clampett as philosophical or assuredly opinionated or idea-oriented as Chuck Jones, an animator who discourses freely on form, movement, primary action, and secondary action, and who is the closest thing to a thinker in cartoonery. If Clampett could direct a sincere flag-waving exercise like *Falling Hare* (1943), he could also turn around and compose *Draftee Daffy* (1944), in which Daffy Duck literally goes to hell rather than endure the indignity of being drafted. Point of view didn't matter. Whereas Clampett mocked Disney grandly in his symphonic *Corny Concerto* (1943)—a takeoff on *Fantasia* (1940) that featured Elmer Fudd as a surrogate Stokowski, and vignette musical episodes choreographed to "Tales of the Vienna Woods" and "The Blue Danube"—Jones went further in *What's Opera, Doc?* (1957), by profoundly upending an entire theatrical experience. Although Clampett liked to toy with shadows, live-action cutaways, and self-intrusions, he never placed Daffy Duck at the whim and mercy of a godlike animator's eraser, as Chuck Jones did so audaciously in *Duck Amuck* (1953), a cartoon that is reminiscent of Buster Keaton's *Sherlock, Jr.* (1924), in its dreamlike experimental quality. Jones parlayed his gimmicks into a concept; Clampett was satisfied with the clever gimmickry. Maybe this is why Clampett's musicalized cartoons are so inordinately successful—the genre emphasizes punditry over profundity. Of course, all the Warner Brothers animator-directors toiled at musical cartoons—that was not only the vogue, but a company rule for the Merrie Melodies; but Clampett—who was himself a songwriter—excelled (see *Goofy Groceries* or *Book Revue* [1946] or *Farm Frolics* [1941]) at such tune-filled escapist fare.

Another thing about Jones: he was obsessive, occasionally bordering on the psychotic. If Clampett was occasionally *excessive* (admirers point to the bad-taste surgery of *Daffy Dog* [1938]), he was rarely *obsessive;* the first is merely a stylistic trait, whereas the latter is a cerebral hang-up. Jones discovered his ultimate obsession in the Wile E. Coyote and Road Runner match-up, two shifty antagonists boiled down to an instinctual kill-fever; together, they expressed a compulsive faith in the creed of Acme technology, commenting wryly on the vicious rat race of modern life. Over a stretch of years, Jones refined his obsession into a sort of pop art; it became a minimalist adventure; the plot was reduced to recurrent gags, the background never altered and the Road Runner never uttered anything beyond Beep-Beep. Few other animators could take such a risk and get away with it, but Jones was fascinated by risks. Clampett, on the other hand, attempted a similar cat-and-canary concept with Tweety and Sylvester the Putty-Tat (already, a more conventional choice of adversaries), but he didn't possess Jones's existential streak or his diabolical temperament. Although, like Wile E. Coyote, Sylvester is in treadmill pursuit of Tweety, it is a far less intriguing quest; there is a coy self-conscious innocence about it, for, as Richard Thompson has written, Tweety "trades on her cuteness as Shirley Temple did." Again, Clampett settles for the amusing gimmick, while Jones explores the stratosphere beyond.

Avery provides a more subtle comparison; superficially, he is kindred to Clampett, what with his lickety-split japes, his explosive inanity, and his deep af-

finity with Bugs Bunny. Ah, Bugs Bunny again. Both Jones and Clampett are very articulate on the subject of Bugs Bunny: Jones saying that Bugs minds his own business until provoked, and then he becomes an anarchist à la Groucho Marx; Clampett saying that audiences adored Bugs "for his lack of inhibitions." Although Avery directed fewer Bugs Bunny cartoons than either of his more loquacious chums (six shorts, including the first true Bugs Bunny cartoon, *A Wild Hare* [1940]), the other Warner Brothers animators usually credited him with helping forge Bugs's character as a misanthrope. It was Avery who said of Bugs Bunny, wisely: "He was always in command, even in the face of gravest danger." Bugs the magnificent and, when provoked, nobody rottener. Jones and even Freleng (who has maestro Bugs shoot a concertgoer before the symphony in *Rhapsody Rabbit* [1945]) and especially Avery understood this malice well; but Clampett, more the virtuous, lacked the vital jugular instinct with Bugs. Indeed, he occasionally victimized him. Thus, in *Falling Hare,* for example, a rare spectacle unfolds: an airsick Bugs Bunny is battered, brutalized, terrorized, and transfigured into a jackass. If Bugs Bunny is, as Richard Thompson has written, essentially a winner, then Clampett offers an unsettling reversal. Now Clampett could weave wonders with such character reversals—as demonstrated by the exhilarating *Tortoise Wins by a Hare* (1943), in which a whammied Bugs Bunny is assaulted at the finish line by underworld thugs; but it nevertheless violates his integrity as Hero to witness Bugs Bunny defeated by a common turtle.

This is a maverick opinion, surely; Clampett himself disputes it by saying that he "always felt more akin, in natural feelings, to Bugs Bunny and Cecil the Sea Sick Sea Serpent." Elsewhere, the animator also says that he greatly disliked directing Porky Pig, whom he found monotonous and unchallenging. Yet it appears that Clampett found a niche with Porky, who was the Babbitt of cartoondom, a simplehearted, stuttering schnook who personified the uptightness of respectable American society. No other director handled as many Porky Pig cartoons during his Warner Brothers tenure as Clampett did, and no other director sculpted him in quite as consistent and poignant a manner. Like Clampett, Porky was Walter Mittyish in complexion, and the director appreciated his mythic significance as well as his contemporary predicament. It was Clampett who cast Porky as an archaeological explorer in *Porky in Egypt* (1938); as a safari adventurer in *Africa Squeaks* (1939); as a time-tripping detective in *Porky's Hero Agency* (1937); and as the intrepid sleuth of *Porky's Movie Mystery* (1938). If Porky was incorrigibly middle class—a perfect all-American sucker in *Get-Rich-Quick, Porky* (1936)—he was also capable of manifesting it at the most peculiar moments. Consider *Wagon Heels* (1944), for example, in which coonskin-hatted frontier scout Porky Pig traverses a perilous stream by yanking a bathtub plug out of the river bottom. (This is also the cartoon, incidentally, in which Porky wears heart-embossed boxer shorts—the New Frontier's favorite undergarment.)

Like Porky, Clampett is incorrigibly mainstream. When his admirers laud his stark hallucinatory animation, his amoral vision, and his vaunted tastelessness, they are really appealing to the fashionably hip culture of Now. True, nothing

beats the bleak urban imagery of *The Hep Cat* (1942) or the mind-spinning dream interlude of *Porky in Wackyland* (1938), a cartoon that is famous for utilizing bizarre pun figures such as a musical "rubber band." But what passed for hallucinatory art in pre–World War II America dims before the dope flashes of R. Crumb and Ralph Bakshi today; enterprising in its day, the Wackyland episode now appears rather quaint. Although Clampett likes to regard the sequence as "in the manner of a surrealistic Picasso-like modern art," Jones has reduced such talk to callow braggadocio. "Picasso surrealistic?," sniffed Jones, writing in the aforementioned grudge letter, "Dali is now joining the Clampett fan club." Likewise, Clampett's misunderstood vision: the jive pell-mell frenzy of *Tin Pan Alley Cats* (1943) helps to obscure the fact that, at the cartoon's end, the protagonist Hep Cat opts for the Salvation Army Band over the reveries of sin-inducing jazz. A moral conclusion, in other words, because Clampett was a rock-firm moralist at heart. His forays into crass humor—the questionable attack on motherhood in *Baby Bottleneck* (1945), the iron-lung banter in *The Daffy Dog*—were merely that, forays. They stand apart from his organic nature, contrivances of circumstance and collaboration. And like hallucinations in the age of "angel dust" and LSD, they are not what they once seemed: certainly not tasteless, certainly not in the age of Farrah Fawcett-Majors, the pet rock, and fascist Chile.

At any rate, Clampett should never be described in such vulgar terms: quite the opposite, he is an ethical showman and a slapstick optimist. Funny, but his best cartoons are so often braying parodies of popular fairy tales, folk parables, and topical generic material. He took Bogart and Bacall and cast a sexy satiric spell in *Bacall to Arms* (1946). He brilliantly squashed a Sunday School lesson in *Tortoise Wins by a Hare.* And his masterwork may well be *Coal Black and De Sebben Dwarves* (1943), although it is little-seen today because of its affectionate "Negro" caricatures. Nevertheless, its quick-blend of Disney, *Citizen Kane* (cavernous lips utter "Rosebud"), Murder Inc., and bebop is exhilarating fun, partly because race[1] is such virgin territory for animators, but mostly because Clampett is so deft. These are among his sublime creations, and they rely strongly upon derivation. Clampett seemed to thrive on derivation as much as he throve on collaboration. Singly, alone with his muse and his talent, Clampett was never quite as punchy: anybody who has been exposed to the silliness of Beany and Cecil would be hard-pressed to disagree.

Sources: Among the best sources on Robert Clampett and the Warner Brothers animators are *Film Comment,* 11, no. 1 (January–February 1975), especially the articles on Warner Brothers by Greg Ford, and "Duck Amuck" by Richard

[1] Ironically, the racism of *Coal Black and De Sebben Dwarves* is directed against the Japanese, the scapegoat-enemies of World War II. Accordingly, a billboard advertises: "We rub out anyone for a price; midgets, half price; Japs, free." Like the other Warner Brothers animators, Clampett rarely broached race in his cartoons, although he was particularly fond of "Rochester" gags—a running joke that seems innocent in light of Jack Benny's prominence at the time. Therefore, his few genuine lapses—such as the Aunt-Jemima-like "Black Beauty" of *Book Revue*—are all the more appalling.

Thompson; *The Velvet Light Trap,* no. 15 (Fall 1975), especially the interview by Tim Onosko; and *Funnyworld,* no. 15 (September 1970), which contains the definitive interview with Clampett, conducted by Mike Barrier.

Acknowledgments: The author wishes to thank Susan Dalton and the staff of the Wisconsin Center for Film and Theater Research for advice and assistance; Mark Kausler, who generously screened numerous cartoons; and Michael Wilmington, who suggested the phrase, "slapstick optimist."

Bugs and Daffy
Go to War
by SUSAN ELIZABETH DALTON

According to film historian John Davis, Warner Brothers was the only studio to take a strong, "premature" antifascist stand in their films prior to American involvement in World War II. "They had been the first Hollywood studio to suspend operations in Nazi Germany (their main representative in Berlin had been kicked to death by Storm Troopers) and they produced Hollywood's first forthright attack on the Nazis with Confessions of a Nazi Spy *(May 1939)."*

Warner Brothers' longtime support for Franklin Roosevelt, since the 1932 campaign, reached patriotic fervor in its backing of FDR against the isolationists over United States participation in the European war. The studio that made Sergeant York *(1941), sending Gary Cooper's hillbilly pacifist into battle, and* Casablanca *(1942), urging Bogart's Rick toward involvement in the war effort, would also thrust its cartoon heroes into the front line. The Popular Front meant* everyone.

World War II cartoons are really incredible. All the violence, the slapstick, the chases, and even the corny gags suddenly take on a new dimension. Seeing Daffy thwack Elmer Fudd is funny, but seeing Daffy give it to Hitler is hilarious—and very satisfying. Bob Clampett, one of Warners' top animators and cartoon directors, explains this phenomenon in a long and excellent interview in *Funnyworld* (no. 12). He tells how Bugs Bunny has never been more loved than he was during the war years. Bugs was, in fact,

> a symbol of America's resistance to Hitler and the fascist powers . . . we were in a battle for our lives, and it is most difficult now to comprehend the tremendous emotional impact Bugs Bunny exerted on the audience then. You must try to recapture the mood of a people who had seen the enemy murder millions of innocent people, . . . blitzkrieg defenseless citizens, sink our fleet in a sneak attack, and threaten our very existence.
>
> Psychologists found that the public subconsciously identified the stupid little man with the gun and his counterparts with Hitler, and strongly identified the rabbit—unarmed except for his wits and will to win—with themselves. They further advised that justification was already established and that the sooner and more often the audience's alter-ego (Bugs) could get back at the Hitler symbol, the greater the therapy.

As it was, Hitler was more than just a symbol in war cartoons, and many times Daffy, Bugs, and others got a crack at him firsthand.

These therapeutic cartoons began in much the same way as Warners defense shorts—with a resurgence of patriotism. Thus in 1939, in a Chuck Jones cartoon titled *Old Glory,* we find Porky Pig having trouble memorizing the Pledge of Allegiance. He decides a nap would be more profitable, and as he begins to dream, who should appear but Uncle Sam. Over a realistically animated and very exciting sequence of the American Revolution, Uncle Sam explains to Porky how the Colonists fought and died to establish the flag, and how the nation has many times had to defend the liberty it provides. When Porky wakes up, his newfound inspiration enables him to memorize the pledge—and recite it with hardly a stutter.

In 1940, a weird, pessimistic cartoon, *The Fighting 69½,* reflected the new mood of the country. A black ant and a red ant argue over an olive at an abandoned picnic lunch. Soon, a full-scale war erupts, replete with guns, trenches, and battle casualties. ("Lieutenant Flit will lead a detail of five men. You will approach from the rear of the potato chips, and, from this point, you'll be on your own. Capture the hot dog and return to your base.") Finally, when the picnickers collect the lunch, leaving only a piece of cake, the ants call a peace conference. Amid loud cheers, the two generals divide the spoils. All goes well until they reach the cherry in the center of the cake and, of course, rather than divide it too, the ants begin to fight again.

A general overview of the war years reveals several differences in the tone and subject matter of cartoons when compared with their peacetime counterparts. The most obvious difference is the number of wartime references. Time after time a "regular" cartoon will end with a phrase such as "Eh, I almost forgot. None of us civilians should be doin' any unnecessary travelin' these days." (Bugs in *The Unruly Hare* [1944]). Other times a gag on such things as meat rationing sets the scene for the story to follow. In *I Got Plenty of Mutton* (1943) an OPA ruling of "No Meat for Wolves" means that the wolf must go after his own. The dogs have all gone to join the army, leaving only an old ram to guard the sheep. You can guess what happens to the wolf. *Ding Dog Daddy* (1942) features a dumb dog madly in love with a fancy female who is actually a metal lawn ornament. She is hauled away in a "Scrap Iron for Victory" collection and the love-crazed dog goes searching for her in an ominously majestic munitions factory where she is converted into a giant cannon shell. The dog makes the mistake of giving her a farewell kiss. Whole cartoons were given to this type of "There's a war on, folks," reminder. Chuck Jones's *Weakly Reporter* (1944), a corny spoof on rationing, has a tire being carried off in an ambulance after an accident, butter being delivered by armored car, and about every imaginable joke on female factory workers.

War cartoons also took advantage of a relaxation of censorship insofar as sex was concerned, and a proliferation of "wolf" gags sprang up. Even Bugs Bunny was to take up "howling at the babes." One of the best, and really hilarious, examples of this new freedom was in *The Wise Quacking Duck* (1943). As Bob Clampett again explains,

Daffy unbuttoned his feathers in the back, let them down, revealing his bare shoulders, then dropped them completely and did a fan dance with the parsley. The audience just roared, but, of course, this was in the period of the war, and during the war there was a permissiveness in the theater very much like what we are getting now. The boys were all in uniform and they wanted this kind of gag.

Besides providing "our boys" with their quota of cheesecake, cartoons took other serious issues to task. Subversion and collaboration were treated in *The Fifth Column Mouse* (1943). It opens with the carefree mice singin' a wartime version of "Ain't We Got Fun"—and then a cat arrives. He catches one of the mice, and with threats and a piece of cheese, persuades the mouse to collaborate with him. To the tune of "Blues in the Night," the fifth-column mouse convinces the others that the cat has "come here to save us and not to enslave us." But enslave them he does. The mice finally regain their courage and triumph over the cat; and when the fifth-column mouse tries to take part of the credit for the victory, he is pelted with rotten eggs.

Another crucial issue was the draft, and cartoons told both sides of the story. In *The Draft Horse* (1942), an overzealous farm horse literally cuts his way through the countryside (his plow's attached) to reach the induction center. Although his eagerness to fight is overwhelming, he only rates a 4F. Tearful and depressed, he makes his way home—right through the middle of a mock battlefield. After barely escaping alive, the horse decides that knitting for the troops is a safer way to spend the war. When Daffy Duck's turn came, however, he didn't take it quite so well. Bob Clampett's *Draftee Daffy* (1944) opens with a flag-waving Daffy wishing he could be at the front. The phone rings. A voice informs him that the man from the draft board is bringing him a letter from the president. Thrill! Excitement! Until, in one of the best "sudden realizations" ever to appear on the screen, Daffy *understands.* Unfortunately, the rest of the cartoon consists of Daffy's blue-streak (and not too funny) attempts to escape Mr. Meek, the man with the summons. After blowing both to smithereens, Daffy finds himself in a fiery inferno. Safe at last! But, of course, Mr. Meek is right behind him with the paper. (A recent showing of this cartoon on the University of Wisconsin, Madison, campus provoked the expected audience reactions—hisses at Daffy's initial patriotism, thrills and laughter at his reaction to the summons, boredom during the chases, and loud applause at the end.)

Daffy again ran into trouble when he met up with Hatta Mari, an evil Axis spy (you can tell by the swastikas on her garter) in Frank Tashlin's *Plane Daffy* (1944). A wonderful spoof on World War I fighter-pilot heroism à la *The Dawn Patrol* (1930), the film finds Daffy, the squadron woman hater, the only one able to resist Hatta's lecherous advances. Or so he thinks. She finally gets the better of him, but Daffy ("I regret that I have but one secret to eat for my country") swallows the document. Hatta's X-ray machine reveals to the Führer the confidential message—Hitler is a Stinker. With an untimely slip of the tongue, Mussolini and Tojo agree. Naturally, they shoot themselves, and Daffy, crying "They lose more Nutzies that way," woo-woos off into the distance.

Daffy really proved his chutzpah in a 1944 release titled *Daffy the Commando*. A huge, hawklike SS officer is spitting German at his aide Schultz, an odd little guy, all helmet and feet. It seems some commandos got through the lines. One of them is none other than our friend Daffy, who proceeds to give it to them "little black duck style." The SS hawk finally manages to fire a huge cannon, but never-daunted Daffy is inside it; and turning into a huge cannonball, he soars all the way across Germany. Landing on the podium where Hitler is sputtering away at a rally, Daffy gives him the old one-two with a hammer.

While Daffy was taking care of Hitler, Bugs Bunny was taking care of another situation. In Friz Freleng's *Herr Meets Hare* (1944) Bugs finds himself in the middle of the Black Forest where Fatso Göring is soothing his shattered nerves. Bugs shows Fatso that the medals pinned to his lederhosen are really fake. When Göring begins to rant and rave ("Ooh dot schmier kaes. Dot cheapen skaten! Do I hate dot Hitler swine. Dot phony Führer"), Bugs really freaks him out with the aid of a little black dirt on his upper lip ("Oh, my Führer. It's not vot you t'inking. It's all a mistaken"). When the ruse is discovered, Bugs eludes him. Suddenly Wagnerian music heralds a new arrival in the forest. Through the slanting rays of sunlight Bugs, dressed as Brünnhilde, comes riding up on a magnificent white stallion. In no time at all Göring is dressed as Siegfried and is making advances to Bugs. Finally, by enlisting the aid of a falcon, Göring bags Bugs and runs to present Hitler with "dot American rabbitsa, Buginheimer Buggy." But Bugs is ready for them and rises out of the sack dressed as Stalin. Exit Fatso and Hitler.

And finally, the most sadistic and unsettling of all the war cartoons, Friz Freleng's *Bugs Bunny Nips the Nips*. This film must have been exhilarating to audiences in 1944, but today it's just too much. Bugs, as he is often found, is floating along in a crate in the middle of the Pacific waiting for "the inevitable little island that inevitably toins up in dis kind of pictures." It does, and the island is so peaceful, so quiet . . . Diving into a haystack to avoid a sudden barrage of bullets, Bugs lands atop a hideously buck-toothed, slanted-eyed Jap. The fight takes to the skies, and as the enemy is parachuting down to earth, Bugs finishes him off by tossing him an anvil with "Here's some scrap iron for Japan." Next, with a mere shrug of his shoulders and a grit of his teeth, Bugs tackles a mountainous sumo wrestler. After an out-and-out confrontation gets him tied up in knots, Bugs has only to dress up as a geisha girl and catch him unaware. Suddenly the Japanese fleet arrives. It's Bugs Bunny against all odds. His thinking cap gives him the idea of—are you ready for this?—grenades inside "Good Rumor" bars. All the chattering Japs rush up to buy one, and Bugs passes them out with "Here ya are slant-eyes. Don't shove there monkey-face." Mercifully, the explosions that follow take place out of frame.

This, then, is the awful extent to which cartoons would go in order to bolster American morale through a long and terrible war. Thank God it's over. At the very least Bugs and Daffy could return to harassing Elmer Fudd, who, as we all know, never really got hurt.

A Chat with Mel Blanc

by PETER STAMELMAN

A former musician and bandleader, Mel Blanc was asked one night in the early 1930s to host a local radio talent show in Portland, Oregon. But a blizzard caused all the contestants to miss their engagement, and Mel was forced to fill a lot of air time. Instead of panicking, he decided to do the entire show himself, posing as a hillbilly, a Swiss yodeler, and a violin soloist, and interviewing each of these "contestants." Amazed by his ability to pull off such a trick, Mel took off for Hollywood where, in addition to landing regular spots on several radio shows (including "The Jack Benny Program" and "The George Burns and Gracie Allen Show"), he was hired by Warner Brothers to create voices for its fabulous cartoon character stock company. He was to become the most famous voice specialist in cartoon history. It is not easy to interview someone who has more than 500 voices at his disposal, but Peter Stamelman made the attempt in the spring of 1977.

PETER STAMELMAN: Go back before Bugs and Porky.

MEL BLANC: I tried for a year and a half to get an audition at Warner Brothers, where Leon Schlesinger was in charge of cartoons. This one guy kept saying to me, "I'm sorry. We have all the voices we need." Finally, this guy died. So I went to the next man in charge, Treg Brown. He said, "Well, come on. Let's hear what you have." I auditioned for him and he liked it. He called in the directors and said, "Would you do it again for them?" And I did it for them, and they got a kick out of it. And one of the directors, Frank Tashlin, said, "I have a story coming up with a drunken bull in it. Can you do the voice of a drunken bull?" Well, I had to think for a moment and I had to create the voice. I said, "Yea, I think I can." He said, "What would he sound like?" *(Blanc does voice of a drunken bull.)* "Now here is a—hick!—sound like he was a little, little—hick!—little loaded and he was—hick!—lookin' lookin'—hick!—for the sour mash—hick!" Tashlin said, "Great, great! What are you doing next Tuesday?" So, the first voice I did in Warner Brothers cartoons was the drunken bull. Then Leon Schlesinger said, "Hey! I got a pig that is a timid little character. Can you create a voice for him? His name is Porky Pig."

When I speak over at the colleges, I tell the kids I wanted to be real authen-

tic. I went out to a pig farm and wallowed around for a couple of weeks. Then I went back to the studio, and they kicked me out and said, "Go home and take a bath." (*Laughs.*) Which I did. And when I came back, I said, "If a pig could talk, he would talk with a grunt. You know. 'Oink! Oink! Oink! Oink! Dlee-dlee-dlee-dlee-dlee-dlee." That's the way Porky got his voice.

Then they showed me a picture of Bugs Bunny. They said, "He is a tough little character and a real little stinker." So I thought, "Which is the toughest voice in the country? Either Brooklyn or the Bronx." (*Blanc does Bugs.*) "So, I put the two a dem together, doc," and that's how I got the voice for Bugs. I knew he was a small character so I gave him a small voice. And so on down the line. They showed me Tweety and Sylvester. Tweety was a little tiny baby bird. So, I had to give him a baby voice. And this big cat. I had to give him a sloppy voice because he's a sloppy-looking character. So, I gave them these. (*Blanc does Tweety Bird.*) "Ooohhh. I taut I taw a putty tat." (*Blanc does Sylvester.*) "Sthufferin' sthuckas-tash! You BET you sthaw a putty tat!" And this voice was very similar to the one I created for Daffy Duck, only the voice is sped up. What I mean by speeding is that they slow down the actual recording of the voice. At Warner Brothers it used to be that they slowed it down from 1,200 rpms to 1,000 rpms. Then I did the voice at 1,000. Then they'd play it back at 1,200, which would actually raise the voice a bit. About eighteen percent. And there are four characters I do who have the raised voice: Tweety, Daffy Duck, Porky Pig, and Speedy Gonzales.

PS: It is true that originally Bugs Bunny was called the Happy Rabbit and you suggested that he actually should be named after the guy who invented him, Bugs Hardaway?

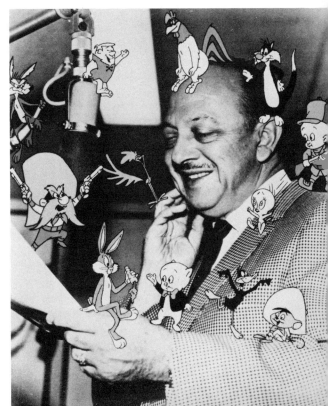

Mel Blanc, the most famous voice artist in cartoon history, has provided the voices for Warner Brothers characters Bugs Bunny, Sylvester, Porky Pig, Daffy Duck, Speedy Gonzalez, and many others. Characters © Warner Bros., Inc.

MB: That's very true. They were going to call him the Happy Rabbit. They were going to have him say, "Hey! What's cookin'?" So I told Mr. Schlesinger, "Why don't you name him after the guy who drew the first picture? Bugs Hardaway. Call him Bugs Bunny instead of the Happy Rabbit. And instead of having him say that corny thing, 'Hey! What's cookin'?,' why don't you have him say (*Blanc does Bugs.*), 'Heya, what's up doc?' " And he agreed to that, and that's how they happened to get the name in the titles.

PS: Your first film doing Bugs was *A Wild Hare*, right? In 1940?

MB: I can't remember exactly what was the first cartoon. You see, I've made over 3,000 cartoons and its hard to remember any particular one.

PS: Was your voice dubbed into foreign languages for overseas showings?

MB: Only in Mexico, I think. Yea. They had some Mexican try and imitate Bugs. But in most countries they show the actual picture with my voice, then they put subtitles in.

PS: What do you think is the toughest voice that you ever had to do?

MB: (*Blanc does Yosemite Sam.*) YOSEMITE SAM! He's a little character, and they said he was two feet tall and he had to be recognized in the picture. So (*Blanc does Yosemite Sam.*) I GAVE 'EM THIS REAL LOUD VOICE! And that, incidentally, is one of the toughest ones on my throat.

PS: I heard that that guy was actually based on Friz Freleng.

MB (*laughs*): It might have been drawn like him. He's just a small, little guy, and Friz is a small guy.

PS: What about Foghorn Leghorn?

MB: Yea. I'll tell you how I happened to get that voice. When I was just a youngster, I had seen a vaudeville act with this hard-of-hearing sheriff. And this fellow would say (*Blanc does voice of an old, hard-of-hearing sheriff.*), "Say! P-pay attenshun. I'm ah talkin' to ya, boy. Pay attenshun. Don't ya know what I'm ah talkin' about. I say. Hey. How's ah everything goin'? Listen. Don't talk so loud. I ain't deef. I can hear ya." And I thought, "Gee, this might make a good character if I made a big Southern rooster out of him." So: (*Blanc does Foghorn Leghorn.*). "And—ah Foghorn Leg—I say, pay attenshun, boy. You lookin' for chickens? Why you see dat little house over there that says D-O-G? Well, that spells chicken. Go get 'em, boy." And that's how I happened to get the voice for Foghorn Leghorn.

PS: I know it's painful, but if it's not too difficult, could you do the Tasmanian Devil?

MB: Oh yeah. They asked me to do a voice for the Tasmanian Devil. I said, "What does he sound like?" They said, "Nobody has ever heard one." So, I had to create a fictitious voice and I gave him this one: (*Blanc does Tasmanian Devil.*) "-eccawchkupkekupke-" Oh boy!

PS (*laughs*): That *must* be painful.

MB: Well, it doesn't make me jump with joy, I'll tell you that!

PS: Is it true you were once paid $800 for one sound of a hiccup?

MB: That's right. It was *Pinocchio* in 1940, a Walt Disney picture. That's one

of the few times I worked with Walt before I was contracted to Warner Brothers. They had this little cat, Gideon, and he was supposed to be the lead. And I did sixteen of these working days at Disney with a hiccup voice. They thought, "Well maybe the hiccup voice might be offensive to kids." So they had another cat do the lines without a hiccup. When I saw the picture, all I heard was one hiccup that Gideon did and for that I got $800. At the time they were only paying $50 a day. Now the fee is up to $125, $150 a day.

PS: Only two of your characters have exactly the same voice: Porky Pig and Private Snafu. Right?

MB: During the war they needed someone to do the voice for Private Snafu. Now this was for pictures that were shown only to soldiers overseas. So, I thought, Porky's voice will be kind of crazy for Snafu because he's a little sad character. And that's the reason I did Snafu practically the same way I did Porky.

One picture was an aerial gunnery picture with Snafu telling what to do. He would always tell them wrong, and they would correct him. I remember there were three guys who had never taken any lessons in aerial gunnery but just saw this picture three or four times. They went up in a plane and they scored three "positives" and one "possible" on their first flight, just from looking at the cartoon pictures. So that shows you how important cartoons are.

PS: How did you come up with Barney Rubble on "The Flintstones"?

MB: Well at first Hanna-Barbera wanted me to imitate Art Carney, and I said, "No. I don't imitate people. But I can use the same type of inflection and give you a different type of voice for him." They said, "Well what would he sound like?" (*Blanc does Barney Rubble.*) "Well, he would sound like the guy who— heh—lives next door to Fred Flintstone. Heh, heh, heh, heh, heh—" With a slow laugh at the end. And they liked that and they used it.

PS: Have you always had a philosophy?

MB: I don't like to imitate anybody, whereas some of these others actually steal the voice and improvise maybe a bit on it. They steal Ed Wynn, you know, and various other characters and they do them for a cartoon or a commercial. And right away I think, "Jesus."

PS: Do TV cartoons of today offend you?

MB: Yes, terribly, and I'll tell you why. They are in limited animation. All Warner Brothers' cartoons, Walter Lantz's cartoons, and Disney's cartoons were fully animated. Today, they can knock off a half an hour show in a tenth of the time it took to make a six-and-a-half-minute cartoon and at one-tenth the price. You have the characters standing still, the eyes blinking, the mouth moving, the background is on a turntable. You see the same thing over and over again. And the story departments they get as cheaply as they can. I don't like to say it, but they are really killing the cartoon industry.

PS: Do you think television has spoiled kids today—they don't know the good stuff?

MB: Well. (*Laughs.*) If they watched Warner Brothers and Disney and Walter Lantz cartoons, they are now spoiled because they say, "Well, that's just

another still picture." Incidentally, did you know that I created the voice for Woody Woodpecker?

PS: Yes! At one time you sued Walter Lantz.

MB: That was because they had written a song, "The Woody Woodpecker Song," and they had stolen the laugh I had created.

PS: What was your inspiration for Woody?

MB: High school. It was a big hallway that had a great echo to it. I would say, "Hello!" And it would answer, "Hello, hello, hello." So, I thought one day I'd do this crazy laugh. And I did this laugh and I ran down the end of the hall. And that's how I created the laugh, by adding a little hacking sound at the end. A little (*Blanc does Woody Woodpecker.*) "Heh-he-ho-ho-heh-heh-heh." And when I was contracted to Warner Brothers, I went to Walter Lantz and said, "I can't do this anymore for you. You'll have to find somebody else." So he tried everybody and he finally found one girl who was very close to it. Her name was Gracie Stafford. Now I say this as a joke but it's really true: He didn't want to lose her so he married her. She became Mrs. Walter Lantz.

PS: You were the first person to get screen credit for your voice.

MB: I'll tell you how I happened to do it. I went to Schlesinger and asked him for a raise, and he said, "What do you want to make money for? You just have to pay more taxes." So I said, "Well, at least give me screen credits for the voices." So he said, "OK. Voice characterization: Mel Blanc." I said, "Fine." Well, you know how much good that did me. In fact, all of the people who had radio shows found out the character who was doing the voices in the cartoons, and they called me and asked if I would work for them. At one point, I was doing eighteen transcontinental radio shows a week.

PS: What is your basic work method?

MB: They show me a picture of the cartoon character that is going to be in the picture and they tell me what the picture is going to be all about. They show me a storyboard which indicates in stills what the characters are going to do throughout the picture. I, in turn, have to create a voice for the character.

PS: Did you ever improvise some of your script?

MB: I ad-libbed a lot. The directors would get a kick out of my ad libs and they would keep them in the pictures. Although the actual picture had to be a certain length and it had to be so many frames, they would cut out some of the parts just to put my ad libs in.

PS: Obviously your voice is insured. Do you treat it in any special way?

MB: Well, I'm very fortunate in that I don't catch too many colds. But when I do, I kinda talk over it. And almost twenty years ago I had my throat X-rayed, and this doctor came back shaking his head. And I said, "Is there something wrong?" He said, "No. But you are the only one that I have ever seen that has the muscular construction of Enrico Caruso." And I said, "Well I can't sing like him." "No," he said, "but you can lose your voice after doing something strenuous and gain it back in an hour." Which is very true. So, that's the only thing I have in common with Caruso.

PS: Do you drink a lot of honey? Do you drink a lot of tea?

MB: No, I never bother. In fact, I even smoke. That doesn't bother me. I've been smoking for sixty years, so if it hasn't killed me now, I don't think it ever will.

PS: Is it strange for you that your voices are known everywhere?

MB: I did not realize how popular these characters were until I had this very bad automobile accident, which was sixteen years ago. I was in a full-body cast for a year. I had a triple skull fracture and twenty-two breaks on my right leg, and practically every other bone in my body was broken. I was in this full cast, and I received over 20,000 letters from children and people of all denominations. Catholic, Protestant, Jews, Mohammedans, Buddhists. Everybody prayed for my getting well. Kids would want to show me how much they loved me. They would send something dear to them like a penny or a nickel or a stick of gum or something. "Please get well, Bugs!" I realized then that this was very important to the American public.

PS: I heard a story. I don't know whether it's apocryphal. When you were in a coma, they were having trouble getting through to you, and finally the doctor appealed to you as Bugs Bunny!

MB: That's very true. My wife and son were both there in the room when it happened. This doctor, this brain specialist, was worried about me, inasmuch as I had a triple skull fracture. And he would come in and say, "Hey, how are you, Mel?" And I wouldn't answer him. One day he got an idea. He came in and he said, "Hey, Bugs Bunny, how are you?" and I said (*Blanc does Bugs.*), "Just fine, doc. How are you?" I couldn't believe it. But my wife and son swear to it. I guess Blanc was dead but the characters were still alive.

BIBLIOGRAPHY

ADAMSON, JOE. "Well for Heaven's Sake! Grown Men." *Film Comment* (January–February 1975). [Mike Maltese, Maurice Noble]

———. "You Couldn't Get Chaplin in a Milk Bottle." *Take One,* 2, no. 9 (1970). [Tex Avery]

BARRIER, MIKE. "The Careers of Hugh Harman and Rudolf Ising." *Millimeter* (February 1976).

———, and Spicer, Bill. "Interview with Chuck Jones." *Funnyworld* (Spring 1971).

———. "Jones: 'Night Watchman' to *Phantom Tollbooth.*" *Funnyworld* (Spring 1971).

———. "Of Mice, Wabbits, Ducks and Men: The Hollywood Cartoon." *AFI Report* (Summer 1974).

———, and Gray, Milton. "Bob Clampett: An Interview with a Master Cartoon Maker and Puppeteer." *Funnyworld* (September 1970).

———. "Interview with Carl Stalling." *Funnyworld* (Spring 1971).

BENAYOUN, ROBERT. "The Roadrunner and Other Characters" [An Interview with Chuck Jones]. *Cinema Journal* (Spring 1969). Translated from *Positif* (July–August 1963).

BOGDANOVICH, PETER. "Tashlin's Cartoons." *Movie,* no. 16 (Winter 1968/69).

CANEMAKER, JOHN. "Animation—the Hollywood Cartoon." *Filmmakers Newsletter* (April 1974).

COHEN, MITCHELL S. "Looney Tunes and Merrie Melodies." *The Velvet Light Trap,* no. 15 (Fall 1975).

FARBER, MANNY. "Short and Happy." In *Negative Space.* New York: Praeger Publishers, 1971.

FORD, GREG. "Warner Brothers." *Film Comment* (January–February 1975).

———, AND THOMPSON, RICHARD. "Chuck Jones Interview." *Film Comment* (January–February 1975).

HALFERTY, GUY. "Famous But Unknown." *The Christian Science Monitor,* August 9, 1947. [Mel Blanc]

JONES, CHUCK. "Diary of a Mad Cel-Washer." *Film Comment* (May–June 1976).

———. "Friz Freleng and How I Grew." *Millimeter,* 4, no. 1 (November 1976).

MALTIN, LEONARD. "The Warner Bros. Cartoons—A Filmography." *Film Fan Monthly* (July–August 1973).

ONOSKO, TIM. "Bob Clampett—Cartoonist." *The Velvet Light Trap,* no. 15 (Fall 1975).

RIDER, DAVID. "That's All Folks!" *Films and Filming* (March 1963).

ROSENBAUM, JONATHAN. "Dream Masters II: Tex Avery." *Film Comment* (January–February 1975).

THOMPSON, RICHARD. "Duck Amuck." *Film Comment* (January–February 1975).

YOUNG, CHARLES M. "Oryctolagus Cuniculus—a.k.a. Bugs Bunny." *The Village Voice,* December 29, 1975.

OTHER STUDIOS

On Mighty Mouse
by I. KLEIN

A brief outline of the professional career of I. Klein:

I entered the animated cartoon field in 1918, continued into 1925. Then I changed to magazine cartoons for the newly established The New Yorker *magazine. I drew over 250 cartoons for* The New Yorker *during the following ten years. I also drew many cartoons for other national magazines.*

In 1935 I returned to cartoon animation by going to Hollywood and joining the animation staff of Screen Gems Studio (Columbia Pictures). The following year I moved over to the Walt Disney Studio as animator and occasional storyman.

I returned East in 1940, to Terrytoons Studio in New Rochelle, New York, as storyman, layout man, and animator. Then in 1945 I joined Famous Animated Cartoon Studio (Paramount Pictures) in New York City. I worked for that studio for fifteen years, as storyman and animator. (Doing stories for animated cartoons meant I did an outline synopsis of the story and followed that by graphically developing the plot in storyboard sketches.)

After Paramount I free-lanced and also worked on the staff of various studios in this new era taken over by TV. I animated many TV commercials and worked on many TV entertainment films. There were occasions when I did entire TV animated shorts—layouts, storyboards, timing, and animating the whole thing. I continued activity in the animation field until recent years.

During the past ten years I have written and published many recollections of the animation studios I had worked for and the animation people I had worked with. (I am also a painter and etcher and have had my work exhibited at various times.)

P.S. I have animated such cartoon characters as Mutt & Jeff, Krazy Kat, Mickey Mouse, Donald Duck, Goofy (and other Disney Studio characters), also Nancy, Mighty Mouse, Popeye the Sailor, Little Lulu, Barney Google, Snuffy Smith, Casper the Friendly Ghost, Beetle Bailey, and many other animated cartoon characters. I received a citation at Expo '67, Montreal, for my short-short animated film Tick-Tock.

<div align="right">I. K.</div>

To avoid breath-holding suspense I shall point my finger at the man who sparked the creation of the superhero, the invincible MIGHTY MOUSE—he is myself, I.

Klein. I was on the staff of Terrytoon Cartoons in New Rochelle, New York, at that time as storyman, animator, and layout man.

The story department of Terrytoons in the first half of the 1940s consisted of John Foster, Donald McKee, Al Stahl, and myself. Also Tom Morrison took part, on and off. The head of this department was supposed to be John Foster, but Paul Terry was very active as boss and storyman. He really was the headman in every way.

The date of Mighty Mouse's birth was in 1942. By that time I had been working at Terrytoons for about a year and a half. I had returned from Hollywood in April 1940 and started my Terrytoons career about two weeks later. When I came up to be interviewed by Paul Terry for the job as an animator on his staff, I brought along a reel of some of my animation, which I did in Hollywood. On that basis Terry hired me. After he had seen my reel and the job thing was settled, we continued chatting. I told him about some laughs I got from an animated cartoon that I had seen the night before at a movie theatre. He listened with an amused smile.

That cartoon was about dinosaurs and cavemen. I described several of the gags. Suddenly Terry asked me if I'd mind working for a couple of days in his story department before I plunged into animation. I said that I wouldn't mind. After all, I did some story work at other studios besides my animation. This included the Disney Studio. Terry then said, "Now that you are one of us, you should meet the man who will put you on our payroll." He introduced me to his

I. Klein, one of our most respected animators, is also a gifted artist. (Photograph by Cori Wells Braun, 1977)

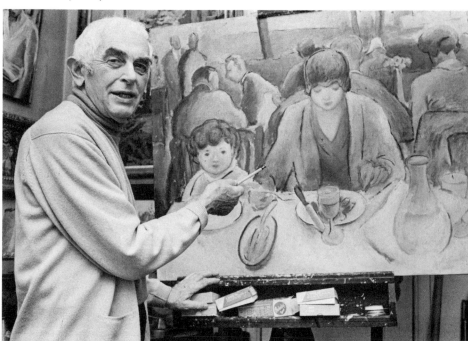

bookkeeper-accountant, William Weiss. William Weiss, years later, became the boss of CBS Terrytoons, after Paul Terry sold out to that company.

The story department was on a separate floor from the animation bullpen and directors' rooms. It was a very large room with a view of Westchester County from its high windows. The studio occupied space in the one skyscraper in New Rochelle. It was twenty stories high. The story room was on the fourteenth floor, hence the view. Terry took me up there to meet the boys.

It was recognizable as a story room by the large fiber boards, about eight feet long and four feet high, attached to two of the walls. These of course were for pinning up the story sketches. One board was pretty well loaded with such sketches, the other had some in scattered groups. There was a long conference-type table around which sat the story crew of four men. Each had a clamp board that held his sketch paper. Each had a cigar box that held his supply of pencils, erasers, some colored crayons. This was each man's "office."

Paul Terry introduced me to the fellows. I knew John Foster by reputation, that is, I heard about him as being one of the early animators. Somehow we had never met before. He was tall, severe looking, and white haired. Donald McKee I also knew by name only. He had been a magazine cartoonist at one time. He was elderly. He had never been an animator. The other two were younger men. Tom Morrison had no previous experience at animated cartoon making before joining the Terrytoons staff. His parents were friends of Paul Terry. Al Stahl had worked at other studios before coming to Terrytoons.

Terry told them that I was to start work in the story department beginning Monday. (This was on a Friday morning.) The visit was brief. Terry and I went down the elevator together, he stayed with me to the ground floor. We shook hands and I went on my way.

I did not know at the time that I would remain much longer in the story department than the few days Terry said I would.

On Monday morning I reported in at the office and then took the elevator up to the fourteenth floor. I was the first arrival. The others drifted in during the next fifteen minutes. Foster came in, shook hands with me, and sat down at the head of the table. The storyboards that had been loaded with sketches were clear and bare.

There was no conversation. Each guy after shaking hands with me sat down at his place and started scribbling or doodling or sketching on the paper of his clamp board. I sat down on an empty chair at the table expecting someone to give me a line on the procedure. I could see from the empty storyboards that a new story was the order of business. I was just ignored. John Foster, after a while, pinned up a short gag sequence on the board. I asked Foster, "Are you putting up a story idea?" He answered briefly and almost curtly, "Yeh, I think so."

I caught onto the drift of the situation. I looked around the room, found a clamp board, pencils, and some paper. I even found an empty old cigar box. I now had my own "office." Cooking up gags was nothing new in my life, and in a little while a spark struck me. I made some sketches and pinned them up on a corner of

the large storyboard. That afternoon Terry came into the room, sort of glanced at the sketches, made some random remarks unrelated to the material, and walked out.

By the following morning there were scattered sketches on both storyboards. Then Paul Terry came in carrying a double spread of a newspaper. He tacked that spread-out paper onto the board. It was a Sunday feature, sensational type of so-called scientific content with large type and several gaudy illustrations. The subject was about cavemen and DINOSAURS. (The studio, I found out later, had a rather good picture "morgue.") Then, without saying a word, Mr. Terry walked out.

That seemed to be the signal for John Foster to go to the storyboard and to remove his sketches. The others did likewise, so what was I to do but to "follow the leader" and to take down my material. I asked Foster, "Is this the order for the next story?" His answer was "I believe so." I said nothing about my telling Paul Terry about the dinosaur animated cartoon that I had seen.

We all concentrated on the caveman-dinosaur subject, putting up ideas during the balance of the week. I soon became aware that the board parallel to the long table was the Foster acceptance board. The other board was the rejection or possibly the "maybe or if" board. John Foster would go to the main board and lift off a gag sequence on to the other board. Those shifted sequences were never his gags. Terry would come into the room once in a while with gag sketches on small notepaper and pin them onto the board. I call them sketches, though they looked more like bird's-feet markings on sand. Foster never moved them to the secondary board.

On Monday of the second week of the story, the director assigned to the picture joined the story crew and threw in his talent on the assignment. By the end of the second week the story was always finished. The final shape-up of the story was made between Foster and Terry. All of Paul Terry's gags were kept. Most of Foster's remained and a sprinkling of the work of the other guys completed the opus. Then the story sketches were numbered in their proper order, and the director would take them to his room to continue the other stages of the belt line. He would return again in due time, after the other three directors went through their cycles of productivity.

Paul Terry took an active part in the story work not only by feeding his own gags to the stories but by a sort of assault-tactic on the story department. During my first two weeks Terry seemed to be a quiet soul, but soon enough his crash method of forcing a story out every two weeks became evident. He considered himself Mr. Story Department for Terrytoons, from whom all ideas originated. Other people's ideas were merely fillers. Nevertheless, he expected and demanded support from the "backfield."

He always chewed on a cigar, which he never smoked. He always wore a vest and a jacket-type sweater. He wore the sweater unbuttoned. His vest seemed to have more than the usual number of buttons, which might have been due to his stoutish figure. When Terry remained for more than a walk-through, he would sit

on an ancient wooden armchair with a leather seat stuffed with horsehair. The underside of the chair's bottom was worn with age so that cloth and horsehair dangled from below. When Mr. Terry sat on this "throne," filling it out completely and slightly sinking into the seat, with the ragged cloth and horsehair hanging underneath, the effect was most picturesque.

That armchair seemed so much to represent the boss. Once, after a very unpleasant session at which Terry ripped some of the story sketches from the board (not his own), did some hollering, and walked angrily from the room, John Foster went over to that throne and kicked it. He swore a blue streak as he swung his toe against the helpless chair. It was a sight to behold, this elderly gentleman going through such a foolish charade. The objective of all this furor was, as we all know, to make hilarious animated cartoons that would tickle the ribs of young and old. Also to make money for this cartoon production company.

Right from the start of a new story period Terry would come in and look at the sketches on the storyboard of suggested story ideas, then walk out again. If by Wednesday there was nothing to his satisfaction, he'd act mad, holler, "What's going on here. This is Wednesday! No brains here!" Sometimes he would look at the stuff in a good-natured way with a smile on his face, but that only happened on a Monday or a Tuesday. There were times when he did find an acceptable idea, but not very often. Eventually he would come into the story room with his small batch of scratchy sketches, pin them onto the board, and that was the theme for the next story.

His ideas were often about mice and cats. Mouse characters appeared in many of his cartoons long before I worked for Terry. One day he came into our room with a big announcement: "NO MORE MICE! TO HELL WITH MICE! WE ARE THROUGH USING MICE IN OUR CARTOONS." A short time after that proclamation, Hanna and Barbera made their big hit with their cat and mouse cartoon series, Tom and Jerry. Then Terry's interest in the household rodents was revived.

I sometimes wondered if Paul Terry's outbursts weren't just put-ons to impress the story crew that he was boss and brains of the outfit. I remember one time when I was away from story and animating in the animation bullpen (as I did from time to time). I had to go up to the story department for some reason. As I approached the story room door, Terry came out. He greeted me with a pleasant, big smile. When I entered the room, I found the fellows in a state of gloom and Foster nervous and mad. He said to me, "What a session! That man must have had a fight with his wife, or a sleepless night or an upset stomach. It was fierce the way he attacked us!"

After the first weeks with this studio and my full understanding of the Terrytoons belt line, I realized that I had a certain amount of leeway for myself. I was fascinated by Terry's chicken-track hieroglyphics and I ventured to make real sketches of them for the storyboard. Since Foster gave out no real directives and Terry made no objections, he soon showed that he liked the idea. This somehow took me into another direction, and into another routine, that of working with the

directors in laying out their pictures during the first week after they picked it up. During that week I laid out backgrounds and extremes for animation. I would cover as much as I could in that period. By that time another story would be underway, and Terry insisted I be back in the story department. The full routine of spending every other week in laying out backgrounds and animation did not develop until I had worked at the studio for about two years.

From time to time Paul Terry would assign me for animating. I would then work in the animation bullpen. Perhaps he wanted to keep his word that he had really engaged me as an animator. Honestly I don't think that was the reason. It happened when the animation belt line hit a snag and was slowed down for one reason or another, and my work helped it over the hump. My activity in that department would only be for several weeks at the most. Sometimes there was a special reason for my animation pinch-hitting, like when one of the animators who was a weekend skier had a bad accident. I took his place on the assembly line until he could again sit on his tail. Another special was when Peggy Roberts, the only woman animator I know (or knew), absented herself to have a baby.

I never knew when Terry would tap me on the shoulder and ask me to go into animation or, for that matter, to come out of animation. Added together I did a considerable amount of footage during those on-and-off periods of work in the animation department.

Well, finally to get down to Mighty Mouse. As I said earlier, it was in 1942 that this hero mouse was born. We were putting up ideas for a cartoon, at the start of a new cartoon story. It crossed my mind that a "takeoff" of the new (at that time) comic-strip sensation *Superman* could be a subject for a Terrytoons cartoon. Since most of the animated cartoon characters of that period were humanized animals and insects, I decided on a super-fly. I had read that a fly, for its size, had super strength. With cartoon license, this fly's strength could be multiplied many times over. I warmed up by sketching a fly wearing a Superman type of cape holding up with one arm an enormous pole, which, related to his size, seemed like a telegraph pole. He was really balancing an ordinary pencil. In a second sketch this fly in Superman cape was flying against the front of an automobile, causing the radiator to buckle and bringing the car to a forced halt. I did not discuss this with the other storymen, Foster, McKee, Morrison, and Stahl. I just pinned the sketches on the board.

These two sketches attracted Terry's attention when he came into the room. He asked for an explanation. I told him about the big hit a new comic strip called *Superman* was making and described the basic idea of that strip. Terry looked impressed, agreed that I had a good idea, but instead of a fly, we will make it a *mouse*—A SUPERMOUSE! (His mind must have suddenly visualized a supermouse hero for all his cartoon mice of the past!) But wait, it was not Terry's conception, this hero protector of ordinary weak mice, even though it was suggested (by way of the super-fly) by a member of his own staff. Thereupon, after briefly discussing the possibilities of this new character, Terry said, "The hell with it. Let's forget it."

As I remarked above, I never knew when the boss would tap me on the shoulder and ask me to pick up on animation in the animation bullpen. That is what happened later that day. He said they were running behind on their animation quota and I must pitch in to help them along. So I did. I picked up a sequence to animate from one of the directors, dusted off my animation desk, and got down to animating. I continued at it for the rest of the week and for several weeks thereafter.

However, on the following Monday Tom Morrison came in to see me at my animation desk. He was laughing and said, "Terry brought in your idea of Supermouse without mentioning your name. He has tacked up some of his ideas on the board, we are going to work on it."

Later that day I went into the story room and sure enough the boss's scratchy sketches were on the board with a mouse in a Superman-type cape in some sort of a rescue action, saving some poor mice from a big villainous cat. I remarked, "I see where Terry has approved of my 'takeoff' on *Superman.*" Foster made no response, while the others nodded and smiled.

The first Supermouse cartoon was released, according to my notes, October 16, 1942. Title: *The Mouse of Tomorrow.* Released by Twentieth Century-Fox. There were three or four Supermouse cartoons made, then the name was changed to "Mightymouse" under pressure from the *Superman* comic-strip owners. The first Mighty Mouse release was February 11, 1943. Title: *The Wreck of the Hesperus.* The running time of the cartoons: seven minutes.

Terry never directly acknowledged that I sparked the Mighty Mouse character.

However, there is an epilogue or postscript to this recital. When William Tytla came East to join the Terrytoons staff as another director, after the Mighty Mouse series was well underway, Terry gave Tytla a restaurant dinner party as a welcoming gesture. We gathered in the story room at 5:30 after working hours, the directors, story crew, and several other people of the staff. Before going to the eating place, we sat around talking for a while. Terry did most of the talking, directing his conversation to the new director. He said, among other things, that in 1942 the prospect of a renewal of a release contract with Twentieth Century-Fox looked very bleak. That Twentieth Century was losing interest in the Terrytoons cartoon product. Then we, Terrytoons, came up with Mighty Mouse. Their interest was rekindled and a new contract was signed. Mighty Mouse had saved the studio. When Terry said, "When we came up with Mighty Mouse," he nodded in my direction. I doubt if anyone was aware of that nod except myself.

Two Premières: Disney and UPA

by DAVID FISHER

There was a time in the early 1950s when UPA studio threatened, at least according to critics, to topple the cartoon establishment. UPA cartoons contained almost no violence, and parents liked that. Intellectuals, who snubbed the Avery school of animation, responded to UPA's literary endeavors, from Thurber to Edgar Allan Poe. Visual experimenters were excited by UPA's incorporation of the abstract, minimalist tendencies of modern art movements; Klee came to the cartoon. This 1953 essay, printed intact, is a typical contemporary appreciation for the UPA breakthroughs, especially as the quality of the Disney feature cartoons declined.

David Fisher's essay came just in time. As Ralph Stephenson reported in The Animated Film *(1973), "By 1955 [UPA] had lost several of its original members, among them those with the strongest personal styles. In the long run UPA settled down to producing cartoons in a few styles which by then had become routine, and given the progress which had been made were not significantly more original than Disney." But UPA had established important artists: John Hubley, Robert Cannon, Ernest Pintoff. More significant, UPA had broken down the animated cartoon in such a way that experimentalists were challenged to reconstruct it with adults in mind, as in Eastern Europe.*

Amid the familiar huffle-muffle of film publicity, premières, and 3-D horrors, two recent events are worthy of note, if only because they seem to suggest the beginnings of a change, or at any rate a new development, in public taste. The two events in question are the arrival of Walt Disney's new full-length cartoon *Peter Pan* (1953), and the première at the Cameo News Theatre in Charing Cross Road of the latest Mr. Magoo cartoon, *The Dog Snatcher* (1952). What is significant is not that *Peter Pan* should have been berated by critics in general, although the Disney True Life Adventure short on the same program won undivided applause, but that Mr. Magoo should have been deemed worthy of a première at all: albeit a première in name only, without newsreel cameras and the rest, still a première. Although it would be a mistake to see in this a definite withdrawal of public favor from Disney and its bestowal on the UPA group, the creators of Mr. Magoo,

178

something has happened. A new cartoon character has arisen to rival Donald Duck, Goofy, and Pluto; a new cult is forming; a new word is perhaps already being minted, *Magooism,* describing benevolent nearsightedness.

With regard to the first première, *Peter Pan* is neither very much better nor much worse than Disney's other attempts upon English children's classics. But then in this case the result matters less than in the past; the play is after all only a classic, as it were, by parental consent. As expected, Disney brings to Barrie's fairy tale his comic-strip mind and sentimental vulgarity. The result is Superman or Super-Pan. The mistiness, the rather dowdy fantasy, are lost: a not very convincing romp with Indians, pirates, and so forth, remains. Personally, I was not shocked by the film, only disappointed. For Disney has done this sort of thing so often before, and with more style. Old tricks are repeated; one recognizes mannerisms. The characterization, for one thing, is all too familiar: the Lost Boys are only cruder versions of the Dead End Kids in *Pinocchio* (1940); the Pirate Crew and the Darling Children, too, one has seen before, stereotyped grotesques and cuties; Wendy, of course, is Alice, is Disney's semiadolescent girl. Neither did I find the much-publicized Tinker Bell a new and exciting character, the transformation of Barrie's disembodied spot of light into this Gorgeous Gussie of the Never-Never Land represents Disney's usual injection of sex. (My own feeling is that Barrie could stand a little sex, even in the shape of this pocket-sized pinup.)

Peter Pan provides Disney with a subject that differs from his previous work in one fundamental: all the principal characters are human. For once, animals take second place; in fact the only animal characters in the film are Nana the dog (a characterization I found physically nauseating) and the crocodile (remembered from *Fantasia* [1940]). Unfortunately this return to the world of human reality is a failure; for Disney has never been happy when drawing human beings. At their worst (the Lost Boys) the characters look like animals; at their best (Captain Hook and Tinker Bell) like personages from an animated "funny." Strangely enough, it is here, in illustrating human beings, that UPA (United Producers of America) is most successful.

The earliest work of this group to be acclaimed in England was a non-Magoo cartoon, *Gerald McBoing-Boing* (Cannon, 1950), a charming and ingenious fantasy about a child whose special predicament, like Magoo's, is a physical infirmity that turns to spectacular advantage. It introduced two names of importance—the executive producer Stephen Bosustow, who founded the company, and the designer John Hubley, associated with most of its best work until he left it a few months ago (under, it appears, an un-American cloud). A few months later, *Rooty-Toot-Toot* (Hubley, 1952) and the engaging *Madeline* (Cannon, 1952) were seen at the Edinburgh Festival. The first, an amusing variation upon the Frankie and Johnny theme, suffered from being sadly overrated because of its newness; the second, different in style and feeling from the others, exploited a self-conscious charm and the *fausse naïveté* of Bemelmans's postwar *New Yorker* cartoons. All three films had wit and gaiety and cleverness, as well as revealing an occasional fondness for the chic for its own sake. But they were, after all, in the nature

of experiments. It was left to the Mr. Magoo film to attempt the major task: the creation of a series of character cartoons with a consistent hero.

Whether Mr. Magoo will eventually supplant Donald Duck or Goofy in the imaginations of the general cinemagoing public is open to doubt. Probably he will not. He and his creators stem from a different tradition from Disney and will presumably appeal to a different type of audience. Whereas Disney is the exponent of the comic-strip technique and the "funnies" mentality, UPA inherits the traditions of the sophisticated magazine cartoon with its visual and verbal criticism of manners and morals. They are the masters of the wry grimace: self-mockery per se. Like the magazine from which they draw inspiration, their comic attitude is molded on Santayana's dictum: "Life is not a spectacle or a feast; it is a predicament." To illustrate this, they celebrate the familiar—objects or situations—in its oddest guise. For them visual eccentricity reflects the oddities of life. They appeal to that something inside us whose reaction to politics, for instance, manifests itself in a desire to paint mustachios on public statues. That they sometimes repeat themselves is inevitable—*Gerald McBoing-Boing's Symphony* (1953), for instance, proved that the joke about the sound effects boy was good for one film only—but it is not the inhuman kind of factory repetition of the Disney group. What UPA lacks as a whole, in fact, is the facility of mechanical invention; when it is closest to Disney, as in the unfortunate *Pete Hothead* (1952), which depends almost entirely on gag situations, it only knows how far away it should really keep from him. It is significant that the "idea" of Gerald McBoing-Boing came from the

UPA's revolutionary drawing style was attractive to animators tired of the conservative guidelines used at Disney, M-G-M, and Warners. Copyright Columbia Pictures Corp. (Courtesy The Museum of Modern Art/Film Stills Archive)

curiously named and talented Dr. Seuss, who provided the stories of the two best George Pal puppetoons, *The 500 Hats of Bartholomew Gubbins* (1943) and [*And to Think I Saw It on*] *Mulberry Street* (1944).

However, it is not an interest in the technique or artistic forebears of the UPA group that brings audiences to the Cameo News Theatre; it is Mr. Magoo himself—a cartoon hero who is not an anthropomorphized dog or duck or mouse. Mr. Magoo is a nearsighted gentleman in late middle age, short, bald, and benevolent, though of a somewhat uncertain temper. Because of his infirmity the world around him remains a blur. Things are never as they seem: his idea of what is happening is always at variance with the reality. The comedy and situations arise from his refusal to recognize the fact.

His courage in the face of wildly improbable obstacles and his conviction that all is well make him a sort of modern Pangloss, a clown at odds with reality. This alone places him in a different category from the famous Disney heroes, who are the objects of gags rather than, like Mr. Magoo, the subject. Like Buster Keaton, he inhabits a world that has been bewitched while his back was turned; unlike Keaton, he is never really aware of the sorcery. He is the victim of a personal fantasy: he believes in the absolute normality of the world. When returning to continue his conversation with Bottomly, in *Fuddy Duddy Buddy* (Hubley, 1949), for example, he does not realize that he is now speaking to a walrus, or when playing golf, in *Grizzly Golfer* (1951), that a bear has taken Waldo's place as his caddy. Mr. Magoo blunders gaily on, missing death and mutilation by a hairbreadth, yet

UPA's top box-office attraction, the cantankerous, nearsighted Mr. Magoo. Copyright Columbia Pictures Corp. (Courtesy The Museum of Modern Art/Film Stills Archive)

saved at every turn by his superb insouciance, the innocence of one who is convinced he is doing the right thing. His very infirmity helps to protect him in a world gone mad; being nearsighted, he does not recognize the anarchy that surrounds him: he can preserve his innocence.

Most of the UPA films reveal a preoccupation with visual reality unusual in any cartoon. Even though Gerald McBoing-Boing, physically handicapped like Mr. Magoo, overcomes his infirmity, he exists in a never-never land of flat-colored backgrounds and outline people; the interest lies in the people and the human situation involved. Mr. Magoo, of course, lives in a world of dog snatchers, burglars, babies, golf, and so forth: the real world. And there, fundamentally, lies the difference between Disney and UPA. The latter rejects the traditional never-never land of the film cartoon in favor of human reality, even though its style is less realistic on the surface: it shows us animals that are animals and not Houyhnhnms. Indeed it is when they come to depict animals that the UPA illustrators fail. The Dog (*Spellbound Hound* [1950]), the Walrus (*Fuddy Duddy Buddy*), the Grizzly (*Grizzly Golfer*) are all Disneyesque characterizations and seem curiously unconvincing. Cuddles, Mr. Magoo's dog, and the Panther, both in *The Dog Snatcher,* represent UPA's first successes at animal character drawing.

What are the reasons for the popularity of Mr. Magoo? Why has a Magoo cult arisen? The answer, I think, lies in the fact that Mr. Magoo personifies a contemporary situation; the Disney heroes no longer do. They were essentially the creations of the 1930s, the period of Astaire musicals and confident, madcap comedies. Donald Duck, for instance, did the sort of things we did not dare ourselves: he was the arch anarchist, the rebel we should have liked to have been. Since then, however, we have experienced a hot war and are in the throes of a cold one. We have had every opportunity, therefore, of studying the nature and results of irresponsible action—and we no longer admire it. Mr. Magoo represents for us the man who would be responsible and serious in a world that seems insane; he is a creation of the 1950s, the age of anxiety; his situation reflects our own.

An Interview with John and Faith Hubley

by JOHN D. FORD

This interview was conducted in September 1973, at the time of Cockaboody, *perhaps the finest of the Hubley films about sibling relations. With the Child Development Center and Graphic Arts Department at Yale University, they produced* In Quest of Cockaboody *(1974), a forty-five-minute documentary about how they used their daughters, Georgia and Emily, for the voices of the sisters.* Voyage to Next *(1974) featured a dialogue between Father Time (Dizzy Gillespie) and Mother Nature (Maureen Stapleton) about the fate of humanity.* People, People, People *(1975) traced the populating of America from 17,760 B.C. to A.D. 1976. And* Everybody Rides the Carousel *(1975) was inspired by the "eight stages of human development" of Erik Erikson.*

The early history is all John Hubley at Disney and U.P.A. But Faith Hubley has proved an outstanding talent on her own. W.O.W. *(1975) is a vastly underrated feminist cartoon, poetic and mythic, made for the International Women's Year. The* Doonesbury Special *(1977) is a stirring political cartoon, finished by Faith and Gary Trudeau after John Hubley's untimely death.*

JOHN FORD: John, at what age did you become interested in art?

JOHN HUBLEY: About three or four. I had a grandfather who was a painter. My mother went to The Art Institute in Chicago, and we had a lot of paintings around our house. I used to watch my grandfather when I was a little kid; so I have that kind of studio background. It was always ordained that I would go to art school. I went a couple of years to college in Los Angeles and then I went to the Art Center and studied painting. After three years I went to Disney. I was exactly twenty-two.

Disney's studio was like a marvelous Renaissance craft hall. Young people were given a chance to study drawing, composition, animation, action. We studied old movies, layout, art direction. All of us were encouraged to take these free courses. They were very anxious to find the exceptional people and move them up fast, because they were going through such a rapid expansion. When I got there, *Snow White* [1937] had just gotten underway. I made background tracings and painted backgrounds and layouts for animators. On *Pinocchio* [1940] I went from

183

assistant art director to full art director; that is, to full layout man. I worked directly with the animation director on scene breakdowns. I did that also on *Fantasia* [1940], *Dumbo* [1941], and *Bambi* [1942].

JF: Was the "Rite of Spring" sequence your work in *Fantasia?*

JH: No, just the beginning. It was broken up between two or three unit directors supervised by one overall director. One director did the dinosaur fight; another director did the beginning: coming out of the galaxy into the molten stage of the planet and the cooling off into the greenery. That's the sequence I worked on. I also did some work on a later sequence when there was a drought. It was not scientifically accurate in terms of the demise of reptiles. More likely they were frozen by the Ice Age. But Disney didn't want an Ice Age; he wanted a desert sequence. I also did background painting on "The Sorcerer's Apprentice."

JF: What happened after you left Disney?

JH: There was a year of working for Screen Gems. Columbia. Columbia had just hired Frank Tashlin, who replaced a man named Mintz. Tash was a Disney storyman, and when the Disney strike broke, he took on the job of refurbishing Screen Gems; so he hired a lot of Disney people. Under Tashlin we tried some very experimental things; none of them quite got off the ground, but there was a lot of ground broken. We were doing crazy things that were anti the classic Disney approach. That was in 1942. Tashlin was replaced by Dave Fleischer—the Out of

The late John Hubley. (Photograph courtesy Faith Hubley)

the Inkwell, Popeye director. I left and went into the Air Force when an Air Force motion-picture unit was formed. About fifty of us formed the animation branch. Frank Thomas was the unit director I worked with. He's still at Disney; one of the grand old men of animation. A nice guy. We worked on training films for three years. We also did a lot of experimental things like flat-area painting techniques and photocollage. We made about four films on aerial gunnery. We had developed a character called Trigger Joe, and Mel Blanc did the voice. We had a lot of fun with the obstinate side of this character, and he turned out to be a very good device for teaching. He kept progressing and growing as weapons developed. First it was a question of just how you aim a freewheeling 50-caliber gun. Then came an automatic sight that you put on the gun, which took care of all the calculations. The only thing you had to do was set it right. So we had to do a film on that with Trigger Joe. Then an automatic system came in, in which all the guns on the ship were run by a computer-automation firing system. The gunners didn't do anything but flip a couple of switches, and all the guns were automatically trained. By this time, Frank was discharged (honorably) and I got a chance to direct. This film put Joe in the B-29s. We had to unteach all the things we had taught him before and ask him to trust the system. The day this film was finished was the day the war was over, literally. I had been doing some moonlighting. It was permitted as long as it didn't interfere with Army duties. I had worked on a film called *The Brotherhood of Man* [1946]—an early UPA picture—so I naturally drifted to UPA when I got out. That's where we did the Navy Flight Safety series, one of which was *Flathatting* [1945]. At UPA I became a full-fledged producer/director.

JF: Why was *Brotherhood of Man* a great breakthrough?

JH: We went for very flat stylized characters, instead of the global three-dimensional Disney characters. It was greatly influenced by Saul Steinberg and that sharp-nosed character he was doing at the time. Bob Cannon did most of the animation; in fact, he was the director. I was a co-writer on it and did the layouts, if I recall correctly. Ring Lardner, Jr., and Phil Eastman shared writing credit. Paul Julian did the backgrounds very flat; he used areas of color that would be elided from the line. Very advanced graphics for that period. It was financed by the United Auto Workers. Victor Reuther, Walter Reuther, and Thomas had been having a lot of problems with racial tension during the war in the auto factories; so they embarked on a big education program on racial equality and antidiscrimination for their membership.

JF: So your responsibilities on it were writing?

JH: I did the storyboards and some of the basic layouts and stylizations, but being in the Army I didn't get involved in the full production. It came out pretty well. I've got one print of it—they're hard to find!

JF: Was it run as a short in theatres?

JH: It didn't get much of a theatre distribution. It was a kind of controversial film at that time, because it dealt with racial equality. It was based on a pamphlet written by two anthropologists, Gene Weltfish and Ruth Benedict, from Columbia University. The pamphlet itself had a heavy distribution—the Army bought

tons of them. At some point some Southern congressman started to squawk about this "equality idea"; he didn't like the fact that the Army was spending money distributing this stuff. The film got involved too. The Army bought something like 300 prints to distribute through the whole overseas operations. When they buy something, they go all out! This congressman threw that in the fire with all the pamphlets, when he got sore about it. So it stopped the showing of the film for a while. The order went out that they couldn't use it. Anyway the film had a very wide circulation in libraries and schools. Then the distribution of it got a little muddy—a question of who really owned it and who had the rights to distribute it. It's still up for grabs; nobody really knows where that negative is. The auto union gave up on it, and are out of it. Brandon Films is reported to have made a lot of money on it.

JF: Tell me about your own work.

JH: I was hired originally as creative head of UPA, as the layout director. For about a year after I was there, we were doing the Navy films. There was an internal fight between the owners of the company. They got into a hassle about direction and policy and they split. Stephen Bosustow went out and raised the money to buy them out. As I understand it, he felt he could raise the money provided I stayed there as head of production. His money source said you can buy it if you keep the staff. I was the staff! The other two owners were both creative filmmakers, but they were leaving. So he came to me and made me a stock deal, and I stayed in. Part of the arrangement in my contract was to become head of production, to get a percentage of the stock, and to have a position on the board. That's when I really moved into a management position in the company. The other two guys moved to New York. We kept making industrial movies. Bob Cannon was there off and on; then he'd go to Warners and work some; then to Disney for a while. Different guys were floating in and out. Then along came the Columbia Pictures deal, which was the old Screen Gems. We were able to sign a contract with them to produce six to eight shorts on a participating basis. They owned these old animal characters—the Fox and the Crow—and they wanted to keep the series going. By this time we were really feeling our oats. We had done the Navy films, *The Brotherhood of Man,* and had the impetus of a new style and a new way of thinking about characters, stories, music, art, design, everything! That interested Columbia, too. They were ready to go with something new. So the first one with the Fox and the Crow was *Robin Hoodlum* [1948]. The Fox as Robin Hood, the Crow as the Sheriff of Nottingham. The Merry Men were a sanguine bunch of tea-drinking Englishmen. It was funny and very sophisticated. Columbia didn't like it—it wasn't a standard audience film. We made another one called *The Magic Fluke* [1949], which was a more popular story. We were using very modern techniques even though we had to use the conventional characters of the Fox and the Crow. We were doing very modern backgrounds with flat patterns, opaque paint. After *The Magic Fluke* we kept hitting Columbia with, "We want to do original shorts and we're stuck with tired animals. Our strength and our vision is to do human characters." We talked them into doing our first Magoo. It was a

bit of a compromise, because we had an animal in it. It was the old *Ragtime Bear* [1949]. The nearsighted old coot goes up into the mountains for a rest. He takes his nephew, a banjo-playing college kid in a fur coat. Magoo mixes him up with the bear; the bear loves that banjo, and the bear keeps trying to get at it. It was a lot of fun, with the voices of Jim Backus and Jerry Hausner. That was the beginning; the pressure was on to get into a series. We started making Magoos. I made (produced-directed) about four more. By that time I was tugging against them. I was instinctively against the idea of a series, of having to repeat things with the same character. Also the studio kept getting bigger as it got more successful. I was really getting spread too thin and was getting no creative work done; too busy being an executive. We arrived at a joint decision of a split between Cannon and me, making two units, each independent. So for several films we did our own thing. But *Gerald McBoing-Boing* [1950] was one of the last of my supervisory period. Cannon was the actual animation director. He really did a great job on that—it was his own personal style. The first thing I did when I got back to directing was *Rooty-Toot-Toot* [1952]—the Frankie and Johnny legend—the shooting of Johnny and trial of Frankie. This was pretty well made. It might be called sexist today. A guy by the name of Phil Moore did the music on it. To my knowledge he was the first black composer to work directly on a theatrical cartoon and to get a screen credit for his work. And then I did a few more Magoos. Then a job called *The Fourposter* [1953] came in, which was a series of interscenes in the Stanley Kramer movie with Rex Harrison and Lilli Palmer, a way of mixing animation with live action.

JF: What happened to Magoo?

JH: The first three or four of those were really great. Developing the character was sort of a creative surge. But it got into a very rote style after a while. They just took very limited aspects of the character—mostly his nearsightedness—and hung onto it. His strength was the fact that he was so damn bullheaded. It wasn't just that he couldn't see very well; even if he had been able to see, he still would have made dumb mistakes. When they started cutting the budget, they used very simplistic animation and the gags became obvious. The simplified nature of the UPA style was due to the fact that we were working on lower budgets. We had to find ways of economizing and still get good results. So we cut down on animation and got into stylized ways of handling action. All of which became a basic pattern for the television daytime serial stuff. It was a natural development for lower budgets. There's no substitute for full animation. What the character can do if you make use of full drawings is really irreplaceable. You just can't fake it. Previously, we used to dream up a lot of subtleties and we ad-libbed a lot of the dialogue.

JF: Then your ad lib technique for dialogue started as early as Magoo?

JH: Yes, I'd say it started with Jim Backus in a limited way. We'd throw him a line and let him play around with it. He'd take about five times more than we'd need, and then we'd go back and decide what we'd use.

JF: When did you and Faith Hubley begin working together?

JH: The first one was *Adventures of An* * [1957].

JF: Faith, we've been talking about John's career up to and including UPA. Now I want to find out what happened after. What is your background in art and in films and how did you and John get started together?

FAITH HUBLEY: We met in Hollywood in 1946 or 47. I was editing a film called *Human Growth* on sex education (I think it was the first) produced by Eddie Albert, directed by Irving Lerner, and UPA did the animation. I started as a messenger at Columbia, in Hollywood, sound effect cutter, music cutter, a film editor, script supervisor (continuity), and an associate producer. I worked on *Twelve Angry Men* [1957] as script supervisor. So my background is in live action, editing, and production, and I studied painting at night. When John started to work on *Finian's Rainbow*—an animated feature that never got made—I was hired as his assistant. We were married shortly after that and we continued working separately, some together. I went to the Art Students League for four years at one point, while working here in the afternoons.

JF: Were you interested in art all the way back to age three like John?

FH: Art and music.

JF: When did you form your own company? Was that the next thing that happened?

FH: There's one step in between that he really ought to tell you about because it's his life and I might not do it properly. The period preceding our move back to New York, he had a company that made principally commercials. I have much stronger feelings than John about the risks of spending one's life in adver-

Faith and John Hubley's *Adventures of An* * (asterisk, 1975). Copyright © 1957 Hubley Studio, Inc. (Photograph courtesy Faith Hubley)

tising. We made a compromise when we moved to New York: we would try to make one serious film a year and do whatever else we had to do to support that film. The first film that we made together was *Adventures of An **.

JF: Do you maintain that commitment?

FH: Yes. If you're a painter, you don't presell your canvases, you just feel you have to work. Sometimes you have commissions, sometimes you don't. The same is true in filmmaking. If you are going to grow, stay alive, remain sensitive, and valid, you have to keep working seriously.

JF: How do you split up the work on a project?

FH: I think John makes the major aesthetic contribution. We both work on storyboard and concept. We both work on sound track. In most cases, John is the director, and I'll help in any way that I can. I'll be production organizer and see that the work gets finished on time. The last film that we made, *Cockaboody*, was the most evenly divided. It is conceivable in the future that we might make films apart from each other, but it's been such a struggle to keep that one film a year commitment that this intense kind of collaboration has been fruitful and necessary.

Adventures was commissioned by the Guggenheim and financed jointly, but it was a big work of love. *Tender Game* [1958], we started ourselves. *The Hole* [1963] had no sponsor. *The Hat* [1964] had a sponsor. *Of Stars and Men* [1963] was absolutely ours. *Tijuana Brass* [1966] was kind of a commercial. *Urbanissimo* [1966] was commissioned by the Central Housing Mortgage of Canada, and it was a serious film on which we worked very hard and loved. *Zuckerkandl* [1968]—half and half with the Center for the Study of Democratic Institutions. *Windy Day* [1967] was ours with a little bit of help from Paramount. *Harlem Wednesday* [1957], we did ourselves. *Eggs* [1970], we did ourselves. *Cockaboody* was made in partnership with Yale—a labor of love, again jointly financed.

JF: Do these movies pay off?

FH: *Moonbird* [1960] is fourteen years old, and it just cleared itself this year. The others, no.

JF: What is most special about your working arrangement?

FH: I can only speak for myself. It's given me a lot of freedom and has been gratifying in terms of expression and how I organize my life. And it's been terrific, being a woman, and being able to have a studio near home. Our kids have all worked here; they can draw, paint, and do voice. It's been like an atelier.

JF: Do you and John do most of the work?

FH: It depends on the project. *Windy Day,* for example, I inked every drawing and sent out for the coloring, because the line was so important. *Cockaboody,* the same. We try to keep the staff at half a dozen. This work is highly personal and it suffers terrifically if it gets farmed out to strangers.

JF: Would you like to do a feature? *Fritz the Cat* [1972] and *Heavy Traffic* [1973] did quite well.

JH: I don't happen to like that level of film, but I can't say I was bored. They made a lot of money, and that has changed a lot of conditions. The industry as such has had a prejudice against animated features. They felt Disney was the only

animator that could do them. Since the UPA days we've had feature projects we would try to get off the ground. We wanted to do *Gulliver's Travels* and had a whole Thurber package. We optioned the rights to some of Thurber's short stories. After I left they finally made one—*The Unicorn in the Garden* [Bill Hurtz, 1953]. It was excellent. But we just couldn't break through the distributors and convince them that a new feature would be commercial. Now there's a climate for it. Faith isn't terribly interested. She doesn't feel a great need to make a feature. Faith's terribly imaginative with writing and ideas, but she's inclined to be uncommercial. At least that's been our past experience.

JF: Where do you get your ideas for visuals?

JH: We scratch around for an image that plays dramatically (a visual metaphor) and that will develop into a scene. Take *The Hole*'s premise. It's a scene, that's all. A couple digging a hole in the ground get into a conversation. That came out of an observation. We had an office on Riverside Drive and 87th Street on the ground-floor corner. We came to work one morning and there was a pneumatic drill right outside the window, busting up the sidewalk. The five workmen stayed there for two or three days, and since I couldn't work, I went out there and started talking to these guys. I started watching them, drawing pictures of them, and gradually got more interested as the sense of what they were doing unfolded. About the same time, this distributor Brandon came around and said if you had a film that dealt with the danger of a nuclear accident and with the whole hysteria that is in the air right now (that was around the time of *Fail Safe*, the Cuban missile crisis), it would really be very successful. They agreed to put up some money to get started. We recorded the sound track and went into the visuals. The visuals were out of this experience with the Con Ed guys.

JF: How has your style evolved?

JH: The graphic attempt, aside from the UPA breakthrough of style from Disney, has always been a tendency toward the modern aesthetic influenced by painters. In the early days it was Picasso, Dufy, Matisse that influenced the drive to a direct, childlike, flat, simplified design rather than a Disney eighteenth-century watercolor. I also always had a terrific rebellion against the sweet sentimental chipmunks and bunnies idiom of animation, saying, "Why can't these be human caricatures and get the same vitality in animation characters that still drawings have?" *Snow White,* especially, began to promise that; the dwarfs had a lot of vitality. Then a Russian cartoon showed up on the Disney lot one day, brought by Frank Lloyd Wright. It was very modern, with flat backgrounds, highly stylized characters, modern music. It was very exciting and had a big influence on me. The Air Force experience was a break that started in that direction. The UPA experience was really a chance to do it, and it paid off. Then we were doing *Finian* and my impulse, with the help of Faith, was to develop the visual art even further than the UPA films had. The need to break through and to play around with more plasticity led to *Adventures of An *. We were commissioned by the Guggenheim Museum to do a film that would say "There is more than one way to look at things." We decided to do a film with music and no dialogue and to deal with abstract characters. We wanted to get a graphic look that had never been seen be-

fore. So we played with the wax-resist technique: drawing with wax and splashing it with watercolor to produce a resisted texture. We ended up waxing all the drawings and spraying them and double-exposing them. We did the backgrounds the same way. It photographed with a very rich waxy texture, which was a fresh look. That film hit European animators like a bombshell, and pow!, it set them on fire. For a while that little * became a symbol in Europe of the breakthrough for animation. From that point on artists started exploring millions of different graphic techniques. So for our own films after that, it was always the question of finding a slightly different technique. *Tender Game* went to another direction: segmented figures. In *Children of the Sun* [1960] we got into oil-painting techniques. In the later years some of our films (*Urbanissimo, Zuckerkandl, Tijuana Brass*) had a tendency to be a little more standard and repetitive in style, partly because they dealt with a content that needed an illustrative form; one couldn't go abstract. It forced us to go back to line again. *The Cruise* [1967] went fairly far out in character design. *Windy Day* had its own spacious look to it, and that was the bottom light and washy watercolors. *Cockaboody* is cutouts—we painted on paper. I'm hoping to get back to ideas that will enable us to make some more exploration in graphics . . . new ways of animation, ways of breaking a figure down and moving it. If you look at the recent Picasso work, you'll see how he breaks faces up and makes huge inner shapes within the faces. I can see animating those kind of shapes inside of a form and letting it gradually reveal a character. That's a direction I want to explore, as well as the surrealist design of character. Why can't a character be made of a lot of crazy odds and ends if he talks and moves around and is interesting?

JF: Like the god image in *Eggs?*

JH: Yes. We tried to make it as cosmic as possible and have aspects of all godlike imagery. We had a lot of trouble with that voice. People said that they couldn't understand it, which was absolutely deliberate. That was done on a frequency modulator which actually takes the voice and reproduces it in thirds and fifths, so that when it was talking it sounded like a chord.

JF: In developing that figure of god, did you both work on that together?

JH: Absolutely. I drew the concept of the god figure image originally, but the first drawings I did were sort of the Michelangelo god. It was Faith's idea to do a god with three faces and all kinds of mouths and it made a terrific difference.

Reminiscing with Walter Lantz

by DANNY PEARY

Walter Lantz likes to tell about the time when, following a showing of a Woody Woodpecker cartoon to a large group of children, he asked the youngsters to name their favorite cartoon character, and they all called out: "Mickey Mouse!" But Walter Lantz has no regrets. If he had managed to finance feature-length cartoons, he might well have been as famous as Walt Disney, but even now he is the one animator other than Disney known around the world, and the only other animator to be honored with a special Academy Award for lifetime achievements.

An American institution in his sixty-fifth year in the cartoon business, his fifty-third year affiliated with Universal Studios (the record time for a studio-producer relationship), and his thirtieth year as an independent producer, Lantz does not want to stop making cartoons. After 1,100 cartoons, he still enjoys the work. "When I retire," Lantz often says, "I'll probably sit on a bank and fish." But then he'll reconsider. "Or maybe I'd rather not retire and continue to make cartoons."

I began drawing cartoons when I was eight years old, and when I was twelve took my first correspondence course in cartooning. In another year I wrote off for the Langdon Animation Course that was being advertised. They sent me about fifty blank sheets of paper and some rough sketches to study and develop. So I continually practiced my drawing.

I was hoping to find work in animation some day, but I couldn't do that in New Rochelle, where I grew up. Finally I went to New York City in 1915. By then there were such cartoons as *Mutt and Jeff* and the Terrytoons, and animation had become a major field.

In New York I got a job as an office boy for Hearst's *New York American*. When Gregory La Cava, who had been working on *Mutt and Jeff* cartoons, was hired by Hearst to set up a cartoon studio, I went to work for him. La Cava was a very talented man who contributed more in the early days of animation than anyone. He was the one who started the really loose style of animation. We didn't create new characters under La Cava, but used famous characters that were featured in the Hearst newspapers. We used the Katzenjammer Kids, Krazy Kat, Happy Hooligan, the characters from *Bringing Up Father, Jerry on the Job,* and so forth. However, all the stories we did were original.

I really started animating on my own when I was about eighteen. On my own—I mean that I was one of a group of animators working for Hearst. Others such as Bill Nolan, Grim Natwick, Frank Moser, Jack King, and George Stallings later became the top men in their field. We'd have huddles with the directors and work out story bits that La Cava would bring together. We'd knock around an idea and develop it in one night. The next morning we'd have a stenographer write out the story and then we'd put it into production.

We didn't have any theories that we discussed in those days. I'd just animate a scene, and say to Nolan, "Look, Bill, I'm taking 'em up from the left and you pick 'em up from there." And he'd animate a scene and tell the next animator, "I'm taking 'em out from the right and you pick up the action from there." And that's how we turned out cartoons.

These cartoons stood up very well in the theatres. Of course, we didn't have any sound—the dialogue was usually shown in balloons or with titles—but the gags were quite good for the period. You see, we didn't go in for slapstick, the broad humor of later years. Our stories were straighter and we put most of our comedy into the dialogue. In those days we didn't know what a *real* gag was, or what "topping a gag" meant.

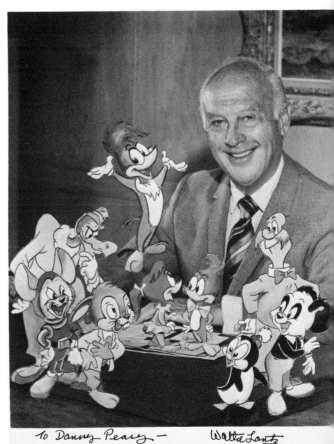

Walter Lantz with some of his most famous characters. © Walter Lantz Productions. (Photograph courtesy Walter Lantz)

To Danny Peary — Walter Lantz

When our animators went off to World War I, the only ones left at Hearst were La Cava, Stallings, and myself. La Cava was making Silkhat Harrys, Stallings was making Jerry on the Jobs, and I was assisting them both. When Stallings left, I was given the Jerry on the Job cartoons. They each ran 250 feet, and I had to write, direct, animate, cut film, project, and do practically everything other than producing the cartoon. But I wanted to become a producer because I wanted absolute control of my pictures.

I really became a producer when I started working for J. R. Bray's studio in 1922. There I created the Dinky Doodle series, about a cute little boy who had a dog named Weakheart. The unusual thing was that I played in the cartoons as a live character seen in situations with cartoon characters. Mr. Bray wanted this live-action sequence so I had my first opportunity in cartoons to experiment. The Fleischers were using a live person in their Out of the Inkwell series, but they used an entirely different process than we did. What I did was photograph all of my action in pantomime on eight-by-ten stills. Once these stills were developed, we would animate our characters right over them. Then we'd rephotograph each still with each drawing.

People really started to know my name because of Dinky Doodle and other series I made for Bray starring Pete the Pup and Colonel Heeza Liar. They all played in first-run theatres. I produced over one hundred cartoons during the four or five years I was at Bray.

After that I worked briefly for Mack Sennett in Hollywood, as a gagman and animator. When Walt Disney left Universal to produce Mickey Mouse on his own, Carl Laemmle asked me if I would set up a cartoon studio on the Universal lot. I'd had ten years' experience working in every phase of animation from washing cels to sweeping floors. So it didn't scare me to take over a studio; I knew what I was doing and was sure I could produce presentable cartoons.

Universal didn't have any drawing boards or desks or cameras or anything. They didn't know a darned thing because Disney had produced his cartoons off the lot. So I had desks built, and other equipment brought in. The only problem I had was getting a staff together. But I knew quite a few animators, so I had some like Jack King, Bill Nolan, and Clyde Geronimi come out from New York. And I hired many out here like Friz Freleng, Harman and Ising, and R. C. Hamilton.

I didn't have any problems at all when I took over Oswald from Disney (he was Disney's character but Universal maintained the copyright). Disney's Oswald was a black rabbit with long black ears, but Universal thought we could change him and make him cuter. So I designed an entirely white rabbit. His mannerisms and features were different, and so were the stories. But we did retain the name Oswald.

In 1930, Universal produced *The King of Jazz,* featuring Paul Whiteman. And they wanted a cartoon prelude showing how Whiteman became the "king of jazz." So I made that sequence. It was the first time Technicolor produced an animated cartoon in color.

My first really big success was a cartoon called *The Jolly Elves* (1933). It was also produced by Technicolor and used the two-color process, which consisted of

the colors red and green. It got an Academy Award nomination, but Disney got the award that year for *Flowers and Trees* (1932), which used the three-color process.

I was very satisfied with my own accomplishments by the early thirties. I was just past thirty and already manager, director, and producer of my own cartoons for one of the biggest studios in the business. I operated my studio differently than Disney, Fleischer, or anyone else. It was like one big family. When I was producing the Oswalds, I had 120 people working under me, and I knew everyone by their first name, and they called me Walter. Later, after I went into production for myself in 1937, I had a staff of 50 to 75 people. When I discontinued production about five years ago, I had people who had been with me for twenty-five, thirty, and forty years. I never fired anybody who worked for me. If anybody wanted to quit, it was because he just thought he could do better at another studio. But he usually came back.

There were times when I would have liked to have produced a feature cartoon, but I couldn't get anyone to put up the money I required. In the forties, I remember, Universal had the rights to *Ali Baba and the Forty Thieves,* and I thought it would make a wonderful feature. I was going to treat it like a comedy. I wanted to use caricatures of Abbott and Costello who were Universal's top stars at the time. And I was going to have four or five thieves act like real burlesque comedians. But when we got down to figures, Universal only wanted to spend $400,-000 and I needed at least a million. We could have done the things Disney did but no one had his money. Disney had his own studio while I was on a weekly salary; if we went over budget, I was sure to hear about it.

But Universal did have great faith in me, and gave me a free hand with my cartoons. I had full say as to the content and was able to create many new characters. Sometimes you'll see a story I used repeated in a Warner Brothers cartoon or in a Tom and Jerry. (This is especially true when you employ a free-lance storyman. He'll sell a story to one studio, and then he'll adapt the same story to another studio's characters and sell it again. And the second studio will produce what is virtually the same picture.) So I think that the main reason anybody can recognize my cartoons is my characters.

Andy Panda and Woody Woodpecker were the two characters that really caught on. I guess the reason Andy became so popular overnight was that no one had ever animated a panda before. He was a hit right from his first picture, *Life Begins for Andy Panda* (1939). He was a natural. He was cute and had a nice voice and always treated his father as if papa didn't know what he was doing. He was smarter than his father—and kids liked that. When Andy started out, he didn't wear any clothes, but later on we gave him a hat and had him put on a pair of pants so he'd look different from other pandas.

Andy Panda never did the rough things Woody did. Woody Woodpecker is an entirely different character. He's precocious, he's fresh, and he likes doing things that are just within the law—things we'd all like to do but don't have the nerve. Woody appeals to just about everybody. I've never seen a character work so well in foreign countries; he's a universal character. I've seen him in theatres all

over the world, sometimes speaking a foreign language, and he gets laughs at the same moments that he does in this country.

My wife, Gracie Stafford, was very instrumental in helping me create Woody. The story is so old now about how a woodpecker pecked on our roof and how we had to buy a new roof and how we tried to get rid of that woodpecker. And because of this incident, Gracie suggested that a woodpecker could make a fine cartoon character. I agreed with her, so I drew a woodpecker and named him Woody. And, of course, Gracie became his voice.

I knew that Woody would be popular at the very first preview of his first film, *Knock, Knock* (1940), an Andy Panda cartoon. Woody went over so big that the audience just howled. You mentioned that the early Woody reminds you of the early Daffy Duck. I don't even compare the two because Woody's personality is entirely different from Daffy's. Woody never really bothered anyone until he was taken advantage of. Then he really went to work on that person. Woody was a little wild at the beginning and he was really raucous and loud in all his actions. But he was never as wild as Daffy Duck.

It's hard to explain why Woody was designed as he was. I guess we considered woodpeckers as being really wild destructive creatures (which they aren't if you get right down to it). I began to realize that his features were really ugly. So over the years we changed him. I think La Verne Harding, who was my only female animator, had a lot to do with it. She was an animator for me for about twenty-eight years, and helped greatly in refining Woody. And then I also had a darned good layout man by the name of Art Heineman, who said, "Walt, why don't we leave off a lot of the colors we have in Woody? Simplify him. Make him red, his bill yellow, and his body just blue and white." We did that in the fifties, and Woody hasn't changed much since.

Chilly Willy is another successful character I created. For years we didn't have him talk. He did all his actions in pantomime, which was very difficult for us. It takes an awful lot of drawings and experienced animators. You noticed that I used many female characters. But we couldn't use pretty girls too often because it took a lot of time to animate them properly. But the women we did turned out great. Grim Natwick. My! He could draw pretty women better than anyone I knew. In fact, he drew most of the females in those black cartoons I produced.

I produced around twenty-six musical cartoons, and I would say about eight or ten of them were with black characters. We used very modern music in them, written by Darrell Calker, and these cartoons went over extremely well in theatres. I never received one letter from anyone who was offended by our use of black characters. But when we went into television, sponsors were reluctant to show my cartoons, figuring blacks would object. But they never tried it, so they never really found out.

I never did anything that was detrimental to anyone. Maybe one of these days TV will show these cartoons; I don't think there will be any problem because even now PBS shows my own personal favorite cartoon *Boogie Woogie Bugle Boy of Company B* (1941) about once a month, and we've gotten wonderful reactions to it.

Andy Panda in Walter Lantz's
Playful Pelicans **(1948).**
© **Walter Lantz Productions,**
Inc.

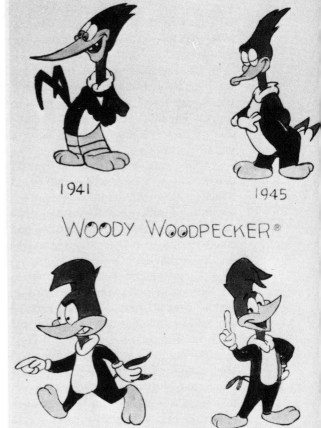

1941

1945

WOODY WOODPECKER®

1950

1960

The metamorphosis of Woody
Woodpecker, Walter Lantz's
most famous character.
© **Walter Lantz.**

I never had a character that, I would say, failed me. The reason I discontinued using some of my characters was that I was only producing thirteen cartoons a year. During my last four or five years, I was limiting myself to seven Woody Woodpeckers, three Chilly Willys, and three Beary Family cartoons.

I've had great success with TV shows. The first "Woody Woodpecker Show" I produced was in 1957. For each of the twenty-six shows I had a five-minute segment in which I showed every phase of the production of a cartoon. These shows played for about eight years. Then I put together another twenty-six shows. This time I showed five minutes of funny newsreels I dug up. That went over well. Later we all got into a hassle about violence in animated cartoons shown on television.

The Beary cartoons haven't played on TV yet, but I think they'll be popular. Paul Frees does the voice for the father bear, Charlie Beary, and his son Junior, and Gracie does the voice of the mother, Bessie Beary. Charlie is the type of character who won't pay to have anything done. If the TV doesn't work, he won't call a repairman, but will try to fix it himself, and end up blowing up the house. That is the basis for all Beary pictures.

I like to give everybody credit who has worked for me, because without these wonderful people I could never have been as successful as I was fortunate to be. Gracie Stafford, June Foray, and Daws Butler are marvelous talents who contributed a lot of voices to my cartoons. They never got the credit they are really entitled to.

I had wonderful musical directors like Jimmy Dietrich. He wrote my score for *The King of Jazz* prelude. And then Frank Marsailles and Frank Churchill left Disney for a while and wrote scores for me. And Clarence Wheeler and Darrell Calker. The last one I had was Walter Green, a very, very talented man. These musical directors must compose an original score for every cartoon. And, I tell you, that's not easy.

I had several excellent writers. Bugs Hardaway was the head of my story department at Universal for maybe ten or fifteen years. And there was Milt Shaeffer. And Sid Marcus was a good storyman and director. Cal Howard was one of the funniest men I ever met. Dalton Sandifer was very broad in his comedy. He's with Hanna-Barbera now. And, of course, there was Homer Brightman who wrote more Woody Woodpeckers than anyone else. He must have written a hundred of them.

The animators certainly contributed an awful lot to my pictures. Bill Nolan was very influential to the early Oswald cartoons. I had other excellent animators such as Frank Tipper, Ray Farringer, Grim Natwick, Ray Abrams, Don Patterson, and Les Kline. I don't think any other female animator could compare with La Verne Harding.

An animator is like an actor going before the camera, only he has to act out his feelings and interpret the scene with that pencil. Also he has to know how to space characters because the spacing of their movements determines the tempo; he must know expression; he must know feeling; he has to know the character, and make him walk with a funny action.

And what makes a top director? Not only an ability to draw and to be a good actor, yet, even further, to be a good comedian. Alex Lovy was one of my top directors. I think he has more on the ball than almost anyone in the industry. Manuel Marino was an excellent director I had back in the mid-thirties. I also had Jack Hannah and Dick Lundy. I consider Paul Smith, James Culhane, Alex Lovy, and Tex Avery the most outstanding directors I used because they were more than directors. They were talented artists. They would make their own layouts; design their own characters; and work on the stories in their own special way. They always had control: they knew how to get light and shade in the story; where to pick up the tempo, and where to slow it down; and how to keep a minimum of dialogue in the picture.

Tex Avery was an entirely different breed. He was a great storyman who liked to work out his own stories. Mike Maltese, one of the best writers in the business, worked with Tex but they didn't see eye to eye. They each had their own way of doing things.

The reason Tex didn't work out too well for me was that he insisted on doing one-shot deals, instead of developing a particular character and staying with him for several cartoons. That has no commercial value. Comic books are not interested in featuring a one-shot character. And you wouldn't get any licensee business that I have for my cartoon characters. The only way you can have by-products is by creating a famous character, and Tex never did that. He did make some of the funniest pictures that have been made, and I admire his work very much. He's a very good friend. In fact, at one time I wanted to set up Tex as an independent producer here. But he didn't want to take a chance; he didn't want to gamble. He was interested in getting that paycheck every week. It's too bad because if Tex had stayed with me, I think he would have been one of the top producers in the business, and would have become a very famous person.

Now onto the subject of violence. I never considered any cartoon I produced too violent. I thought of them as slapstick comedies. I didn't know what slapstick was until I came out here and worked for Mack Sennett. Then I realized that it took pratfalls and socks on the head and being shot at to get big laughs in the theatre. The pies in the face, and so forth. So we just went one step further and exaggerated the gags. It takes a physical gag to get a belly laugh. In cartoons especially, you don't get it very often with just dialogue.

I wouldn't say that the Tom and Jerrys, the Bugs Bunnys, the Popeyes, or the Disney cartoons were violent. They used the same techniques that I used. Nobody really bleeds or dies in these cartoons. If someone is shot full of holes, he is back to normal in the next scene; if his teeth fall out, he has a full set an instant later. The trouble today is that these groups have set themselves up as censors, and they don't know what they are talking about, because they don't look at these cartoons through the eyes of children. They should be home taking care of their kids instead of setting themselves up as critics.

I think I've helped contribute to the cartoon field I've loved all my life. I feel I've brought an awful lot of enjoyment to people all over the world. I'm very grateful that I've been accepted by them.

In the early days we got a lot of fan mail. It slowly petered out, but built up again when we went on television. I get letters from kids living all over the country. They want to know where Woody sleeps, what he eats, and whether he's just as fresh at home as he is in the movies. I always answer these letters and send the young children a picture of Woody or an autographed photo.

One thing that I enjoyed was when Gracie and I went overseas in 1968 to entertain the wounded boys. We visited twenty-seven hospitals in twenty-six days. We visited some hospitals in the DMZ where they only had about twenty men, and they hadn't seen anyone from Stateside in over a year. And Gracie and I went there in a helicopter and spent a day with them. We went to the Philippines, Guam, Korea, and Vietnam. It was really worthwhile to see the joy Gracie and I were able to bring these young men, some who would never walk or see again. We were able to spend five or ten minutes with them and give them something they'll always remember.

Recently, we made a tour of Texas, Oklahoma, and New Mexico, and visited hospitals where the World War I and World War II vets were. Some of them were ninety years old. I'd draw a picture of Woody Woodpecker, and Gracie would do her impersonation of Woody for them. These people really look forward to something like this. We went to hospitals where they hadn't seen a celebrity in forty years.

In 1977 we attended the Special Olympics in Los Angeles, where 2,600 handicapped children competed in numerous sports contests. I drew a picture for the kids and Gracie did her Woody laugh for them, and they took a Polaroid picture of a youngster and myself and gave it to the child. Now that was something more rewarding than producing cartoons. These are things that I get out of this business. Next week we are going down to the Orthopedic Hospital and run some cartoons and talk to the children there. Gracie and I are fortunate that we are still healthy, so we can continue doing such worthwhile things.

Gracie and I were thrilled by the tribute given to us in 1977 at The Museum of Modern Art in New York. That was a real thrill, and even when we got back to the hotel there were young people waiting to get a little drawing of Woody Woodpecker. So you see, it goes on and on.

Strike at the
Fleischer Factory
by LESLIE CABARGA

The following excerpt from my book The Fleischer Story *represents, literally, one chapter in the total picture. It would be unfortunate to form an opinion of the Fleischer brothers from the limited description here. Their reaction to the strike in 1937 was about typical of many of the employers similarly affected in that year when union organizing was widespread. In the larger scheme the Fleischers were loved and respected by the persons working for them. That the "good" cartoons reflected so much the personalities of the brothers is proof that each was intimately involved with the animators and storywriters in the creative process.*

<div align="right">L. C.</div>

In April 1935 *The Animated News,* the in-house organ of the Fleischer Studio in New York City, contained open letters from Max Fleischer and his animator Tom Johnson. They were responding to a pamphlet sent to members of the studio by the Animated Motion Picture Workers Union, the first attempt at organizing the studio's labor.

Johnson's letter, addressed to the so-called union, stated:

> The things that struck me most forcibly in your paper were your black jack [*sic*] and brass knuckles attitude and your communistic "Let's take it" platform and your unfounded attack on Max Fleischer in the Dan Glass Case.

(Glass had been at the studio for two years, working long hours for around $14 to $16 a week, when he became ill and had to leave, eventually dying from tuberculosis. The Animated News Relief Fund, established in the second issue of the *News,* sent its first payment along with Glass to his home in Arkansas.)

Johnson's letter further argued:

> I don't think this "Let's take it" attitude would be good for either the business or my career. Max knows what he can pay to keep things going steadily. With over twenty years' experience in the animated cartoon field he knows how to nurse things along when necessary. Another thing: since I have been here the plant has never been closed a single day. You could put me on strike at will. I need my salary fifty-two weeks in the year. Can you guarantee that? Max Fleischer can!

Johnson's philosophy gives an idea of the close-knit "family" feeling that prevailed among some studio workers, particularly the animators, who had been long with the Fleischers. Max Fleischer replied to Johnson's letter with thanks:

> Your letter is more significant in the fact that it was written entirely of your own volition and in the further facts that you are in no way related to me, that you are not an officer of the corporation, that you are not in any managerial position and that you are one of our employees of five years' standing.

This exchange in *The Animated News* was only the beginning. In July 1935 the Wagner Labor Relations Act was approved by Congress, making lawful the employees' rights to self-organization—to form, join, or assist labor organizations and to bargain collectively through representatives of their own choosing. Unfair labor practices on the part of the employer included interfering with, coercing, or restricting employees in the exercise of their now lawful rights. Also an employer was prohibited from discharging or discriminating against an employee who gave testimony. Finally it provided for the formation of a National Labor Relations Board as the grand arbiter in labor disputes.

The Wagner Act served to fire further the discontent among workers that had been kindled with the onset of the National Recovery Act. By 1937 the country was exploding with strikes. The United Auto Workers and Chrysler and then General Motors struck; railroaders struck; the Hershey factory was hit by a strike; subway newsdealers called a sit-down strike, as did the Blind Workers' Union. And with increased union activities came shootings and muggings of unionists by loyal "anti-communist" workers.

Then in April 1937 the Supreme Court upheld the Wagner Act, declaring it was constitutional in all its sections. New York Senator Robert Wagner, who had fought two years for its acceptance, was jubilant. He declared in a radio address, "Let employers and workers come freely before the board with their difficulties." One month later over one hundred Fleischer employees announced that they had allied themselves with the Commercial Artists' and Designers' Union (CADU) and were filing a complaint against Max Fleischer for refusing to negotiate after hearing their complaints: they were working a forty-five-hour week with half days on Saturdays. They had no paid vacations and no sick leaves.

The union also contended that, although the animators had individual contracts and were paid $30 to $100 a week, others worked on a conveyer-belt system and were paid only $15 to $27 a week. To this Max Fleischer made the statement that he had no statement to make because he knew of no labor troubles involving his artists. "Anyone can come into my office with their grievances and/or personal problems and talk directly to me," wrote Max in his 1939 autobiography. But former head animator Orestes Calpini said, "After the strike Max retreated into his office. *The Animated News* stopped and the family feeling was gone."

The animators stuck with Fleischer. Dave Tendlar insisted:

> The strikers comprised only a small part of the studio employees (if not small in number, small in the functions they performed). There were a lot of people there who did not want to be organized. They were puzzled as to who these organizers

were and so for a while two factions developed; those that went with the studio and those that did not. This ended the happy camaraderie around the studio and marked the first time that there were any ill feelings between studio members.

Some animators were sympathetic with the unionists but were afraid to impair their standing with Max and Dave by taking a stand. Alden Getz, who had worked for the Fleischers and joined the union, described a pamphlet that was sent around to employers on "How to Break a Strike" based on the U.S. Steel strike that year. One method was to fire several of the unionists as examples, giving arbitrary reasons for their release (under the Wagner Act no one could be fired for union activities). Another method was to hire thugs and detectives to infiltrate and make the going rough for the unionists. A guard could be posted at the front door of the building so no one could enter without a special pass issued from the studio. All this the Fleischers did.

CADU's complaint turned to rebellion when fifteen Fleischer employees belonging to the union were fired. A strike was called and, on May 8, 1937 (the day of the *Hindenburg* dirigible disaster), picket lines formed outside the studio's offices on 1600 Broadway and 49th Street. Some of the signs (painted in the studio's art department and utilizing studio cardboard and wood) read: "I make millions laugh but the real joke is my salary." and "We can't get much spinach on salaries as low as $15.00 a week." Accompanying striking Fleischerites were members of the Longshoreman's Union, who helped out on the picket lines.

In the course of the demonstration that night, several nonstriking employees who tried to enter the building were engaged in fistfights with the strikers. Real trouble broke out later when ten policemen arrived to keep the picketers to one section of the sidewalk. The cops surrounded the picketers, knocking and kicking them about. A general free-for-all started and fists and placards were swung with abandon. Two thousand people gathered to watch the Fleischer employees utilizing their "twisker punches" on the police. "Peace" was restored after ten strikers were arrested and later four more were picked up for having allegedly assaulted a loyal Fleischer employee. Max issued a statement expressing shock that his workers felt underpaid. He claimed, "Inexperienced employees receiving the lowest pay are advanced after a short period to $40, $50 and some as high as $90 to $200 a week."

The arrested strikers were taken to night court. Then they were set free in the early hours of the morning. After the first big ruckus with the police, James Hully, president of CADU, sent a letter to Mayor LaGuardia deploring the police brutality against members of his union. The letter proved effective because at the next picketing (at the Paramount and Roxy theatres that were running Popeye cartoons) the police stood by as strikers blocked the sidewalks, forcing the public onto the street. The picketers sang, "I'm Popeye the Union Man."

On June 26, fifty strikers bought tickets to the Paramount theatre and began a raucous demonstration of booing and hissing as the Popeye cartoon flashed on the screen. One striker yelled, "Get that scab picture off the screen!" The din continued throughout the cartoon. At the end members of the audience broke into loud applause to drown out the opposition.

(Lou Appet, another member of the striking Fleischer staff, said that the

demonstrators were successful in getting some theatres to boycott the Fleischer cartoons, and he believes that the studio was significantly hurt by it.)

The police broke up another noisy demonstration outside the Fleischer studio's building on July 3 by arresting Ellen Jenson for felonious assault, biting and kicking an arresting officer on the left arm, and Helen Kligle for kicking and scratching Elizabeth Howson, a loyal employee. Seven men also were arrested.

The Fleischers began hiring cabs to pick up their employees. For a while CADU was able to get the cabdriver's union to resist picking up the scab employees of the studio but the drivers needed business and discontinued their help. A highlight of the strike was the stench-bombing of Dave Fleischer's house. One of the strikers told him later that they meant to bomb Max's house.

The strike was extremely hard on the union members, who received no pay throughout. Collections were taken up at other unions but because some had families to support, they broke down and went back to work. Looking back, however, those that were involved in the strike all seem to remember only the good times, full of optimism, determination, and companionship.

For example, there was a humorous day for the strikers, after the National Labor Relations Board finally stepped into the Fleischer labor dispute (after thirteen weeks of striking) and arranged for an election to be held within thirty days to see if the studio employees wanted CADU as their collective bargaining agent.

On August 5, 1937, they hitched a box kite covered with written appeals onto gas-filled balloons and hoisted it to the windows of the animation rooms.

At the predetermined time of 1:00 P.M. four reporters and a crowd that had gathered waited for the kite to arrive from the union's 34th Street headquarters. At 1:30—still no kite. Then word came that one of the knots fastened to the kite had slipped and the balloons lifted the whole thing skyward. Left were thirteen balloons that read "Vote CADU" and these were let loose at the foot of the

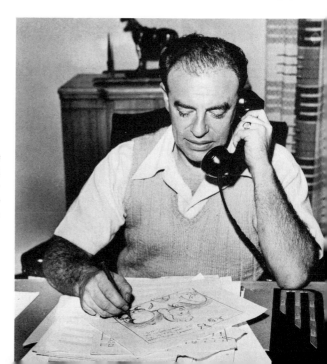

Dave Fleischer at the time he was directing (and Max Fleischer was producing) *Gulliver's Travels* **(1939). Copyright 1939, Paramount Pictures Inc.**

building to reach the animators' windows. The few that did were shot down with paper clips and rubber bands. Most flew up and away from the building.

When the vote was held, CADU was unanimously chosen as collective bargaining agent. But out of 129 studio artists eligible to cast ballots, only 74 did. The remaining 55 were the animators and their assistants who did not wish to be represented by CADU.

The next day, Max announced that he would challenge the validity of the NLRB's decision to have CADU as the bargaining agent. The animators had voted that they would not accept the union and the whole thing was unfair because the company wasn't represented. Max vowed that he would take it to court if necessary.

Yet, on October 1, the papers announced that the strike had ended by verbal agreement. But by the next day the agreement was rescinded and more picketing and scuffles with the police followed. A final contract was signed on October 13, after six months of striking.

The settlement forced major compromises from the strikers. Yet it was accepted, according to Getz, because "We were a hungry lot." The strikers received what they asked for, but in much smaller percentages. The key part of the agreement was that only those who wished to be represented by CADU had to be. That was about sixty-two percent of the studio. Ironically, even the nonstriking artists profited because the animators were given raises to prevent them from joining the union.

Then in December 1937 Walt Disney's first feature-length cartoon, *Snow White and the Seven Dwarfs,* was released. Paramount encouraged the brothers to think about making a similar film [the project would emerge as the full-length animation, *Gulliver's Travels,* in 1939.—Eds.].

The similarities between different studios' animation styles are apparent when one takes a look at the character on the left in a scene from the Fleischers' *Gulliver's Travels* (1939) and Disney's *Pinocchio* (1940). Copyright 1939, Paramount Pictures Inc. (Courtesy The Museum of Modern Art/Film Stills Archive)

A notice was sent around the studio announcing that new offices were being built in Florida for the purpose of producing a feature. "This came as a surprise," Alden Getz said, "Because when we were bargaining they said they had no money and then it seemed as if they had an endless amount." Max told the unionists they would be welcome in Florida because they were experienced and a lot of workers would be needed on the feature picture.

There were many reasons for the Florida move. First, because Florida was not much of a union state, union activity could be easily squelched without much government interference. Second, renting the space needed to produce the feature was much too expensive in New York. And third, Max had a vacation home in Miami and he liked the place. A final factor was the passing of a new bill onto the Miami books that movie studios were tax exempt for a period of several years. Later, Max told reporters that he moved his studio to Florida because he felt his workers would be more creative as well as happier and healthier in tropical surroundings. As he put it, "They need loose clothing so their imaginations can work."

BIBLIOGRAPHY

ADAMAKOS, PETER. "Ub Iwerks." *Mindrot,* no. 7 (June 1977).

BECKERMAN, HOWARD. "Whatever Happened to Ernest Pintoff?" *Filmmakers Newsletter* (January 1974).

BOSUSTOW, STEPHEN, and MAHON, JOHN C., JR. "American Animation Films Today." *Journal of the University Film Producers Association* (Summer 1956).

CROWTHER, BOSLEY. "McBoing-Boing, Magoo, and Bosustow." *The New York Times Magazine,* December 21, 1952.

CULSHAW, JOHN. "The Virtue of Flatness." *Fortnightly Review* (October 1953). [UPA]

HUBLEY, JOHN, and SCHWARTZ, ZACHARY. "Animation Learns a New Language." *Hollywood Quarterly,* no. 1 (1945–1946).

———, and LARDNER, RING, JR. *et al.* " 'Brotherhood of Man': a Script." *Hollywood Quarterly,* no. 1 (1945–1946).

IRWIN, NICHOLAS. "Walter Lantz." *Films in Review* (April 1971).

IWERKS, UB. "Movie Cartoons Come to Life." *Popular Mechanics* (January 1942).

KIESLING, BARETT. "They Paint a Million Cats." *Films and Filming* (November 1956). [Tom and Jerry]

KLEIN, I. "Cartooning Down Broadway." *Film Comment* (January–February 1975). [Van Buren Studio]

———. "The I. Klein Story." *I.A.T.S.E. Official Bulletin* (Autumn 1967).

———. " 'Screen Gems' Made of Paste—Memories of the Charles Mintz Studio." *Funnyworld,* no. 20 (Summer 1979).

KNIGHT, ARTHUR. "U.P.A., Magoo and McBoing-Boing." *Art Digest* (February 1952).

———. "Up from Daisy." *Theatre Arts* (August 1951). [UPA]

LANGSNER, JULES. "UPA." *Arts and Architecture* (December 1954).

MACDONALD, DWIGHT. "Complete Works of Ernest Pintoff." *Esquire* (April 1964).

MAYERSON, MARK. "The Lion Began with a Frog." *The Velvet Light Trap,* no. 18 (Spring 1978). [M-G-M cartoons]

OERL, G. "UPA, A New Dimension for the Comic Strip; with German and French Texts." *Graphics,* 9, no. 50 (1953).

SCHEUER, PHILIP K. "Walter Lantz Draws His Cartoons Just for Laughs." *The Los Angeles Sunday Times Calendar,* November 31, 1959.

SCOTT, VERNON. "Out of Sight, but Not Out of Mind." *The Los Angeles Times,* September 1976. [Jim Backus]

SELBY, STUART A. "Ernest Pintoff, Fireman." *Film Comment* (Summer 1964).

SELDES, GILBERT. "Delight in Seven Minutes." *The Saturday Review* (May 31, 1952). [UPA]

SMITH, DAVID R. "Ub Iwerks." *Funnyworld* (Spring 1972).

SULLIVAN, CATHERINE. "United Productions of America." *American Artist* (November 1955).

WEINBERG, GRETCHEN. "Interview with Ernest Pintoff." *Film Culture,* no. 31 (Winter 1963).

WINGE, JOHN H. "Cartoons and Modern Music." *Sight and Sound* (Autumn 1948). [M-G-M cartoons]

CARTOON
CHARACTERS

Seduced and Reduced: Female Animal Characters in Some Warners' Cartoons

by SYBIL DELGAUDIO

Had Gertie the Dinosaur *been an indication of things to come, female animal characters would, at least, have had a featured role in cartoons of the future. But Winsor McCay's 1914 film was the first in a very short line of cartoon abstractions that used female animals in starring roles;[1] and even Gertie suffered from "reductio ad femininam," forcing her (and later female animals as well) to act and react in stereotypically "feminine" ways. In* Gertie's *case, the choice of female dinosaur was essential, for it permitted McCay, by way of title cards, to chide and reprimand the character for her contrary "feminine" behavior, as the rock-throwing Gertie consistently disobeyed McCay's paternal orders to perform and "be a good girl."*

S. D.

Anthropomorphic characters are a step removed from human characters and require a certain degree of imitation or impersonation of human traits in order to succeed. Thus, Bugs and Daffy are, in a sense, impersonating male humans with respect to their values and behavior, just as Petunia (Pig), Minnie (Mouse) and Daisy (Rabbit) are impersonating female humans with respect to theirs. The major difference is seen in the degree and type of abstraction: whereas the male characters are abstracted to actions and "masculine" traits (for example, cunning, aggressiveness), the female characters are abstracted and reduced to physiological characteristics and recognizable "feminine" traits (for example, shrewishness, passivity). Therefore, female animal characters become immediately recognizable as "women" because of what Molly Haskell sees as the simplicity by which the concept of woman is identified. Haskell suggests that the idea of woman is identifiable by a "set of external playable mannerisms," whereas the idea of man "is as unlimited as the ocean" ("Women in Pairs," *The Village Voice*, April 28, 1975). Thus Bugs and Daffy as male rabbit and duck can be seen as trickster, cowboy, spaceman, among a thousand roles, whereas Petunia Pig and Daisy (both Duck and Rabbit) are reduced to the physiological and emotional characteristics associated with the idea of woman, complete with makeup, breasts, and susceptibility to seduction. Even when the androgynous Bugs impersonates a female in order to fool Elmer or Porky, his demeanor does not differ markedly from that of the "per-

[1] In Fleischer cartoons, Betty Boop began in the 1920s as half dog before quickly transforming into a woman.

211

manent" females—he is just a lot stronger, more physically aggressive, and a good deal smarter.

Most of the female animal characters are as unnecessary in the world of the cartoon as they are in buddy movies.[2] In cartoons, the female as comic foil for the male is superseded by all-male rivalries in which comic incongruity is created by means other than sex differences. Elmer and Bugs, man and rabbit, hunter and hunted; Sylvester and Tweety, cat and bird, predator and prey—all represent natural foils, and judging from the proliferation of such battling pairs (Coyote and Road Runner, Tom and Jerry, and others), the cartoon seems to be a favorite place for the depiction of the pursuit/capture plot structure. When female characters enter the picture, they automatically take their places in line with the pursued, while the means of pursuit is changed to seduction and the end is clearly sexual. In fact, if some male cartoons are about violence, it seems conceivable that some male-female cartoons are about rape—specifically, how funny rape is. Metaphorically speaking, this seems implied in the idea that it is humorous to see a male chase a female who doesn't want to be chased.

Until Popeye came to the screen, Betty Boop was the Fleischers' most popular cartoon star. Today she is regarded as the most interesting female character in the history of the animated cartoon. She had a pet dog named Bimbo; indeed, Betty, herself, had evolved from being a dog. Characters copyright King Features Syndicate.

MOST UNIVERSALLY POPULAR STARS IN ALL SCREEN-LAND!

Betty Boop

and

Bimbo

They've Captivated Millions! They've Set up a Kingdom in the Hearts of Young and Old!

[2] And there are male buddy cartoons: if no symbiotic Heckle and Jeckle team existed at Warners, Daffy was often paired in a squabbling friendship with Porky or Bugs. In Friz Freleng's *Tick Tock Tuckered* (1943), for instance, Daffy and Porky are factory workers who share the same flat.

Daisy Rabbit, in Freleng's *Hare Splitter* (1948), typifies the female cartoon animal. Fought over, yet unseen for most of the cartoon, Daisy (a Freleng invention) finally appears, looking no different than Bugs looked when he impersonated her to fool the dimwitted Casbah, a muscular rival rabbit. As with other female animal characters, Daisy's possibilities have been narrowly circumscribed by physiological and emotional traits. False eyelashes, red lips, hare ribbon, clinging skirt and sweater emphasizing her human breasts make it perfectly clear that Daisy is an abstracted "woman." The cartoon begins by suggesting that the best way to win a "woman" is to present her with more expensive gifts than the other guy. The male rabbits alternately pop erectly out of their holes, each carrying more elaborate gifts than the one before, until they can hold no more. Arriving at Daisy's place, Bugs spots her "Gone shopping" note and decides to eliminate his rival by impersonating Daisy. He uses makeup, affects a female voice, and acts generally "feminine." Bugs sees being a female in much the same grotesque way that the animators do—that is, in the exaggerated, garish garb of the transvestite—and has no difficulty in deceiving the horny Casbah. The one moment of recognition of woman's position-as-object is expressed by Bugs-as-Daisy while Casbah paws him. Looking at the camera, he asks, "Do all you girls out there have to go through all of this?" This question seems possible for Bugs because, at this moment, he is literally inside a woman's shoes. But his solution to the situation is one that would almost never be afforded to a female character: he uses extreme physical violence to extricate himself. By blowing up Casbah with an exploding carrot, Bugs makes use of an exclusively male weapon, which turns out to be sexually exciting to Casbah. His "Wow! Whatta woman!" is echoed later in the cartoon by Bugs and the real Daisy respectively ("Wow! Whatta woman!" "Wow! Whatta man!"), and Daisy eats the exploding carrot as the two jump with glee, having been driven to ecstasy by "the power of the carrot."

In the Pepe Le Pew series, directed by Chuck Jones, the female cat is constantly mistaken for a skunk by the persistent Pepe, who never witnesses the white paint or shoe polish accidentally making a stripe down her feline back. She is consistently on the run and out of breath as Pepe, a French chauvinist paramour modeled on Charles Boyer (Pepe Le Moko in *Algiers* [1938]) tirelèssly bounces after her, undaunted in his pursuit. However, she is rarely permitted the kind of retaliatory action afforded the Bugs-as-Daisy character. Rather, she weakens as the films progress, perpetuating the myth that unrelenting pursuit leads, inevitably, to final surrender and capture of the heart.[3] In *Two Scents' Worth* (1956), while Pepe's macho womanization of Fifi the cat is gently satirized by Jones in the dialogue ("Eet is not just a case of physical attraction—I admire her mind, too."), the cartoon ends with her fate uncertain as they parachute down together, Pepe blindly interpreting her terrified clinging as love. The cat finally strikes back in the Academy Award-winning *For Scent-imental Reasons* (1949). After falling into

[3] Jones said, in an interview with Greg Ford and Richard Thompson, "... Pepe always represented ... what I *wanted* to be, and what I think every man would like to be: irresistible, at least in one's own eyes. You don't have to be irresistible in women's eyes if you *think* you are ... [A]ll the girls I've ever known adore the Pepe character as a sex-object, you might say—he was really irresistible" (*Film Comment* [January–February 1975]).

a vat of blue paint, the scraggly cat is no longer attractive to fetishist Pepe. However, the cat gazes at Pepe in a point-of-view shot: he is objectified as a muscular, strongcat, and in a startling role reversal, she pursues him, affecting *his* casual bounce. The perplexed Pepe races away, wondering out loud about himself, "I guess there is such a theeng as being *too* attractive." Like *Hare Splitter, For Scent-imental Reasons* shows that even in role reversal, the male character cannot fully understand the female's position. Pepe interprets his situation in an entirely egocentric way, reversing the negatives of objectification into the positives of ego reinforcement.

In Frank Tashlin's *Plane Daffy* (1944) the female animal character is again in pursuit of the male, this time using her superfemme style to extract classified information from "American" pigeon fliers. Hatta Mari, the female spy-pigeon, is a seductive bird of prey whose stylized "womanly" features (long blonde hair, huge breasts,[4] shapely legs, and hourglass figure) create an irresistible force against the twenty-eight fliers who have already succumbed to her wiles. It is only "Daffy-the-woman-hater" who is able to counteract her compelling approach with his usual maniacal rantings. Here the female animal character is man's natural, as well as political, enemy, a physically overpowering force (she is much larger than the male characters she encounters) threatening man's essential self. Unlike the male animal characters, who pursue females for seemingly innocuous sexual ends, Hatta Mari's motives are more demonic, as she threatens not only Daffy's male ego (the retention of secret information by the male hero as the representation of loyalty, sense of honor, and courage was a value expounded in many noncartoon war films) but his duck life as well.

The seductio/reductio approach is carried to even further absurdum in Freleng's earlier *At Your Service, Madame* (1936). Widow Hamhock is visited by a W. C. Fields-like pig who has read of Mrs. H.'s recent inheritance, and intends to partake of its rewards. The only pig who doesn't see through his transparent approach is Mrs. H. Even her tiny piglets (all male) display far greater perception than Mama, who, blinded by compliments, gifts, and promises, plays an accompanying piano to the male pig's song. Here the message is clear: females can be won over by even such an obvious boar as this. The right approach includes flowers, candy, and other sweet nothings, both material and verbal, designed to break down the female's limited resistance. Again, the female can do little to extricate herself from the "seductive" male character, and must be rescued by her male sons, who torment and torture the Fields pig and finally eject him from their house.

In Frank Tashlin's *Swooner Crooner* (1944) female hens contribute to the war effort by laying eggs at the Flockheed Eggcraft Company. Here the females

[4] Tashlin said, in an interview with Peter Bogdanovich, "The immaturity of the American male—this breast fetish. You can't sell tires without breasts . . . We don't like big feet or big ears, but we make an idol of a woman because she's deformed [*sic*] in the breasts. There's nothin' more hysterical to me than big-breasted women—like walking leaning towers." (In Claire Johnston and Paul Willeman, eds., *Frank Tashlin* [Edinburgh: The Journal of the Society for Education in Film and Television, 1973]). Tashlin, placing himself among the guilty, later guided Jayne Mansfield through *The Girl Can't Help It* (1956) and *Will Success Spoil Rock Hunter?* (1957).

are reduced to the exclusive fulfillment of their biological destinies, as they contentedly produce and procreate. The appearance of a Sinatra-type rooster disrupts the mechanical productivity, and the bobby-soxed hens race out to hear their idol. One by one they faint, until production at the factory ceases completely. A frantic Porky advertises for a "singing rooster . . . to keep hens producing," and from a number of Chanticleer applicants, ranging from Durante to Jolson types, he chooses a Crosby-cock, complete with pipe and Hawaiian shirt. As Bing croons, the hens awaken, producing as they have never produced before. Even Porky gets into the act, laying scores of eggs himself! The suggestion here is that female duties for the war effort bear little resemblance to required "male" acts of valor and commitment associated with war. Females must do what they are biologically suited to do. Here again, the females are seduced by song (a metaphor for sweet talk). The end result is carried a step beyond the usual sexual goal to one of reproduction, but the message is still the same: females/hens can be sweet-talked/crooned into submission/production by persistent males/roosters until they reach states of ecstasy/procreation.

Another in the series of seductio/reductio cartoons is Frank Tashlin's *Porky's Romance* (1937), in which Petunia Pig is introduced into the Warners lineup of animal characters. The tight-skirted, large-breasted, rosy-cheeked Petunia initially rejects Porky, until she spots his oversized box of candy. Again, the presentation of material offerings and sweet nothings becomes enough to break down female resistance; but when Porky tries to reap his reward by placing his arm around Petunia, her dog literally pulls the rug out from under Porky's proposal. The male pig experiences a nightmare expressive of his fears of marriage: as "time munches on," Petunia, growing more obese with each bite of candy, progressively leaves more and more of the housework and child care to the poor, overworked Porky. As usual, when in role reversal, a male character assumes responsibilities generally assigned to females (for example, care of home and/or children), the experience takes on an air of horror.

Daffy Duck, too, has his problems with role reversal in Freleng's *Henpecked Duck* (1941). At his appearance in divorce court with a screaming, violent Mrs. Duck, he relates his sad story. Ordered to baby-sit on an unhatched egg while Mrs. D. goes shopping, Daffy magically makes the egg disappear. Unfortunately, he can't figure out how to bring it back, causing Mrs. D. to become frantic and enraged. As was the case in *Swooner Crooner,* when Porky parallels the productive hens by equaling their outlay of eggs, the male character is permitted to tackle an exclusively female task. In an all-out effort somewhat reminiscent of labor (a good deal of huffing, puffing, and straining takes place), Daffy produces the missing egg. An older hen's exclamation that she's been "doin' it the hard way for fifteen years" suggests that even in childbirth/reproduction, the male might accomplish the job more efficiently, if only given the chance.

When domesticated female animals do not embody the myth of the monster wife, they may more closely resemble the docile Mama Bear in Chuck Jones's Three Bears series. In the first of the group, *Bugs Bunny and the Three Bears* (1944), Mama's casual nightclothes do little to hide her sagging breasts. Her Edith

Bunkerish personality (throughout all the cartoons her repeated phrase, "But Henry, . . ." is reminiscent of Edith's plaints) changes radically when Bugs, trying to avoid becoming rabbit stew, appeals to her latent vanity as his only hope. He showers her with exaggerated physical compliments ("Your eyes . . . your lips . . . you're beautiful!"). Mama so loves the objectification that she protects Bugs, and in a few quick costume changes, joyfully becomes what she thinks Bugs wants her to be: the happy hooker, the blonde bombshell, the bathtub beauty. Her relish of the roles is evidenced by her pursuit of Bugs, from whom she wants to hear more. As in *For Scent-imental Reasons,* the male can go too far, unleashing a female monster who turns objectification onto its creator. Unlike Pepe, however, Bugs really wants "out" of the relationship (as does the Wolf chased by sex-crazed Grandma in Tex Avery's 1943 M-G-M cartoon, *Red Hot Riding Hood*). If his androgyny allows Bugs to feel empathy with Mama Bear's position as an unfulfilled housewife, his flight is motivated by his fear of another familiar female stereotype: that of the insatiable woman.

Cartoons, as abstractions from life, have not differed markedly from mythological, philosophical, and psychological conceptions of woman. Male animal characters are permitted a wide range of roles, while female animal characters have been consistently reduced to physical, emotional, and cultural stereotypes. It's not that female animal characters need always to be positive and powerful—in the comedic world of the cartoon, someone has to be a comic foil—but perhaps, once in awhile, we could be treated to an Amazonian canine, a Deirdre Dog, who, like Bugs and Daffy, outwits those who hunt her because she is stronger, more physically aggressive, and a good deal smarter than they are!

Warners' animators evidently thought it was easier to dress up its already existing characters in female garb than to create significant female characters. © Warner Bros. Cartoons Inc.

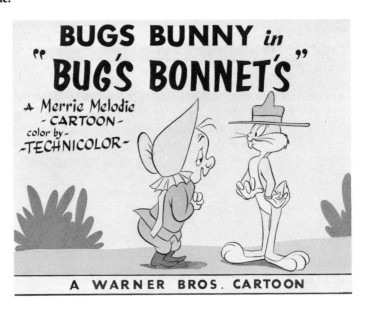

Meep-Meep![1]
by RICHARD THOMPSON

Calling Duck Twacy, calling Duck Twacy, Twacy, where are you?—Say, I'm *Duck Twacy!*
—DAFFY DUCK in *The Great Piggy Bank Robbery*

AN OLD LADY: *Mr. Jones, can you tell me why one finds so much violence in American cartoons, why your gags are so sadistic and cruel?*

CHUCK JONES: *We receive lots of critical letters, reproaching us on one point or another, 100,000 letters a year. But we have never received a complaint from educators, cultural organizations, or parents which accused us of being violent. There is never any identification of children with my characters—with the Coyote or Bugs Bunny. But the child, at the sight of these duels, gets rid of his feelings of aggression. Furthermore, I have never pursued the problem in that sense. I made films which make me laugh, and I try to communicate my hilarity to others, period. That's all. I took notes on the films shown at Annecy, and I noticed that at least a third of them reflected a veritable obsession with death. There are decapitations, dismemberments, as in* The Theatre of Mr. and Mrs. Kabal *[1964] by Borowczyk. This morbidity is typically European, it seems. Americans are possibly preoccupied by violence, but in Europe, it's death and decomposition which seem to rule the imagination.*

JOHN HALAS: *My dear friend Chuck Jones will not contradict me if I conclude that this violence is a response to a state of being in American civilization, the most violent in the world. Fortunately, the suffering in gag cartoons is never communicated to the audience. It seems to provide a form of relief for them. That is no doubt the secret and the excuse for American violence.*

PETE BURNESS: *Everybody is forgetting something very important. In the American cartoon, death, human defeat, is never presented without being followed by resurrection, transfiguration. A cartoon character can very well be crushed into a plate by a steamroller, may be fragmented, cut up by a biscuit-cutting machine, but he arises immediately, intact, and full of life in the next shot. So it seems evident to me that the American cartoon, rather than glorifying death, is a permanent illustration of the theme of rebirth.*

—*Press conference extract printed in* Positif, *54–55 (July–August 1963).*

Translated by the author.

[1] Although Chuck Jones writes Road Runner's words as "Beep-Beep," he acknowledges that Mel Blanc's delivery sounds more like "Meep-Meep."

Through the 1910s and 1920s American animation, like American comic strips, was full of twisted, surreal versions of the world, impossible to capture with real-life photography. It was powered by a glorious primitivism, unlike the increasingly sophisticated live-action films. The revolution for both cartoons and strips came in the 1930s. For cartoons, it happened at Warner Brothers, where happy chance threw together two seminal geniuses of the Warners school—Fred "Tex" Avery and Chuck "Acme" Jones. Behind these two a marvelous team formed, including other nutty animators like Robert Clampett, Robert McKimson, Frank Tashlin (later to invent the cinema for Jerry Lewis), and pioneer Friz Freleng; Mel Blanc's voice; Carl Stalling's music-sound-effects montages on the sound track; Maurice Noble's background designs (he took John Ford's two-dimensional Monument Valley and turned it into the functionally three-dimensional home of Road Runner and Coyote); storywriter and gagman Michael Maltese; and producer Leon Schlesinger, whose only apparent constructive function was to pick up the Oscars earned by his underpaid zanies. In the 1930s they invented Porky Pig (and Petunia), Elmer Fudd, and Bugs Bunny. In the 1940s, the Minah Bird (of the Inki and the / at the . . . series), Daffy Duck, Sylvester and Tweety, and Wile E. Coyote and the Road Runner. In the 1950s lesser stars such as Pepe Le Pew, Speedy Gonzales, and Foghorn Leghorn.

Not much attention has been given to these remarkable creations. Back in 1943, Manny Farber wrote about them perceptively (why is it Farber was so often there first?); next round went to the writers at *Positif,* especially Robert Benayoun, the man who made Jerry Lewis a critical star; more recently, interviews have

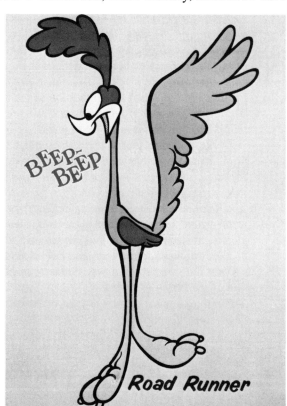

Chuck Jones's Road Runner.
© **Warner Bros., Inc.**

begun to appear in various places, most consistently in Mike Barrier's *Funnyworld*. Part of the problem is that the cartoons of these men quickly got a bad rep for violence and (especially in the case of Tex Avery) sex. It must be remembered that cartoons and audience expectation about cartoons had theretofore been heavily influenced by Disney and by subgenres of the cuddly-cute-little-animal cartoons. Some of the best Warners efforts are frontal attacks on Disney stuff: Bob Clampett's *Corny Concerto* (1943) destroys the Silly Symphonies just as *What's Opera, Doc?* (1957), deals a deathblow to at least four separate sequences of *Fantasia*. As Jones points out, *What's Opera, Doc?*, contains 104 cuts in slightly over six minutes, a frequency ratio that makes Alain Resnais look like Antonioni.

These cartoons were made by *grownups* without much condescension to kids whatsoever; like the best subversive and surreal art, they were recognized as dangerous by defenders of propriety. And fortunately for the men who made them, the genre, the audience, and the filmmaking system coincided so perfectly that, with very rare exceptions (Avery's sex, say), they could give complete, unfettered expression to their personal visions in the cartoons. Much more than B pix, the antic art of cartoons provided an outlet for truly offbeat, antiestablishment ideas and images.

Avery and Jones are the two poles of this movement. Avery's roots are very deep in the earlier comic-strip heritage of the all-out nuttiness, of antilogical events and whimsy, of burlesque and vaudeville humor, exemplified by Krazy Kat, Thimble Theater (Popeye), and the work of Rube Goldberg, Milt Gross, and Fred Opper. In one of his cartoons, a character says, "Anything can happen in a cartoon," and that is Avery's credo. Leaving Warners, he went to M-G-M, where he created Droopy; a series on life in the future; and marvelous one-shot films. Through them all, time and space are totally in Avery's control: he recognizes no rules of any sort. The only consistent characteristic of his work is that, while all the other characters are elegantly stylized animals, the girls are ravishing chicks. Quite a bit of time in films like *Swingshift Cinderella* (1945) and *The Shooting of Dan McGoo* (1945) is devoted to torchy song-and-dance numbers (suggestive enough to lead one to fantasies about storyboard meetings considering whether or not to show a touch of pubic hair).

Bernard Cohn has said of Avery,

> Texaverienne creatures are nearly always neck-deep in violent trials: cut-up, squished, decapitated, chewed up, blown up (*The Cuckoo Clock* [1950]), or more simply pursued by a vengeful and insatiable pencil sharpener (*The Cat That Hated People* [1948])—they nevertheless always recover their elegant shapes and their personalities. . . . Droopy, the most fabulous of Avery's creations, deserves a place in posterity with Tartuffe and Madame Bovary. Under the appearance of a taciturn Mahatma, this short, stout dog with the enigmatic asides conceals a vicious soul and passes his time, thanks to his ubiquitous and unfailing talents, torturing poor wolves whom he scatters toward all horizons. But if, by chance, a chanteuse with an unbelievable figure enters his field of vision, his sex life can't help but turn up, and we are treated to an Everest of visual obscenities, which, with unrestrained

graphicness, Avery directs to an extremely suggestive symbolism. The lunacy of Avery occurs at all levels. If he strikes frequently below the belt, he is also capable of giving metaphysical vertigo through his interplanetary visions, as *The Cat That Hated People* proves with a series of dadaist objects passing before us during a maddening noise of bells, sucking, and panting.

Avery's films are filled with such distancing devices as signs, asides to the audience, anticlimactic revelations and gags, and extremely stylized exaggeration. To understand fully Avery's position in cartoon life, imagine Mickey Mouse jumping up and down, flying like a skyrocket, making smacking and howling sounds, with various portions of his anatomy distending and thumping. His eyeballs fly from his head over to a more-than-anthropomorphically-endowed Minnie, giving her an intense up-and-down, while she stands there, saying, "C'mon, Mickey, let's get laid." For a topper, Avery would probably have Mickey take time out from his gyrations to deadpan an aside in a funereal voice: "You know what? I'm happy." During the war, when Avery was making training cartoons for the Army, they made him take out some sexy sequences. In a cartoon yet.

Not Jones.

The cinema of Chuck Jones rests on two conceptual bases: the realization of his characters as fully developed characters rather than reflexive puppets (Woody Woodpecker), to the extent that Jones can parallel live-action films' use of stars' dynamics by having Bugs or Daffy playing a distinct role and being aware of it; and a completely linear, logical development of a single premise, a syllogistic method as wasteless as Keaton's. There are no irrational, inexplicable, whimsical events in the work of Jones. He approaches each film in terms of the character's personality, a construct that exists before any films are made with the character. In terms of rules, the limits and demands of the genre and of the specific type of cartoon are imposed. Avery violates the sanctity of the forward motion of a cartoon and of the frame lines with crazy arrogance—characters running out of the frame, or hauling the title panel back into the frame after it's passed; Jones violates the reality of the frame only as an exercise in precise logic (Daffy—and ultimately Bugs—in *Duck Amuck* [1953]).

God knows how Avery was able to produce his works at M-G-M; they were certainly the most iconoclastic, and probably the sexiest films that studio released in its stodgy 1940s and early 1950s period. But the stuff at Warners, whether consciously or not, relates directly to the hard, fast, antiauthoritarian, sez-who, wisecrack-and-velocity motherlode that Warners monopolized in the 1930s.

As his work proceeded, Jones's cartoons became more sparse, stripped down closer to the premise. Along the way, he did the most chilling cartoon I've ever seen, *Chow Hound* (1951), which has the air of vintage E. C. Comic Books. There's a strapping big dog who can never get enough to eat, so he has a racket: an enslaved cat whom he sends on a route into various houses to get food—"And don't forget the gravy!," he says every time. The cat is known by a different name in each house and gets some food, but is always chided by the dog for bringing no gravy. The second time around the route, the dog gives the cat an equally en-

slaved mouse to hold in its jaws, which brings even greater rewards in terms of food—no gravy, though. Ultimately, the dog works a swindle and has enough money to buy his own butcher shop and have, at last, enough meat. Fade out. Fade in to emergency room, with grossly bloated dog lying on a gurney; stomach horribly inflated and slightly throbbing, he looks miserable. Cut to close shot of door opening and of cat and mouse entering with funnel and huge drum labeled GRAVY. As they put the funnel in his mouth and raise the drum to it, the cat says, "This time we didn't forget the gravy . . ." Beads of sweat roll from dog's face in close-up, on which we iris out.

Although Jones's work never quite reached the minimal stage, he came close. Perhaps his greatest creation, certainly the simplest and most direct, is the Road Runner series, starting in 1948 and running till the end of Warners' cartoon shop in the early 1960s. These cartoons are about a single character named Wile E. Coyote. The films are seen from his point of view. The situation has been simplified past need for words: there is no dialogue, and only an occasional label (Acme Slingshot, Acme Rocketsled, Acme Flying Suit). The signs for Free Bird Seed are used as bait either to stop the Road Runner at a certain point, so that something can drop on him, explode under him, or entrap him, or in order to feed the Road Runner earthquake pills or metal shot, the latter so that he can be caught with a magnet. Time is not an issue; only logical sequence. Plot has been superseded. Road Runner films rank among the most austerely pared-down works of modern art.

As in New Wave theory, situation and character fill the vacuum left by plot. Even in this, Jones insists on a special purity: it is always the same situation, repeated several times in each cartoon. The Coyote has a self-defeating obsession: to exercise his will over the actions of a force of nature, a demiurge, an occasionally seen Road Runner bird. Unlike the Coyote, the Road Runner bird must remain on the road at all times, and almost never takes any active role in the hostilities (sometimes, the bird uses its distinctive Meep-Meep sound to startle the Coyote into falling or dropping or whatever; sometimes, the bird appears at the end of the film at the controls of the truck or locomotive that flattens the Coyote). All of this takes place in an abstract desert of boulders, cacti, buttes, and flatness all the way to the horizon, strategically filled with two-lane blacktops with lines down the middle and occasional overhangs, bridges, detours, and switchbacks.

An infrequent gesture toward motivation of this obsession is made, giving the Coyote a knife and fork or letting him look hungry; but it's clear that his mania has long ago outstripped natural causes. Jones claims that he invented the series as parody of the chase cartoons that were proliferating at the time, but that no one took them that way; evidently he failed to consider that in the field of cartoons, reductio ad absurdum is simply the logical conclusion of the genre.

The dichotomy of natural force (Road Runner) and active character (Coyote) is reflected at the grosser levels of mise-en-scène. All the screen time is spent with the Coyote, from his point of view, and in sympathy with him. The bird appears rarely, is usually seen at a distance, and (aside from gobbling birdseed, run-

ning like lightning from nowhere to nowhere, and sticking out its tongue when the Coyote falls) exhibits no characteristics. The operations of the film are effected through the Coyote. His obsessed nature contrasts with the carefree, intuitive bird. He thinks, thus he loses, doomed by his own intellectuality. He resorts to increasingly complex technology in his efforts to trap the bird, and clearly reaches a point at which his fascination with clever machinery rivals his passion for the bird—the sort of perverse passion that keeps Ignatz throwing bricks at Krazy Kat. Jones presents these mechanical schemes as balletic essays on the unforeseen aspects of the principles of the lever, the wheel, the inclined plane, gravity, trajectory, velocity, Newton's Laws, and Archimedes's idea that if he had a lever and a place to stand, the Coyote could make the Earth fall on himself.

Two classical ideas are at the core of the series. Hubris, certainly in the Coyote's application of the fruits of reason (technology) to an effort past rational bounds (his obsession with the bird). Trying to extend his abilities and control through mechanical aids only elaborates his inabilities and lack of control. Following this line, the imagery of failure in these cartoons parallels the imagery in live-action road films (*Thunder Road* [1958], *Red Line 7000* [1965]); the Coyote's defeat often comes when he tries to extend the road itself or the function of the road beyond the actual fact of the road. Of all road films, Jones's most clearly show the American neurosis of euphoric vehicular ambition. The Coyote's failure results not from faulty thinking—his ideas are ingenious and valid—but rather from not quite thinking on a large enough scale to foresee chance reversals of

Road Runner and Wile E. Coyote. Copyright © Warner Bros., Inc.

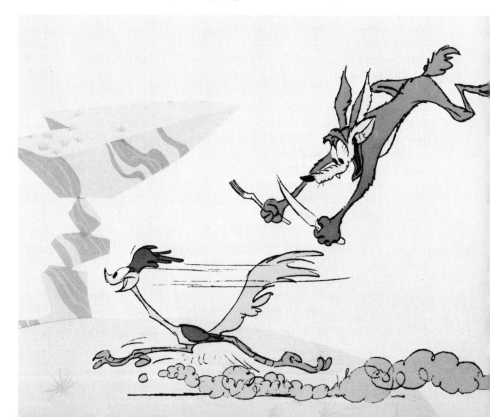

physical principle. Certainly boulders are heavy enough to fasten something to, but when it's a truly enormous rubber band . . .

The other idea is the myth of Sisyphus. Like Hawks, Jones scraps pretense in using popular genres and admits, since form and outcome are known, that it is character and the way in which the foreknown is accomplished that are the concerns of popular works. Ultimately, for both men, this is a bleak view of the world—and a cyclical one, one without meaningful beginnings or endings, one best presented through an image of life as a closed system like a gameboard. Road Runner cartoons aren't even seven-minute works; they are seven minutes filled with nine or ten nearly identical minicartoons, or maxigags, in which the Coyote desires, conceives, builds, executes, and loses, and then does it again, and again. He is clearly doomed to be his own constant victim; as for us, it is only through this cycle that we know the Coyote: it is all he is.

In *Wild About Hurry* (1960), after some standard opening bits about a rocket, a giant slingshot, a jet-propelled handcar, and a magnet-grenade combination, Jones unleashes a long sequence in which the Coyote sets up inclined-plane troughs from a hilltop down to the road, jumps in an armored basketball, and rolls down, picking up speed all the way to pursue the bird. He goes off the road, falls through many calamities, reaching nadir on a river bottom, going over the falls, and then is catapulted up, through all the geographic levels he has passed, to the very peak on which he started, and as the cartoon irises out at the end, he has gently begun to roll down the same trough . . .

It is clear that *Last Year at Marienbad* (1962) is a ritzed-up live-action no-violence child of the Road Runner series, and that the same key unlocks them both, if you like that kind of workout.

While it is known that the Coyote loses, as an ironclad rule, I am not sure that the loss itself is the part of the cycle we respond to. One of the most beautiful moments, both visually and emotionally, in the series comes in *Gee Whiz-z-z* (1956), when the Coyote unpacks an Acme Flying Suit, dons the brilliant green suit (complete with goggled helmet), extends his graceful, sweeping wings to fill the screen, and takes off. He falls, in cutaway long shot, all the way to the bottom of the cliff, *but just at the bottom he pulls out and begins to fly!*[2] We cut back to close shot as he takes a stroke with the long green wings, like a swimmer, nearly, spurts ahead through the air. He turns to us to smile—and crashes into a cliff, with predictable ensuing events.

The Coyote is rigorously required not merely to be violently defeated, but each time to become aware of his doom, to recognize and understand his fate, before it can occur. He must look down and see that he is standing on air, look up and see the boulder falling, look around and see the shortening fuses on the dynamite. This is lent emphasis in the mise-en-scène. From long master shot of Coyote, equipment, etc. (often a tracking or panning shot to keep up with the chase),

[2] This is Jones's animated re-creation, as homage, to the moment in Howard Hawks's *Only Angels Have Wings* (1939) when Bat McPherson takes off from the tabletop butte without enough runway, doing thirty-two feet per second and hoping the laws of aerodynamics will take over from the law of gravity.

sometimes with an insert of the coming instrument of disaster, we cut to tight close-up of Coyote's face as he sees it coming. Then cut back to medium shot to see it happen. Jones likes to attenuate a simple event even further. A constant structural element of the films is the disaster, as described above, then the strangely graceful, placid long fall, seen in godlike shot from directly above, with a long, diminishing whistling sound finishing with a barely seen puff of smoke down there, a moment later joined by a muffled crash sound. It finds its place in the rhythm of the film as a grace note, a coda.

The occasional role of magic in the films amplifies the intuitive/rational dynamic. The Coyote can erect a screen or barrier across the road hiding a chasm or a brick wall, and paint on it the road continuing as usual. In the ensuing chase, the Road Runner traverses the illusion as though it were the real road, turning a stipulated two dimensions into three, illusion into reality, apparently through guileless instinct—or faith. Puzzled, the Coyote attempts to do the same, but falls into the chasm or smashes into the wall, thwarted by his very knowledge—and culpability. This is an old cartoon device but it seems important in the Road Runner films, with their insistence on the curse of knowledge. The Road Runner can also paint a phony "bridge out" scene across the road, run through it and past on the substantial, real road, while the following Coyote falls into the (false) gorge.

In contrast to other chase films, like Tom and Jerry films, Road Runner films do not depend on long, detailed, picaresque chase sequences. The series is so conceived that the chases, like everything else, are essential rather than actual. In *To Beep or Not to Beep* (1964) Wile E. has a Roman catapult loaded with a boulder. He triggers it and the rock falls on him. Fair enough. Then, cutting quicker and quicker each time, moving toward signs of meaning rather than events, Jones repeats the gag, having the Coyote hide in different places each time—to one side, to the other, behind, above—and each time the boulder finds him. Finally, he hides beneath the massive launcher, triggers it, and the whole affair collapses on him. In close shot we see a plate on the gizmo that says BUILT BY ROAD RUNNER CATAPULT CO. Innate use of formal conception and signification, to warm a semiologist's heart, reaches the limit in *Beep Beep* (1951), when the chase goes into a mine shaft. The mine is dark, and soon we no longer see figures, but merely their miner's headlamps; then Jones cuts away to an ant-farm cross-section schematic of Piet Mondrian interlocking tunnels, a maze, with two circles of light chasing each other.

Jones has writing as well as directing credit on two Road Runners, and in each he departs from the standard form to elaborate another level. In *Hopalong Casualty* (1961), he rushes through standard preliminary gags to get to the Earthquake Pills. Wile E. uses the Free Bird Seed gimmick and loads the Road Runner up, then discovers Road Runners are immune to the pills—after he himself in defiant derision of the Acme Drug Company has chugged the entire bottle. There follows a brilliant sequence in which the Coyote becomes an internalized earthquake, accompanied by a sound-track barrage composed of city sounds: auto horns, air hammers, squealing brakes. Several times it subsides, only to return

again, a perfect image of one victimized by his own body, by uncontrollable inner forces.

It seems necessary in discussing these films of Jones's to return to the image and reconstruct it precisely, because in cartoons the image *is* the idea, the unit of meaning, if the cartoon is any good. And cartoon images, like *film noir,* and good Surrealism, occupy our attention for their flashy virtuosity, while on another level they slowly corrode away the legs of rational conceptions of the world.

In the other written-directed opus, *Lickety Splat* (1961) the first gag finds the Coyote drifting over the landscape in a gas balloon, with a couple of dozen sticks of dynamite with little wings at one end and a needlenose at the other, which he would drop on the Road Runner. He looses them all at once, and they take off like a flight of swallows, a lovely line of gliders looping arabesques around and over the balloon—but the last one doesn't make it, and hits the balloon, explodes, Coyote falls, and so forth. Fade out. Next gag is totally unrelated, but at its conclusion, one of the remaining missiles from the last gag enters the frame and explodes. And so it is in each succeeding gag: at its conclusion, some of the lovely flying darts drop in. BLAM. The sins of the fathers.

Which brings us to the end of the field work. It seems to me that there are three areas suggested by these works. Interpretations of the metaphors, like the one just recounted, for literarily inclined types; evaluations of the iconography of the films, essentially a visual criticism project; and a semiological/structuralist analysis of the cartoons, which seem made for such work.

P.S. As far as the Burness statement at the head of this piece goes, it's all right; but what is at issue in the Road Runner and other cartoons is not that rebirth occurs, but why it occurs. Not that death per se is a possibility in cartoons—although terminal catastrophe is a staple, for finishing sequences—but that resurrection at the bottom of every cartoon cycle exists solely and cynically so that the victim can proceed to his next debacle. More absolutely than zombies, vampires, and the undead are cartoon characters denied the solace of eternal rest.

Pronoun Trouble

by RICHARD THOMPSON

Daffy began the same way as Bugs, near the end of the 1930s, hatched under the in-fluence of Tex Avery, intended as second banana antagonist for then-reigning Warner Brothers stars—Porky, mainly. At the start, both bounced around the frame as if it were a racquetball court, warbling "Woo-woo!" or singing silly songs, pro-claiming their dizziness as they kissed their foils and elicited thirty-two-frame slow burns. Partly because neither Porky nor Elmer filled the heroic need of Warners' World War II cartoons, Daffy and Bugs rapidly eclipsed their peers to become WB's top cartoon stars.

<div align="right">

R. T.

</div>

Chuck Jones is most responsible for maturing Daffy, elongating and angularizing the form, making it less ducklike, and for overseeing Mel Blanc's development of a rounded vocal personality. In the 1950s, Jones took DD on an odyssey through the genres, doing for Daffy what Andrew Sarris claims Howard Hawks did for Bogart: putting the most profound explorations of the star's persona on the screen in the most analytic way. Jones's verbal capacity—matched by his unit's writer, Michael Maltese—separates his Daffy Duck immediately from those of his col-leagues; Daffy and others are more fully characterized by their words than in other WB units, although lines are so deeply welded to performance that they pale on paper.

In *Rabbit Fire* (1951), while setting out spurious Rabbit Season signs, Daffy explains, "Survival of the fittest, and besides, it's fun!" In *Rabbit Seasoning* (1952) Daffy locates the cause of his diegetic problems: "Aha! Pronoun trouble!" Or take Daffy's final speech to Elmer in *Duck! Rabbit! Duck!* (1954), with its *Merchant of Venice* overtones, "Shoot me again, I enjoy it! I love the smell of burnt feathers and gunpowder and cordite! I'm an elk, shoot me, go on, it's elk season! I'm a fid-dler crab, why don't you shoot me? It's fiddler crab season!" This is spiced with Daffy's excellent mime of an elk and a fiddler crab through tangled arrangements of black limbs and digits.

There's not space here to detail Daffy's development fully, or to dwell on the nuances of each director's work with him. Obviously, Tashlin, Freleng, McKim-

son, and Clampett found him indispensable. The question is: with situation and stimuli in common, how do Daffy and Bugs differ?

Bugs is modeled on a prototype: Groucho Marx; Daffy is himself a prototype, a complete original. Bugs's period is the 1930s–1940s, tough, urban, I-can-take-care-of-myself Cagney attitudes and verbal sparring, screwball-comedy expertise, with wisecracks underplayed and thrown aside with relish. Daffy is part of the postwar mentality—our world view, our angst. If Warners were still making cartoons, this year's top entry would be *Daffy-EST*, in which Daffy enrolls in a 1970s self-improvement program and learns to counter adversity with, in succulent sibilants, "Thankth, I accthept your hothtility!"

Bugs is a strong traditional American hero who reacts to threats upon his person or property with appropriate(?) violence. Daffy is much more complicated. He's a coward, he claims, but a *live* coward. Daffy feels a preemptive necessity to set someone else (Bugs) up for the destruction he knows is stalking any film he's in. He initiates deceit. His yen for heroism (or its appearance) as well as his tenacity and lack of scruples in that quest are balanced by his capacity for self-pity, self-righteousness, and self-aggrandizement. There's a lot of schlemiel in the mix, and a lot of proto–Jack Lemmon.

Bugs is a winner and Daffy is a loser—not just in the limited terms of plot, how each confrontation turns out, but in the much larger terms of identity. Greg Ford has pointed out that in the few Elmer-Daffy-Bugs films, we have the general roles defined: Elmer never knows what's going on;[1] Daffy's bright enough to figure out what's up but he always fails in taking control; Bugs adds to Daffy's intelligence and insight a self-actualizing ability to manipulate and take over. Daffy and Bugs are con men and talkers, but Daffy talks much too much. Both are vain, but while Bugs's indiscreet vanity leads him into situations he can resolve, Daffy's vanity is disastrous. Bugs stands back from a situation, analyzes it, and makes his move; Daffy involves himself emotionally, loses distance, and blows it. His one-track mind fixes on a single facet of a problem—the most immediately ego-challenging—and he loses sight of the larger pattern.

When thrust into a costume drama, Bugs never appears as anything but present-day Bugs among period rustics, whereas Daffy wears period costumes and tries to speak and play the role à la Robin Hood or Buck Rogers; Daffy longs to be a movie hero. Bugs is suave in his pearl gray outfit trimmed in white. Sans garb, Daffy is all black, less sleekly contoured, ring-necked (oh, the indignity!), his main feature is a cantilevered orange-yellow beak that indicates the center of his character. He looks much different from his frame-mates. Even his place in the de-

[1] Elmer has two main functions in these cartoons: (1) source of danger; (2) dupe. He's dangerous because he's a hunter with a gun, and consequently quite certain that he is there to shoot something—anything; also, he's dumb and unstable. To Elmer, reality is whatever he's just been conned into thinking it is. Elmer's third function, of course, is to represent the rounded, bulbous, pink, overdetermined, cuddly-cute cartoon style the Warners cartoonists were striving so successfully to overcome; Avery launched this dialectic, and Elmer became the formal means of continuing it.

coupage is different: Bugs's reaction shots represent a wide range of emotions, responses, comments; cutaways to Daffy have only two purposes: to show him recognizing his impending doom; or to document the damage done.

Bugs and Daffy enter into shots in a manner befitting their personalities. Bugs is usually discovered by a cut, immobile at the center of the frame and commanding it, or rising into it from his hole. Daffy walks into a static shot; or he is found by cutting from a static shot of Bugs and Elmer to a shot tracking with Daffy as he moves into what were the frame lines of the first shot to join his costars: even the mise-en-scène designates him as an outsider, less privileged, disenfranchised. All of which tips the viewer that Bugs is at the center of events, the hub, nearly (but not quite yet) the *meneur de jeu;* and as corollary, that Daffy's constant (eccentric) movement is an attempt to find a similar spot at the eye of the storm.

At the end of the last who-shoots-who argument in *Rabbit Seasoning,* Bugs narrows Daffy's choices down to whether Elmer will shoot Daffy immediately or wait till he gets home. "Oh, no you don't," says Daffy, "he'll wait till he gets home." Daffy and Elmer go off arm in arm into Elmer's cabin. Interior explosion

From the late 1930s on, Bugs Bunny was the top cartoon character at Warners. As the years went by, however, it became evident that Daffy Duck was a more interesting character, who also deserved star billing. © Warner Bros. Cartoons Inc.

seen from outside. Daffy, blasted, returns to tell Bugs, "You're dethpicable."

Daffy's beak is used indexically in his films: each time he suffers a shooting, it is rearranged on his head, or parted from it, in some wrong fashion; upside down and mounted over his eyes, so that he thinks everything is inverted; in Kwakiutl thunderbird-mask style, so that his entire face is inside his opened jaws; spinning around his head like a shooting gallery target; or simply crumpled like tinfoil after sticking his head out of a rabbit hole to see if Elmer's still there: KA-BOOM! "Still lurking about," he says.

I'm particularly interested in this late part of Daffy's career, when Chuck Jones brought him into direct confrontation with Bugs in the aforementioned *Rabbit Fire, Rabbit Seasoning,* and *Duck! Rabbit! Duck!,* a series of remarkable films in which Jones explored each character in terms of the other and refined their differences. With a sense of roots, he returned to Avery's *A Wild Hare* (1940), in which Elmer first glimpsed the primeval Bugs.

In Jones's trilogy, the continuing gag has Bugs trying to convince Elmer that it's duck season, and Daffy telling him it's rabbit season. These films share the same key points: how dumb can Elmer be (pwetty dumb); how clever—and ruthless—can Bugs be; and how much can Daffy suffer.

Phase 1. In the first stage of each of these cartoons, Bugs and Daffy are actually under Elmer's gun as they try to get each other shot. Bugs always wins by playing

Elmer, Bugs, and Daffy in Chuck Jones's *Rabbit Fire* (1951). © 1979 Warner Bros., Inc.

on Daffy's impatience and perversity. "It's duck season," Bugs tells Elmer, and swings the gun toward Daffy. "Rabbit season," counters Daffy as he swings the gun back toward Bugs. This repeats, speeding up, until somewhere in the middle, Bugs says, "Rabbit season," and feints with the gun, leaving it pointed at himself. "Duck season!," exults Daffy, swinging the gun to himself. Elmer follows Daffy's command: "Fire!"

Phase 2. The action then escalates into more involved, second-stage con duels. In *Rabbit Fire:*

BUGS (*reading from* 1000 Ways to Cook a Duck): "Duck polonaise under glass." Um-*mmmm.*

DAFFY (*reading from* 1000 Ways to Cook a Rabbit): "Rabbit au gratin de gelatin under tooled leather." Duh-*rool,* duh-*rool.*

B: "Barbecued duck meat with broiled duckbill milanaise." Yumeeyum.

D: "Chicken-fried rabbit with cottontail sauce braised in carrots." Mmm-mmmmmmmm.

ELMER: I'm sowwy, fewwows, but I'm a vegetawian—I just hunt for the sport of it. Heh-heh-heh-heh-heh.

B (*accusingly*): Oh, yeah? Well, there's other sports besides huntin', you know!

D (*emulating Bogart's Broadway juvenile entrance, in whites with rac-quet*): Anyone for tennis?

(*BLAM! Daffy is shot up.*)

D: Nice game. . . .

The process is more involved in *Duck! Rabbit! Duck!* when Elmer identifies Bugs as a stewing rabbit and invites him to say his prayers.

B: Look, Doc. Are you lookin' for trouble? I'm not a stewin' rabbit. I'm a fricasseein' rabbit.

(*Bugs shows the label on his ankle: "Fricasseeing Rabbit."*)

E: Fwicasseein' wabbit?

B: Have you got a fwicasseein' rabbit license?

E: Well, no I . . .

D (*outraged*): Just a parboiled minute! What is this, a cooking class? Shoot 'im, shoot 'im!

E: But I haven't got a license to shoot a fwicasseein' wabbit.

D (*exiting*): Don't go away, Daniel Boone, I'll be back in a flash . . . (*Writing.*) "This license permits the bearer to shoot a . . ." (*to Bugs*) Say, bud, how do you spell "fwickasseein'?"

B: F-R-I-C-A-S-S-E-E-I-N-G- . . . D-U-C-K-

D (*to Elmer*): Here you are, leatherstocking, all nice and legal. Hurry up, hurry up, the fine print doesn't mean a thing!

(*BLAM! Elmer blasts Daffy.*)

D: Here, let me see that thing. (*Reading.*) "Fricasseeing Duck." Well, I guess I'm the goat.

> (*Bugs raises a "Goat Season Open" sign. BLAM on Daffy!*)
> D (*to Bugs*): You're a dirty dog.
> B (*to Daffy*): And you're a dirty skunk.
> D: I'm a dirty skunk? *I'm* a dirty skunk?
> > (*Bugs raises a "Skunk Season" sign. BLAM on Daffy!*)
> D (*disgusted with himself*): Brother, am I a pigeon.
> > (*Bugs raises a "Pigeon Season" sign . . .*)

Phase 3. The final stage of these narratives involves variations on role and identity through imitation and disguise, with Daffy and Bugs trying to confuse Elmer further by dressing up as each other. These broadly comic episodes are surprising and funny because of our knowledge of each character and our interest in how each chooses to ape the other, rather like Walter Brennan doing John Wayne in *Rio Bravo* (1959). Jones provides feather dusters, swim fins, and a shower cap for Bugs's dumber and noisier version of Daffy. Daffy's rendering of Bugs emphasizes slick belligerence. The coup de grace is Mel Blanc's creation of voices of Daffy imitating Bugs, and so forth. Finally, we see Bugs's drag act, for which Elmer is always the sucker. Bugs as a charmingly inept huntress invariably bowls Elmer over, often to Daffy's dismay.

Signs on trees claiming Duck Season or Rabbit Season are major props, although we usually don't know whether or not they're true, or who put them up. At the end of *Rabbit Fire*, Daffy and Bugs pull such signs off a tree; under each sign is the other sign, back and forth, until the last sign is revealed: Elmer Season. Elmer gives an "Uh-oh" aside, and we cut to Daffy and Bugs in unison stalk and hunting costume as Bugs says, "Be vewwy vewwy quiet, we're hunting Ewmers," and Daffy says, "Heh-heh-heh-heh-heh."

Duck Amuck

Duck Amuck (1953) is Daffy's Book of Job and the acme of his work at Warners. It is one of a handful of American animation masterpieces, and probably the most cerebral. Daffy makes the most of his opportunity for a definitive tour de force. It is at once a laff riot and an essay by demonstration on the nature and conditions of the animated film (from the inside) and the mechanics of film in general. (Even a quick checklist of film grammar is tossed in via the "Gimme a close-up" gag.)

The frame and the frame lines are basic to the ideas set forth. The strategy within those lines develops through frustrating incongruities. The comic payoff is the reflection of these themes in Daffy's character, his responses, and—within the world of the cartoon—his literally cosmic humiliation. The film is quite conscious of itself as an act of cinema, as is much of Jones's later work.

The swashbuckler credits set the scene for another epic adventure such as *The Scarlet Pumpernickel* (1950). With extreme economy, Jones plays out the first *Duck Amuck* sequence in an unbroken right-to-left (the hard way) tracking shot that takes up nearly one-third of the film. The entire world of the cartoon is *not* inside the frame lines: the director, as in live-action cinema, uses the frame selectively to show what he chooses to show. This is emphasized each time Daffy exits

and enters past the frame lines, making repeated costume changes in a futile effort to match the changing backgrounds (environment), recalling a scene from Buster Keaton's *Sherlock, Jr.* (1924). In this solo piece for a put-upon actor, Daffy is deserted by his context, the integrity of the layout is unexpectedly destroyed. Jones demonstrates that although Daffy's spirit and personality, as abstractions, are unassailable, his physical person is up for grabs. Daffy is erased (see Derrida's *sous rature*), redrawn as the Flub-a-Dub, and saddled with dead-wrong sound effects. His (apparent) vocal objections are replaced on the sound track by various tropical birdcalls. *Duck Amuck* illustrates film theorist Noel Burch's dialectic notion of film elements: foreground and background, space and action, character and environment, image and sound track, all are in conflict with one another.

Obviously, Daffy is more sympathetic in this film (in a square, old-fashioned sense) than in the hunter trilogy because he is not preying on anyone else; he is the victim, instead, no longer of himself but of some malignant power or of the medium itself. Unable to cooperate with this force, Daffy takes responsibility for the picture upon himself, motivated by both the egotism of his starhood and a commitment to deliver the entertainment the audience deserves. Appropriately, at this moment, his soft-shoe is disrupted as the image rolls out of frame, the frame line splitting the horizontal of the screen and providing us with *two* images of Daffy. This event dictates that Daffy fight with his other self.

Then a turn for the better as Daffy is given the lead in an aviation saga. He handles an offscreen crash into a matterhorn with Errol's equilibrium—"Uh-oh! Time to hit the old silk!"—and seems to have regained control until his chute is turned into an anvil. The film pivots on this occurrence.

Daffy loses his heroic posture, his physical well-being, and his grip on (such as it is) reality. He winds up reciting "The Village Smithy" while hammering on a sixteen-inch naval shell's detonator. It explodes. This particular image is emblematic of Daffy's entire career. It recalls by contrast *Forward March Hare* (1952), one of Bugs's service comedies made by Chuck Jones, which concludes with Bugs inspecting shells. If they don't go off, he is supposed to stamp them DUD—and, this being Bugs, none of them does. (If this were Daffy testing shells, even the "duds" would go off.)

Daffy's last indignant attempt at self-assertion begins the final shot of the cartoon. He literally pulls himself together and says, "Who is responsible for this? I demand that you show yourself. Who are you? Huh?"[2] During this speech the omnipotent pencil has lubitsched in a doorframe and a door; and as Daffy finishes, the eraser end of the pencil nudges the door closed, settling Daffy's hash as finally as Ralph Bellamy's in the last scene of Hawks's *His Girl Friday* (1940). As the shot continues, the frame limits are profoundly violated. The camera tracks back until we see the animation board, and then the animator—a gloating Bugs—eight and a half beats later.

Two years after *Duck Amuck*, in *Rabbit Rampage* (1955), Jones remade this film with Bugs as the victim and Elmer the cartoonist misusing his powers. It isn't so successful. Daffy *is* the perfect paranoiac (he has his reasons, most of them

[2] Well may he ask.

rooted in himself), whereas Bugs, the winner, doesn't quite fit the scenario. And Elmer as the all-powerful creator??? In Bugs's version a major issue is Bugs's contract with Warners, and whether he'll live up to it. The play with space and the medium is more limited and less pointed. It's the difference between bizarre sitcom and go-for-the-jugular *comédie noire*. The Daffy version takes us much further inside ourselves: it's incandescent. The Bugs version is cooler. *Duck Amuck* can be seen as *Daffy's Bad Trip;* his self-destruction fantasies and delusions, with their rapid, unpredictable, disconcerting changes of scene and orientation, are the final extension of downhill, ego-on-the-line dreams. Is it reassuring when we see, at the end of *Duck Amuck,* the concentric, esophageal Warner Brothers cartoon logo?

Chuck Jones said: "But what I want to say is that Daffy can live and struggle on in an empty screen, without setting and without sound, just as well as with a lot of arbitrary props. *He remains Daffy Duck.*"

Character Analysis of the Goof—June 1934

by ART BABBITT

Art Babbitt dreamed of becoming a psychiatrist but he became an astute personality animator instead. In 1932 he worked for Paul Terry in New York; in July 1932 he traveled to the West Coast and started at $35 a week for Disney. Within two years he was earning a $15,000 salary and specializing in drawing Goofy—thus this 1934 character sketch, first published in 1974. In 1933 he was one of four animators picked to draw Three Little Pigs, *the breakthrough film for individualized characterization in animation. He also was charged with the pre-hag Queen in* Snow White, *Gepetto in* Pinocchio, *the mushroom dance in* Fantasia. *Then came the strike of 1941, called by the Screen Cartoonists Guild in direct answer to Disney's firing of Babbitt.*

Later on he would be employed at UPA, animating Hubley's Rooty-Toot-Toot *(1952) and assisting on the very first Mr. Magoo,* Ragtime Bear *(1949). Finally, he became a teacher of animation, first at the University of Southern California, recently at the Richard Williams Studio in London. "A caricature is a satirical essay, not just doubling the size of a bulbous nose"—that is a statement from a Babbitt lecture. He is perceptive also in discussing Goofy.*

In my opinion the Goof, hitherto, has been a weak cartoon character because both his physical and mental makeup were indefinite and intangible. His figure was a distortion, not a caricature, and if he was supposed to have a mind or personality, he certainly was never given sufficient opportunity to display it. Just as any actor must thoroughly analyze the character he is interpreting, to know the special way that character would walk, wiggle his fingers, frown, or break into a laugh, just so must the animator know the character he is putting through the paces. In the case of the Goof, the only characteristic that formerly identified itself with him was his voice. No effort was made to endow him with appropriate business to do, a set of mannerisms, or a mental attitude.

It is difficult to classify the characteristics of the Goof into columns of the physical and mental, because they interweave, reflect, and enhance one another. Therefore, it will probably be best to mention everything all at once.

Think of the Goof as a composite of an everlasting optimist, a gullible Good Samaritan, a half-wit, a shiftless, good-natured colored boy, and a hick. He is loose-jointed and gangly, but not rubbery. He can move fast if he has to, but would rather avoid any overexertion, so he takes what seems the easiest way. He is a philosopher of the barbershop variety. No matter what happens, he accepts it finally as being for the best or at least amusing. He is willing to help anyone and offers his assistance even where he is not needed and just creates confusion. He very seldom, if ever, reaches his objective or completes what he has started. His brain being rather vapory, it is difficult for him to concentrate on any one subject. Any little distraction can throw him off his train of thought, and it is extremely difficult for the Goof to keep to his purpose.

Yet the Goof is not the type of half-wit that is to be pitied. He doesn't dribble, drool, or shriek. He is a good-natured, dumbbell who thinks he is pretty smart. He laughs at his own jokes because he can't understand any others. If he is a victim of a catastrophe, he makes the best of it immediately, and his chagrin or anger melts very quickly into a broad grin. If he does something particularly stupid, he is ready to laugh at himself after it all finally dawns on him. He is very courteous and apologetic and his faux pas embarrass him, but he tries to laugh off his errors. He has music in his heart even though it be the same tune forever, and I see him humming to himself while working or thinking. He talks to himself because it is easier for him to know what he is thinking if he hears it first.

His posture is nil. His back arches the wrong way and his little stomach protrudes. His head, stomach, and knees lead his body. His neck is quite long and scrawny. His knees sag and his feet are large and flat. He walks on his heels and his toes turn up. His shoulders are narrow and slope rapidly, giving the upper part of his body a thinness and making his arms seem long and heavy, although actually not drawn that way. His hands are very sensitive and expressive and although his gestures are broad, they should still reflect the gentleman. His shoes and feet are not the traditional cartoon dough feet. His arches collapsed long ago and his shoes should have a very definite character.

Never think of the Goof as a sausage with rubber-hose attachments. Although he is very flexible and floppy, his body still has a solidity and weight. The looseness in his arms and legs should be achieved through a succession of breaks in the joints rather than through what seems like the waving of so much rope. He is not muscular and yet he has the strength and stamina of a very wiry person. His clothes are misfits, his trousers are baggy at the knees and the pants legs strive vainly to touch his shoe tops, but never do. His pants droop at the seat and stretch tightly across some distance below the crotch. His sweater fits him snugly except for the neck, and his vest is much too small. His hat is of a soft material and animates a little bit.

It is true that there is a vague similarity in the construction of the Goof's head and Pluto's. The use of the eyes, mouth, and ears are entirely different. One is dog, the other human. The Goof's head can be thought of in terms of a caricature of a person with a pointed dome—large, dreamy eyes, buck teeth and weak

chin, a large mouth, a thick lower lip, a fat tongue, and a bulbous nose that grows larger on its way out and turns up. His eyes should remain partly closed to help give him a stupid, sloppy appearance, as though he were constantly straining to remain awake, but of course they can open wide for expressions or accents. He blinks quite a bit. His ears for the most part are just trailing appendages and are not used in the same way as Pluto's ears except for rare expressions. His brow is heavy and breaks the circle that outlines his skull.

He is very bashful, yet when something very stupid has befallen him, he mugs the camera like an amateur actor with relatives in the audience, trying to cover up his embarrassment by making faces and signaling to them.

He is in close contact with sprites, goblins, fairies, and other such fantasia. Each object or piece of mechanism, which to us is lifeless, has a soul and personality in the mind of the Goof. The improbable becomes real where the Goof is concerned.

He has marvelous muscular control of his bottom. He can do numerous little flourishes with it, and his bottom should be used whenever there is an opportunity to emphasize a funny position.

This little analysis has covered the Goof from top to toes, and having come to his end, I end.

Mickey and Minnie in *Mickey's Steamroller* (1934). © Walt Disney Productions. (Courtesy The Museum of Modern Art/Film Stills Archive)

Mickey Mouse and Donald Duck were joined by Goofy in *Tugboat Mickey* **(1940).**
© **Walt Disney Productions.**

Mickey and Minnie
by E. M. FORSTER

I am a film-fanned rather than a film-fan, and oh, the things I have had to see and hear because other people wanted to! About once a fortnight a puff of wind raises me from the seat where I am meditating upon life or art, and wafts me in amiability's name towards a very different receptacle. It is a fauteuil. Here art is not, life not. Not happy, not unhappy, I sit in an up-to-date stupor, while the international effort unrolls. American women shoot the hippopotamus with eyebrows made of platinum. British ladies and gentlemen turn the movies into the stickies for old Elstree's sake. Overrated children salute me from Germany and France, steam tractors drone across the lengths and breadths of Russia, with the monotony of wedding chimes. All around me, I have reason to believe, sit many fellow film-fanneds, chaff from the winnowing like myself, but we do not communicate with one another, and are indistinguishable from ecstasy in the gloom. Stunned by the howls of the Wurlitzer organ, choked by the fumes of the cigars—and here I break off again, in a style not unsuited to the subject. Why do cigars and cigarettes in a cinema always function like syringes? Why do they squirt smoke with unerring aim down my distant throat and into my averted eyes? Where are they coming from? Where are we going to? Before I can decide, the greatest super-novelty of all time has commenced, Ping Pong, and the toy counter at Gamage's is exhibited as a prehistoric island. Or mayn't I have a good laugh? Why certainly, why sure, that's what we take your money for, a good laugh, so here's a guy who can't swim and finds he can racing a guy who can swim and pretends he can't, and the guy who can't get a laugh out of that had better—.

But now the attendant beckons, a wraith in beach pyjamas, waving her electric wand. She wants someone, and can it be me? No—she wants no one, it is just a habit she has got into, poor girlie, she cannot stop herself, wave she must, it is a cinema. And when she is off duty, she still cannot stop herself, but fanned by she knows not what sits skirted and bloused in the audience she lately patrolled. I do think though—for it is time for optimism to enter—I do think that she will choose a performance which bills a Mickey Mouse. And I do hope that Mickey, on his side, will observe her fidelity and will introduce her into his next Silly Symphony, half glowworm and half newt, waving, waving. . . .

—E. M. F., 1934

What fun it would be, a performance in which Mickey produced the audience as well as the film! Perhaps Mr. Walt Disney will suggest it to him, and I will provide the title gratis: "Plastic Pools." We should see some gay sights in his semidarkness, and more would get squirted about than smoke. Siphons that pour zig-zag, chocolates exploding into fleas—there are rich possibilities in the refreshments alone, and when it comes to Miss Cow's hatpins and fauteuils for the dachshund sisters, why should there be any limits? Yet I don't know. Perhaps not. "Plastic Pools" is withdrawn. For much as I admire Mickey as a producer, I like him as a lover most, and rather regret these later and more elaborate efforts, for the reason that they keep him too much from Minnie. Minnie is his all, his meinie, his moon. Perhaps even the introduction of Pluto was a mistake. Have you forgotten that day when he and she strolled with their Kodaks through an oriental bazaar, snapping this and that, while their camel drank beer and galloped off on both its humps across the desert? Have you forgotten *Wild Waves* [1929]? Mickey's great moments are moments of heroism, and when he carries Minnie out of the harem as a pot-plant or rescues her as she falls in foam, herself its fairest flower, he reaches heights impossible for the *entrepreneur*. I would not even have the couple sing. The duets in which they increasingly indulge are distracting. Let them confine themselves to raptures appropriate for mice, and let them play their piano less.

But is Mickey a mouse? Well I am hard put to it at moments certainly, and have had to do some thinking back. Certainly one would not recognize him in a trap. It is his character rather than his species that signifies, which one could surely recognize anywhere. He is energetic without being elevating, and although he is assuredly one of the world's great lovers he must be placed at some distance from Charlie Chaplin or Sir Philip Sidney. No one has ever been softened after seeing Mickey or has wanted to give away an extra glass of water to the poor. He is never sentimental, indeed there is a scandalous element in him which I find most restful. Why does he not pick up one of the coins thrown to him in that Texas bar? Why does one of the pillows in *Mickey's Nightmare* [1932] knock him down? Why does Pluto—Or there is that moment in *Wild Waves* when Minnie through some miscalculation on her part is drowning, and he rushes for a boat. As he heaves it out of the sand, two little blobs are revealed beneath it, creatures too tiny to be anything but love-items, and they scuttle away into a world which will scarcely be as severe on them as ours. There are said to be "privately shown" Mickeys, and though I do not want to see one, imagination being its own kingdom, I can well believe that anyone who goes so far goes further.

About Minnie too little has been said, and her name at the top of this article is an act of homage which ought to have been paid long ago. Never before has she headed an article in *The Spectator*. Nor do we know anything about her family. When discovered alone, she appears to be of independent means, and to own a small house in the midst of unattractive scenery, where, with no servant and little furniture, she busies herself about trifles until Mickey comes. For he is her Rajah, her Sun. Without him, her character shines not. As he enters she expands, she becomes simple, tender, brave, and strong, and her coquetry is of the delightful type

which never conceals its object. Ah, that squeak of greeting! As you will have guessed from it, her only fault is hysteria. Minnie does not always judge justly, and she was ill advised, in *Puppy Love* [1933], to make all that fuss over a bone. She ought to have known it belonged to the dogs. It is possible that, like most of us, she is deteriorating. To be approached so often by Mickey, and always for the first time, must make any mouse mechanical. Perhaps sometimes she worries whether she has ever been married or not, and her doubts are not easy to allay, and the wedding chimes in *Mickey's Nightmare* are no guide or a sinister one. Still, it seems likely that they have married one another, since it is unlikely that they have married any one else, since there is nobody else for them to marry.

What of their future? At present Mickey is everybody's god, so that even members of the Film Society cease despising their fellow members when he appears. But gods are not immortal. There was an Egyptian called Bes, who was once quite as gay, and Brer Rabbit and Felix the Cat have been forgotten too, and Ganesh is being forgotten. Perhaps he and Minnie will follow them into oblivion. I do not care two hoots. I am all for the human race. But how fortunate that it should have been accompanied, down the ages, by so many cheerful animals, and how lucky that the cinema has managed to catch the last of them in its questionable reels!

Mickey *versus* Popeye

by WILLIAM DE MILLE

Richard Koszarski, in his collection Hollywood Directors 1914–1940 *(1976), offered the following astute comment about this 1935 de Mille essay, which compared the young fans of Disney's Mickey Mouse with those of the Fleischers' Popeye:*

> *This sly little article tells us nothing about the films of William de Mille, but plenty about the tongue-in-cheek humor of the man whose film career was always overshadowed by the success of his younger brother, C. B. . . . This humor is in ample evidence throughout the following article, which stops to analyze the recent victory of Popeye the Sailor over Mickey Mouse in a national popularity poll. He discusses this poll with a mock seriousness that parodies that of the* Literary Digest, *claiming to see, among other things, a general swing toward fascism on the part of cartoon watchers.*

Whenever the motion-picture industry creates an outstanding piece of work like *David Copperfield* [1935], it points with pride to the wonderful effect this picture will have upon the youth of the country.

When the same industry puts forth a gangster story, it takes great pains to explain that the youth of the country is in no way affected by what it sees on the screen; that the portrayal of vice and crime can act only as a warning to little would-be murderers and racketeers; and that by producing these pictures in sufficient volume, the cumulative effect upon the younger generation will be to disgust it with all criminal activities, through sheer boredom.

Thus, to the studious observer, the general effect of feature pictures upon our young remains in a state of academic obscurity.

But the animated cartoons give a surer indication of how our future citizens react to life's values once they are divorced from tedious reality. In the cartoons we find super-nature in the raw, and it is even less mild than nature under the same conditions.

A vote was taken recently among schoolchildren of the United States, to decide which of the well-known cartoon characters was the most popular. The ordinary adult would say at once that Mickey Mouse, the "little friend of all the world," would win in a walk. But the election went otherwise.

Popeye, the Sailor Man, carried many states by safe majorities, and, while the balloting as a whole was close, it is probable that Popeye has carried the country by a small number of votes.

This is amazing and revolutionary.

Do the kids want a new deal in their two-dimensional heroes? Must the gentle altruism of Mickey bow to the rugged individualism of Popeye?

There have always been two schools of juvenile thought in the land: the party of the Right, based upon the firm rectitude and irreproachable philosophy of Sanford and Merton and the various examples of youthful perfection as drawn by Horatio Alger; and the party of the Left, whose ideals are founded upon the more violent careers of Nick Carter and Jesse James. Under the drive of modern progress and world mechanization, each of these schools has evolved its screen symbol: Mickey, a veritable Sir Galahad, polished, courteous, unselfish, and full of a great desire to help the world; Popeye, sinister, self-assertive, worshiping strength rather than justice, determined to dominate rather than to help.

Should Popeye commit an uncouth act, which he does frequently, he excuses it by the nearest approach to an apology he can find in his nature: "I yam what I yam, and that's all I yam."

It is saddening to see Popeye, like a Hun from the north, threatening the more cultured supremacy of Mickey, Minnie, and the intelligent and devoted Pluto.

That Popeye and his ever-present companion, Olive Oyl, should be accepted as Mickey's and Minnie's equals indicates a definite degeneration of domestic ideals.

Mickey, the devoted husband, the generous provider, Minnie's infallible refuge in times of storm and strife, and Minnie, the faithful helpmate, presumably the fond mother of those hundreds of little mice who from time to time form part of this joyous household—these two stand for the integrity of the American home.

Nothing less than violent abduction causes Minnie to notice any male but her own; no blandishment or seductive female charm ever lures Mickey to forget for one instant the sanctity of his hymeneal vows. Their relationship forms an inspiring picture of perfect matrimonial union that cannot help encouraging those children who attend the theatre after witnessing an unpleasant tiff at the breakfast table between dear Papa and darling Mama.

What are we to think, then, when we find young America accepting with equal gusto the vague and somewhat equivocal relationship between Popeye and his not-so-charming Olive Oyl? There is certainly no indication that they are legally wedded. On the other hand there is no suggestion that they are living in sin. They remain perpetually *in statu quo,* a sort of permanent engagement without the object of matrimony. Popeye's treatment of his girl friend is not only extremely boisterous but at times positively rude. Such gestures of affection as they indulge in are distinctly anatomical rather than spiritual. It may be that their remarkable powers of recuperation from physical shock would make a less strenuous gesture inadequate to express their true feelings.

In physical type Popeye and Mickey and their respective companions represent two distinct schools of aesthetics: Mickey's voice gentle, childlike, charming; Popeye's rough, raw, and raucous, with a suggestion of salt air blown through adenoids. Mickey's graceful movements and his long and expressive tail are poetry, whereas Popeye's movements are uncouth, jerky, expressive of power without beauty.

The Fleischers' first Popeye two-reeler, *Popeye Meets Sinbad the Sailor* (1936). Characters copyright King Features Syndicate. Film copyright 1936 Paramount Pictures Inc. (Courtesy The Museum of Modern Art/Film Stills Archive)

2 HAIRS WHEN HAT IS OFF
NO HAIRS WHEN HAT IS ON.
NO CIRCLE AROUND EYE IN
LONG SHOTS.

FOR MOUTH ACTIONS
ANIMATE JAW AND PIPE.
TEETH ONLY USED IN TALKS.

Instructions showing how to animate Popeye. Character copyright King Features Syndicate.

KEEP PIPE ON OUTSIDE OF FACE.
ONLY ONE LINE ON PIPE STEM AND
NO ANCHORS ON ARMS IN LONG SHOTS.

Mickey's whole life suggests the beloved Don Quixote, with Minnie as the fair Dulcinea and good old Pluto fulfilling the duties of Sancho Panza. Popeye, on the contrary, is more like Captain William Kidd, taking his own or anyone else's where he finds it and being not so much interested in righting the wrongs of the world as in seeing to it that the world takes no advantage of him.

Strange that two such contrasting figures should divide the affections of our children. The idealized mouse and the human figure that falls so far short of Grecian standards of beauty; the lovely, fascinating tail of Mickey against the hideous but terribly powerful forearms of Popeye. When Mickey smiles we feel that the sun is shining and all the little birds are singing. Popeye's infrequent grin is that of the absolute sensualist.

One quality they have in common, and it may be that in this lies the secret of their influence over the youngsters. That quality is courage. No two heroes since the world began have so frequently dared the impossible as these two. By all the laws of nature and man the two have died a thousand deaths; but Mickey's ingenuity and Popeye's remarkable anatomical construction have always brought them through unscathed. In this respect Popeye has one great advantage over Mickey. That advantage is spinach.

It is the one practical lesson in living that Popeye has to offer his admirers. When the youthful but prehensile mind comprehends the amazing effects that a few mouthfuls of spinach can achieve in deciding the outcome of a major battle, it undoubtedly eases the lot of millions of American mothers who find difficulty in persuading recalcitrant offspring that the homely vegetable is a desirable food.

To be fair to Popeye, it must not be thought that he is not always willing to fight for his Olive. He is fond of his own and ready to protect the weak; but he fights for her because she *is* his own; he is protecting his property, not rescuing a loved one; and when he comes to the aid of strangers in distress we cannot help thinking that he is reveling in his own prowess rather than feeling the glow of civic virtue that comes from doing justice.

These two strange figures, Mickey and Popeye, products of a humorous but desperate age, have won the hearts of those to whom we will, tomorrow, turn over the country. What is their secret? Probably power.

They both achieve. Each in his own way strives to solve the world's problems. It will be interesting to see which will dominate the future thought.

As Mr. Gilbert once remarked:

> *Every boy and every gal*
> *Who's born into this world alive*
> *Is either a little Liberal*
> *Or else a little Conservative.*

So the Mickey Mousians of today will be the New Dealers of tomorrow, whereas the Popeyesians will breed a race of Fascists.

Memories of
Mr. Magoo
by HOWARD RIEDER

Early in 1949 John Hubley asked Jerry Hausner if he might try to help him find a voice for a new cartoon character, a nearsighted little man named Mr. Magoo.

Jerry Hausner remembers it this way:

> Jim Backus had just come out from New York with the Alan Young Show. He was already fairly well-known as the voice of Hubert Updyke, the richest man in the world.
>
> We had been friends for over twenty years. I spoke to Hubley about Backus and he wanted to meet him. I arranged a luncheon at the Smoke House Restaurant, next door to the UPA studio in Burbank. Hubley spoke of this new character he was trying to find a voice for. He didn't want to have to ask Backus to audition for him because it might be an affront to an actor as well established as Backus.
>
> Hubley asked Backus if he could recommend someone to play the part. Backus asked what he was like, what he looked like. Hubley said, "Well I haven't any pictures with me, but if we could wander over to UPA I will show you some sketches and a rough storyboard."
>
> We walked over and looked at it. Backus studied the character, and when Hubley said he was nearsighted and lived in his own little world, Backus said he could do it. He said, "My father lives in his own little world, never quite seeing things the way they really are. It isn't that he's nearsighted, but his whole attitude toward life is a kind of personal isolation toward the rest of the world."
>
> Backus mentioned that he used to do a character called the Man in the Club Car. It was the character of the businessman, the tycoon, the loudmouth talker that you meet in a railroad train who offers all kinds of information on world events and who is filled with misinformation. He began to use this voice and it was the voice that ultimately became Mr. Magoo.

The genesis of the character of Mr. Magoo was explained in a letter to the writer by John Hubley:

> The character was based upon an uncle of mine, named Harry Woodruff, at least insofar as my relationship to Magoo was concerned. Jim Backus, who was

introduced at an early stage, formulated a concept based upon his father, a Cleveland businessman and owner of a prosperous pump works. My Uncle Harry was a division head of a large national insurance company.

Magoo, we decided, would always make an appraisal of a situation in one glance. . . . His stubborn rigidity was such that, having made a snap judgment, nothing could convince him he was wrong. Don't you know people like that? They become determined to act on the erroneous judgment, no matter what. This can lead to great comedy (or tragedy).

Jerry Hausner was chosen by Hubley to play the part of Waldo, and he was present at the recording session for the first film, *Ragtime Bear* (1949). Recalling this, he says:

We went into the studio with two pages of dialogue. We read all of the speeches that had been written down. Then Hubley did something that no other animated cartoon director has ever done in my presence. He said, "Let's do it again and ad lib around the subject. Throw in any wild thoughts you might have."

We did another version of it. Backus began to go crazy and have a good time. . . . He invented a lot of things and brought to the cartoons a fresh, wonderful approach.

In the second cartoon there were no other voices besides Backus'. I think Backus was alone in the studio.

The morning after, very early, I got a telephone call from John Hubley. He said, "I've been up all night and I'm worried. I'm very concerned because I had a recording session with Jim Backus last night and he didn't come off as funny as he did in the first one. I can't understand. We're losing what we had in the first one. I suddenly got a thought this morning.

"Backus is the kind of man that needs an audience. Put him in a recording studio alone and it's like locking Danny Kaye in a broom closet. I'm going to set up another recording session and we're going to do it over. You and Backus are close friends. You appreciate each other. I have no part for you, but I will pay you to come to the studio and be there so that Backus will have someone to talk to."

We did that, and it changed everything.

Development of Style

To the casual observer, the Mr. Magoo cartoons might appear to be similar in style to *Gerald McBoing-Boing* (1950), *Madeline* (1952), *Rooty-Toot-Toot* (1952), and others UPA has done. This is not completely so. Magoo cartoons have a style closer to the Disney representational type than any other produced by UPA.

Commenting on the differences between Gerald McBoing-Boing and Magoo, Robert Cannon (who directed the Gerald series) said that Magoo is a three-dimensional character "set in space." He is flat, part of the overall design of the frame, but his movements, or his path of movement within the frame, are "design in motion." For Gerald, all but the essential background details are removed.

Pete Burness, who directed most of the Magoo series, put it this way: "We developed strong, definite, clearly readable poses, with a minimum of follow-

through." Magoo's animation amounted to about a halfway point between the extreme literalism of Disney and the stylized animation of the more offbeat UPA films. Burness adds:

> We got as much design value or high styling as we could into the backgrounds, but we tried to keep the characters representational.
>
> There was a consistency in color, as well as in design and animation. Our semi-representational styling was not compatible with a textured, colored area. Practically all colored areas were flat color. This is part of the technique.
>
> But there were times when a texture was part of the story. If you wanted a stone wall or stucco wall, or even the ground, you would never paint it as such. The artist would take a sponge and simulate a texture. He would never take his brush and carefully render a three-dimensional, representational image. Many times on interiors we used colored papers, textured and patterned papers, even wallpaper samples.

Crotchety Like W. C. Fields

The character of Mr. Magoo has been compared with the late W. C. Fields. Burness recalls:

> We had been working with him for a short period, and it occurred to us that he had a lot in common with W. C. Fields. After we had made three or four pictures, we felt that there was a great deal in common. We got W. C. Fields pictures and ran them and studied them just to see what they would suggest. We wanted to see if there were dimensions that we were missing that we could put into Magoo.
>
> W. C. Fields was terribly suspicious of the whole world and hated much of it. Magoo loved the world. He loved people. He was a man of principles and he would defend and fight for those principles. . . . He was similar to Fields in that neither one of them had patience with weaknesses or inequities as they saw them. Of course, Fields was basically a con man. Magoo was terribly civic minded. . . .
>
> We studied the Fields pictures in terms of the way Magoo walks through a situation, which in many cases was the same way Fields would move through a situation.

Jerry Hausner added these contrasts between Magoo and Fields:

> Fields was a loud, boisterous, irascible, irritated man. . . . Magoo was well thought of, a kindly person. He was courtly, Victorian. He always took his hat off to ladies he met. Even if he bumped into a tree and thought it was a lady, he would take his hat off. W. C. Fields always had conflicts with little kids. Magoo would never do anything like that. He would always be trying to help.

Stephen Bosustow, principal owner of UPA Inc. from 1943 to 1960, said that he felt they had noted similarities with Fields at the very beginning:

> W. C. Fields used to hate kids. He would take a pass at them. Well, we had a running gag with Magoo in which he carried a cane and would lash out at what

looked like dogs, crying, "Down! Down!" He really wouldn't hit a dog, but would hit what to him looked like a dog. Sometimes it was a fire plug, sometimes something else.

Robert Cannon, who directed two of the Magoos, confirmed that this piece of business—Magoo swatting at objects—was taken from W. C. Fields. Cannon also felt that Backus picked up elements of Fields's laugh.

A number of changes took place over the ten years of production of short subjects starring Mr. Magoo. These changes were influenced primarily by the individuals working on the series at different times. Having directed the first few films, John Hubley asked to be taken off the project so he could do new things. He continued to function as supervising director of all films in the studio, and on the next few Magoo pictures worked closely with Burness. Commenting directly on the changes, Burness said:

> It was felt that Magoo should have a warmer side. In the first one he was almost completely disagreeable and ill-tempered. It was felt by many of us that it would be a good characteristic . . . if he would have a warm, sentimental side. I felt this was true and proceeded on this assumption. . . .
>
> John Hubley, who had more to do with the creation of Magoo than anyone else, was in disagreement with this.

Mr. Magoo in *The Dog Snatcher* (1952). Copyright 1952 Columbia Pictures Corp. (Courtesy The Museum of Modern Art/Film Stills Archive)

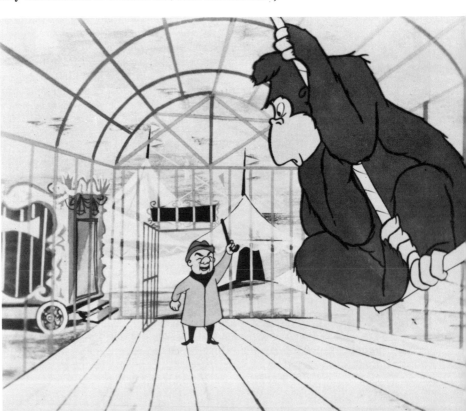

I have later wondered if I was right. I have wondered because he got progressively warmer until he was weakened. We should have used more discrimination. He might break out from time to time in a sentimental mood, but I believe that his basic character would have been stronger if he had continued crotchety, even somewhat nasty. I think there was a certain dilution of his character in making him too sweet.

John Hubley commented on this point:

I feel that as the series developed the formula became somewhat mechanical. There were too many nearsighted gags, not enough situation comedy and character conflict. His motivation became unclear. In earlier shorts he was doggedly trying to get some rest, or prevail upon a lackadaisical friend to engage in energetic sport, or to file a claim for insurance on a bogus policy. Always involved in a pulsing, dynamic action.

Magoo was a human being, not an animal character. He could not undergo the physical destruction Tom and Jerry and Bugs Bunny indulge in. Pete Burness said:

Violence is a thing that is associated with most other cartoon series; their whole approach to story is based on violence; characters destroy each other. The pattern is that the character is burned to a crisp or chopped into pieces. Then, in picking up the next sequence, he is as good as new. It's a kind of magic thing that works well in *Tom and Jerry* and *Bugs Bunny*. But Magoo, being a human being more than a magic kind of cartoon character, doesn't work well with this kind of violence. . . . He behaves almost like a live character actor.

Often in Danger

At the same time, an element that Burness feels works particularly well in the development of a humorous situation in a Magoo film is the element of suspense created when Magoo is in danger of being hurt, particularly when he *is* in danger of falling. This device worked effectively in both *Trouble Indemnity* (1950) and *When Magoo Flew* (1954), the latter an Academy Award winner. In the first instance Magoo was wandering about on the girders of an unfinished building; in the second, he was walking on the wings, body, and tail of an airplane in flight.

Burness felt the high point of the series was represented by *When Magoo Flew*.

The premise came from a writer who is not in the cartoon business, Barbara Hummer. . . . She had this story idea of Magoo getting on an airplane by mistake. He wants to go to the neighborhood movie, but takes the wrong street and goes to the airport. To Magoo it looks like a theater. He goes in, and in his usual bullheaded way, gets on a plane. When he sees the "Fasten Seat Belts" sign flash he thinks it's the title of the picture. He remarks about loving airplane pictures. Then he gets out on the wing and wanders around. . . .

. . . I knew this picture would be scrutinized very carefully by Columbia, and I also felt that it had a good strong story. In practically every instance, where nec-

essary, I risked the wrath of the production office by reshooting or making other changes. As a result we came out with a fine picture. Everyone did a beautiful job on it. It was well written, well designed, nicely colored, excellently animated, and beautifully scored.

An analysis of Mr. Magoo's character and its appeal was made by a Yale University professor of psychology in the *Quarterly of Film, Radio, and Television*. Milton J. Rosenberg looked at him this way:

> In all of his adventures, Mr. Magoo has been in a desperate situation. He is virtually blind, pitifully weak, and very small. He is handicapped also by a majestic inability to understand the dynamics of the world through which he stumbles. Yet every time we encounter him, he is face to face with malignant and inimical forces of both inanimate and animate orders. Shysters, confidence men, and bandits try to do him in or bleed him dry. His near-blindness inevitably carries him to a point just short of irredeemable destruction. . . .
>
> Mr. Magoo's survival in the face of danger is inexplicable. It seems to us a sheer gratuity, totally unrelated to any source of power in the man himself. But is that true? *Is Magoo just plain lucky?* . . .
>
> Running through all the Magoo cartoons, there is, I believe, a secret intimation that it is not fate that has saved Magoo but rather he has saved *himself*. . . .
>
> The values Magoo lives by are those of yesterday's self-made man. In comic guise, he is a personification of the verities of a social era contiguous with our own. He is American individualism in its purest moral form.

Pete Burness affirms this reading:

> There are many philosophies and religions that feel you make your own destiny. You create your own good fortune by your attitude and the forthrightness of your point of view. We always felt this was Magoo's prime characteristic. The near-sightedness was just a device. The important thing was Magoo's absolute self-confidence, the absolute certainty he feels that he is right at all times.

BIBLIOGRAPHY

BERTINO, TOM. "Taking the Boop Out of Betty." *Mindrot* (October 1977).

BRAGDAN, C. "Mickey Mouse and What He Means." *Scribners* (July 1934).

BROWN, HARRY. "Road Runner and Wile E. Coyote." In *Close-Ups: The Movie Star Book*. Edited by Danny Peary. New York: Workman Publishing, 1978.

COMSTOCK, SAM. "The Bunny Emotes—An Animation Analysis." *Mindrot* (January 1977). [Bugs Bunny]

DISNEY, WALT. "The Life Story of Mickey Mouse." *Windsor Magazine* (January 1934).

———. "Mickey as Professor." *Public Opinion Quarterly,* 9, no. 2 (1945).

———. "Mickey Mouse—How He Was Born." *Windsor Magazine* (October 1931).

FOX, JULIAN. "Felix Remembered." *Films and Filming* (November 1974).

KAUSLER, MARK. "Tom and Jerry." *Film Comment* (January–February 1975).

KLEIN, I. "A Vision of Katzenjammers." *Funnyworld* (Spring 1972).

MALTIN, LEONARD. "Betty Boop Is Back." *Film Fan Monthly* (April 1972).

———. "Popeye." *Film Fan Monthly* (June 1973).

MISSINE, JEFF. "Playing Cat and Mouse." *Mindrot* (March 1977).

MOELLENHOFF, FRITZ. "Remarks on the Popularity of Mickey Mouse." *American Imago* (June 1940).

NUGENT, FRANK. "That Million Dollar Mouse." *The New York Times,* September 21, 1947.

RIDER, DAVID. "Don't Shoot the Woodpecker." *Films and Filming* (July 1975). [Woody Woodpecker]

———. "Just Good Friends." *Films and Filming* (July 1963). [Tom and Jerry]

ROSENBERG, MILTON J. "Mr. Magoo as Public Dream." *Hollywood Quarterly,* 11 (1956–1957).

SCHICKEL, RICHARD. "Bringing Forth the Mouse." *American Heritage* (April 1968).

WAGNER, DAVID. "Donald Duck: an Interview." *Radical America,* 7, no. 1 (1973).

WARSHOW, ROBERT. "Woofed with Dreams." In *The Immediate Experience.* New York: Atheneum Publishers, 1970. [Krazy Kat]

WATKIN, LAWRENCE EDWARD. "Mickey Mouse: Disney's Stand-In." In *Close-Ups: The Movie Star Book.* Edited by Danny Peary. New York: Workman Publishing, 1978.

CARTOONS
TODAY

A Conversation with Bill Hanna

by EUGENE SLAFER

In 1976 William Hanna and Joseph Barbera placed their star in front of 6753 Holly-wood Boulevard on the Walk of Fame in honor of over one hundred television series since 1957 and eight Emmys. For many, the star is the final irony in careers that went from talent and creativity to presweetened, non-nutritious Saturday morning pablum. As Leonard Maltin has uncharitably explained, ". . . the cartoons produced by Hanna-Barbera and their legion of imitators are consciously bad: assembly-line shorts grudgingly executed by cartoon veterans who hate what they're doing. Most serious . . . millions of children eagerly await new episodes of Magilla Gorilla *and* The Jackson Five."

Maltin acknowledged that the original Hanna-Barbera "planned animation," Huckleberry Hound *(1959) with Yogi Bear, was amusing, at least for its voices. But the next ten years offered "the same canned music, the same gags, the same sound effects and gimmicks, and the same characters in different guises. The Hanna-Barbera format of a tall and a short sidekick wore out its welcome" (Film Comment, 1975).*

Remember, however, these are the same Hanna and Barbera who perfected Tom and Jerry at M-G-M in the 1940s and won a series of deserved Academy Awards. There can be no greater tribute to their true talent than that from Chuck Jones who, after 1964, directed some Tom and Jerrys himself. Jones concluded: "Hanna-Barbera handled those characters beautifully, much better than I did. Jerry was a much more charming character in their best cartoons than I could ever make him, simply because I could never understand him."

EUGENE SLAFER: What is your relationship with Joe Barbera?

BILL HANNA: One thing that has probably kept us together is that, while we work very closely here at the studio, his outside interests are entirely different from mine, and we never see each other socially. We have had strictly a business relationship all along.

When Joe and I did the Tom and Jerry cartoons at M-G-M, Joe did all of the drawing, and I did all of the timing and directing. We'd sit across a big desk and together we'd develop all the material. Since we've been in business for our-

selves and the company has expanded, Joe has worked with the development of material and its presentation to the networks. He also has worked on the development of characters. My talent, I believe, has been in organization. I'm still directing pictures, but I'm also directing the work of other people. And I also spend a lot of time with the writers. My own efforts have always been in writing: I have written the main titles and lyrics for over one hundred series.

ES: You said Joe Barbera did the drawing in the beginning. Why was that?

BH: I wasn't a good draftsman when I started, and I'm still not.

ES: How do you feel about the animators of today?

BH: There are simply not enough good animators to go around. There is a reason for the sad current situation. For the last fifteen or twenty years there has been almost no work done on animated features, so all the old animators have been involved in Saturday morning cartoons, which is a different kettle of fish altogether. Now most of the veterans are dead or retired; and most of the new animators have been trained solely in Saturday morning techniques. So it's hard to find a really good animator. Dick Williams gathered animators from all over the world for *Raggedy Ann and Andy* [1977], but couldn't even find twenty.

In the last couple of years several animated features have gotten underway; and there seems to be a resurgence toward full animation. There's a mad scramble to snatch up all the good animators for these features, and Saturday morning cartoons suffer because TV producers can't afford to pay animators as much as feature filmmakers can pay.

In the past years we have started an animation school. We have interviewed literally thousands of young artists, and from that group have trained between sixty and seventy-five new people. Unfortunately, we have trained them in Saturday-morning-type animation. At least when we made the feature that we have out now, *Heidi's Song* [1981], we placed our trainees with our veteran animators so they'd be exposed to full-animation techniques. In this way, we hope to develop some more "old-type" animators.

ES: *Heidi's Song* uses full animation. Is that economically feasible today?

BH: *Heidi* has grossed back all of its negative cost, all of its distribution costs, and we expect it to make a very nice profit. We feel that it will continue to make money because the story "Heidi" has such international acceptance.

ES: Let's look back to the Hanna-Barbera unit at M-G-M. It is obvious from your work that your approach to cartooning is much different than it was back when you were making the fully-animated Tom and Jerrys.

BH: The pressures of television are much greater than the pressures of producing films for theatres. Back when we made the M-G-M cartoons, we worked at a more leisurely, almost relaxed pace. There was infinitely more care put into the drawing, timing, sound effects, and the recording of the music. Much more time was taken to discuss the stories and to design the characters; pictures were reviewed in pencil-test form, and changes were made before they were inked and painted. It was an elaborate process. Every phase of production was handled much more carefully than it is today. We just don't have the time today to put in all that effort.

ES: You used to turn out about fifty minutes of film a year when you did full

animation. But for your early TV shows such as *Ruff 'n' Ready* [1957–1960], *Huckleberry Hound* [1958–1962], *Yogi Bear* [1958–1963], and *The Flintstones* [1960–1962], I believe you had to churn out sixty minutes of film a *week*. That's a drastic change.

BH: As it is now, we're turning out eight half-hour shows a week. One person works on more footage per day than all of us combined used to. Back in the Tom and Jerry days, I personally did a minute and a half of film a week; now I do as much as thirty-five minutes a week. So you can see the quantity produced is much greater today. The economics has a lot to do with it, of course. The economics of TV dictates the quality. I think we do a fair job on character design and we do a good job in voice casting and in backgrounds, but we fall short in actual animation. It is unfortunate that more money cannot be spent on animation. The cost per foot of Tom and Jerry–type animation would be prohibitive, even for theatrical shorts. I think that to achieve the same standards today, a six-minute Tom and Jerry would cost in the area of $100,000. They only cost $30,000 to make in the forties.

ES: Besides being well produced, the Tom and Jerry cartoons were very distinctive. For one thing, neither Tom nor Jerry spoke. Remarkably, each one of these cartoons appeared original, although all of them used some variation of the "cat-and-mouse" motif. But what made these Tom and Jerry cartoons particularly unique was that they reached a new degree of comic violence. Did you have a violence "quota" for a Tom and Jerry cartoon?

BH: No. But we knew that the more "hard" gags we had in a cartoon, the more laughs we were going to get.

ES: What comments were made about the violence in your cartoons? Did you have to defend the violence?

Bill Hanna and Joseph Barbera were among the most respected people in the animation field back when they directed Tom and Jerrys at M-G-M. © Metro-Goldwyn-Mayer, Inc.

BH: Studio officials used to say things like, "You really do beat the shit out of that cat." But they were joking.

My argument against our critics is that there are two kinds of violence. There is violence just for violence's sake, presented in a realistic form; and there is fantasy violence, done in comedy form. I agree with critics who say that imitative violence is bad. Now the psychologists and program practices people are easing up on us because they have come to realize that our type of fantasy violence is just for fun and is not imitative.

I always say that the ones setting the standards for our cartoons were raised on Tom and Jerrys and I don't think they were hurt by them. I think we have a pretty good grade of adults in our country, and I would like to think that the young people of today will grow up to have the same values as the older people who watched Tom and Jerrys and Bugs Bunnys and all the other "rough" cartoons.

It is interesting to note that the early Warner Brothers cartoons are still run on Saturday mornings. They may be edited a bit, but they are nevertheless the "roughest" cartoons on the air and contain things that we could never get away with if we were making cartoons fresh for television.

ES: At the time you and Joe Barbera were making Tom and Jerry cartoons, Warner Brothers alumnus Tex Avery was heading the other unit at M-G-M. Was there a rivalry between your two units for Fred Quimby's support?

BH: I wouldn't say we were competing; we were working together. Tex had a little different approach to cartooning than us, and I always thought his cartoons were funnier than ours. I really have great admiration for Tex Avery, both as an artist and as a creator. He did much to establish animation styles and techniques.

ES: Can you explain the appeal of the Tom and Jerry cartoons?

BH: The bad guy always gets it in the end. He gets the comeuppance he deserves. These films are basically one on one entertainments. They follow a simple formula: Tom and Jerry struggle, and Tom loses.

ES: Tom and Jerry remind me of an old vaudeville team, like Abbott and Costello or Laurel and Hardy. You obviously like to set up twosomes because with *Huckleberry Hound, Yogi Bear,* and *Quick Draw McGraw* [1959–1963], you also had a straight man and a foil. Maybe that comes from your working together with Joe Barbera.

BH: That could be. But Tom and Jerry don't represent anyone. We always try to come up with a cartoon character that we can work off another character. When Joe and I work on stories, we always try to set up a situation that we can develop material around. If the characters go well together, then the story is easier to develop.

ES: Many of your characters have worked. But what about the losers?

BH: I once created a scarecrow character that I designed to teach nutrition. I presented the character at a convention for cereal companies, but the idea did not go over well at the time. Now everyone's talking nutrition.

We have submitted many concepts to the networks that haven't been ac-

cepted, and, of course, we've had some shows that didn't work. I would say we've been fortunate in that more shows have succeeded than have failed. We try to get rid of anything that has little chance of succeeding before taking material to a network.

ES: Why have there been so few good female cartoon characters?

BH: I can't entirely explain that, but I do think that there is more good male voice talent than there is female. There are just more male comedians and mimics. It's not just because the animators are men that there aren't more female cartoon stars.

ES: What about June Foray? She's certainly a first-class voice expert.

BH: I think June Foray has contributed more to voice artistry than anyone I know.

ES: A lot of your cartoon characters have been around a long time. When do you feel a character has stopped evolving?

BH: The evolution of a character is a gradual process. When you first think up a character, almost anything new adds to it. When a character is given a voice, for instance, a whole new dimension has been added that has a lot to do with whether the character is accepted or not. Next comes the writing end. A writer can help the cartoon by writing material that goes with the particular voice being used. Then, as we mentioned, we have to find a second character to work with the first. It takes many elements before a character really starts to build. From then

The Hanna-Barbera feature *Hey There, It's Yogi Bear* (1964) starred the famous television characters. Copyright © Columbia Pictures Corp.

on, it is just a question of getting a writer who understands the basic characteristics that your characters have. All the ingredients have to be right to make a success. Also a lot depends on luck.

ES: Where do writers for TV cartoons come from?

BH: We have three kinds of writers. We have many who have written for comic books; others who have written motion-picture comedies; and others who have written a lot of television live-action pieces. All these writers have adapted to animation.

This particular season [Spring 1977] we are employing more of the "old-time" cartoon writers, because the trend is away from the superheroes and toward cartoons full of gags. This has been brought about by the longtime acceptance of the old Warners cartoons being shown on TV. They seem to hold up better than the superheroes. We've got some guys who are my age thinking up gags for us.

ES: How do you compare your recent cartoon series to your first animation ventures in the late fifties and early sixties?

BH: Our recent series are not as good. Again, it's the economics: we simply don't have the time to accomplish what we want.

ES: Are you accomplishing what you believe is good TV animation?

BH: No, I do not.

ES: Have you ever been ashamed of your work, especially since parents have ranted about the general lack of quality on Saturday morning cartoon shows?

BH: Actually I feel like I should crawl under a seat sometimes. I don't think there has been a phase of my animated cartoons—timing, voices, music, recording, sound effects, animation—that I haven't been embarrassed about. But when I see something on the screen that I'm really proud of, it almost chokes me up. I feel that strongly.

ES: Are your cartoons made just for children?

BH: I really believe that, while adults can be entertained by animation, the world looks at cartoons as a form of entertainment for children. It is a fantasy-type of entertainment. I am not prudish, but I resent the medium being used for such pictures as *Fritz the Cat* [1972], because there are enough good things that can be done tastefully. We don't have to pervert the industry. I truly feel that our medium should be used in the proper manner. Disney proved that, so did *Charlotte's Web* [1973], and now there's *Heidi's Song.*

Cartoon, Anti-Cartoon
by GEORGE GRIFFIN

George Griffin is the prototype of the "new" animator. Without ever abandoning the revered methods of traditional cartoon animators, Griffin is striving for liberated and original forms for his works. As he explains, "I came from a self-taught background in drawing, still photography, and poster design. A one-year apprenticeship in a New York cartoon studio and subsequent free-lance work served as an introduction to character animation. I am attempting to reconcile this experience in a popular art form with the medium's potential for experimentation and self-expression. My work has moved from cartoons with obliquely narrative structures to anti-cartoons: films that explore the illusionistic process of animation."

In the most important sense, Griffin's essay should be taken as a representative statement by one animator for a generation of experimentalists in cartoon animation. But Griffin is a truly important young animator, whose thrilling homage to the early cartoon, Viewmaster *(1976), is a certified animation masterpiece.*

The studio production system of making cartoons is inextricably bound up with one technique—cel animation—and therein lies its insurmountable handicap. Central to the technique is an assembly-line compartmentalization of labor, beginning with the separation of two basic functions—"design" (the look of a single frame) and "animation" (the spatial displacement that occurs *between* the frames), and percolating down through other stages: backgrounds, inking, opaquing, camera, editing. There is no crossover among these functions, no integrated attitude toward the final film, and no personal involvement with the materials and process of creation. The ultimate result is artistic alienation: the separation of worker and product.

For the modern studio cartoon, the designer is usually an illustrator who may or may not develop a storyboard, may or may not oversee or execute the background, may or may not pick the color schemes, but never does s/he make the sequence drawings necessary for animation. The animator, on the other hand, must be content to move a predetermined character within a scene that is already carefully prescribed by someone else's layouts and track. The animator's creativity is thus confined to touches, flourishes, and fine points of timing. In most cases

the animator's duties focus only on creating rough extremes, poses in the character's action, and filling out the exposure sheet (the sequence plan for shooting the drawings). The task of drawing all the intermediate poses is then left to a Byzantine hierarchy of assistants: clean-up people, assistant animators, in-betweeners. Their responsibilities, of course, are even more restricted, by the character-model sheet and the animator's spatial notations. As for their "artistry," it is measured in footage for the animator and actual number of drawings per day for the lowly in-betweeners. Those who produce the final stage of the artwork, the inked and opaqued acetate cel, are usually accorded the same honor as any factory worker: the time-clock punch.

The collation of all these artwork production stages occurs in the animation camera. Because traditionally thought to be a forbidding, mysterious process where all the magic takes place, photography is left to a "professional," which means someone who can follow the animator's instructions, control dirt while changing the cels, and expose the film correctly. This is accomplished on the animation stand, an imposing mechanical apparatus designed to shoot frame-by-frame and move the artwork by slight increments. The operator mustn't deviate, even by a frame, from the exposure sheet "script," or the delicate chain of illusion will be broken. Although the animator must know the stand's capabilities, s/he is never allowed to operate it.

Within this process directorial control is exercised at each stage, but with primary emphasis on the earliest stages: character design, storyboard, recording, layout, and animation extremes. However, once creative decisions are made and the studio organism is set in motion, deviation, or creative initiative, cannot be tolerated.

Historically, the issue of initiative is tied to subjective role designation. The early pioneers Emile Cohl and Winsor McCay worked as artist/entrepreneurs, solely responsible for the story, design, and animation. Because they were inventing a grammar of synthetic figurative movement practically from scratch, the production process was, by necessity, slow paced and experimental. As the cel animation production-line process was perfected, roles became more differentiated, yet the relationship between character design and animation remained dynamic. One thinks of Otto Messmer's Felix the Cat, drawn with Deco comic-strip boldness, possessing an indomitable spirit of ingenuity, possible only with animation's capacity for transformation—the prototypical animator's character. During the Golden Age of the Hollywood cartoon, background, story, and character design increasingly became the domain of specialists, although animators still retained "authorship" by their use of a highly developed vocabulary of personality. "Squash and stretch" cannot begin to describe the kinetic inventiveness of Donald Duck, Popeye, or Bugs Bunny. But ironically it was the isolating of character animation as a craft at the expense of other formal and narrative elements that led to today's studio animators acting chiefly as interpreters of presold comic-strip characters (the Peanuts gang, Fritz the Cat, Raggedy Ann). Character animation has thus changed from an experimental interplay of form and sequence to a formulaic technique harnessed to an approved design vehicle. The end product is invariably a television commercial or program material designed to deliver a target audience

(usually children) to an advertising sponsor. Is it any wonder that the term *screen cartoonist* now has a hollow ring?

Compare the 1930s–1940s work of the Disney, Fleischer, and Warner Brothers organizations with that of today's children's television series, specials, and occasional features to see that dynamic, rubbery characters have become stiff, mechanical, pedestrian; that florid, airbrushed rendering has been replaced by a Xerox edge; that delicate gouache storybook backgrounds have turned to colorade monotone; that everywhere there is an appalling lack of imagination.

Outside the dead-end realm of the studio system is a vigorous, expanding art form, which relies so much less on budgetary and marketing considerations and so much more on a personal exercise of the medium in the spirit of the early cartoon pioneers, as well as those whose work has made the very term *cartoon* inappropriate: Hans Richter, Norman McLaren, and Robert Breer. In many cases independent animators began working with dance, photography, painting, or drawing before turning to animation. They have also come from art schools and universities where courses in animation and film production in general developed dramatically during the early 1970s. Including a seemingly equal number of men and women, in sharp contrast to the sexist studio division of male animators and female opaquers, they often perform all the tasks necessary for productions themselves: design, animation, coloring, shooting, even animation-stand building. Because all responsibilities are assumed by the filmmakers, each stage can become an area for experimentation and discovery in itself. And no time clock.

A discussion of all the tendencies within the spectrum of independent animation must be left to a future study. By examining some of my own work as a representative of this movement, I hope to suggest the range of concerns the new animation embraces. My first film, *Rapid Transit* (3 min., 1969), was made at night, after work as a studio assistant animator. Instead of cel animation, or even sequence drawings, I chose to manipulate silhouettes on a simple animation stand that I had set up in my apartment. Upon a sheet of back-lit white Plexiglas were placed hundreds of dried black beans to form mandalalike patterns that I shot on black-and-white high-contrast film. Compared to the tedium of the daily studio procedures, this technique was immediately satisfying. It broke all the rules of specialization by allowing design and animation decisions to be made simultaneously, recorded on film, then instantly altered according to creative whim or preconceived plan before shooting the next frame(s). After a weekend of shooting I was left with a pound of beans, a three-minute record of their movement, and a vivid illustration of Norman McLaren's suggestion that animation is not moving drawings but the act of drawing movement. For me, the process of animation and the film's eventual shape were discovered in manipulating the material itself, not by imposing a technique from above. The result was a kind of reductive shorthand, not unlike calligraphy, a direct transfer from my hand to the film plane/screen. The process forced me to step completely outside the figurative complexity of my previous concerns and deal with the problem of drawing in time.

In *Rapid Transit* the design as well as the animation tended to be both abstract *and* highly personalized. Besides circular and square patterns shifting and bouncing off one another, associative elements were included: silhouettes of a film reel, a hand, and a bean-patterned self-portrait that vibrates briefly before being whisked away unceremoniously. I had originally planned to use only circles and lines to discipline and "purify" the design, but as references to both the film process and my own presence kept creeping in, I decided to allow these impulsive flights to remain, contending with the anonymity of the abstract forms. The film owes a debt, more in spirit than in style, to Robert Breer, whose work fuses both abstract and representational ideas into unified, pulsating exercises of perception and form. Technically it is similar to the direct approach of Eli Noyes, whose *Sandman* (3 min., 1973) is a whimsical, kinetic poem executed with textured and silhouetted grains of sand.

Besides blurring the distinction between abstraction and representation, the new animator can also operate within the pictorial cartoon tradition. As above, this new cartoon may bear only a passing resemblance to the entertainment short of the past and it may even actively parody its style and intent. One way it often differs is in the treatment of themes once considered taboo—like sex. In the Golden Age, cartoon sexuality was either sublimated (for example, Betty Boop as the cutesy vamp and Disney's infantile barnyard humor, later sanitized for family consumption) or expressed overtly as in *Everready Hard-On* (c. 1928), the anonymous stag film classic dealing with the trials of outrageous proportions.

Seeking to extend *Everready*'s genitalian hyperbole and yet create a cartoon statement on sexual discrimination and male bonding, I made *The Club* (4 min., 1975). Here "members" loll about in stuffy Edwardian decadence, sipping sherry, reading *The Wall Street Journal,* watching TV, or working out in the gym. Inspiration for the characters came from the phallic satires of Japanese Shunga scrolls, but the sensibility is also heavily indebted to *The New Yorker* magazine's businessman's club cartoon genre. The only womanly presence is a painting, dimly lit in the background, depicting a frontal close-up of hips and pubic hair. Most of the art on the walls depicts a variety of manly heroism (war, sports). Rather than rely on a narrative structure, the film adopts a voyeuristic point of view, roaming from room to room observing the members in their habitat. There are a few sight gags (like penis push-ups in the gym) engineered mainly for punctuation in what is otherwise a one-line joke. Once the visual incongruity of giant penises behaving like men is accepted, we can reflect on a society in which only men (white) are admitted to the hallowed halls of privilege and power. There is little else to call *The Club* except *cartoon,* a word sorely in need of resuscitation after years of referring only to kiddie films—as though children are the only audience suited for humor and satire.

The Club shares with other new animation both a direct technique of manipulating cutout drawings and a focus on personal and cultural secrets. Victor Faccinto's cartoons (*The Secret of Life* [1971], *Fillet of Soul* [1972], *Shameless* [1974]) use highly stylized, almost mythical characters, set in an elaborately patterned fetishistic world, mercilessly to expose the depths of his subconscious.

Three films by George Griffin:
(a) *One Man's Laundry* (1971),
codirected by Fred Aronow;
(b) *The Candy Machine*
(1972); (c) *The Club* (1975).
Copyright © 1971, 1972, 1975
by George Griffin.

Suzan Pitt Kraning's *Crocus* (7 min., 1971) is a painterly, surreal "family film" depicting young parents' sexual pleasure and fantasy in the face of their baby's own selfish needs.

In 1973 I began to question formally, through my films, the proposition that animation is, in fact, "cinema." If "bringing to life through the illusion of movement" qualifies as its definition, then animation is well possible without the technology of cinematography, sequence photography, and projection. In fact, animation had its origins in the precinematic phasic constructions that made their way into nineteenth-century parlors in the guise of toys like phenakistoscopes, zoetropes, and flip-books.

Sequence photography from Muybridge and Marey to the Mutoscope, which depended on the individual viewer to turn a crank to read the spool of photographs, worked brilliantly without a projection system. Likewise I began printing and producing flip-books to keep my film's images in their original medium. As a cheap, disposable art, flip-book animation depends on viewer initiative and expertise. Page/frames can be read forward, backward, upside down, and at any speed—like the Mutoscope but in contrast to the projector's uniform direction and speed for "movies."

A further evidence of animation's independence from the material and theoretical demands of cinema is the noninsistence on photography. Images can be drawn directly on the film base and brought to life when projected. As developed by McLaren, Len Lye, and Harry Smith, here is perhaps the most perfect form of reflexive animation, in that it continually reaffirms the actual size and properties of the medium.

This ability to bypass either projection (via flip-book) or camera (drawing on film) suggests a potential unity of intention, method, and effect comparable to painting, but with the added dimension of time. To illustrate this unity I made a film of a flip-book, *Trikfilm 3* (3½ min., 1973), in which I intercut between two scenes: the first a normal view of animated line drawings in which there is the typical illusion of movement; the other a wider view showing the physical environment in which this illusion is created. *Trikfilm 3* is one of a series of flip-book films set to sections of Bach's *Well-Tempered Clavier,* in which I explore variations in shooting small-scale sequences drawn on dime-store memo pads. The title, referring to the German word for animated film, contains an appropriate connotation of magic. The imagery is of a metamorphic fantasy involving Mayan architecture, water, and sex between two New York City skyscrapers. But the real subject of *Trikfilm 3* is the unmasking of illusion. The wide frame shows the artist's coffee cup, dinner plate, drawing pad, and speeding hands as the drawings unfold. It is an anti-illusionist documentary that suggests that the very mechanism of fantasy is of greater interest than its symbolic content.

Winsor McCay's *Gertie the Dinosaur* (1914) was introduced by an elaborate live-action narrative using sets and actors to dramatize the artist's motivation (a wager that he couldn't do it) and his methods (huge barrels of ink and cartons of paper are delivered to the studio). The opening shot of *Little Nemo* (1911) shows the animation stand and identifying numbers on the animating drawings before

moving closer into the drawing field. This preoccupation no doubt derived from McCay's career as a quick-sketch artist in a burlesque act (also a setting for his early film presentations). He was already involved with revealing process. Similarly, when we see Max Fleischer drawing Koko the Clown or Betty Boop, or inadvertently allowing them to pop out of the inkwell, he is accentuating the tension between three-dimensional "reality" and flat drawing/film space as well as reaffirming a parental symbiosis between the creator and the created.

Live photography or reference to process was used in this early animation as a framing device. Today it is a key to understanding self-referential animation. *Head* (10½ min., 1975) continues the examination begun with *Trikfilm 3*. It is different in that it relies heavily on structural editing rather than on the linear development of a single concept. I had haphazardly executed a great number of flip-books, photomat mug shots, and footage of their animation without a clear idea of whether they belonged to the same film. Then, using the camera, both for single-frame self-portraiture and recording masklike sequence drawings (sometimes simultaneously), I constructed a symmetrical scheme that contrasted photography's reality to drawing's fantasy. Where *Trikfilm 3* reveals only the animator's hands at work, *Head* reveals his face as well, setting up a system of mirrored self-images. A sync-sound, live head shot of the animator at the film's beginning, explaining that his drawings have become simpler in style as his face has aged into complex "character," is contrasted to an animated self-caricature who delivers the same monologue at the film's end.

Head then is self-referential in its double focus on the mediating process of art and the image of the artist. Both gain meaning most when seen in relation to one another. This impulse toward self-discovery in process is also found in the work of Kathy Rose, particularly *The Doodlers* (5 min., 1976). Using an expressionistic linear and color sense close to that of Saul Steinberg, she constructs a bizarre kindergarten of jabbering artists who frantically paint, draw, criticize, until brought under control by their creator, Miss Nose, a realistically drawn character resembling the animator.

My most recent films have dealt with visual and sequential circularity. The most accessible is *Viewmaster* (3 min., 1976) in which a host of running characters (stick figures, cartoon bugs, mechanical men, a happy blob) are slowly revealed by an oddly curved tracking shot. Just as the first character reappears and a sense of déjà vu occurs, a cut to a long shot reveals all the characters jogging in place around a circle. The animation was created by eight drawings, each containing all the characters. By executing a slow circular pan at a very tight field, I scanned the artwork much like a microfiche. Through this process the drawings lose much of their reference to film frames and assume an affinity with a book's pages. In the clearest sense *Viewmaster* reveals animation's power to shape static art by framing, in both time and space. It is a cartoon homage to Eadweard Muybridge, the original sequence photographer of the "wheel of life."

The new animation ranges from cartoon to anti-cartoon, "naïve" fantasy to self-conscious examination of form and process. It has grown from both popular entertainment and fine art traditions and now addresses a totally new, expanding

audience in museums, galleries, festivals, and noncommercial theatres. But if the new animators gain something in personal expression through their direct control of the medium, they must acknowledge certain fundamental handicaps. Working alone, for instance, can severely limit the artist's output. A five-minute film can easily take a year to complete, and anything approaching feature length (at present the only commercially viable format) is out of the question. But even more problematic is the psychological myopia that occurs without the benefit of feedback from collaborators. Having overcome alienation from the process, today's independent animators might easily become alienated from each other. Many with a few short films under their belts have begun to talk enthusiastically of producing a longer, personal film without reverting to the hierarchic studio system and cel animation. One alternative would be a project involving a group of animators who pool their talents without giving up their individual approach to the medium. This might take the form of a Canterbury Tales–type of narrative collection, each told in a different style and technique: ten diverse animated shorts that add up to a unified whole. Another approach could be the use of music. *Yellow Submarine* (1968) used only the Beatles and, except for George Dunning's brilliantly rotoscoped "Lucy in the Sky" sequence, Heinz Edelman's graphics. Imagine a feature incorporating the variety of, say, jazz (classical, big band, bop, free form, avant-garde) as a thematic underpinning, allowing the graphics to range from abstract to figurative to restructured photographic animation—a contemporary *Fantasia* that would acknowledge the dynamics of variation.

The Golden Age cartoon is dead. As mass entertainment it thrived in a naïvely optimistic cultural climate when the guys and the gals at the studios were a swell gang; and their innocent art still delights even the most hard-nosed realist. But it is a serious error to resort to the same production apparatus for contemporary animation. As an independent animator I deplore the spectacle of a $4 million production like *Raggedy Ann and Andy* (1977), in which fine animators, a competent director (Richard Williams), and composer (Joe Raposo) could not get close enough to their material and their personal sense of fantasy to make a satisfying film. Nearly every scene and musical number is designed for aesthetic overkill, and although there are flashes of individual animator's genius, the film as a whole is impoverished by a shocking lack of personal vision. *Raggedy Ann and Andy* operates as a merchandising gimmick on the part of an anonymous media concern: a presold product, not a work of art.

It is the task of the new animation, whether it addresses a limited art audience or a more general entertainment audience, to stretch and redefine its form through experimentation while realizing the medium's potential for expressing a personal vision.

A Talk with Ralph Bakshi

by PATRICK MCGILLIGAN

Once he was the much-cussed, much-discussed bad boy of animation, today he is practically respectable. The grosses for a squeaky-clean Wizards *were high, for his epic version of* The Lord of the Rings *they were higher. Could it happen to a nicer guy? I telephoned Ralph Bakshi one hot summer day in 1977 when he was still working on* The Lord of the Rings *and requested an interview; without hesitation, he invited me over to his high-rise quarters on Sunset Boulevard in Los Angeles for the first of several scattershot bull sessions. Work was not interrupted—we borrowed time at the end of the day and during lunch hours; with obvious pride, Bakshi escorted me through his artists' chambers, pointing out Hobbit sketches in various stages of completion. He was charming, talkative, infinitely distracted, whimsical, and obsessed. His grin was sloppy and disarming, his trousers faded. We talked for hours at a throw. He would chain-smoke nervously, gaze out the window absent-mindedly. Once, as we talked, I noticed a paperback at his elbow: Ishmael Reed's* Mumbo-Jumbo. *Somehow it was the perfect match-up. Like Reed, Bakshi is driven by the images of his hell-born youth—the knotted visions of guilt, terror, alienation, paranoia, controlled fury, and innocent misogyny. Like Reed, also, Bakshi is a vivid unmistakable stylist, a maverick, and a loner, whose collected body of work, already at this early juncture, marks him, at least in this country, as the foremost feature animator of his generation.*

P. M.

RALPH BAKSHI: I was a cartoonist because I went to an art school in New York and took a cartooning course. Well, when I graduated from the High School of Art & Design, Terrytoons offered the top student in art a job based on his portfolio. I had no background or knowledge of film. I wasn't a film buff. My thing was to be a comic-strip artist. But I had to earn a living, and that was in animation and I haven't left animation since.

PATRICK MCGILLIGAN: Were you trained at all in animation?

RB: No, animation comes very naturally. I find animation excruciatingly easy, as compared to, say, illustration or painting. On the other hand, I'm not sure whether it's animation that comes easy to me or filmmaking.

PM: What kind of cartoons did you draw as a kid in the 1950s?

RB: Garbage. Basically I was trying to be ultracommercial. My stuff wasn't anything too different from what was being bought at the time. *L'il Abner* was still pretty big when I was young, as was *Beetle Bailey*. *B.C.* had just arrived. *Hi and Lois, Buzz Sawyer, Prince Valiant.* The standard run-of-the-mill stuff. That was what I grew up with, that I was trying to feed off of, that I was dying from. I didn't even have the background of the forties pulp situation. I started cartooning late.

PM: When you first started working for Terrytoons, it had an extremely poor reputation in the industry.

RB: The worst. The end of the line. But I spent ten years there and finally ended up running the place. A lot of it has to do with my insecurity and a lot has to do with its being the best job I could ever get in my life, coming out of Brownsville. Understand, I was making two or three grand a week as a twenty-three-year-old kid. I was rolling in women and money.

When I came there, a very talented man named Gene Dietch was running the place. But Dietch was up against it. He just didn't have the right people up front, for the creative work. Animation at that point was trying to lean toward very hip ideas and abstract designs. You have to remember that the action artists were very big in the 1950s, all this abstract and way-out stuff. Jackson Pollock, you know, with his swirls. So cartoons were changing styles to what we call modern design. Guys kept thinking about the way the backgrounds looked and the shape of the characters. But the content did not change at all. Or the approach. It was like a quest ending with nothing. The nothing being the mentality of still dealing with children.

I sat down one day and said very clearly to myself that even if I created the greatest animated short in the world it would be just that and nothing more. And that was already done, as far as I was concerned, by Bugs Bunny, Porky Pig. I said to myself, what am I doing? The heck with Mighty Mouse and Tom Terrific.

The problem had nothing to do with design. It had to do with being honest on the screen. That's it. And honesty on the screen meant whatever I really felt should be put on the screen. With no holds barred.

When we got into story meetings, I would ask writers what they knew about the characters they were portraying. *Who* is this crow that's dropping a coconut on this elephant's head? I wasn't angry about it, I was really confused. I said, what does the elephant have to do with any of our lives?

PM: As for style, you say you were a reactionary, in the sense that you were always——

RB: Looking backwards.

PM: Away from——

RB: The style of the day. Did I tell you what looking backwards means to me? It's important. There was a period of art in this country before money was king. We're talking about the Golden Age of Illustration, from 1890 to 1904. We're talking about guys like M. C. Wyatt and Pyle and English illustrators also, like Arthur Rackin and Dulac, artists who portrayed honestly what they were feeling to produce little masterpieces of art. I'm talking about the Ashcan School of artists, like John Sloan and Reginald Marsh, guys with a far more individual approach.

Rackham

This was the stuff I just drifted to naturally. I went into the story department at Terrytoons, and on the floor were all these first-edition illustrations, bought over the years, lying with broken bindings and coffee stains. The stuff was so mistreated that I asked if I could take it home. Because I loved the stuff, and they did not care for it.

I picked up the largest collection of illustrated children's books in the history of the world, I'm sure; I had to have a truck pick them up from the studio. And these are the books that taught me about animation and where I had to go.

PM: Did you create any substantial characters in your years at Terrytoons?

RB: I made a thing for CBS called "The Mighty Heroes," you know, superhero stuff. There was a character called Sad Cat which I created. There were also two mean brothers. And there was a latent homosexual that I did but couldn't show.

PM: What about when you moved to Paramount, after eight months as head of Terrytoons?

RB: That was my big break. They gave me a title of producer-director, and I ran the studio myself, without television on my back or anything. Yet what happened there was the same as at Terrytoons. The excitement of totally running my own place and of creating new ideas was there. But the ideas had to fall into the same format: good children's cartoons. So I threw up my hands and quit after six months.

PM: What did you do there within that six-month period?

RB: I was trying to get close to *Mad* comics. I was trying to make the stuff adult. I was trying to do that kind of wacky humor, which was a little bitter. But it was the same characters and the same corny voices doing the same corny sounds.

I did try one thing which was interesting, The Mini Squirts, a bunch of kids trying to act like adults. Now had I been able to carry the material far enough, it would have stood a chance. But it just turned out cute, very cute.

PM: What were the Paramount cartoons at the time?

RB: Casper, Little Audrey. But every studio was trying to create the new wave, and nobody was creating it. In short, everything had been said, goddammit.

PM: How did you make the leap to *Fritz the Cat* [1972]? It seems like an entirely different consciousness.

RB: It wasn't. You've got to back up. You have to understand, this is the thing I wanted to do. I left Paramount in 1969 because I wanted to do cartoons for adults. Now *Fritz* only came about because I loved it: one. But two: it was the tradition of motion pictures to find the book that sold. (I really had *Heavy Traffic* [1973] already under my arm, but it had all brand-new characters.) Plus, *Fritz* was a great transitional picture for me. Understand, I was dealing with animals in *Fritz*, which I was familiar with, right?

PM: Had you read R. Crumb's *Fritz the Cat?*

RB: Oh, I was reading it. I was a fan of all the underground comics at that point. I would say the underground comics pried me loose. Because I got so furious with myself. If they could do it in their medium, why couldn't we do it in ours? What was worse, these guys were younger than me (*laughs*).

PM: Who put up the money?

RB: Warner Brothers put in a little, and then Farley's Cinemation. A lot of private investors. Then we made the film for $700,000. Complete.

PM: How much production was done on the East Coast?

RB: Twenty-five percent. After a few months I realized there weren't enough animators. So I moved it to the West Coast. It was incredible. It was crazy. I mean, to move a whole movie and meet total strangers was nearly a disaster for me.

PM: How did you obtain the rights?

RB: Well, I haven't got the rights to *Fritz the Cat.* I had nothing to do with the business end. That was all taken care of by my partner in the thing. I had nothing to do with the contract on any level, including my own.

PM: Did you meet R. Crumb?

RB: Once. We had a falling out.

PM: At the first meeting?

RB: No, the falling out was when he saw the movie. He didn't like it. The first meeting, I told him I wanted to do it. He said yes. Deep into the film, he decided against it. But the contract was signed, and hundreds of thousands of dollars were spent, and the film *had* to proceed legally. But that's very bitter for me, and I would really like to avoid going into it.

PM: It sounds as though a brick fell on your head.

RB: Yeah, it was like that. My anxiety and anxiousness to do the film propelled me on. I did nothing more than go into a room at nine o'clock in the morning and leave at twelve at night, trying to do this movie for $700,000 and for a year

Fritz the Cat **(1972), an X-rated feature, was a long way from Ralph Bakshi's Terrytoons roots. © 1972 Warner Bros. Pictures Inc.**

and a half. I have ill feelings about it because I got caught in the middle. I don't know if Crumb believes that totally, but that is the case.

PM: How did the studio react to the picture?

RB: Warner Brothers threw the picture out. The first thing I showed them was the "Big Bertha" sequence, freaky stuff. Cinemation, the distributor that picked it up, was doing this X-rated stuff anyhow. They thought it was the greatest thing in the world. They wanted to see sex in every scene.

PM: The bad publicity helped the box office?

RB: There's no question about it. It made the distinction between this film and anything Disney ever did. Even the X rating helped, which I fought against vehemently. It deserves off.

PM: How did you approach sex in making *Fritz?*

RB: I had never done anything like *Fritz.* I had a fifteen-year history of doing just the opposite. How much sex? I didn't know. It was like being the Wright Brothers.

There was a massive fight over another matter: Fritz is going over the bridge in a car; Duck the black crow actually *turns* into a crow and flies out of his car, plucking Fritz to safety. I argued, "This is wrong. We're not doing crows." Otherwise I was back with the format where a character can defy gravity.

PM: How much of the animation were you controlling at this point?

RB: Every scene. Everything. I storyboarded the entire *Fritz the Cat* movie and the entire *Heavy Traffic.* The animators and everyone came to me; all the work was handed out from me. I had total control, except for the dollars.

I think if I have made any major change in animation, it's that I'm directing as a live-action filmmaker would because of low budgets and a small crew. Animated films had been done by 200 separate people, each with a little piece. Everything was basically a committee choice. The producer was king. That's where Disney got his reputation, and that's where Max Fleischer got his reputation. But starting with *Fritz,* every color, every cut, every determination had to be mine.

PM: How do you write a script?

RB: In outline form. It's not broken down into dialogue unless the dialogue starts to flow. It's almost a poem approach.

It churns for a long period of time and then comes out. My wife tells me this because I say, "God, this went quick." And she says, "Who are you kidding? You've been thinking about it for three years already." What I don't do is polishing. Maybe I'm afraid to look at it, but I don't sit down and go over it. I think that's a major fault of mine. The area I'm concentrating most in now is story. Decent dollars will deliver decent animation, but story is the key.

PM: What happened to you after *Fritz* was released?

RB: *Fritz* went boom.

PM: All of a sudden, you found yourself king of the world.

RB: Not king of a world I understood. All of this and all of that and Cannes Film Festival and Europe for the first time in my life and the whole Hollywood hype descended on my head. Then they wanted another *Fritz* from me, another animal film, and my big fight was to do *Heavy Traffic.* I wanted to do what I

wanted to do, which is human animation. So I wrote *Heavy Traffic* and, finally, because I didn't do anything else, I sold it.

PM: What was your idea behind doing *Heavy Traffic?*

RB: To make a more personal film than *Fritz.* It had to deal with my background, my life, the things which I observed directly. I tried to make a film instead of a cartoon. *Traffic* is closer to film. *Wizards* [1977] is a cartoon. *Fritz* will always be a cartoon. *Coonskin* [1975] is a film. The thing with *Heavy Traffic* was to make the transition to film. That was the intent.

PM: Were your experiences as bleak and nasty as *Heavy Traffic* suggested?

RB: One doesn't have to be involved directly. If one grows up in an environment, if the environment totally passes him by physically, he is affected by it mentally. I'm not saying that [the character] Ida was my mother or [the character] Angie was my father, but I'm telling you that if they weren't, they were living next door to me. Some other kid had an Ida and an Angie. And there were more Idas and Angies, they were all people I knew. That makes it autobiographical. So I'm saying this is the total effect of growing up in Brownsville, on the screen in *Heavy Traffic.* That's what I was after.

PM: Whatever possessed you to tackle *Coonskin?*

RB: Well, the word *tackle* is wrong. If you saw *Fritz* and you saw *Traffic,* you'd know it was an obvious extension. *Fritz* examined the sixties in a certain way, college and revolutionary types. *Traffic* examined a personal boyhood experience. And *Coonskin* was examining the black experience, examining the Superfly type.

My approach to all three movies was total honesty. These were my observations, my knowledge, right? I didn't have to research black men. I grew up with them.

PM: Did you have any sense of the impending controversy?

RB: No, making this film was the most joyous. You have to understand, the film opened up Bakshi Productions. It also almost closed down Bakshi Productions. But even when the film opened up, it was only attacked by one group.

Whether they were right or wrong in what they wanted, I don't know, because I don't know what it was. But I am opposed to that sort of censorship. I think that's what we're talking about: censorship. I'll argue forever whether *Coonskin* is anti-black. But the line of attack at The Museum of Modern Art was that it would never be shown anywhere in the world, and "we're going to see to that."

PM: This was a group from CORE [Congress of Racial Equality]? What did they say?

RB: Oh, you know, "It's racist." "You can't draw big lips." Mind you, I'd done all this in previous films, too. And, of course, the cliché: "Where does a white director come off doing black characters in cartoons?"

PM: That was the first public screening?

RB: The museum had seen the film and loved it, a breakthrough in animation. They set up a very special night to screen it for film people. They invited me. I brought the film over. It was the first screening in public. And it was quite sur-

prising—I would have thought any group would have waited until they'd seen the film. But it was attacked almost from the titles.

The room was filled, although there weren't many protesters from CORE there, eight or nine. Screaming, "You can't watch this film!" People pulling people out of their seats. It was that kind of night. The audience was very frightened. They were being attacked verbally throughout the movie. People kept running up and down the aisles in pitch blackness. It was very strange. Very surrealistic.

I was angry. When the lights came on at the end, I was supposed to speak. So I walked down the aisle to talk to the audience. I wasn't going to be chased out. We had a whole battle up there. A lot of pushing and shoving. It was very ugly. Then I went back to Hollywood.

PM: What happened from that point on?

RB: *Coonskin* was dropped by Paramount, given to a small distributor over whom I had no jurisdiction, and the distributor went bankrupt in two weeks after the film was released.

PM: It sounds like a crushing experience.

RB: It would have to be. I had a lot of good things to say about how poorly we treat black people. And how poorly some black people treat black people. And it was a good movie. One I loved dearly. And one that will remain one of my favorites, not because of the controversy, but because it is a very well-made movie that looks at who really controls the ghettos, and why.

PM: How did *Coonskin* affect Bakshi Productions?

RB: Very strongly. I had trained for the project, for the first time in Hollywood, nine black animators off the streets of the ghetto, which I thought was pretty sensational. They left, out of embarrassment and confusion.

The energy of the studio diminished slightly. There was confusion, there was anger. A lot of guys had worked very hard on the film. Then the film did zero business, and we had to start from scratch again. It was just a time of, what went wrong?

PM: What was the genesis of *Hey, Good Lookin'*? And why has it never been released?

RB: It was one of the repercussions of *Coonskin*. Meaning that it was also an exploratory film on the fifties, on the whole black, leather-jacket gang situation, which was very "big" when I was growing up. It basically dealt with a black teen-age gang and a white counterpart. And, obviously, I had to animate some black characters in the film. Is it obvious to you what the problem was?

Not that I had even finished it. I had set the finish with the crew for three or four months away, practically a wrap-up for us. But it kind of cooled at that point. *Nobody told me they weren't going to release it.* Obviously there was a decision made as to whether a *Coonskin* was going to happen all over again.

I really don't want to discuss it because, at this point, everybody assures me that it is a much superior film to *Coonskin*. We are finishing it. It will be released.

PM: Let's go on to *Wizards*.

RB: Great. *Wizards* was an attempt for me to cool it. There is a lot of personal pain doing a *Traffic* or *Coonskin* which I can't explain. They don't come

easy. So *Wizards* was an attempt by me to have some fun, meaning to practice the art of animation, do my first PG, let the audiences, too, cool down a little. This is after *Coonskin,* after all.

It was my easiest film. There were no directorial problems, no points I had to clear up in my head. "What do you mean by that, Ralph?" Nothing. And that's how it ended up. Nice. Pretty good. Made a lot of money.

PM: Was *Wizards* a dress rehearsal for *The Lord of the Rings* [1978]?

RB: You can call it that, but that isn't why I did it. It's a dress rehearsal because I went through some minor fantasy; and, sure, it's going to help *The Lord of the Rings.* But *Wizards* compared to *Rings* is like a comic book compared to great illustration. There's a big gap between the movies.

PM: What's the history of your involvement with *Lord of the Rings?*

RB: I had wanted to do it since 1956. I kept bothering the motion-picture company that owned the rights. As the years rolled on, twenty years, my stature grew, I guess. And the project had fallen apart for them. So on my two hundredth try with the same motion-picture company, they said yes.

Now *Rings* is a two-hour epic with a huge cast of characters. This is the most complex animated story ever attempted, and for me, it is a matter of how I can increase the art of animation visually, and how I can surpass anything I've ever done.

The first thing I said to myself was get a producer who understands this, get a writer, and let's build a team to do it. Well, I got involved with Saul Zaentz, who produced *One Flew Over the Cuckoo's Nest* [1976]. And we brought in Peter S. Beagle, who wrote *The Last Unicorn* [1968], and this young guy called Chris Conkling, who has never written anything before but who is quite talented.

We're not doing *The Hobbit,* incidentally. *The Hobbit* is a joy, but the *Rings* are what it's all about. Also, we are dividing it into two pictures, a book-and-a-half per picture. We'll finish the first and look at it. And then, depending on what we see, we'll decide how the second one should be approached, if at all.

PM: What will it look like?

RB: It's going to be like nothing you've ever seen. I'm attempting, for the first time, a totally realistic animated film, not only in content but in style. What is a realistic painter as opposed to a cartoonist? Michelangelo and Rembrandt drew real muscles in the right proportions with real painted backgrounds, right? That's the intent of the movie.

PM: I often wonder why your ideas are comparatively different from anything else that's ever been attempted in animation.

RB: I've thought about it. Let me tell you something that is probably totally wrong. There has never been a man who has run an animation studio and who has a background like me. What does that mean? Did Walter Lantz live in Brownsville? *There* has to lie the answer.

PM: Could we talk a bit about your background?

RB: It embarrasses me: the poor boy, tough kid of the streets who makes it big. Embarrassing. It's like a B movie. I'll try to give you a visual picture. Immigrants living on the streets. Poor, hustling, trying to maintain some sense of sanity.

Wizards (1977), a fantasy Ralph Bakshi made while looking forward to his epic, *The Lord of the Rings.* Copyright © 1976, 20th Century-Fox Film Corporation.

The Nine Companions with Gollum in *The Lord of the Rings* (1979) by Ralph Bakshi. Copyright © 1978 The Saul Zaentz Production Company.

Their children become gangsters, in the true sense of the word: sinister and power-ful men in the neighborhood.

You are talking about very tough, angry black kids in gangs. You are talk-ing about absolute poverty. You are talking about a total ghetto mixed-ethnic-groups situation where you played in the streets and lived in the streets and died in the streets. You are talking about a school system that was just there, basically, to keep you in your seat. Not to teach you anything, because most of the teachers were wrestling with six-foot giants who they had to subdue with rubber hoses. And this is my school experience. On the other hand, you are talking about a cer-tain sense of freedom and spirit that, I think, was good too. You are talking about a boy's American dream of trying to make it one way or another. You are talking about flashy cars and flashy girls. The sexual approach was always the James Dean approach. Tough, slick, cool.

PM: It sounds like an angry life.

RB: Yeah, I lived very angry without realizing it at the time. My total expe-rience was anger, over which I've probably mellowed a little, I have to tell you. And the films probably helped me.

PM: Did you yourself experience the violence?

RB: It's a small example but it's interesting. Obviously you can't afford cars in Brownsville. The young kids can't, OK? Three o'clock in the middle of some dark ghetto street, right? These buildings after buildings after buildings. Like, you drop your girl friend off on a stoop and you walk home, right? Well, you were li-able to walk into anything. A twenty-block walk home on a cold winter night—it's a gauntlet. Just walking in the neighborhood at night is a totally fearful experi-ence, whether someone drags you into the hallway and puts a knife to your throat, or whether some woman walks by and asks you up to her apartment, and what the hell does she *really* want? On and on. Well, do that over an eighteen-year period. I'm not just talking about the walk. I'm talking about all the tributaries of that kind of existence.

PM: What was your life-style like, later, in the 1950s? Were you a beatnik?

RB: No, no, I can't say I was anything at all. That includes the sixties as well as the fifties. I observed everything. I never became part of anything.

PM: Have drugs influenced your animating?

RB: No, I've never taken anything more than an occasional what we call a reefer (*laughs*). And that was before the drug thing. Back in '53 or '55. But I have no connection with drugs whatsoever. I'm even afraid to take any aspirin when I get sick. I'm totally opposed to dropping pills of any nature. I wish I could learn to take tranquilizers.

PM: So many characters in your films are "high"—

RB: Because that's what I observe. Everyone is either high or losing his mind. Cocaine, for example, is running rampant in Hollywood. It's lunacy. Drugs are as much part of our culture now as anything. I can't avoid that part of it.

PM: It's amazing that you are so tuned in to the consciousness of the 1960s without considering yourself part of it.

RB: That's interesting. Other people have said the same thing. But I think

one cannot observe the truth when he is enmeshed in the situation. Being a hippie, for lack of a better word, doesn't allow one to see everything that's really coming down. Or being black. It's being separated and not being part of the group, it's the one who lays back and just observes everyone's ideology. In the sixties I knew who the phony revolutionaries were and who weren't, and a lot of very intelligent friends of mine, involved tooth and nail, could not or would not see beyond the last speech they heard. I don't know why, but I feel that I'm able to observe even the smallest thing, because I am apart from what's happening.

PM: You describe yourself almost voyeuristically.

RB: Yeah, but again, it all ties in. If you are talking about walking down that street alone, you are talking about that attitude carried over into other things. Not the fear—the way of life. Now you may be walking on the outskirts of a bohemian situation. Or you are walking on the outskirts of a drug culture. It gives you a better perspective than being caught in the middle of it. I suppose. Although I could be wrong.

Women and Cartoon Animation, or Why Women Don't Make Cartoons, or Do They?

A Canadian-based Essay

by BARBARA HALPERN MARTINEAU

The history of women as filmmakers is only now being invented. I say, invented, because to write such a history it is necessary to find new categories, ways of describing work that has been carried on underground or buried in the margins and footnotes of patriarchal histories. So it is with the subject of women in cartoon animation. Nothing has been written before, there are no guidelines; women working in the industry are naturally hesitant to see themselves as women animators because the term carries a stigma, like poetess *or* mistress—*besides, how many women have made cartoons?*

Other types of animation, yes. There is Lotte Reiniger, the splendid inventor of silhouette animation. Mary Ellen Bute has produced abstract films, "abstronics," set to classical music, since the mid-1930s. Evelyn Lambart has been making experimental animations at the National Film Board of Canada since the early 1940s, doing pioneer work in map animation, cutouts, and collages. Claire Parker of the United States has collaborated with Alexander Alexieff of France since the 1930s in pinboard animation. Hermina Tyrlova in Czechoslovakia is famous for puppet animation. And there are many women working now in experimental animation.

As for cartoon animation, well, think of Hollywood. No names of women who have made Hollywood cartoons come to mind. Ah yes, women have inked and painted anonymously for years in the great Hollywood cartoon factories, just as women have cut negatives and held scripts for feature films. But at least there have been a handful of women who've directed features. Where is the Dorothy Arzner of cartoons?[1]

Some digging in histories of cartoon animation outside Hollywood yields the following names: Joy Batchelor, who has collaborated with John Halas in England since the 1940s on numerous successful cartoons, including the feature Animal Farm *(1954); Valentina and Zenajeda Brumberg, sisters who made cartoons in the Soviet Union beginning in the late 1920s; Tissa David, who has worked in Budapest, Paris,*

[1] Howard Beckerman offered these names to trace down: "Some of the names of women animators that come to mind are La Verne Harding who worked for Walter Lantz for many years; Xenia Somerville who worked with Chuck Jones; Retta Scott who was part of the Disney organization; and Edith Vernick and Lillian Friedman worked with Fleischer" (*Filmmakers Newsletter* [Summer 1974]).

and since 1956 in the United States, most recently with John Hubley, and on the feature Raggedy Ann and Andy *(1977);* Katja Georgi, *working in East Germany since 1958;* Faith Hubley, *longtime collaborator with her late husband John Hubley in the United States. A small handful.*

B. H. M.

It has become fashionable to seek out the handful of prominent women in any field and point to their achievements as evidence that women can do anything. But the questions of how accessible a given field is to women in general and why women have chosen one field over another are more difficult to resolve and less spectacular to explore. Yet such questions illuminate the broad base and effects of sexism in a way that profiles of exceptional women do not.

I am presented with the problem of writing about what women have done in a field where few women are visible: cartoon animation. Knowing that women *have* made strong contributions to the related area of experimental animation, I decided to ask some of them why they chose to work in that field rather than in cartoons. Because I live in Eastern Canada, I had not far to go: the National Film Board in Montreal, where I interviewed five women working in English-language animation: Ellen Besen, Joyce Borenstein, Caroline Leaf, Lynn Smith, and Veronika Soul. All but Caroline Leaf, who is on staff, are free-lancers; Ellen Besen *is* a cartoonist and the other four are experimental animators; Ellen Besen and Joyce Borenstein are Canadian and Caroline Leaf, Lynn Smith, and Veronika Soul are American.

I interviewed each woman separately. But because they work in such prox-

Phyllis Bounds, a Disney artist at the time of *Dumbo* (1941). Characters © Walt Disney Productions. (Photograph courtesy *Movie Star News*)

imity and constantly mention each other in speaking about their work, I decided to construct the following discussion in a conversation format. The conversation never actually happened, but might have.

(The first matter to be resolved: what is cartoon animation? The consensus is that cartoon animation involves work that is prepared ahead of time for the camera, drawings on acetate or paper cels, which are then shot according to a prepared plan. The actual shooting may be done by someone other than the original animator.)

Ellen Besen is the cartoonist. She is working on *Sea Dream,* the fantasy of a little girl from a poem by Debbie Bojman.

> Cartooning is a fairly controlled method of filmmaking—I find my most creative stage is doing the storyboard and from then on it's more mechanical. The most fluid time is at the very beginning of the film and after that it becomes progressively more set . . . I prefer cartoon animation—dealing with multiple drawings— to working directly under the camera.

Caroline Leaf's film *The Street* (1976), made by painting with tempera colors on glass, was nominated for an Academy Award. She took Veronika Soul as her escort to the presentation ceremony in Hollywood.

> I always work under the camera. My images are immediately recorded on film, so the motion created in the sequences of drawings becomes film motion without any intermediate stages. Traditional cel animation confuses me. There are sheets of paper to draw on and keep track of, images are broken into parts according to how and when they move and sequences are constructed in layers. It gets too far away from film and the camera.

Caroline Leaf, a prizewinning Canadian animator. (Photograph courtesy Caroline Leaf)

Le Mariage du Hibou (1974) by Caroline Leaf. (Photograph courtesy National Film Office, Canada)

Joyce Borenstein is making her fifth film at the National Film Board. Her work, which has won many awards, utilizes drawings, photographs, and clay animation. Her last film, *Traveller's Palm* (1975), involved animating bas-relief sculptures under the camera.

> The whimsicality of the medium is greatest when one animates directly under the camera. Although I create an elaborate storyboard, I let the film evolve as it is worked on, so that there is an element of chance, of discovery, both in the making of the film and in the viewing. With cartoon animation everything must be determined to the last detail before production begins because of the large crew involved and the huge budget. I find unpredictability lacking.

Lynn Smith is working on a sponsored film, a fantasy in which a night watchman is escorted by a matter-of-fact Muse around a museum and introduced to the life behind the objects.

> I draw and erase essentially on the same sheet of paper, filming the changes, sometimes the erasures as well as the newly drawn positions. Color Xerox enables me to record recognizable images from museums. So a type of collage technique has evolved in which real known museum objects appear with pastel drawings. I'm able to build an image over the Xeroxed areas and continue to animate, or I can draw in pastel and erase down to a concealed color Xerox. Working directly this way doesn't permit much checking, whereas in cel animation you can check at different points, by flipping your drawings, by shooting a black-and-white line test before coloring in; and you can make corrections without having to go back to the beginning.
> Why work directly under the camera? Because during the actual animating process the experience is more intense. I feel the final result often has a special, more lively energy than animation done in stages.

Veronika Soul, of all the women interviewed, is most clearly an experimentalist outside the bounds of cartoon animation:

I'm inspired by garbage, leftovers, by being incapacitated, by knowing what it is I do, by not understanding light . . . All I know roughly is how simple equipment works. I like to work as a deprived person. I like to work without an animation stand. I like to move things very loosely or to hold them by hand. If I need to anchor anything I use scotch tape and pinholes. I love to make mistakes and to take advantage of mistakes.

I saw one film that had a wonderful track of kids' voices, *Windy Day* [1968] by John and Faith Hubley. It was well animated, but I'm not interested in that kind of representational drawing. I like it when it gets stranger, like Lynn's—it gets into another realm. I don't feel that she's trying to draw a person—there's something else in all her wonderful color and distortions. These things are more real to me than drawings that attempt to be real, and I guess that's what I can't stand about cartooning. It attempts to be real in drawing and it falls flat. There's no finesse, intellect, passion, mystery. Cartoon animation is the one film form which cannot touch me.

LYNN SMITH: Cartoonists have another way of drawing things, the way they do their curves and their feeling for circular three-dimensional objects is not exactly the way I see things.

JOYCE BORENSTEIN: I enjoy working with clay most of all. Strong chiaroscuro effects can be created more easily than with drawn animation, simply by changing the angle and/or intensity of the lighting.

VERONIKA SOUL: Right now I'm interested in using paper as slides, coloring paper and using Xerox and shooting light through it. I'm interested in combining all film forms, like live material, slides, still photographs, negatives.

BARBARA MARTINEAU: What do you think of the depiction of women in cartoon animation?

VS: When I think of cartoon animation, the only thing I think of is stereotypes. When a person draws a woman cartoon character, it has all the external

Joyce Borenstein in *Portrait of Joyce Borenstein* (1977). (Courtesy Joyce Borenstein)

earmarks of a woman, so nobody can make a mistake and say, ah, that's a sailboard! But the cartoon form doesn't move beyond that level for me.

All the fantastic cartoons were the early ones. Wasn't it Max Fleischer who used the inkpot where you see the hand on the screen? That was innovative and witty because you can be that person drawing. Or I think of *Gertie the Dinosaur* [1914]. Now Gertie's a real person for me. It's the dumbest film in the world, who could get excited about a dinosaur lifting a foot? But I love that film and I just can't stop being delighted with it. Because I'm made to feel I'm a person, whereas with modern cartoons I'm not. They're insulting not just to women but to people.

CAROLINE LEAF: There is a limited range of ways of showing women and men in traditional cartoon animation. But in another sense, the concept of stereotypes is interesting. Animation must concentrate a lot of visual material in very little time, things happen quickly. Therefore to be clear and legible you need to simplify, to economize perhaps by exaggeration. The characters in *The Street* are stereotypes. I use what you already know to save time, so that there is a lot that I don't need to draw and say. Yet you can feel that they are unique humans too, because within the broad recognizable outline I pick out details of individual feelings and gesture. That is simplification and exaggeration.

The problem that I have with cartoon animation, and I haven't seen much of it—it bores me—is that it doesn't use emotions. It will make people laugh with a story or idea joke—that might be the whole point of the film. I also like to make people laugh, but I don't tell jokes. My humor is in some human gesture or intonation somewhere along the way.

I begin to think sometimes of live action, if I'm making characters why not make them real people? But there's still some magic thing that I can do with animation.

BM: What are the influences and inspirations of your animation work?

JB: The influences on my work have been primarily musical. Studying Bach and Debussy taught me the essence of structure in art and the ability to translate feelings into this structure. I am indebted to Norman McLaren and Ryan Larkin whose films were the initial inspiration for my trying animation. Over the years Pat O'Neill, Jules Engel, Alexander Alexieff and Claire Parker, John and Faith Hubley, Walerian Borowczyk and Caroline Leaf have been important influences.

ELLEN BESEN: I like Hollywood animation and I like the Film Board work—that's my favorite animation, like *The Wind,* and Caroline Leaf's work, Lynn Smith's work.

LS: I love the work of Caroline Leaf, and she's my very close friend. And just talking to Veronika is "a trip-and-a-half." Her work has her lively spirit. But I'd like it to be very clear that without the support of men in the field I'd not be in animation: Derek Lamb, my teacher and mentor, and Wolf Koenig, who invited me to work at the NFB in 1973—two very important people in my life. There are also men animators who've been a great inspiration—Len Lye, Don Ariole, Paul Driessen, and Zlatko Grgic. I don't see the world breaking down into men animators and women animators.

CL: Well, my friends influence me a lot. Lynn Smith is an influence for style. Veronika is too, maybe not so much in films as in the drawings I do now. Their

work feels closest to me. I go when I have problems to someone who empathizes with me. There are men too whom I go to—Paul Driessen, Sheldon Cohen, Norman McLaren, Derek Lamb.

BM: What are your thoughts about being women working in animation?

LS: In the last fifteen years there has been a trend for people to work on their own films entirely by themselves. I think this trend made it easier for women to enter animation.

CL: I think that if I were a woman filmmaker making a live-action film with a whole crew of people I would have other problems as a woman director than I do being a director just of myself.

EB: I think in many ways it's better here for women—I have a feeling the Hollywood system is production line. My work pattern is to start in chaos, and gradually pull form out of it. This used to bother me, but people at the Film Board have backed me up, saying that it's a creative way to work and there's no reason to feel bad about it. This is the first time I've had encouragement from someone I think of as professional to not mind working slowly and experimenting. I had problems when I was producing *Metric-Metrique* [1976]: I think it's a combination of being a woman, and being very small, and looking like I was about twelve years old, having to step on people's feet to get attention . . . I think a man would have been more confident to plunge in and not worry about his mistakes . . . being a woman and being small, people just automatically assume that you are immature and you don't understand, so you have to really fight for the recognition of your intelligence. On the productions before this one I was working with a lot of men, and I found it frustrating because I would let their ideas take control over mine— it was always a battleground.

BM: For *Sea Dream* you are working primarily with women, the musicians you've chosen are Beverly Glenn-Copeland and Sharon Smith, is there any particular reason for that?

An American, Faith Hubley, continues to do exciting work in the animation field. (Photograph by Cori Wells Braun, 1978)

W.O.W. (1975) by Faith Hubley was made to commemorate the International Women's Year. (Courtesy Faith Hubley)

EB: I don't think I'd go out looking for a woman and turn down a man who I knew I could work with—I'm just finding that, for me personally, it might be that it is better to work with women, that there is a better understanding and that I am able to be more creative. Obviously I relate to material with women in it and I don't if it's just men.

The author of the poem the film is based on is also a woman—Debbie Bojman. It wasn't a conscious move. What happened was that I heard the poem and liked it and I asked Debbie if I could do the storyboard for a film with Beverly's music. Since I met Beverly three years ago, I've been looking for the right vehicle to do that. I'm really pleased that it happened this way because emotionally and creatively it's been one of the most satisfying things I've worked on as a group project. There's been a nice back-and-forthness. There hasn't been the same fighting for control—this has been a much healthier situation.

BM: Could you discuss the narrative elements of your films?

LS: In my films, in general, I tell stories. But since most of my films have been sponsored, the story formats are not always as crazy as I'd like them to be. I stand by these sponsored works, I guess because I've been able to include other messages besides "Don't smoke" or "Use the metric system." Remember Joseph, who was asked to interpret the dreams of the Pharaoh? I'm sort of in that position, or sometimes in another position, where the sponsors don't even know the dream they had, and I can tell them that. The challenge of sponsored work is to tell their message in my human terms.

It's my hope to do my own film next—it's been cooking for a number of years, and it's not sponsored.

CL: My films are from stories that I've found or been given. I don't write stories really, but I can work with a very simple one and elaborate it—that's what I like most to do, figure out how to visualize a story.

For my first films I completed the animation and then built the sound to fit the picture. For *The Street* I made the voice track first because it was dialogue, and I animated the people talking to their words. I would like to work more this way. I would like to try to make a sound track and see what it suggests for the animation, rather than start with a written story as I always have in the past.

JB: I've been particularly interested in the musical and visual aspects of animation because of my background in painting and music. The sound tracks to the films I did in California were created by an excellent composer, Carl Stone. We worked concurrently so that the sound and picture would grow together. Lately I've realized the potential of animation as a vehicle for character portraiture and storytelling. I would hope to be able to make "total" animated films, so that my audience experiences the film as an intellectual, emotional, visual, auditory event.

EB: *Sea Dream* is a kids' film, so I think technique is less important than the story. At the beginning there's a girl lying in bed remembering her bad day, and I want the atmosphere to feel charged with her emotions, so I try to work a static-y kind of feeling. The rest of the film takes place underwater, and I'm working on dissolving backgrounds so that you get the feeling of light moving through water.

I'm interested in mythology, but I'd like to do it in a way that will bring across its mystical, magical qualities, not just mock it or make a shallow version. I'm interested in the Mary Poppins books, which create their own mythology. Disney did a film based on Mary Poppins, but he didn't do anything with that aspect. It's like a child's view of the creation of the world, with the governess at the center—it's a very cohesive mythology and it works beautifully.

VS: I'm very interested in asexual films—to have voices that you can't tell whether they are men or women . . . and what they are or aren't doesn't matter . . . the way songs on the radio are extraordinarily moving while the voice can belong to anybody . . . male or female. I like ambiguity. That's what I want to do in films . . . to make images that are stunning, not because it's a man or a woman but because whoever the hell it is . . . is alive. Again, that's why I don't like cartoon animation . . . it's not alive . . . and all other film forms are.

Some fairly clear results emerged from the Montreal interviews and subsequent research: (1) that women have not been a strong force in cartoon animation in the past, and particularly not in Hollywood, because it has been impossible to gain artistic control of the filmic process or even to find creative places in the hierarchy; (2) that there is a new, active generation of women animators, many of whom were trained in animation courses, and who are very much aware of and influenced by each others' work (three of the women interviewed mentioned Mary Beams and Suzan Pitt Kraning in the United States as animators they admire); and (3) that many of these women have made a clear choice to work directly

under the camera, sometimes with minimal technology and maximal resourcefulness, because they feel that such work offers them greater satisfaction as artists. Whether their films should be discussed under the rubric of cartoon animation remains a question. They often use clear story lines and have recognizable characters. Obviously there is need for more extended comparisons of cel animation and experimental animation.

One basic problem was presented to me in the interviews and subsequent revisions: although these women are clearly and consciously indebted to each other for support and direction, and although each shows an independence and confidence in the validity of her own work, which is a delight to see, there is no historical sense of how women have had to struggle alone in a hostile industry; neither is there any explicit recognition of how dependent their position at the NFB or in the industry in general might be on remaining "neutral," that is, on standing outside of a feminist position and perspective about the role of women in animation. This is a complex issue, not to be resolved by any simple slogans of solidarity.

I've noticed, in interview after interview with prominent creative women, a frequent refusal to identify with feminism on the grounds that feminists hate men and that such an attitude is incompatible with creativity. And merely to speak out in support of women is very often assumed to be an attack on men. None of the women interviewed has made films with explicit feminist content; neither has any produced offensive stereotypes of women or men. Veronika Soul's films, which are certainly not cartoons, are perhaps most interesting in terms of exploding stereotypes and conventional attitudes—I would suggest that the most consciously feminist and revolutionary work by women in animation is, for now, being done in more experimental forms.

In that light, more need be said about the crucial distinction made by all the women interviewed: that they prefer working alone or in very small groups. The concept of creativity expressed here, linked to the preference for working directly under the camera, is an individualist concept, and, interestingly, it's seen as being suited particularly to women. Perhaps, rather than assuming that it is female nature to work alone and with little technology, it can be said that group work and work involving complex technology are set up by the industry in such a way that they are alienating; and that the socialization of women has made it especially difficult for them to respond creatively to alienating conditions.

To make a virtue of political necessity is not a bad thing, and many Third World filmmakers have demonstrated the power of what I increasingly consider to be an aesthetic of poverty: "poor films" that are rich in meaning and impact. But it is essential that a limitation of resources be seen in context, as a conscious refusal of the structures of an alienating system, not as a "natural" tendency of women to work alone or with minimal equipment. It hasn't been demonstrated that cel animation, that cartoon making, is innately unsuited to women. What has been strongly suggested is that the system of production surrounding that technique has not been encouraging for women (or men) who have wanted, simply enough, control over the means of production.

The International Tournée of Animation —Talking with Prescott Wright

by JOAN COHEN

Now in its fourteenth series, the Tournée of Animation is a one-of-a-kind event in the United States. Basically a sampling of the best of animation from all over the world, the tournée is best described as a touring show that travels yearly to museums, universities, and art theatres all over the country, and includes about forty regularly scheduled exhibitions. It is often the only chance audiences devoted to animation have to see what is currently going on in the field, for the twenty or more films that are shown in each tournée cover the entire spectrum of the world of animation—from humorous, linear cartoon stories, to abstract, complex, and often personal films. The tournée is put together by a board of professional animators and educators from ASIFA-West—the International Animated Film Society—who assiduously watch and weigh hundreds of animated films each year. The coordinator of this monumental task is Prescott Wright, formerly of Brandon Films, the American Film Institute, and the faculty of San Francisco State College, who functions as the chief administrative officer of the tournée. From his office in San Francisco, Wright works all year producing this show. He finally launches the tournée from the Bing Auditorium of the Los Angeles County Museum of Art, the first stop of its extensive itinerary. This interview took place in 1977.

JOAN COHEN: What are the ways in which the films are selected?

PRESCOTT WRIGHT: It was pretty simple in the earlier days. Some of the committee simply went to the international festivals at that time either in Mamaia, Romania, or Annecy in France, and then later in Zagreb, Yugoslavia, where the major international festival was held. They would then select films from these places. But for the recent twelfth tournée we had a unique situation when the international festival came for the first time to the North American continent. Because of floods in Mamaia, they couldn't hold it there, so Ottawa got the bid through the Canadian Film Institute to put together a six-day exhibition. The advantage of Ottawa '76 was that we got eight out of twelve members of our selection committee up there, and they were able to preselect some of our films. Whenever there were unanimous votes, we firmed up agreements with the producers or distributors on those films.

In addition to international festivals, we have open screenings both in Los Angeles and San Francisco in January to solicit films. ASIFA-East also has their preselection competition in January, and we are sent the winning films. Anyone who wants to submit directly to the tournée sends us their film. Animators in North America thus have an opportunity to enter films which have missed getting into the European festivals because of the complex entry regulations. Typically, we've screened about a hundred films submitted this way a year.

JC: Where does most of the final selection of films come from?

PW: Probably more from the festivals, because we see more of those films. I myself screen over 500 films a year, and other members of our committee will screen 200 to 300 at various festivals and recommend them to the committee as a whole.

JC: As the coordinator of the Tournée of Animation, what do you think are its main goals?

PW: I think the basic premise of the tournée is to find films from around the world which are outstanding in terms of their form, structure, techniques, stylizations, and characterizations. For example, we find that just about every other year we will end up with maybe one film each from Zagreb, the Pannonia Studio in Hungary, the Film Board of Canada. The second premise of the tournée is to provide a showcase for outstanding animation, and this includes everything from first films right up to professionals who have been in the business twenty to thirty years. We try to put together a balanced and entertaining package so that each tournée will have at least one film by a new filmmaker, one film by a professional, with a wide range in between.

The third premise of the tournée is to provide an alternative form of income for animators. The tournée is set up essentially as a nonprofit corporation by which we return fifty-five percent of the income to the participating artist and producers.

JC: Do you sign a contract with each individual filmmaker whose film is accepted for the tournée?

PW: As a rule, yes. Some, of course, have to be treated differently. For example, we're obliged to deal with the distribution arm of each Eastern European country—Polish films must come from FilmPolski, et cetera.

JC: I can think of a couple of people you've showcased who are very well known, like the late John Hubley and Bruno Bozzetto.

PW: Bruno was known to us in the international festivals, and about four years ago we began to program some of his films like *Opera* [1974] and *Self-Service* [1975], outstanding full-animation films. Here's a specific case where Bozzetto is a professional animator, but he makes his living from doing television ads, mostly animated ones. The films that we see in the tournée are what he and those like him call their "free" films—made as labors of love rather than as a matter of income.

JC: Do you ever use commercials?

PW: Particularly in the last few years, with so many animators doing ads, we're finding that the higher form of the art is often found in commercials. So now

Opera (1974) by Bruno Bozzetto, Italy's most re-nowned animator, was a selection of a recent International Tournée of Animation. (Courtesy Los Angeles County Museum of Art)

we have a few minutes in each program to highlight an animator such as Bob Kurtz who did that incredible Exxon ad which explains in thirty seconds about how oil is discovered. We've highlighted Haboush Company who used to animate here in Los Angeles, and Jeff Hale's Imagination Inc. in San Francisco. This year we're featuring the ads from three different animators from the ASIFA-East group.

JC: How long does the tournée travel?

PW: Each of the tournées tours for two years and then they expire.

JC: So two tournée programs would be touring at the same time?

PW: Right, but it takes about a year to get promotion and booking across the country. Many of the universities book a year ahead. When we première one at the museum here in Los Angeles, it sometimes takes a year to a year and a half to actually get to a college in North Dakota or in New York.

JC: And when you say the tournées expire, what happens to them physically? Do the films sit in your office?

PW: No, they're disassembled and the prints are returned to the filmmakers.

JC: Do you maintain an archive of all the past tournées?

PW: Yes, but the utilization of the prints is very restricted. We have to maintain a situation where we're not in competition with distributors.

JC: Once the films have been laid to rest and returned, the filmmaker is then free to do what he wants with his or her film?

PW: They are usually free even during the tournée to accept other bookings separately. Our only restriction is to ask the filmmakers not to enter their films in a competitive touring program during the first year of the tournée.

JC: That gets me back to distribution. What does it cost to rent the tournée package?

PW: We offer a straight rental agreement, which is a $300 minimum for the

tournée films against fifty percent of gross income. Because it's such a popular program, the universities and museums welcome it. They make a few dollars on it, the filmmakers make a few dollars on it, and everything works out pretty well. And places where the tournée has shown over the last three or four years will have especially good followings. I'm thinking of The High Museum in Atlanta and the Walker Art Center in Minneapolis, which have built audiences that come knocking at their door, the same as they do at the Los Angeles County Museum, now in its twelfth year of presenting the show.

JC: Would you say that the bulk of the audiences are college age?

PW: The mean audience is probably the older college student and the young married couples, mixed in with people in their forties and fifties who have grown up with either animation in the theatres or with some film society background. We don't particularly program the tournée for children.

JC: Do you find that the films have changed since you first became connected with the tournée?

PW: Yes, animation often reflects the social and political sensitivities of the times, We went years where everybody was doing films on ecology, and many years before that the animated form was one of the ways we saw free expression coming out of Eastern Europe. We have a very unique situation in the twelfth tournée. Over the years we've, of course, been under pressure for more women's animation. And naturally many women animators work on the films—Faith with John Hubley, Ruth Kissane who was the main animator in *John Henry* [1975]. But this year was unusual: we saw six different films by women, four of which we knew had no contact with each other, all of which involved women's fantasies about a bed and a window.

JC: Are these filmmakers all American women?

PW: No, they were from around the world: three from America, one from Canada, one from France, and one from Belgium. And it's sort of unique that four had this same theme that they were working from. So we have three of those films featured in the twelfth tournée—three window-bed fantasies, each with a different style of animation. One, *Toilette* [1977], by Joan Freeman of Boston; *Madsong* [1977] by Kathleen Laughlin of Minneapolis, a very strong message film; and a little erotic fantasy by Monique Renalt of Amsterdam called *À la Vôtre* [1977].

JC: Do you think that more films now are a result of the work of one person instead of a collaborative effort?

PW: I think it varies. The more professionally produced films have to be a collaborative effort. But it does seem that a particular person will have a period where we will put his films in two or three consecutive tournées. For the last years we've been featuring Paul Driessen, who is a Dutch animator working with the National Film Board of Canada, and which therefore entails a collaborative effort. We had his film *À Bout de Fille* [1975] in one tournée and the next year we had his little film *Air* [1976]. This year [the twelfth tournée] we'll show *Un Vielle Boîte* (An Old Box) [1977]. In a different vein, we've featured in the last three years the films of Gisele and Ernest Ansorge from Lausanne, Switzerland. They

An Old Box (1977), produced by Paul Driessen for the National Film Board of Canada, was also a selection of a recent International Tournée of Animation. (Courtesy Los Angeles County Museum of Art)

work as a husband and wife team who do everything themselves. The tournée functions as a showcase for young animators. In the past year we have featured Jim Gore's little film *Dream of the Sphinx* [1968], which Jim shot in 8mm and had blown up to 16mm. It's been noted for its graphics in *Graphis* magazine and well hailed in Europe. We've also highlighted Vince Collins from San Francisco, who's a beginning filmmaker, and Adam Beckett from the California Institute of the Arts, who contributed *Flesh Flows* [1974]. One of our noted successes is *Frankfilm* [1973], which appeared in the tournée before it won the Academy Award for Frank Morwis.

JC: Have you thought about showing the tournée on public television?

PW: We had one program for which I was a consultant—the National Animation Festival, which my colleague Sheldon Renan produced for public television. That survived twenty-six weeks, but there was no follow-up to that. The same thing proved true on airplanes. We thought that "in-flight" would be an ideal place because the animation could easily be broken up to service the length of flight—forty-five minutes, thirty minutes, one hour. But the answer we got was that the art form of animation was far too sophisticated for the audience. They wanted simply pure "take your shoes off" entertainment.

JC: We'll end this with your telling me something about ASIFA: the history of it, what it is.

PW: ASIFA ties in with the beginning of the animation festivals in the fifties, where the artists from different countries wanted to get together on a very informal artistic basis rather than a political basis. So they formed ASIFA, which means Association Internationale Filme d' Animation. This was started in Europe by many of the artists that we know—Norman McLaren was the first president and John Hubley was the vice-president, Les Goldman was involved, Alexander Alexieff, Ivanov Vano from Russia, Gyorgy Matolcsy from Hungary, John Halas from England. They formed this association, which at that time was no more than a couple of hundred members of animators, artists, and aficionados. ASIFA has grown now to include well over twenty-five different countries and well over 1,000 members. The largest group is the ASIFA Hollywood group. There are 300 formal members. The ASIFA-East has 175 and two years ago we started a branch in San Francisco which now has over 100 members. Another branch is starting in Chicago and another in San Diego.

JC: Do the local ASIFA chapters work directly with the tournée?

PW: It's a symbolic relationship. On occasion, the ASIFA relations in Europe are helpful in endorsing the program, permitting us to get certain films which otherwise might not be brought into this country. And we all did have a seed grant from ASIFA to get started, which was paid back the second year.

JC: How do you see the future of the tournée shaping up? What are your needs? How would you like it to change?

PW: The number of places where we exhibit has to increase so that the tournée can get on a better financial basis, afford to still pay the filmmakers the better percent of the income and yet still be able to afford promotion. Major publicity work is needed. We attended the National Entertainment Conference in Washington. That's a programming and booking conference for college students events programs. We had a booth there, and I flew to Washington, stayed there for four days in the booth describing the films. But that cost us over $1,200 just for three or four days. We don't have the money to do that where it's needed.

JC: Finally, what is the ultimate philosophical end of the tournée?

PW: I'd say the basic principle of the tournée is to put itself out of business. If the tournée works as well as it could, we would create such a demand for animation that it would be back in the theatres where it's supposed to be.

BIBLIOGRAPHY

ALPERT, HOLLIS. "The Manic World of Ralph Bakshi." *Saturday Review World* (March 9, 1974).

ANDERSON, YVONNE. "Film Animation at the Yellow Ball Workshop." *Design* (Fall 1967).

BAKER, ROBB. "Ralph Bakshi for the Defense." *The Soho Weekly News,* August 28, 1975.

BARRIER, MIKE. "The Filming of *Fritz the Cat* Part I." *Funnyworld* (Spring 1972).

———. "The Filming of *Fritz the Cat* Part II." *Funnyworld* (Fall 1973).

———. "Going by the Book." *Funnyworld,* no. 20 (Summer 1979). [*The Lord of the Rings, Watership Down*]

———. "John and Faith Hubley Transformed." *Millimeter* (February 1977).

———. "Lights Who Failed." *Funnyworld* (Fall 1977). [*Wizards, Raggedy Ann and Andy*]

———. "Triple Feature." *Funnyworld* (Spring 1971). [*A Boy Named Charlie Brown, The Phantom Tollbooth, The Aristocats*].

BECKERMAN, HOWARD. "Animated Women." *Filmmakers Newsletter* (Summer 1974). [Tissa David]

———. "In Memoriam: John Hubley." *Filmmakers Newsletter* (May 1977).

BEKE, GYORGY. "Ralph Bakshi—MOMA Will Never Be the Same." *Millimeter* (April 1975).

BERGER, JAN, and SANT' ANDREA, ALICE *et al.* Coalition Against Racism and Sexism. "Letter to the Editor." *The Soho Weekly News,* September 4, 1975.

CANEMAKER, JOHN. "Behind the Scenes with *Raggedy Ann and Andy.*" *Millimeter* (February 1976).

———. "George Griffin—Making Art Frame by Frame. *Funnyworld,* no. 20 (Summer 1979).

"Close Up: Tissa David, Jim Simon, Tobe T. Fedder." *Millimeter* (April 1975).

CRICK, PHILIP. "Notes on Jimmie Murakami." *Film* (Autumn 1965).

EYMAN, SCOTT. "The Young Turk—Junk–Culture–Junkie Takes on a Hobbit." *Take One* (November 1978). [An interview with Ralph Bakshi]

GILBERT, RICHARD. *"Fritz the Cat." Sight and Sound* (Autumn 1972).

HARBERT, RUTH. "Mr. Tom and Mr. Jerry." *Good Housekeeping* (March 1956). [Bill Hanna and Joe Barbera]

HUBLEY, JOHN. "Beyond Pigs and Bunnies—The New Animator's Art." *The American Scholar* (Spring 1975).

"Jim Simon." *Millimeter* (April 1975).

Kael, Pauline. *"A Boy Named Charlie Brown."* In *Deeper into Movies.* Boston: Little, Brown, 1973.

KAUSLER, MARK. "The Animation of 'Rings.'" *Funnyworld,* no. 20 (Summer 1979). [*The Lord of the Rings*]

NARDONE, MARK. "Saturday Morning Cartoons." In *TV Book.* Edited by Judy Fireman. New York: Workman Publishing, 1977.

OLSHAN, MIKE. "Interview with Ralph Bakshi." *Millimeter* (September 1974).

PEARY, DANNY. "The State of the Animator's Art." *L.A. Panorama* (August 18, 1976).

SCHENKEL, THELMA. "Poets of the Single Frame—New American Animators." *Millimeter* (February 1977).

SKOLNICK, SHARON, and SMITH, GAR. "Ralph Bakshi: 'No One Dies Easy in *Wizards.*'" *Image* (Spring 1977).

GENERAL BIBLIOGRAPHY

ADAMSON, JOE. *Tex Avery: King of Cartoons.* New York: Popular Library, 1975.

ALEXIEFF, ALEXANDER. "Reflections on Motion Picture Animation." *Film Culture,* 32 (1964).

ANDERSON, YVONNE. *Make Your Own Animated Movies: Yellow Ball Workshop Film Techniques.* Boston: Little, Brown, 1970.

———. *Teaching Film Animation to Children.* New York: Van Nostrand Reinhold, 1970.

ARMITAGE, PETER. "Animation." *Film* (Spring 1966).

Basic Titling and Animation for Motion Pictures. New York: Amphoto, 1970.

BECKER, STEPHEN. *Comic Art in America.* New York: Simon & Schuster, 1959.

BECKERMAN, HOWARD. "A Sly History of Style in the Animated Film." *Filmmakers Newsletter* (November 1976).

BENAYOUN, ROBERT. "Animation: The Phoenix and the Road-Runner." *Film Quarterly* (Spring 1964).

———. *Le Dessin Animé après Walt Disney.* Paris: Pauvert, 1961.

CABARGA, LESLIE. *The Fleischer Story.* New York: Crown Publishers, 1976.

CANEMAKER, JOHN. *The Animated Raggedy Ann and Andy: The Story Behind the Movie.* Indianapolis, Ind.: Bobbs-Merrill, 1977.

———. "June Foray—Woman of a Thousand Voices." *Millimeter* (April 1976).

COATES, ROBERT. "Contemporary American Humorous Art." *Perspectives USA,* 14 (1956).

CROY, HOMER. *How Motion Pictures Are Made.* New York: Harper, 1918.

CULSHAW, JOHN. "Violence and the Cartoon." *Fortnightly Review* December 1951).

DORFMAN, ARTEL, and MATTELART, ARMAND. *How to Read Donald Duck—Imperialist Ideology in the Disney Comic.* Translated by David Kunzle. New York: International General, 1975.

EDERA, BRUNO. *Full-Length Animated Feature Films.* Edited by John Halas. New York: Hastings House, 1977.

FANUCCHI, KENNETH. "Can't Place the Face, but the Voice Is Sure Familiar." *The Los Angeles Times,* October 10, 1976. [Daws Butler]

FAURE, ELIE. *The Art of Cinéplastics.* Boston: The Four Seas Company, 1923.

FEILD, ROBERT D. *The Art of Walt Disney.* New York: The Macmillan Co., 1942.

FINCH, CHRISTOPHER. *The Art of Walt Disney.* New York: Harry N. Abrams, 1973.

FORD, GREG. "The Hollywood Cartoon: A Soft-Cel Retrospective." *Take One,* 5, no. 1 (1976).

GEIPEL, JOHN. *The Cartoon.* Cranbury, N.J.: A. S. Barnes, 1972.

GOULD, MICHAEL. *Surrealism and the Cinema.* Cranbury, N.J.: A. S. Barnes, 1976.

GRIFFIN, GEORGE. *Frames.* Montpelier, Vt.: Capital City Press, 1978.

GRINDE, NICK. "Greasepaint, Inkwell and Co." *Screen Writer,* 2 (September 1946).

HALAS, JOHN, and PRIVETT, BOB. *How to Cartoon (For Amateur Films).* London: Focal Press, 1955.

————, and MANVELL, ROGER. *Art in Movement: New Directions in Animation.* New York: Hastings House, 1970.

————. *The Technique of Film Animation.* New York: Hastings House, 1968.

HENDERSON, DONALD. *Creators of Life—A History of Animation.* New York: Drake Publishers, 1975.

HERMAN, LEWIS. *Educational Films.* New York: Crown Publishers, 1965.

JOHNSTON, CLAIRE, and WILLEMAN, PAUL, eds. *Frank Tashlin.* Edinburgh: The Journal of the Society for Education in Film and Television, 1973.

JONES, CHUCK. "Animation Is a Gift Word." *AFI Report* (Summer 1974).

————. "Music and the Animated Cartoon." *Hollywood Quarterly,* 1 (1945–1946).

KINSEY, ANTHONY. *How to Make Animated Movies.* New York: The Viking Press, 1970.

KNEITEL, RUTH. "Out of the Inkwell." *World of Comic Art* (Fall 1966).

KYROU, ADO. *Le Surréalisme au Cinéma.* Paris: Le Terrain Vague, 1963.

LACASSIN, FRANCIS. "The Comic Strip and Film Language." Supplementary notes by David Kunzle. *Film Quarterly* (Fall 1972).

LUTZ, E. G. *Animated Cartoons.* New York: Scribners, 1920.

MADSEN, ROY. *Animated Film: Concepts, Methods, Uses.* New York: Interland, 1969.

MALTIN, LEONARD. *The Disney Films.* New York: Crown Publishers, 1973.

MANVELL, ROGER. *The Animated Film.* New York: Hastings House, 1955.

————. "Giving Life to the Fantastic." *Films and Filming* (March 1963).

MARTIN, ANDRÉ. "Animated Cinema: the Way Forward." *Sight and Sound* (Spring 1959).

MCCAY, WINSOR. *Dreams of a Rarebit Fiend.* New York: Dover Publications, 1973.

MEKAS, JONAS. "On the Misery of the Animated Cartoon." *The Village Voice,* July 27, 1967.

MILLER, DIANE DISNEY. *The Story of Walt Disney.* As told to Pete Martin. New York: Henry Holt, 1956.

MUSSEN, PAUL, and RUTHERFORD, ELDRED. "Effects of Aggressive Cartoons on Children's Aggressive Play." *Journal of Abnormal and Social Psychology,* 62 (1961).

PALMER, CHARLES. "Cartoons in the Classroom." *Hollywood Quarterly* (Fall 1947).

POLT, HARRIET. "The Death of Mickey Mouse." *Film Comment* (Summer 1964).

PONCET, MARIE-THÉRÈSE. *L'Esthétique du Dessin Animé.* Paris: A. G. Nizet, 1952.

Retrospective Mondiale du Cinéma d'Animation. Montréal: La Cinémathèque Canadienne, 1967.

RUSSETT, ROBERT, and STARR, CECILE. *Experimental Animation.* New York: Van Nostrand Reinhold, 1976.

SCHICKEL, RICHARD. *The Disney Version.* New York: Simon & Schuster, 1968.

SCHWERIN, JULES. "Drawings That Are Alive." *Films in Review* (September 1950).

———. "Galloping Mirror of Nature." *Theatre Arts* (October 1949).

———. "The Rise of the Movie Cartoon." *Tomorrow* (June 1950).

SELDES, GILBERT. *The Public Arts.* New York: Simon & Schuster, 1956.

SHALE, RICHARD ALLEN. "Donald Duck Joins Up: The Walt Disney Studio During World War II." Ph.D. dissertation, University of Michigan, Ann Arbor, 1976.

SMITH, ALBERT E., and KOURY, PHIL A. *Two Reels and a Crank.* Garden City, N.Y.: Doubleday & Co., 1952.

STEPHENSON, RALPH. *Animation in the Cinema.* New York: A. S. Barnes, 1967.

STRAVINSKI, IGOR, and CRAFT, ROBERT. *Expositions and Developments.* Garden City, N.Y.: Doubleday & Co., 1962.

TAYLOR, DEEMS. *Walt Disney's Fantasia.* New York: Simon & Schuster, 1940.

THEISEN, EARL. "The History of the Animated Cartoon." *Journal of the Society of Motion Picture Engineers* (September 1933).

THOMAS, BOB. *Walt Disney: The Art of Animation.* New York: Simon & Schuster, 1958.

———. *Walt Disney: Magician of the Movies.* New York: Grosset & Dunlap, 1966.

THE CONTRIBUTORS

Joe Adamson is the author of *Groucho, Harpo, Chico, and Sometimes Zeppo* (1973) and *Tex Avery: King of Cartoons* (1973). He has administered oral histories on early animation for the American Film Institute and taught at Penn State University.

Art Babbitt was a chief animator at the Disney Studio through the 1930s and later worked with John Hubley at UPA. He has taught at the University of Southern California and at Richard Williams's Studio in London.

Tom Bertino is an animation historian who writes regularly for *Mindrot*.

Peter Brunette is an associate professor of English at George Mason University in Virginia. He has published in *The Chronicle of Higher Education, Cinéaste, Film Comment,* and *The Washington Post,* and has edited a book of American readings for French university students.

Leslie Cabarga, an illustrator living in San Francisco, is the author of *The Fleischer Story* (1976).

John Canemaker is a prolific writer of articles on the history of American animation and has produced and hosted network television documentaries on Otto Messmer and Oskar Fischinger. He is the author of *The Animated Raggedy Ann and Andy: The Story Behind the Movie* (1977).

Joan Cohen is Assistant to the Director of Film Programs at the Los Angeles County Museum of Art and a free-lance writer and researcher in the area of film.

E. E. cummings (1894–1962) is the renowned American poet who in 1947 wrote a famous essay on Krazy Kat.

Susan Elizabeth Dalton is the head archivist of the Wisconsin Center for Film and Theater Research in Madison. She is the former coeditor of *The Velvet Light Trap*.

Sybil DelGaudio teaches film at Brooklyn College and The New School for Social Research and is a member of NOW's Images of Women in Film Committee.

William de Mille, brother of Cecil B. de Mille, was a director and executive at Paramount Pictures in the 1920s and 1930s.

Manny Farber is the author of *Negative Space* (1971), a sampling of his extensive critical writing from *The New Republic, Cavalier, Film Culture, The Nation,* and *Artforum.* He teaches Cinema at the University of California, San Diego.

David Fisher wrote for *Sight and Sound* in England during the 1950s.

E. M. Forster (1879–1970) is the distinguished British novelist.

George Griffin is an award-winning independent animator who has taught at New York University and Harvard University. A 1977/78 recipient of a Guggenheim Fellowship, he edited *Frames* (1978), a selection of drawings and statements by independent American animators.

William Horrigan has written for *Jump Cut* and *The Velvet Light Trap* and served as editor of *The Northwestern Reader*. He is completing a Ph.D. dissertation on film melodrama at Northwestern University.

I. KLEIN, eighty years old, has recently composed memoirs of his days as animator of the Katzenjammer Kids, Mutt and Jeff, and Mighty Mouse. His writings have been featured in *Cartoonist Profiles, Film Comment,* and *Funnyworld.*

BARBARA HALPERN MARTINEAU teaches film production and theory at Queen's University in Toronto and has made a documentary about day care. She has written many film articles from an evolving feminist perspective for *Women and Film, Cinema Canada, Breaking Out,* and other publications

PATRICK MCGILLIGAN was arts editor for *The Real Paper* in Boston. He is the author of *Ginger Rogers* (1975) and *James Cagney: the Actor as Auteur* (1976) and is completing a book on Karl Armstrong, who was jailed in Wisconsin for blowing up the Army Math Research Center in 1969.

MARK NARDONE studied film at the University of Southern California, specializing in screenwriting. He wrote on television animation for *TV Book* (1977).

HOWARD RIEDER is director of advertising for a California toy and hobby corporation and has written, produced, directed, and acted in the broadcasting medium. He has an M.A. in Cinema from the University of Southern California.

RONNIE SCHEIB has taught French at Rutgers University and written on Hitchcock for *Film Comment.* She is working on books about William Wellman and Ida Lupino.

ROBERT SKLAR, author of *Movie-Made America: a Cultural History of American Movies* (1976), is Chairman of the Cinema Studies Department at New York University. He writes regularly for *American Film* and *The New York Times Book Review.*

EUGENE SLAFER is an independent screen writer and producer and has worked for several years in network television in Los Angeles.

CONRAD SMITH has taught at Temple University and currently teaches journalism at Idaho State University.

PETER STAMELMAN is an agent working in Los Angeles and has been West Coast editor for *Millimeter.*

RICHARD THOMPSON has taught Film at the American Film Institute, the University of California, Riverside; the University of California, San Diego; and UCLA, where he has finished his Ph.D. in film-critical studies. Currently he is chairman of the Cinema Studies Division at La Trobe University in Australia. He writes regularly for *Film Comment,* among other publications.

GREGORY A. WALLER has taught Film and English at SUNY, Stony Brook; the University of Nevada, Las Vegas; and currently, the University of Kentucky.

MICHAEL WILMINGTON coauthored *John Ford* (1976) with Joseph McBride, and has written numerous articles for *The Velvet Light Trap.* He is the film reviewer for *The Press Connection* in Madison, Wisconsin, and a correspondent for *The Real Paper* in Boston.

INDEX

Page references for illustrations are in **boldface** type.